Vanished Kingdoms

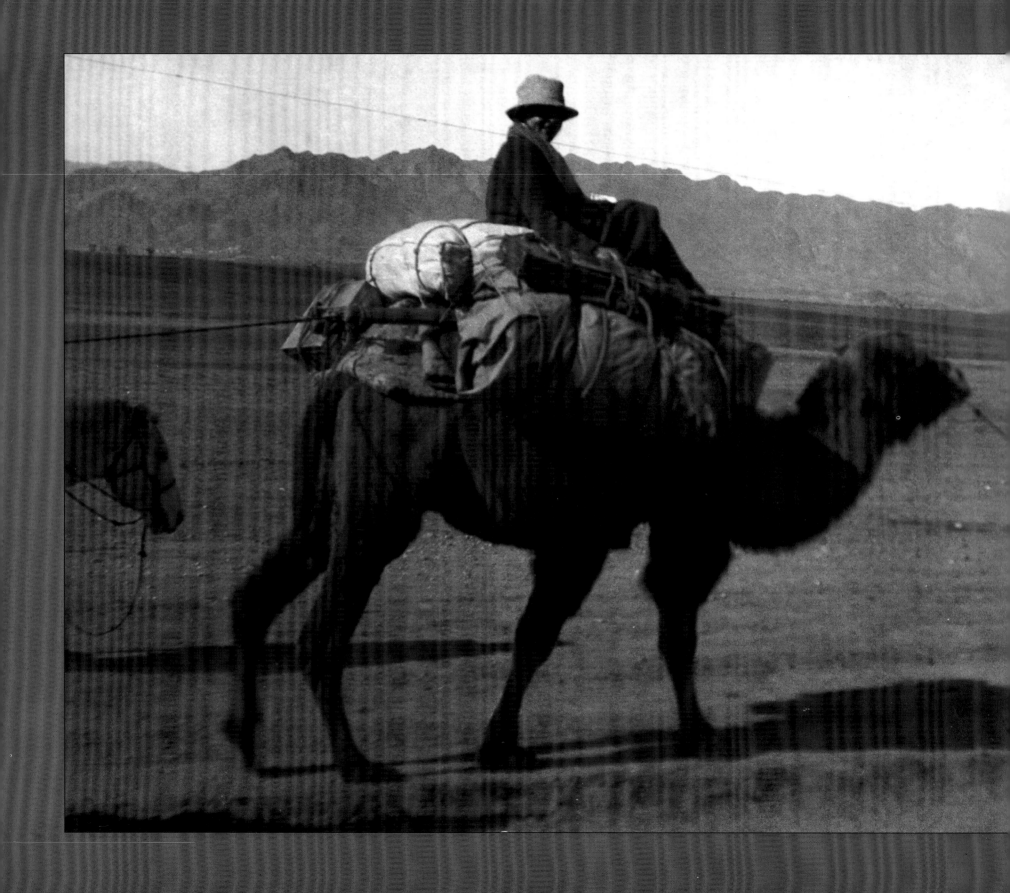

Women explorers have been compared to shadows flitting across a landscape.[1] Few have left records. Their footprints have vanished in the sands, and their memoirs have often been published anonymously.

Janet E. Wulsin arriving by camel in Yirgo, Shansi, October 1921.

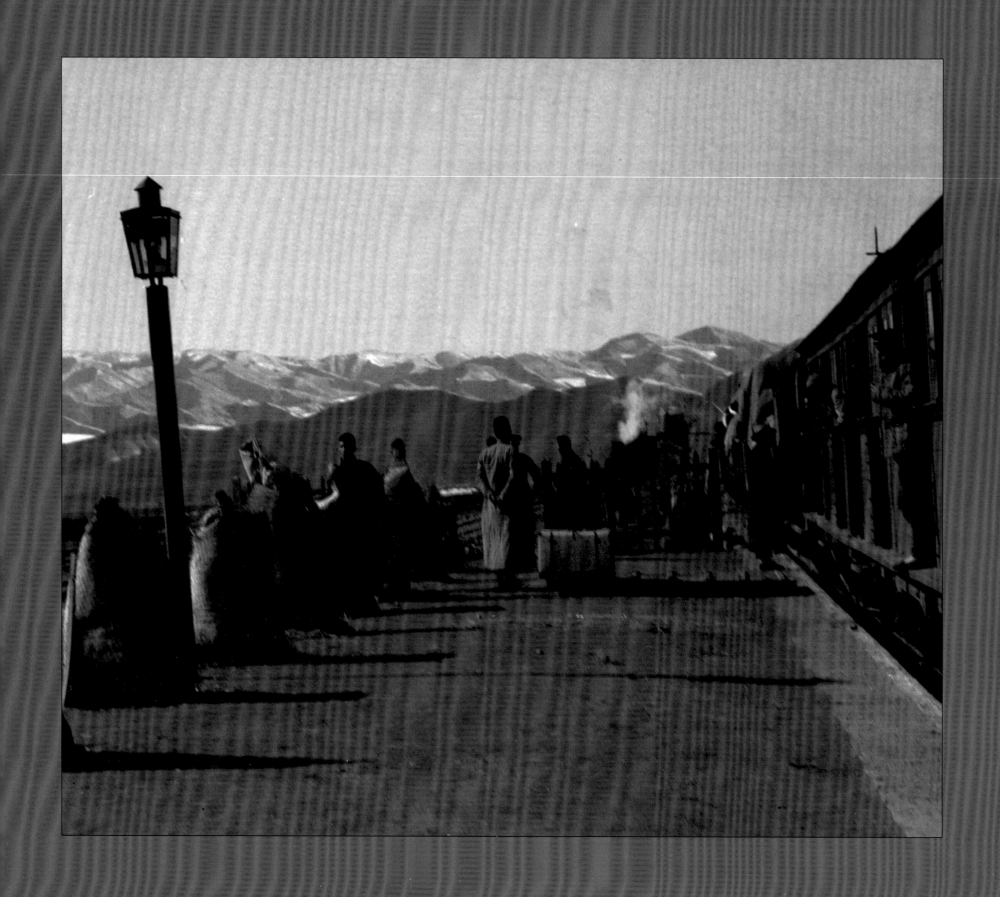

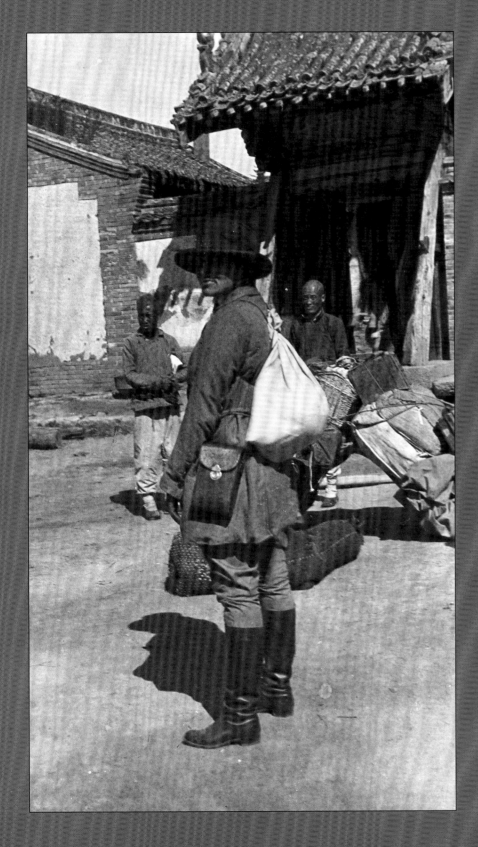

Women explore differently from men: they often let their instincts guide them, following the trail wherever it leads.[2] *Janet Wulsin was no exception.*

Opposite: The end of the line: the railroad station in Kweiwhating, Shansi. *"An excellent narrow gauge railway, built by French capital, crosses the mountains of Eastern Shansi, and ends at Taiyuanfu, the provincial capital. The mountains are covered with snow in early November, and the shrubs on the platform are carefully packed in straw to protect them from frost."* —Frederick R. Wulsin (F.R.W.), November 1921

Janet preparing to travel by mule litter on her first expedition, Taiyuanfu, Shansi, 1921.

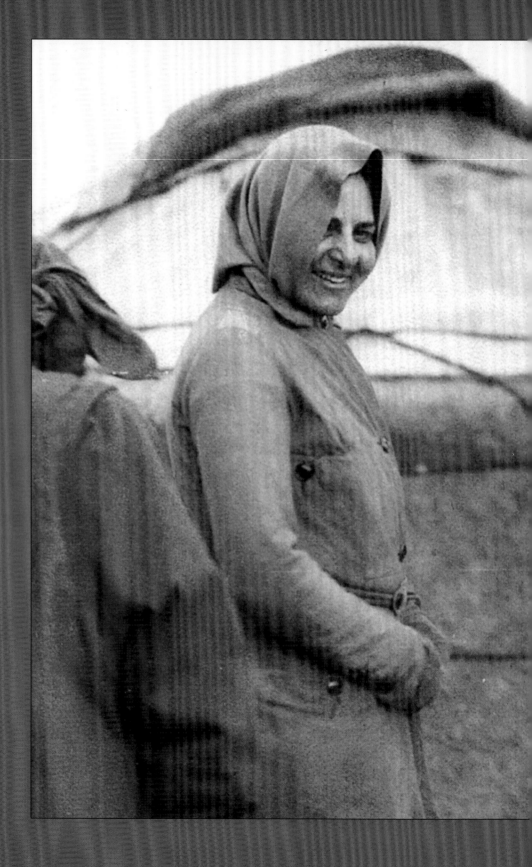

While traveling with her scientist husband, she recorded the sights, sounds, and smells of the now-vanished kingdoms she discovered, bringing them to life in her writings.

Janet at Ta Shui K'o, an Alashan Desert oasis, in front of a Mongol yurt, April 1921.

Page eight: Temples outside Wang Yeh Fu, Mongolia on the edge of the Alashan Desert, Kweiyuanfu, Shansi, May 1923.

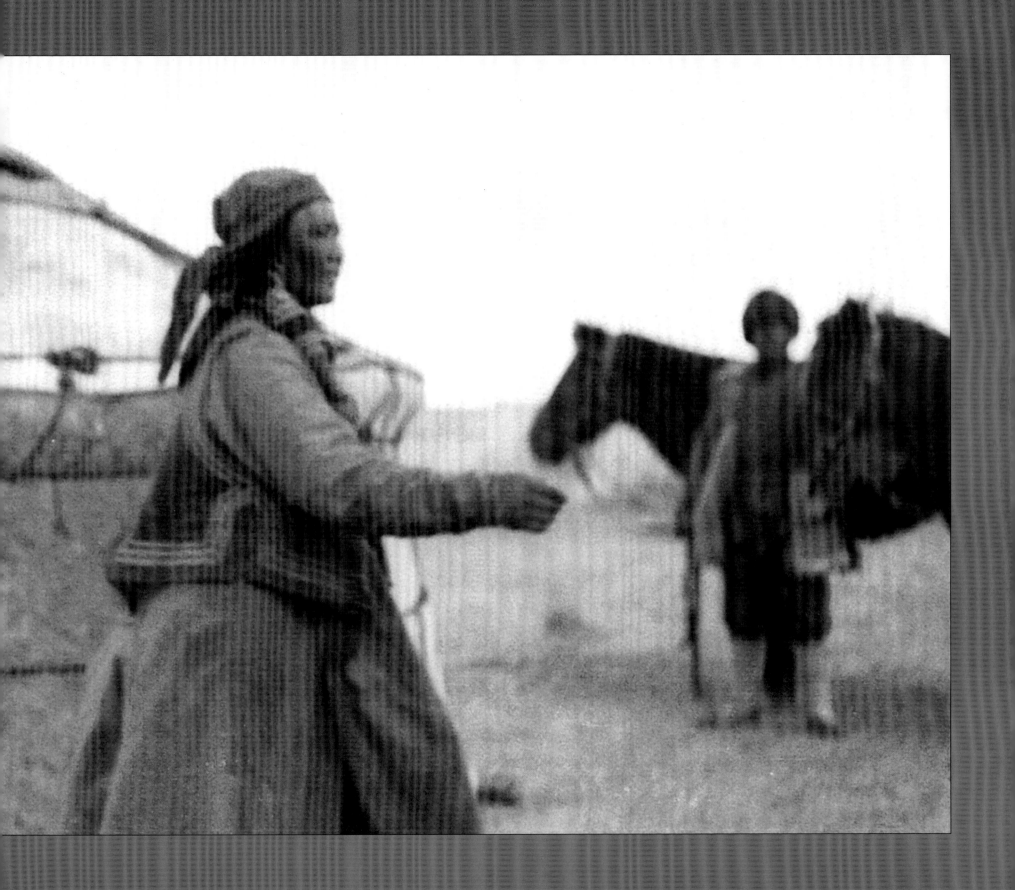

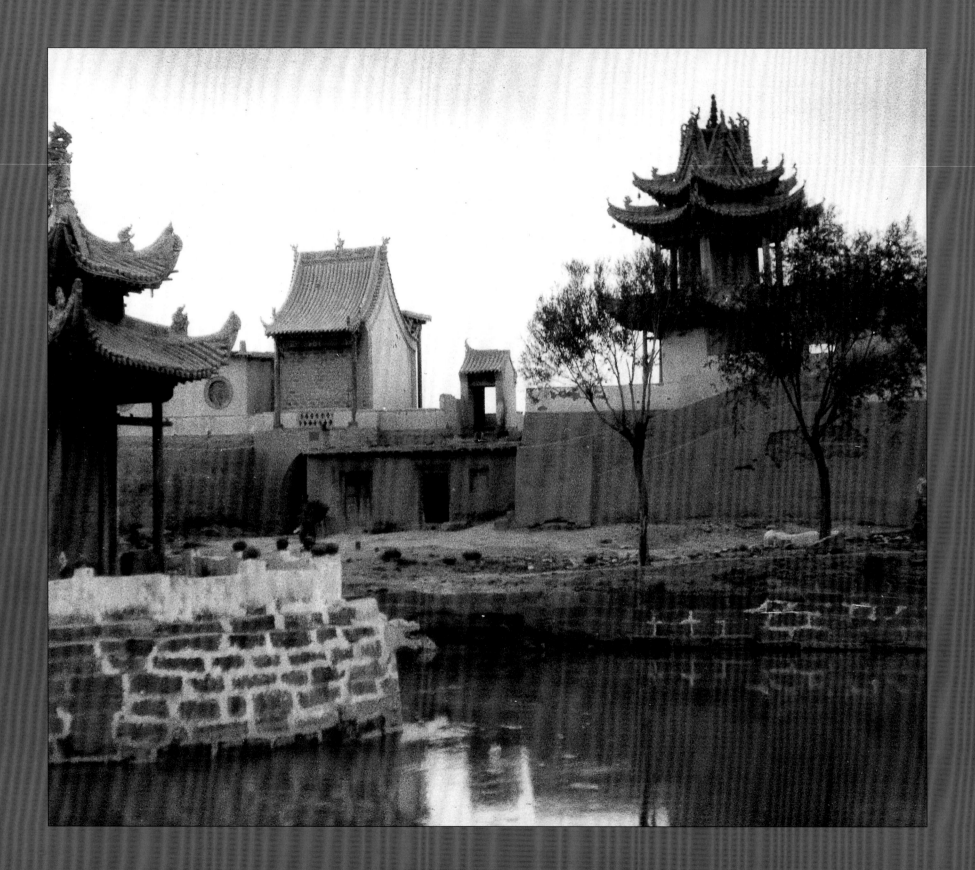

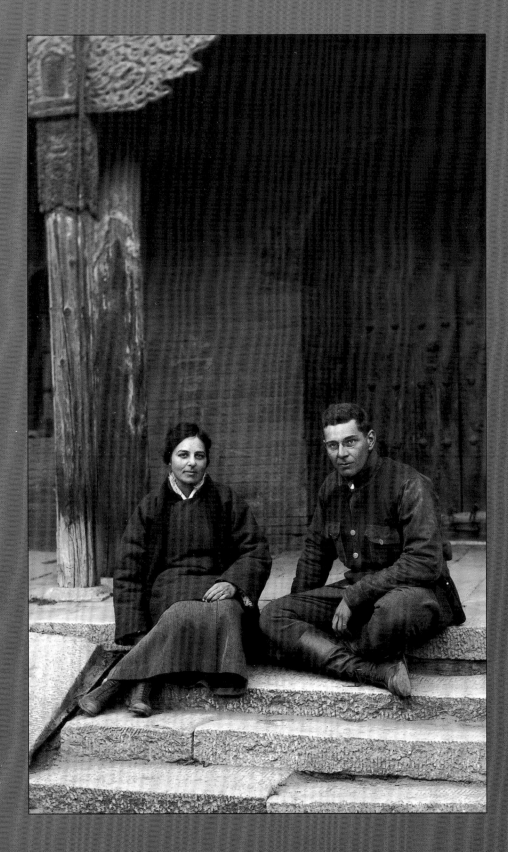

*Among the hills of the Tibetan borderlands,
the sands of Inner Mongolia, and the fading glory
of Imperial Peking she found fulfillment
never equaled in her life in America.*

Janet and her husband, Frederick R. Wulsin, on the steps of their temple lodgings, Shansi, October 1921. The country Buddhist shrines resembled medieval monasteries, with a few monks who welcomed travelers.

Frontispiece: The Chanting Hall at the Great Monastery at Labrang, Tibet, August 1923.

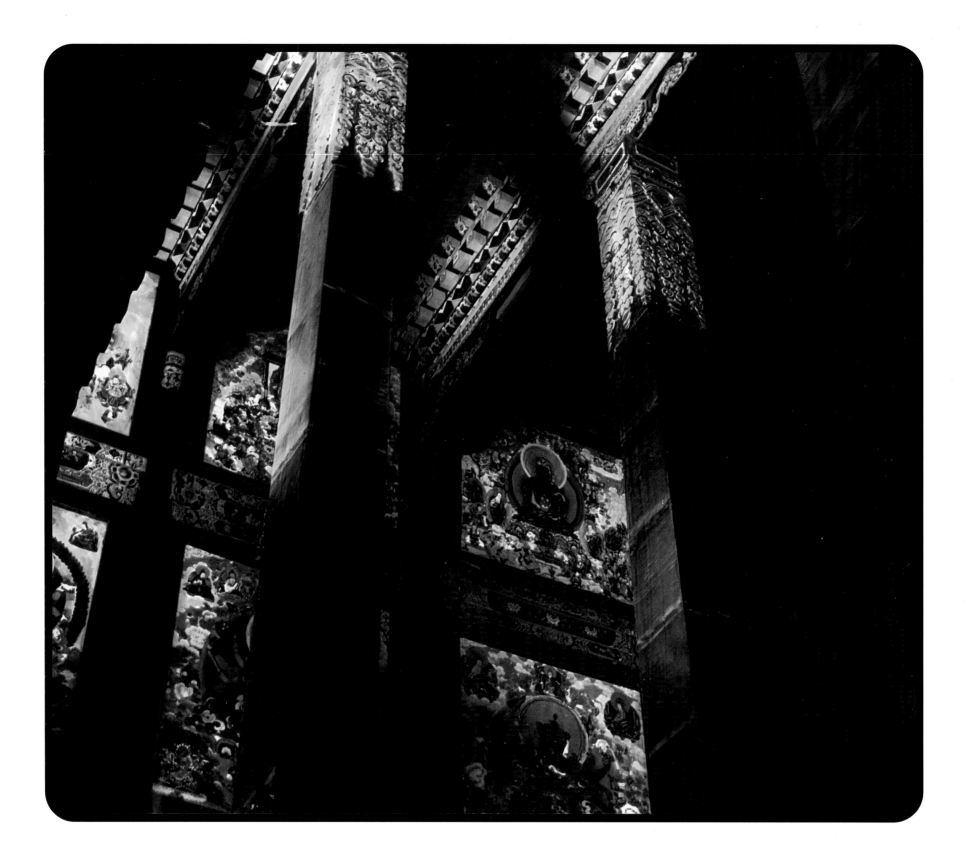

Vanished Kingdoms

A WOMAN EXPLORER IN

Tibet, China & Mongolia

1921 – 1925

BY MABEL H. CABOT

Preface by Dr. Rubie Watson

APERTURE *in association with* THE PEABODY MUSEUM OF ARCHAEOLOGY AND ETHNOLOGY, HARVARD UNIVERSITY

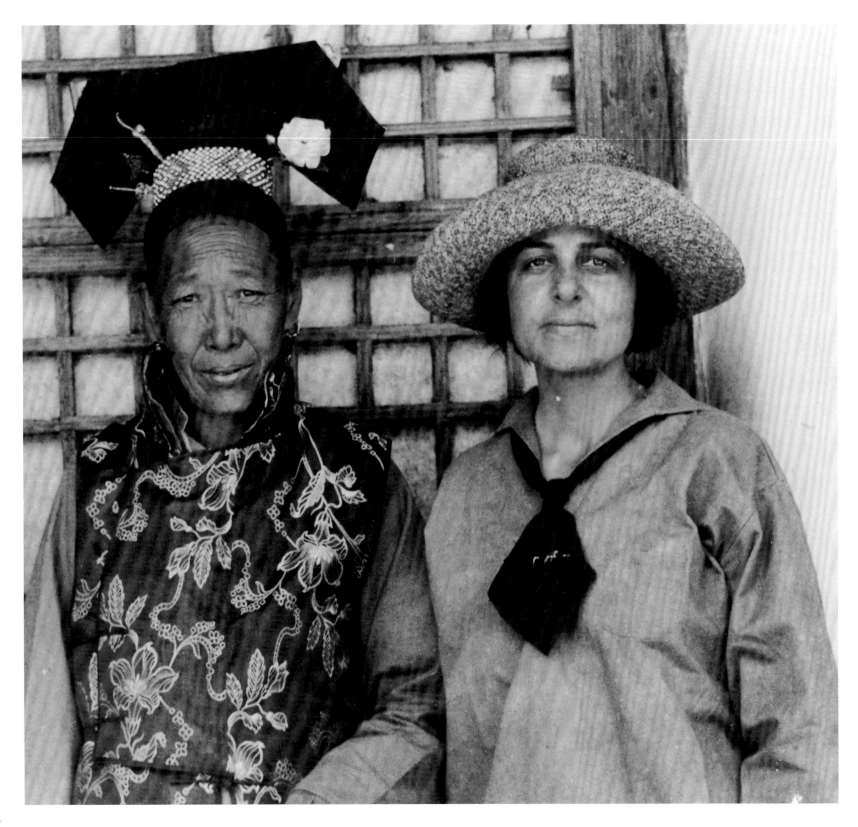

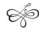

TO JANET JANUARY ELLIOTT

out from the shadows at last

Janet and the mother of the Prince of Alashan in court dress, Wang Yeh Fu, Mongolia, May 1923.

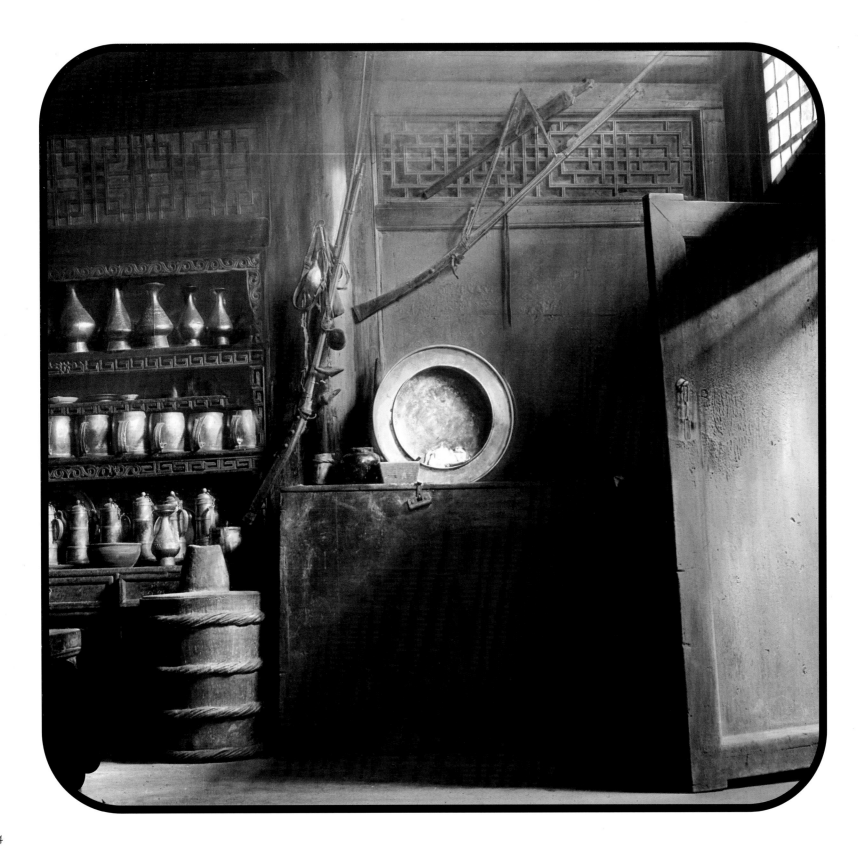

PREFACE

In April of 1921 Janet Elliott Wulsin set out with her husband Frederick Wulsin for China. Although her husband's interest in China's natural and cultural history provided the stimulus for their journey, Janet Wulsin was not a passive bystander to his pursuits. During their residence in Peking and travels in northwestern China, she prepared specimens for transport, developed and documented thousands of photographs, and recorded her vivid impressions of the people and landscapes she encountered. Janet Wulsin's diaries and letters to her family and friends reveal a sometimes reluctant but always observant traveler. Her words and the Wulsins' photographs have been beautifully woven together by her daughter, Mabel H. Cabot, in such a way that we can both see and read about Mongol caravans, the great lamasery at Choni, remote villages in Kansu, and elaborate Buddhist rituals. Mabel H. Cabot has produced a book in which words and photographs meld to create a set of dramatic images.

Vanished Kingdoms chronicles Janet Wulsin's growing self-confidence and interest in China's western frontier. During many months of arduous and sometimes dangerous travel, she met people and experienced places that were completely foreign to what she had heretofore known as the sheltered daughter of a prominent Boston family and dutiful wife of an aspiring naturalist. Her descriptions—still fresh—retain a sensitive directness that make them not only informative but also a pleasure to read.

The Wulsins traveled and collected during a period of great change when exploration was giving way to more institutionalized forms of research and study. Their standards for success were very much those of the nineteenth-century explorers whom they respected and emulated, and Janet Wulsin describes their frustrations and triumphs in this regard. Also striking are her intimate passages about expedition housekeeping—packing camels, meals good and bad, finances, specimen preparation, hospitality received and offered, and the social life of Peking's foreign community during the early 1920s.

Both Janet and Frederick Wulsin became proficient photographers, although Frederick was responsible for the bulk of the expedition's photographs. Through teamwork, the photographic record that the couple created and documented is significant in both its breadth and detail. Their photographs are extraordinary not because of their technical or artistic virtuosity (although they are certainly good), but because they offer rare glimpses of a part of China's visual past that has been poorly documented. In some cases, present-day travelers can see what Janet Wulsin saw more than seventy-five years ago, but for the most part the temples, towns, and villages pictured in these photographs no longer exist or have been dramatically altered. And, of course, the people and many of the customs the Wulsins captured on film have disappeared forever.

The Wulsin Collection, the source of many of the photographs that appear here, was donated to the Peabody Museum in the 1950s. It contains a remarkable archive of over 1,900 photographs, negatives, and lantern slides augmented by written materials. More than two thirds of this collection pertains to China and Southeast Asia. In 1979, an exhibit, *China's Inner Asian Frontier: Photographs of the Wulsin Expedition to Northwest China in 1923*, and a book by the same title highlighted a selection of photographs from the collection. *Vanished Kingdoms* is an important addition to this earlier work and to the published work of Frederick Wulsin himself. Together these publications provide different but complementary perspectives on an expedition and a time and place that continue to command our interest and attention. Through painstaking research using photographs, family records, and archives at Harvard University, the author has produced a uniquely readable and visually compelling account of a remarkable journey through the eyes and pen of Janet Wulsin. Once again, it is exciting to see this collection come to life. As director of the Peabody Museum and as someone with a long-term interest in China, I am very grateful for the author's skill, sensitivity to detail, and perseverance in bringing to light her mother's extraordinary travels in China.

DR. RUBIE WATSON

Director, The Peabody Museum of Archaeology

and Ethnology, Harvard University

Opposite: Tibetan kitchen with a matchlock gun hanging on the wall, Archuen, Kansu, 1923.

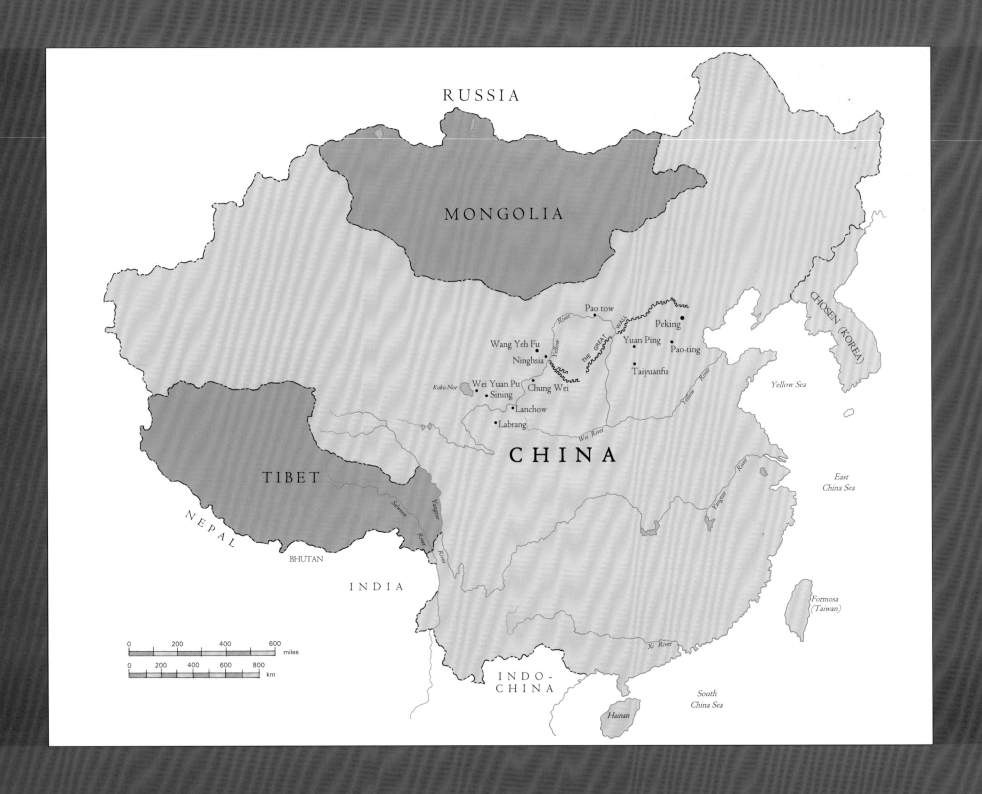

RUSSIA

MONGOLIA

TIBET

NEPAL

BHUTAN

INDIA

INDO-
CHINA

CHINA

River

Pao tow

Peking

Wang Yeh Fu

Yuan Ping

Ninghsia

Pao-ting

Yellow

THE GREAT WALL

Taiyuanfu

Koko Nor

Wei Yuan Pu

Chung Wei

Sining

Yellow River

Lanchow

Labrang

Wei River

Yangtze River

Salween River

Yangtze River

Yellow Sea

CHOSEN (KOREA)

East
China Sea

Formosa
(Taiwan)

Xi River

South
China Sea

Hainan

0 200 400 600 miles

0 200 400 600 800 km

BOOK I

~ PARIS TO PEKING ~

WHERE IT ALL BEGAN

Little in Janet Elliott Wulsin's background had prepared her for her adventures in the far reaches of China, Tibet, and Mongolia. The daughter of the president of the New York, New Haven, and Hartford Railroad, she had been raised in the sheltered microcosm of affluent Boston and New York during the fading years of the Gilded Age. Hers was the cloistered world of Edith Wharton, where decorum and manners were of primary importance. Janet studied literature, poetry, music, and some history, but her exposure to mathematics and the sciences was minimal. First and foremost, her Southern mother schooled her in the domestic arts in preparation for a good marriage. She was educated at Miss Porter's School, a finishing school in Farmington, Connecticut, but was forbidden to apply to Bryn Mawr by her autocratic father, who decreed that "ladies don't go to college."

While she was growing up Janet had often traveled with her railroading father, exploring the Pacific Northwest. These journeys nurtured her innate sense of curiosity about new lands, which would become a defining element of her character. An adventurer at heart, she was intelligent, imaginative, and headstrong, with dark hair, large, dark eyes and an infectious laugh.

During her early twenties, as World War I progressed, Janet became increasingly restless. The superficial social life of her world in New York bored her. On her twenty-fourth birthday, she responded to a summons from the American Red Cross that requested "two thousand women for canteen and hospital and hut service in France." They called for "the highest type of American woman . . . strong, cheerful, energetic, self-reliant, and typically American, capable of self-sacrifice and devotion"[3] —a description that suited Janet perfectly. In October of 1918 she sailed for France on a troop ship of sixteen hundred soldiers and sixteen Red Cross nurses and aides. She wanted to support the war effort—and to be near her fiancé, Frederick Roelker Wulsin, an officer on the Belgian front.

Frederick was a handsome twenty-six-year-old who had graduated from Harvard in 1913 with a degree in engineering. Fascinated by tales of exploration and foreign adventure ever since he was a boy in Cincinnati, after graduation he had spent a year traveling through East Africa and Madagascar collecting specimens for Harvard's Museum of Comparative Zoology. At the conclusion of his trip to Africa he wrote to his mother in Paris, "I really think now that this—a mixture of scientific exploration and collecting—is the work I was born for, and I see that I have a fair sort of knack at this and what I want now is training in zoology, botany, geology, anthropology and practical astronomy, so that when I travel I can do every bit of scientific work that circumstances permit and do it properly."[4]

Upon his return to America, Frederick took a job as an engineer in the Allied Machinery Company. At the outbreak of the war in 1917, he enlisted vol-

EDITOR'S NOTE: Chinese place names used are those in common usage in 1921–1925. See pages 180–181 for an itinerary and modern Pinyin glossary.

17

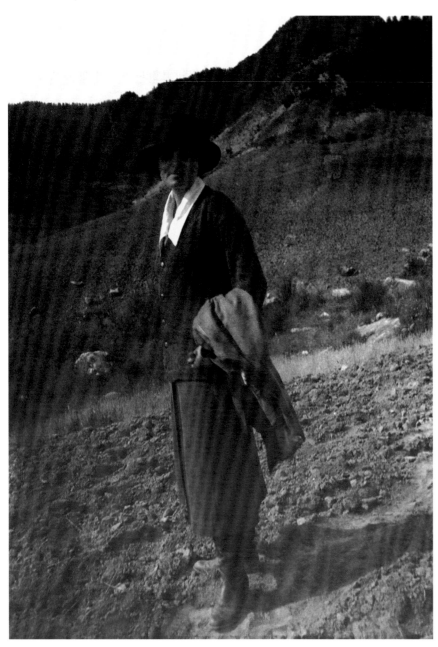

Janet in the Western Hills outside of Peking, dressed in boots from Italy, long skirt from Paris and black felt hat from New York, spring 1921.

untarily in the army and achieved the rank of first lieutenant. He had been impatient and unchallenged at the company, and resolved not to return to it but to pursue a life of exploration after the war.

He and Janet met at a ball in Boston in 1917. The crisis of World War I quickly propelled their courtship from dancing at house parties on Long Island to weekends with friends in New Hampshire. There they motored in the country, walked in the woods, and talked for hours about Frederick's travels in Africa and his dreams of further exploration. Janet had never met anyone like him, and was enthralled. He was charismatic, intense, and used to getting his own way.

In September 1917 Frederick wrote to his mother:

It's funny we seem to have been brought up in much the same way, and have the same point of view on many little things. With each day that passes, even when we are apart, we seem to grow closer together. Being with her is not like being with somebody else, but like being with myself, complete, and the rest of the time being about half a self. She feels the same way.[5]

After meeting Janet's father, Howard Elliott, later in New York and officially asking for her hand, Frederick proudly wrote, "I think the day is won."[6] He continued, "Janet wants to wait 'til I am back from the war for the wedding, so we will do that. I surreptitiously sneaked into Cartier's and Tiffany's yesterday, and looked at some rings." Despite the fact that he was going through what he called "a period of acute poverty," Frederick sold some shares of stock to buy Janet a ring. "I want to give Janet all I can now, while I have the chance," he wrote. "After the war I can make more [money]."[7] In the meantime, he presented Janet with a duck-shaped pin given to him by his mother, adding two sapphires to symbolize the two most important women in his life.[8]

Despite Frederick's limited finances, he never neglected his charismatic and domineering mother, Katharine Roelker Wulsin, who lived in Paris. During the war he managed to send her hundreds of pounds of sugar, oatmeal, cornmeal, and hominy, provisions unavailable in war-torn Paris. She was the most influential person in his life, and Frederick continually confided in her. Although she would often challenge him about affairs of state as well as his

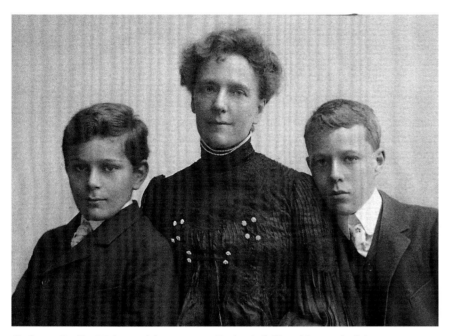

Katharine Roelker Wulsin with her two sons, Frederick (left) and Lucien (right), Cincinnati, Ohio, 1903.

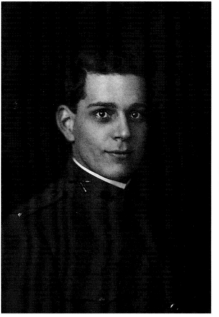

Frederick Roelker Wulsin as a young lieutenant in the United States Army during World War I, Paris, 1918. *Right:* Janet (left) as a nurse's aide in the American army hospital in Paris, where she became the Red Cross director of thirty wards, May 24, 1918.

own life, theirs was a deep intellectual and emotional bond.[9] As Frederick wrote to her in 1921, "You can be sure that I will never take an important step without consulting you first."[10]

In the few weeks that remained before he was sent to the front, Frederick and Janet spent as much time together as possible. The starry-eyed young lieutenant wrote to his mother, "You have no idea what a wonder she is."[11] Frederick joined his Forty-second Infantry Division in October 1917 and proceeded to Belgium, where he saw active duty and for his valor was decorated by the Belgian government with the Belgian War Cross. He wrote to Janet frequently during the war, but shielded his mother from the knowledge that he was often caught on the line of fierce battles. Finally, in late December 1918, he was reposted to Paris in the Signal Corps.

PARIS, 1918

When Janet arrived in Paris on December 5, 1918, she went immediately to the apartment of her future mother-in-law, whom she had never met. It was only weeks after the armistice treaty ending World War I had been signed by President Woodrow Wilson and Maximilian, Prince of Baden.

Katharine was the first female intellectual that Janet had ever met. She was also the first person to take Janet's quick mind seriously—as seriously as Janet's own mother took the arrangement of her wardrobe. As a young woman, Katherine had married Lucien Wulsin, chairman of the Baldwin Piano Company of Cincinnati, and raised their two children in their palatial house, "The Hermitage," while he directed his company to a large fortune. After Lucien's death

in 1912, swathed in elegant widow's weeds and ropes of pearls, Katharine broke with tradition and returned to Europe, where she had been educated. In her elegant eighteenth-century *hôtel particulier* she hosted international political and military leaders before and during World War I. Aubusson tapestries, busts by Houdon, and the only known life portrait of Benjamin Franklin by Greuze welcomed the steady stream of visitors as they entered the parquet entrance hall. She was painted by many of the leading French painters of her day, and was at ease in the world of foreign intellectuals and politicians. Katharine remained in Paris throughout World War I, reading voraciously in several languages and writing a voluminous correspondence to her family back in Ohio. In Janet she found the daughter she never had, and she set about cultivating Janet's capable young mind. Katharine introduced her to a new world of literature and ideas, and opened intellectual horizons alien to Janet's staid, conventional family. Janet wrote home, stating, "Each day is full to overflowing with things of great interest and some of historic values."[12]

Meanwhile, the small print of Janet's contract with the Red Cross in France revealed unexpected challenges. Not only would her position require that she "run a branch of the Government Quartermaster's store, dispense hot soft drinks, run the Red Cross hospital library, [and] initiate the holding of classes and lectures," but she would also "gather casualty information, in a work requiring great tact, sympathy and resourcefulness, write letters for the soldiers, and perform many other tasks for which the nurses have no time."[13] Despite the hard work, Janet enjoyed the challenges and excelled at her duties. Her Red Cross supervisors quickly recognized her tremendous administrative skills, and after less than a year of service she was put in charge of all Red Cross activities for thirty wards at the American Army hospital in Paris.

Janet's life in France was a mosaic of contrasts. By day she would comfort dying soldiers, write their final letters home, and light their last cigarettes. By night she would sit at Katharine's gleaming table, discussing the reconstruction of France with key officials, journalists, and intellectuals while eating delicious food and sipping the finest wines.

She was crestfallen to be so late in serving in the war effort, but determined to help in the reconstruction of shattered France. Her first letter home shimmers with excitement as she describes the entrance of President Wilson into Paris after the armistice: "After breakfast I looked out of my window on the Place du Palais Bourbon right across at the Chambres des Deputies where masses of people were waiting to watch Clemenceau come out and enter his motor. Most of them were women, in the deepest mourning with little children—and some were soldiers in their beautiful blue." They had a spectacular vista:

Such a view—the Arc de Triumph on one end and the Place de La Concorde on the other—and all along the line of march the French poilus [regular French troops], just as they came home from the war—muddy uniforms, knapsacks...everything. They were magnificent, and they were our defenders. Here and there was a group of young lancers on their horses carrying their red and white regimental colors. But the French poilus made me weep. People were up in the trees, on the roofs, at the windows, vegetable carts had been dragged over and whole families sat on top, many brought ladders, and old women, girls, boys, wounded men sat on each rung—and . . . as we looked down on the crowds, you could see every nationality—our own dough-boys [enlisted soldiers] and sailors, Tommies [British troops], Anzacs, Hacks from Africa, Belgians with their picturesque headdresses—and girls in all manner of uniforms, and the young French girls heavily draped in black. Pretty soon the sun came out, the poilus stiffened up—and there was a great sound of whistling and movement—and a lovely Airedale tore down the Avenue. Everyone cheered and said, "go it boy." Then after several minutes arrived the gendarmes on their bicycles, all in their dark blue uniforms and their capes, and then, before we knew it the open carriage with the two Presidents—our own smiling and bowing to everyone—and all the people waving handkerchiefs and American flags and crying "Vive Wilson...."[14]

This infectious atmosphere swept up the young American Red Cross worker. "I stopped and bought all sorts of things for my men, American flags, French rosettes, tiny Dough Boy and poilus hats made out of tin that one can pin on one's coat. Everywhere the Dough Boys salute us—it is a real tribute to the Red Cross, but makes me feel very awkward as I never know what to do in recognition—women are not supposed to salute."[15]

The telegram from Frederick to his mother, Katharine R. Wulsin, in Paris, announcing his engagement, 1917. *Above*: Lieutenant Frederick R. Wulsin and his bride, Janet January Elliott Wulsin, on their wedding day, Paris, March 12, 1919.

Later that same evening, Janet continued,

I went to a dance at my hospital—part of my duty. It was fun. I have never been such a belle and from 8:30 until eleven I was literally whirled off my feet. We danced on the marble floor in the big hall and it was a saving grace to wear woolen stockings, and low shoes with rubber heels.... And how the men love to dance and how well they dance— you would be amazed. They almost hold you like a gentleman should and are most courteous in every way.[16]

The sheltered New York debutante was beginning to enter the real world of war-torn France, and she clearly found her new life enjoyable. Janet continued, "Only the Red Cross girls are allowed at these dances, for they do not want to let in any of those professional creatures of Paris. These are all enlisted men—and some day I shall tell you all about them. A cleaner, more wholesome lot of boys you cannot imagine."[17]

Four months later, after a telegrammed approval from her family, Frederick and Janet were quietly married in the American church of Paris

on March 12, 1919, with a handful of French and American friends in attendance. Frederick wore his lieutenant's uniform and Janet wore a simple, long-sleeved white chiffon dress (see page 21). Mr. and Mrs. Elliott declined to cross the Atlantic for the ceremony, saying that they did not want to miss the birth of Janet's sister Edith's second child. But Janet also sensed their subtle disapproval of her marrying a Cincinnati man in Paris, far from the confines of her family's insular world in Upper East Side Manhattan. Nonetheless, Katharine Wulsin and a small gathering of friends toasted the couple with champagne, and they sped off to their honeymoon at a country inn in Saint Germain-en-Laye.

Their bliss was shattered a few days later, when news arrived by cable that Janet's sister Edith had died in childbirth in New York. Waves of grief, guilt, and isolation swept over the young bride. She longed for the safety and comfort of her family, despite the fact that she had rebelled against this protection only a year before. This deep conflict would never be completely resolved as she traveled further and further away from the protective influence of her family. Yet a year later she reflected, "I am every day more thankful that I went to France and unconsciously and consciously absorbed a different atmosphere—otherwise I should be as blind as many seem to be on this side to what their men really went through."[18]

It was not only her experience on the war front that transformed Janet. Equally important was her growing relationship with Katharine, who challenged her mind, and encouraged her to reach for new intellectual horizons. During their free moments, she and Katharine attended the theater and the opera. They roamed the art galleries and museums, and in the evenings they often read aloud by the fire. Janet's French improved dramatically, and her mind was ignited by the stimulus of Paris. Although Janet cared deeply for her own mother, it was Katharine who became her role model. To Janet, she embodied a probing, informed mind while still maintaining her charm and femininity. She and Janet remained close friends throughout their lives, exchanging books, articles, and candid thoughts in their frequent letters.

NEW YORK, 1919

It took four more months for Frederick to be discharged from his post. Both Katharine and Janet's father worked hard to get him an early discharge from the army, but the bureaucracy moved slowly across the Atlantic and many American troops were not discharged for over a year. Finally, in late June 1919, the couple returned to New York City. Frederick attempted to please his father-in-law by rejoining the Allied Machinery Company as an account executive. He also joined the Explorer's Club and became the vice president of the Young Republican's Club.

The transition from Paris to New York proved difficult for the pair. Frederick wrote to his mother, "The cost of living here is appalling. Higher than Paris! The impression of oozing wealth and of bustle nearly knocks you down when you first get here."[19] Frederick's vigorous, energetic nature chafed at the routine of office work, and he was miserable in the business world. After a year of boredom and restlessness, he turned his attention back to his real passions—exploration, archaeology, and cultural anthropology.

Inspired by a brilliant lecture by Roy Chapman Andrews at the Museum of Natural History, and encouraged by his mentor, Dr. Thomas Barbour, at Harvard, Frederick set his sights on China. The Harvard Museum of Comparative Zoology offered him a small stipend to enlarge its China collection. After carefully weighing his options, he wrote his mother that he had decided to "go to China as a scientific traveler, learn Chinese, go into official and other society all I can, and travel through the interior sufficiently to get a thoroughly good idea of it and to make useful scientific records—zoology, meteorology, geology, and botany if possible—and thorough economic and political and social observations."[20]

Katharine sent her son a typically candid answer. "As long as I have known you science has bored you—you can't improvise technical attainments of that kind, nor can you give yourself the observing eye which notes unconsciously cultural phenomena," she wrote.

Your mind runs in a different direction. Economic, political and social observations are more in your line, and if you give yourself up to studies on those subjects, you certainly ought to be able to achieve good results and not merely amateurish judgments which will carry no weight. In order to carry out these studies practically, you ought to go to China with a job. You will learn more of economic, social and political conditions in a month if you are doing practical work than you will in a year if you are going about as a traveler.

Katharine concluded, "Your old mother sympathizes with your vision and has faith in your brains and actions, but she also wants you to keep your feet on the ground. Get a definite business proposition in going to China which Mr. Elliott approves of, and I will give you all the help I can."[21]

Janet's father supported Frederick's idea, but also strongly urged him to seek out business opportunities while in China. He initiated discussions with the board of the Northern Pacific Railroad to explore the possibility of employing Frederick in the development of a trans-Pacific trade that would bring freight to the railroad. Frederick also approached Allied Machinery with a plan as a consultant, but recession was already in the air in New York and jobs were scarce. All that Allied would offer him was a leave of absence. No one was willing to make a firm commitment to support an untried young man's endeavors in China. "If we go we gamble on a big success, the worst that can happen is that they [Allied Machinery] won't want me back," he wrote to his mother in January 1921. "There is less risk in that than in staying, with the practical certainty of being let go in a few weeks to reduce expenses."[22] As the financial situation in New York grew tighter still, a move to China looked increasingly attractive.

Despite the risks involved, Janet remained supportive of Frederick's desire to become an explorer and scientist. Although she respected Katharine's opinion, she reminded her skeptical mother-in-law, "Remember, this trip may lead to fame, if not fortune for Frederick."[23] Frederick recognized Janet's support. "Jan is perfectly splendid—just as loyal and full of pep as she can be. It is much more of a leap into the unknown for her than for me, but she has the right spirit."[24]

After eight hectic weeks of purchases and preparations—tents from Abercrombie and Fitch, anthropological instruments, fine thermometers, drawing materials, saddles, camping equipment, medicines, and innumerable guns and cartridges—the supplies were packed and ready. Frederick went to Washington to meet with the Secretary of State, Charles Evans Hughes, and other Wulsin family friends. He arrived home armed with "more letters of introduction to different people than the mind of man can imagine."[25] Frederick referred to these letters as "soup letters [see page 24]." As Peking was the intellectual, diplomatic, and political capital of China, the Wulsins decided to head there first, despite the fact that they had few friends, no job, and no idea where they were going to live.

On April 2, 1921, the young couple, full of typhoid inoculations, settled into Janet's father's private railroad car and headed by rail for Seattle. After four days crossing the continent they boarded the *Wenatchee*, a brand-new steamer making her maiden voyage across the Pacific. On April 9 they sailed for China, stopping for several weeks in Japan and Manila on the way. Their great adventure had begun.

Despite her misgivings, Katharine gave them her blessing: "I like to think of you off by yourselves, leading your own lives on your own way outside the feverish current of New York. I hope, darling, that all will go well with you and that you will be very successful."[26] She continued, "Lots of people envy you and Jan and your quest of the Golden Fleece of knowledge and adventure."[27] Frederick responded, "As we crossed the Pacific we both felt the lure of the great things that will come some day in this part of the world. I think Jan feels it too. Our horizon before was so much smaller. I feel an incredible sense of joy and relief having the world before me."[28]

CHINA, 1921

Six weeks after leaving Seattle, Janet and Frederick landed in Shanghai early on the morning of May 11, 1921. Already, Janet was becoming a more seasoned traveler and observer. In her letters she urged her family to "please remember that in every place we visit there are three distinct impressions—the first or initial one; the

Letter of introduction from the French Ministry of Foreign Affairs, The Office of the Minister, to the French Ambassador in Peking introducing the Wulsins with instructions to accord them "the best welcome," January 1922.

second after the place becomes a bit habitual; the third, after leaving and looking backwards."[29]

Her first impression of Shanghai was not pleasant. The rain came down in sheets, the air was muggy, and the customs officials were irritable. Luckily, however, the Wulsins' mounds of baggage, including nine trunks and eleven pieces of hand luggage, went through without any trouble. Their guns were released in only twenty-four hours, despite the warnings of the Chinese legation in Washington that it might take several months.

However, their ammunition—sent from Holland and Holland in London—required a *hoochow*, or permit, from the Imperial Government in Peking, as the importation of ammunition was illegal. The cartridges were sealed in large tin boxes and included one hundred rounds for the .465 bore express cordite rifle, forty rounds of solid nickel 480-grain bullets, and sixty of 480-grain soft point bullets.[30] The U.S. consulate had sent up for a permit on May 12, but it had not yet arrived, and Janet and Frederick were forced to wait for it for several weeks. These delays for special permits and permissions would plague them throughout their travels in China and Tibet.

They found Shanghai a strange city. "It suggests Constantinople in some ways, in others Marseilles, and it is quite different from either of them," wrote Frederick. "The foreign concessions, areas governed by foreigners through their own municipal officers, cover most of the city's territory. These areas are well paved, well lighted, clean and well policed. One has practically no occasion to go outside them. One can buy automobiles, silver, eyeglasses and so on. There are half a dozen department stores. The place is full of clubs, including country clubs far finer than most of those at home."[31]

Finally, armed with their letters of introduction, the Wulsins departed Shanghai by train to Peking, stopping briefly in Nanking. They sped through the impoverished Chinese countryside as starving peasants flung themselves towards the tracks, begging foreign passengers to throw food from their windows.

Despite the scenes of starvation and social unrest around them, Frederick remained optimistic about his prospects professionally.

The opportunities here in China are perfectly marvelous for what I want to do—science, writing, then politics. There is a big field for anthropology and investigation of aboriginal tribes in certain provinces, and for digging up things like Troy which will show the earliest history of Chinese civilization and the early connections with the West. The entire place simply seethes and reeks with politics. One hears it all the time. Indications are that some day

there will be a war between us and Japan. . . . Out here people feel it is a certainty. It is only a question of time.[32]

ARRIVAL IN PEKING, 1921

On their arrival in Peking, the Wulsins stayed at the Hotel de Pekin while making the social rounds, leaving their cards on silver plates at various legations and private homes. An old friend of Janet's from Boston, Julia Deane, had moved to Peking with her husband, Fritz. They immediately took Janet and Frederick under their wing and helped them find a small house, complete with a domestic staff, to rent for six months.

In 1921 Peking was a fascinating international city, the grandeur of its Imperial past juxtaposed with a teeming, industrialized city pushing its way into the twentieth century. As Janet and Frederick discovered, "The town like the country had shown the same power of taking fresh masters and absorbing them. Both have passed through dark hours of anarchy and bloodshed."[33]

The ancient city was originally conceived on a grand design, with the nobility of its surrounding walls and gates, the splendor of its palace squares, and the vivid colors of its Imperial roofs. Seen from a distance, with its walls and gate towers sharply defined against a background of hills, Peking looked little changed from when it first became the capital of China in the Middle Ages: a Tartar encampment in stone. Gazing at the temples, walls, tombs, and palace halls, Janet could easily imagine Peking's history—its bitter sieges, martyrdoms, and religious struggles; Tartar, Mongol, Manchu, and Chinese conquests, Western invasions, and Persian, Indian, and Jesuit influences. She envisioned gorgeous pageants, traitors and soldiers of fortune, and the great Kublai Khan, who made Peking the capital of one of the largest empires the world has ever seen.

Peking had remained for centuries a place of mysteries, of closed gates and barring walls. The greater the beauty of a rich man's house in Peking, the more carefully it was hidden. Even when the main gates were thrown open, the view of

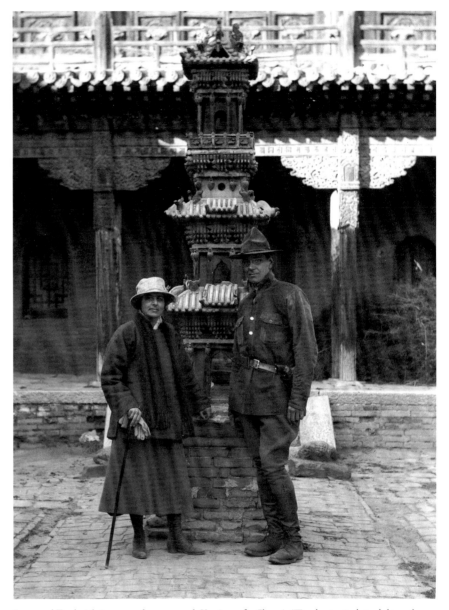

Janet and Frederick in a temple courtyard, Kweiyuanfu, Shansi. *"Temples give far better lodgings than inns, when one arrives early enough to hunt up the priest. For a Chinese temple is not like a Christian church, a building meant only for worship. It has far more the character of a medieval monastery, with a few monks, or of a shrine where services are sometimes held."* —F.R.W., September 1921

the buildings and gardens within was blocked by a "spirit screen" that ensured additional privacy and protection from evil influences.[34] Once these interiors were revealed, the wonder and delight of the temples and palaces surpassed all expectations.[35]

Not until 1860, when Prince Kung gave special new orders, were foreigners allowed to walk along the ramparts. This became a favorite stroll for Janet and Frederick, as they could see the original plan for the four cities from the heights of the city walls. In the center lay the Forbidden City—the innermost heart of Peking, soaked in history and mystery—surrounded by two miles of massive pink-washed walls, with four gates and a pavilion at each of its four corners.[36]

As steeped as it was in the past, Peking was entering a period of great social change, moving from a feudal past to a modern democracy. Under the last Empress Dowager, Tsu-Hsi, certain improvements had greatly altered the face of the city: newly paved streets made way for automobiles, and a new police force struggled to contain the roiling tide of traffic. Tien Amien Square was drastically altered to accommodate railroads and electricity. Even the ancient stone lions guarding the gates were moved—to honor the tradition of feng shui, however, the statues were blindfolded before being moved so that they would not be traumatized by their dislocation.[37]

By the time the Wulsins arrived in 1921, anarchy was in the air. Foreign legations continued to host scholars, intellectuals, diplomats, and adventurers from all corners of the globe, including many Western writers—such as André Malraux, André Marois, and Bertrand Russell—who were fascinated by the profound social and political changes. Prominent Chinese, like the infamous Sung sisters, were now being educated abroad and returning home to take part in the New China. Peking was electric with a sense of excitement and challenge. The old order had passed, and a new one was struggling to emerge from the shadows of Chinese history. No one knew exactly what form the New China would take.

Peking was a cauldron of contrasts and contradictions: opium dens flanked the recently constructed Rockefeller hospital; Western charities existed alongside deep corruption on all levels; beauty, fantasy, and mystery glimmered amid fear,

poverty, starvation, and disease. Regardless of the chaos, China continued to fascinate the West and, like a magnet, drew entrepreneurs, intellectuals, and adventurers from overseas.

Despite the growing civil war in the south, Janet and Frederick had already begun to formulate plans for an expedition during their crossing of the Pacific. By the time they reached Peking, Frederick had abandoned all thoughts of joining an American business. There were few positions available in American companies, and the invigorating atmosphere of exploration in Peking was contagious.

They believed that their stipend from the Baldwin Company and the grant from the Zoological Museum would enable them to organize a modest expedition into the neighboring province of Shansi. An elated Frederick reported back to his mother in Paris, "Your little son is not going to be idle for the next few years. That much is perfectly evident. Being a well authenticated and endowed explorer calls for sweat in large measure. But I am enjoying it greatly, and I think I shall thrive on the work."[38]

During their early months in Peking, Janet and Frederick were quickly welcomed by the international community. Several thousand foreigners lived behind high walls with their large staffs, primarily near the legation section of the city. They constantly entertained each other—English- and French-speaking Chinese officials as well as visiting scientists, writers, philosophers, and explorers from abroad.

The Wulsins labored daily at Chinese with their teacher, Mr. Wu Tze Pin, known as Mr. Wu (see page 28), and sought out people with a real knowledge of China's interior. Their circle included explorers, missionaries, seasoned travelers, and geologists searching for oil on behalf of large American companies. Travel and exploration were considered an art in Peking, and the traveler who had braved unknown regions was widely admired. Many wrote about their adventures, and small publishing houses privately published volumes of exotic travel writing.

Soon after their arrival, the Wulsins sought out the renowned explorer Roy Chapman Andrews, whom they had first met at a lecture in New York. Andrews was a charismatic explorer—eventually immortalized as "Indiana Jones"—who

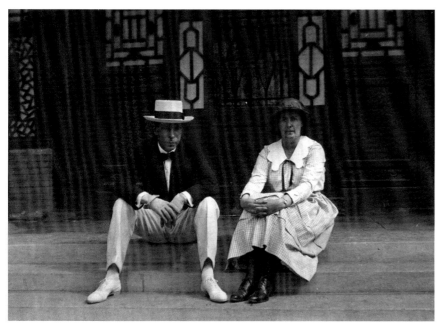

Henry Crosby Emery (Harry) and Susanne Allinson Emery, dressed for a luncheon, Peking, 1921.

gave fascinating lectures throughout the United States to help attract funds. Both he and Frederick were eager to make their names and reputations in the exploration of the vast lands of western China. In 1921 Andrews had not yet discovered the giant dinosaur eggs at Bayan Zag, the Flaming Cliffs, which would establish his international reputation. Competition among these young adventurer-explorers was fierce, and was felt by the wives as well. Janet wrote home that Roy treated Frederick quite differently when Frederick later captured a rare Chinese dolphin. "Mrs. Andrews gushed over me profusely since I spent the summer in Southampton, and was probably 'some one' at home. Maybe I do them an injustice, but their worldliness is always so apparent."[39] Despite these initial misgivings, the Wulsins and the Andrewses eventually became great friends.

Janet often entertained at her Chinese house, gathering friends in the lantern-festooned courtyard and showing Chinese shadow puppets after dinner. She and Frederick spent their weekends visiting friends who had rented temples

in the Western Hills outside the city walls. One of their favorite destinations was a hillside temple rented by their new friends Susanne and Harry Emery, another American couple. As chairman of the Asia Bank, Harry had use of a large car and chauffeur, and the four would ride out of Peking in luxury, passing villages and leaving a cloud of dust and scattering chickens in their wake. At the temple, they would read, hike through the hills, and explore other temples.

SUSANNE AND HARRY EMERY

The Emerys would play a crucial role in the Wulsins' life in China. The two couples were introduced by a letter from Alice Roosevelt Longworth, the flamboyant daughter of President Theodore Roosevelt. At twenty-four, Harry had been the youngest tenured professor of political economics in the history of Yale University. A brilliant economist with a gift for languages, he later became chairman of the prestigious Tariff Commission under President Taft. In 1916, on the eve of the Russian Revolution, he was sent by the Guaranty Trust Company to Moscow to preside over its offices there and encourage new business.

His wife, Susanne, the daughter of the chairman of the Classics Department of Brown University, was from an old Pennsylvania Quaker family. Although not a beauty, she was tall, straight and slim, and full of charm, humor, and a "delicious independence."[40] She raced through her social obligations in Peking to allow more time for studying Chinese, reading, and riding with Harry. She was an avid horsewoman and great dog lover, and her house was always full of strays she had rescued from the streets of Peking. After graduating from Bryn Mawr College, where she studied architecture, she worked on archaeological projects in Greece. In 1917 in Saint Petersburg, Russia, she married Harry—her father's brother-in-law, and many years her senior.

Shortly after their wedding, the Emerys were forced to flee for their lives across the ice in fur-lined sleighs through the Red and White Guard barricades to the Finnish Aland Islands from the Russian port of Abo.[41] The Germans

captured them there on the island of Mariehamn in a surprise raid, and interred Harry in a prison camp at Fuchel, but freed Susanne to travel to Stockholm. After ten months, they were reunited in New York and eventually sent to Peking by the Guaranty Trust. There, Harry served as chairman of the Asia Bank. In Peking they were considered important hosts, entertaining a constant flow of diplomats, journalists, intellectuals, and adventurers. Janet initially thought that they were an ideal couple.

THE NEW CHINA

By 1921 the new Chinese Republic was losing control of the old Ch'ing Empire, causing chaos and the erosion of civil order. "The Central Government has no power," wrote Janet.

> *The local Tuchuns (military governers)—an outgrowth from the days of Yuan Shih-Kai [the former Empress Dowager] are the really powerful men; most of them are unscrupulous, tax the people most unmercifully, steal the money that should go to the Central Govt. and are a power and law only unto themselves. Many people out here in business would prefer to deal directly with the Tuchuns instead of through the Central Govt.*[42]

Despite the evident corruption and growing chaos, many in the expatriate community in Peking clung to their sheltered world of luxury and social rituals. The regatta on the lake outside of Peking, coinciding with the Henley Regatta in England, still served as a high point of the Westerners' social season. Clothes were sent from Paris and New York, and women discussed fashion in one breath, conjecturing about the falling regime and the civil war in the next.

Nonetheless, the turmoil was beginning to permeate their sheltered world. The sumptuous supper parties at the Peking Hotel, the dances until dawn, and the annual American Bachelor's Ball of seven hundred foreigners continued, but poverty and unrest among the Chinese population grew. Fear filtered through the local community like the ever-present opium. While warlords swept through the neighboring hills, the Chinese army disintegrated into bands of marauders,

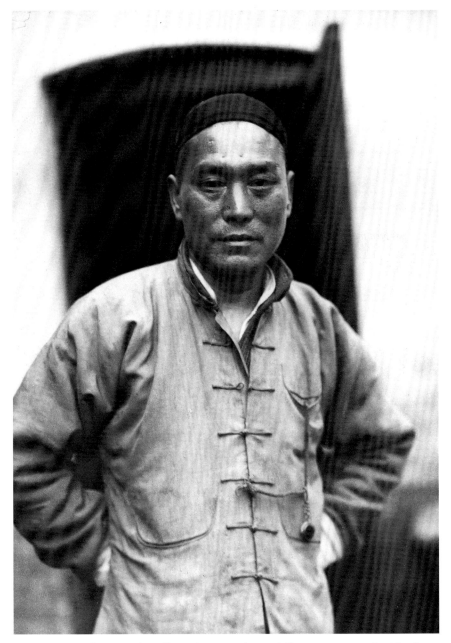

Mr. Wu Tze Pin, former cavalry officer, Chinese teacher, and Chinese manager and guide of both Wulsin expeditions, 1923.

and the foreign community fled to houses by the sea or temples in the Western Hills. A sense of unease seeped into every aspect of city life. As Janet's friend Julia Deane wrote home to Boston, "We are due for another revolution. The present government is a mess."[43]

Frederick described the complex political situation to his mother.

Each Chinese province nowadays is ruled by a military governor, known as a Tuchun. Some are super Tuchuns, with a number of provinces under them. Two of these worthies had a falling out: Chang Tso Lin, an old scoundrel and former brigand chief, super Tuchun of Manchuria, and Wu Pei Fu, a very brave and apparently honest and patriotic officer, who is the super Tuchun of the Yangtze valley. Chang has been making and breaking promises for some time, putting in one rogue after another, all of them looting the treasury for Chang's benefit. Finally, Wu protested in a series of red-hot telegrams to the world at large during the Washington Conference. Now, Chang has moved 70,000–80,000 troops inside the Great Wall with the avowed intention of suppressing Wu Pei Fu. However, Wu knocked the spots off him in a series of engagements. Chang is now making tracks for Manchuria, and his troops are being rounded up and disarmed. This last scrap took place on a little line south of the Peking Tientsin railway. We were out at our Temple when the firing began. We could hear it all day, but could see nothing from the hilltops except the peaceful plain, even with field glasses. In the afternoon the soldiers from the Peking garrison brought word that we ought to go home. Similar instructions came from the Legation via the Emerys' chauffeur, so we got into their car and came back.... A couple of days later, there was a sharp burst of firing near our house, just outside the city wall. It developed that some of Chang's routed men had tried to force a city gate in a train. The garrison shot them up. Throughout Peking the Peking garrison preserved excellent order and kept out both sides.... The South is still in a ghastly mess, with brigands operating in bands of 600 to 800. Sun Yat Sen, the talking calamity, who is the cause of most of the trouble down there and the bar to reunification, seems much weaker of late.[44]

With warlords and their armies prowling the Chinese countryside, danger was never far away.

By the time the steaming heat arrived in July, Janet and Frederick had established a daily routine. They had breakfast at eight, followed by Chinese lessons all morning—Frederick at home with Mr. Wu, and Janet with Julia Deane at her house. At one o'clock they shared a modest *tiffin* (lunch) and then continued their Chinese lessons for several more hours until they had "tea" in front of Julia's electric fan, consuming a cold glass of grape juice or ginger ale. After Janet's return home in the late afternoon, the Wulsins' groom took their horses outside the city walls, where they rode until dusk. Janet claimed that "the sweating does us both lots of good and the sweat rolls off me in buckets."[45] The twilight was long and they would return home and dine at nine o'clock in their cooled courtyard.

Despite the ferocious heat, the Wulsins occasionally visited the polo grounds, swam in a legation pool, and attended dinner parties including diplomats, visiting doctors preparing for the opening of the Rockefeller hospital, and businessmen trying to figure out how to conduct business in a country with no government. Foreign movies also provided occasional outings to the local theater, the Peking Pavilion, where crowds of upper-class Chinese, Russians, Japanese, French, British, Dutch, and Americans relished the latest antics of "Tarzan of the Apes."

The Peking lights were "nil" at night, as the central power was not sufficient to illuminate the whole city, so Janet and Frederick read by an American oil lamp. Janet scattered candles throughout the house as well. Their social life was quiet. "It is really too warm to do much, and besides almost everyone has left town for the hills or Peitaho [the seashore]," Janet reflected.[46]

During the weekends they went sightseeing.

In the morning [we went] to what is called the Winter Palace, being a collection of palaces, temples, shrines, marble bridges, etc., situated on the "Three Oceans"—which are in reality three lakes. They were formerly marshes and were drained off by Kublai Khan. Now they are very shallow and covered with beautiful lotus blossoms which at this time of year are in their glory with their huge pink and white blossoms on long slender stems sticking out of the water. Chinese architecture has no originality, so after one has seen several temples or palaces they become monoto-

nous, except for the charm of their surroundings. The "devil screen" to keep away the bad spirits is one of the famous sights at the Winter Palace. It is out of doors, made of glazed tiles, 50 feet long, 12 or 15 feet high, and the design is nine coiled dragons each trying to catch a pearl.[47]

"A Chinese dragon is always trying to catch a pearl. I wonder why it is," she mused.[48] They also rode out to the Temple of Heaven, where they saw the Altar of Heaven—

… a massive marble platform open to heaven, where each year the Emperor went and consecrated himself. At that time no one was allowed to see the emperor travel from his palace to this temple, and all the shops and houses along his route were tightly shut. The Emperor and all those who took part in the ceremony wore blue; the sacrimental [sic] vessels were blue, everything blue, the color of Heaven.… Today all the temple buildings have roofs of a deep cobalt blue.[49]

Janet and Frederick were busy trying to understand the complicated Chinese political situation. Understandably, the Peking papers were preoccupied with the crisis. Janet observed that the papers were barren of any U.S. news. "Everyone out here is much interested in the coming Pacific Conference.… China is wondering whom to send as her delegates. This country is a fascinating political study."[50]

On July 17, 1921, Janet informed her family that

F. [Frederick] has put in for permits to go into Shansi, Chili, and the 3 Manchurian Provinces. We shall in all probability go into Shansi near Suiyuan, N.W. corner, about September first. As to when we come out, where we will be next winter, etc., I cannot say. I have schooled myself not to look ahead. With F.'s temperament it is easier for me not to, and anyway the money end is taken care of. F. feels quite confident that there is a big field for him here, but it takes time. I think his studying Chinese is a wise beginning, and will be a valuable asset.[51]

She closed by saying, "We are all well and flourishing, though a cool swim in Southampton would be paradise."[52]

By late July the ferocious heat had settled over Peking.

This life is certainly restful if one could only accept it, but unfortunately I am a restless soul and long to "do." That seems to be the only verb I understand and I only wish that long ago I had learned to "think," so that maybe as I approach the horrible age of thirty I might be even able to acquire the art of meditation. New York to Peking is a great jump … However, do not think that I am unhappy—if it were cooler I could "do" more, and not be forced to "think" so much. But then it is a good plan to learn the latter, and what better place than here?[53]

She was impatient to put her studying to the test and begin to explore China.

Janet's mule litter before the high walls of Suiyuan, Shansi, August 1921. "It is a most perfect and delightful way to travel. There are two long poles, the ends resting on a mule in front and one in back. Strung between these poles are ropes and over all a matted top which is covered by Chinese oilcloth to keep out the rain. Over the ropes we put two big bags of straw, then a piece of 'ewe-bo' [oilcloth] then a blanket and with five cushions, coats, cameras, guns etc., I felt like a queen." —Janet E. Wulsin (J.E.W.), September 1921

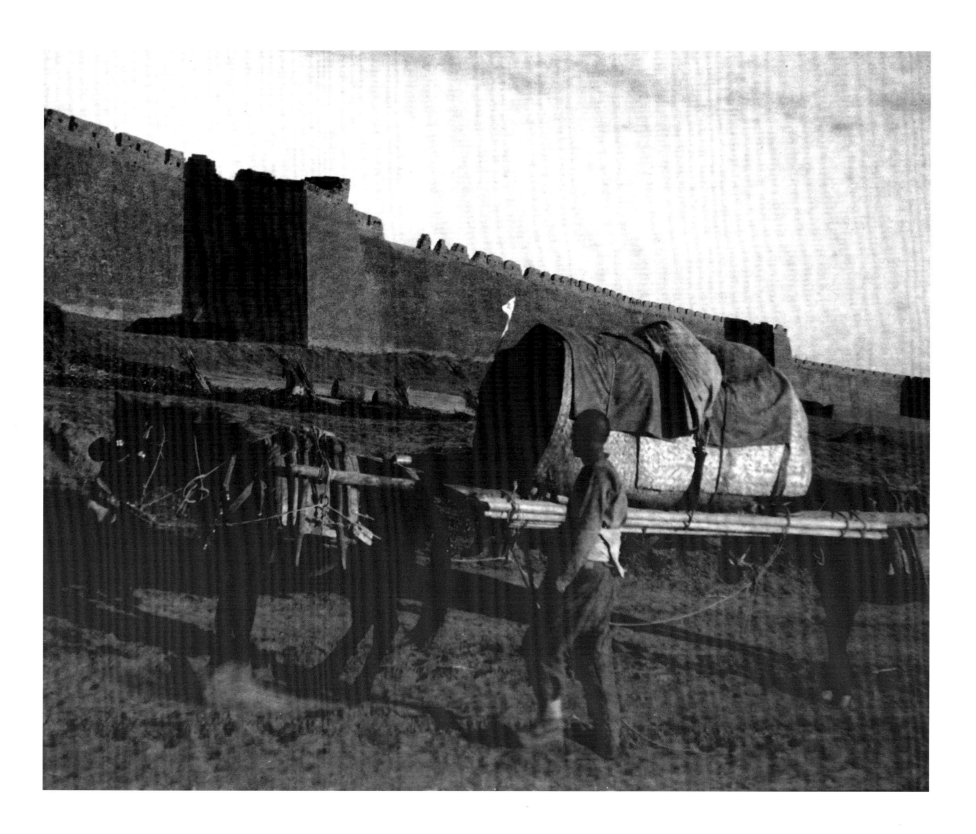

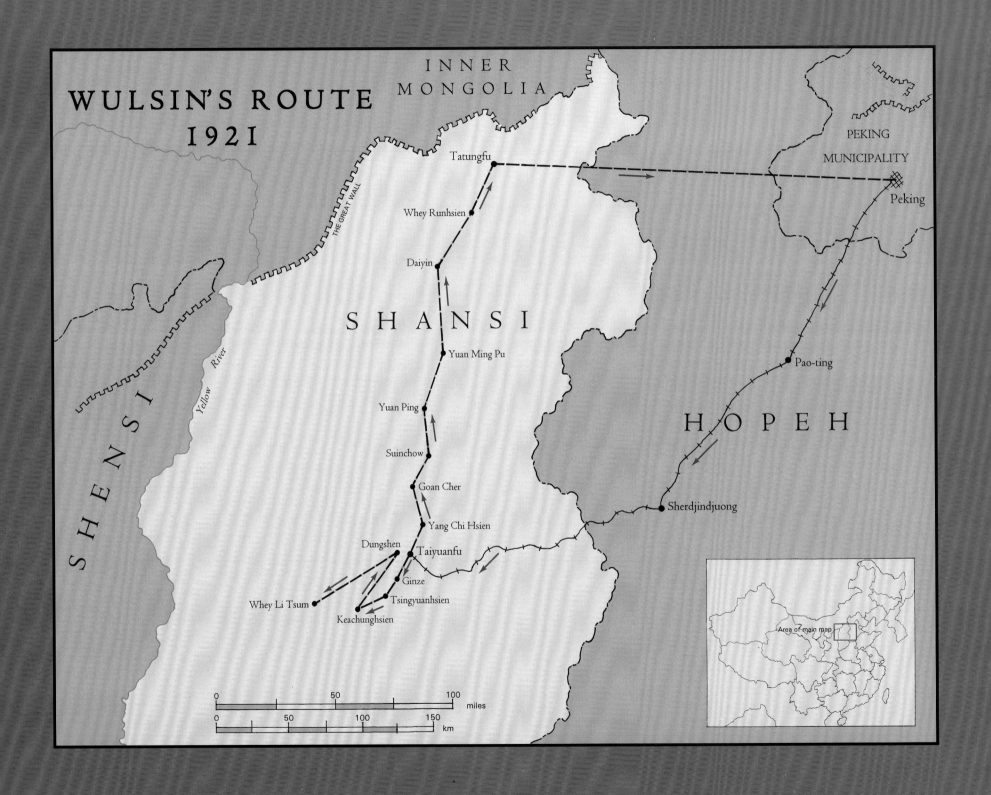

WULSIN'S ROUTE
1921

INNER
MONGOLIA

SHENSI

SHANSI

HOPEH

PEKING
MUNICIPALITY

Peking

THE GREAT WALL

Yellow River

Tatungfu

Whey Runhsien

Daiyin

Yuan Ming Pu

Yuan Ping

Suinchow

Goan Cher

Yang Chi Hsien

Dungshen Taiyuanfu

Ginze

Whey Li Tsum Tsingyuanhsien

Keachunghsien

Pao-ting

Sherdjindjuong

0 50 100
miles

0 50 100 150
km

Area of main map

BOOK II

~ THE FIRST TREK: SHANSI, JULY 1921 ~

By the end of the summer of 1921, the Wulsins' Chinese was now adequate for limited conversations, and they could recognize nearly one thousand written Chinese characters. They had studied the geography and the history of Shansi and counseled with knowledgeable travelers, hunters, and missionaries about the region in great detail. They planned for a five-month expedition that would cover over five hundred miles into some of the most remote corners of the province.

Throughout the summer, Janet had busied herself "buying equipment too in the way of extra riding togs, pongee [raw silk] pajamas and undergarments (fleas hate pongee)."[1] Janet described her hectic preparations for the journey. "Boys to engage, tents to get for Ho (the taxidermist) and Wu, the Chinese teacher, food supplies, camp clothes put in order and all the thousand one things." she wrote.[2]

Janet's extensive inventories reveal her attention to minute details in packing for the expedition. From basics such as guns, cameras, and medicines to lists of the developing materials necessary for film processing in the field, she and Frederick recorded the contents of their saddlebags, including "toilet articles, a mirror; toilet paper, a flash light, 2 notebooks, 1 sweater, 2 films, 1 package of tobacco and 2 slabs chocolate."[3] Janet added a bottle of malted milk, a bottle of Epsom salts in a sock, a can of insect powder, a book of the essays of Rabelais, and a collection of O. Henry short stories.[4] She and Frederick left letters of credit and Janet's few

pieces of jewelry at the International Bank, and opened a checking account with the Bank of China that would enable them to draw money throughout their journey in the post offices in the larger towns.

They hired their Chinese teacher, Mr. Wu, to help manage the expedition and assemble the team. An ex-cavalry officer, he was a born leader and gifted linguist who spoke many dialects. He commanded attention wherever he went, and, although rather inscrutable in his bearing, could erupt with a ferocious temper when the occasion demanded. He enabled the Wulsins to better understand the communities they visited by translating and explaining the local history and customs.

Janet and Frederick dispatched the first part of their team with Mr. Wu and the horses ahead of them on August 13. Two days later they paid off their remaining household servants, closed up their house, and set out from the gates of Peking.[5] Leaving the stultifying heat of the city behind, they headed for the great plateau of central Shansi—southwest of Peking, three days by rail—to acquire new specimens for the Agassiz Museum of Comparative Zoology at Harvard University.

The earliest annals of China describe Shansi's fertile Wei River valley, nestled along the middle course of the Yellow River and the upper Han River, as the

seat of the first agricultural kingdom. Shansi had been the national capital during thirteen of China's dynasties, an important political and cultural center that reached its zenith during the T'ang dynasty when Xi'an had a population of one million. By the early part of the twentieth century, Shansi had declined in cultural importance, and was the scene of innumerable famines and floods and well as several Muslim rebellions.[6] Despite these troubles, however, Shansi was rich in animal life, and Frederick was convinced that he would be able to capture zoological specimens not yet known to the West.

In a jaunty interview in the *Peking and Tientsin Times* on the eve of his departure, Frederick described the life of a zoologist as mostly a matter of luck: "I once spent months in Madagascar and British East Africa collecting specimens, and when I returned, I found that the only new varieties I had were some lizards I had captured in a hotel bathroom." Shansi, however, beckoned as a region containing many rare specimens "with unpronounceable names and unlovable dispositions," according to Frederick. The article concluded, "The interior of China is a vast zoological museum, for the most part unlabeled and un-catalogued."[7]

On their departure Katharine warned Frederick, "This is Africa over again with its long waits, only this time you are not alone, but have dear Jan with you…. Take care of her and remember that a woman can't do as much as a man no matter how much she loves him and may want to."[8]

Their journey began on the night express train from the crowded Peking station to Hankon. From there, they boarded another train to Taiyuanfu from where they would climb into the mountains of the western border of Shansi. They hired a new young servant, Bill, as their "boy"—the term commonly used at the time to refer to one's manservant. Bill accompanied them, checking thirteen pieces of baggage, including army trunks, duffle bags, cartridges, and food. Stowed into their small compartment were an additional seventeen odd pieces, including cameras, suitcases, books, magazines, a box of candy, and several guns. Luckily, wrote Janet, China was "a country of coolies, and there is always an eager jabbering throng ready to earn a few coppers by carrying things."[9]

TAIYUANFU:
MANAGING A MULE LITTER

At five p.m. the next day they reached Taiyuanfu, where they met Mr. Wu and the rest of the expedition team. Frederick referred to his team as his "army." It now included four servants; their "boy," Bill; a cook; a coolie, or porter, whom they called Aristotle because of his vast knowledge of the area; a *mafu*, or groom; Mr. Ho Ting Sho, the dour but experienced Shanghai taxidermist and botanist, with his assistant; and the invaluable Mr. Wu.

Janet further described their team. "The boy was a tall, slender, Chinese, very clean about his clothes and person, 'elegant' describes him. He has brains, is quick, silent, without humor, understands some French, but quickly grasps my poor Chinese." Their cook was "short, stocky, with a round, smiling face, and short stiff black hair." He spoke quite good English, and was "brimful of humor and initiative." Janet found him a great talker and a good mixer with all the country folk, whereas the boy was a snob about the people of rural Shansi.[10] Aristotle, the porter, had been trained in his previous position by Mr. Wu. He was always on the job—as Janet put it, "the man who always has string or a nail just when you want it."[11] He was eager to learn English, as his only vocabulary was, "God damn," "yes," "copper," and "alright." "He is very ugly, with a huge mouth full of teeth, but is never afraid of work. He looks after the horses, cleans the shoes, does all the thousand and one odd jobs."[12] Janet was often impressed by the fact that no one was afraid of hard work in China. "After this life with men servants," she mused, "I sometimes wonder if I can ever go back to women [servants] with their aches and pains and nerves."[13]

Their mule team consisted of seven mules for baggage, and two additional ones for Janet's mule litter. They christened their horses. Mr. Wu rode "Cream," Frederick traveled on "Oatenmeal," and Janet named her horse "*Talachey*"—the cry of the beggars on the Peking streets—because he was continually begging for food.[14]

Loading the expedition's carts in a temple courtyard, Shansi, September 1921.

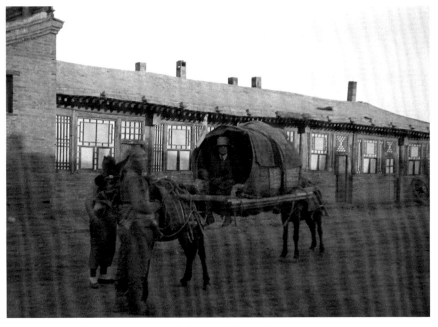

Janet in her *dja-wher*, or mule litter, ready for travel, Shansi, September 1921.

According to Frederick, the capital city of Taiyuanfu had become "one of China's most progressive cities" under the leadership of its "model governor," General Yen.

> With its well-paved streets, its public museum, its college; its electric lights and telephones, its clean and well-disciplined soldiers, it is an example of what the Chinese can do for themselves when the curse of misgovernment is lifted. Here one sees the process of absorbing from the West in full swing—not the Westernizing [sic] of the Chinese, but the turning of Western ideas to Chinese uses. For that ingenious people always tests, accepts, rejects and tests again, but eventually makes over what it adopts into a part of its own strong civilization.[15]

While the rains continued, Mr. Ho and the *mafu* repacked their baggage and caught up on the local gossip. Soon the days became clear and cool. Janet tucked away her copy of *Henry Esmond* and the party made their final preparations to depart. Frederick was "done up in khaki shirt, coat, breeches," wrote Janet, "and

I am in a khaki skirt, coat (mother's old one) and an old white waist, old white tennis shoes, and brown stockings, and to top me, my black sailor hat."[16] At the last minute Frederick and Janet rushed to the local bank where they drew enough money for the journey, communicating in a mixture of Chinese and German. All their financial needs were converted into Mexican silver dollars—the standard foreign exchange in China at the time—at the equivalent of twenty-three cents to the U.S. dollar.

The mules arrived two hours late for their departure, and the crew was in a frenzy of last-minute preparations as Janet walked down to the mission courtyard to watch the packing: "Boxes of tinned foods, army trunks containing our personal things, sacks with tents, bedding rolls, queer Chinese packages holding our boys' belongings, two big cans in wicker baskets, one full of kerosine [sic] for the stoves and lanterns, and one full of alcohol for the specimens"[17] were loaded carefully. The

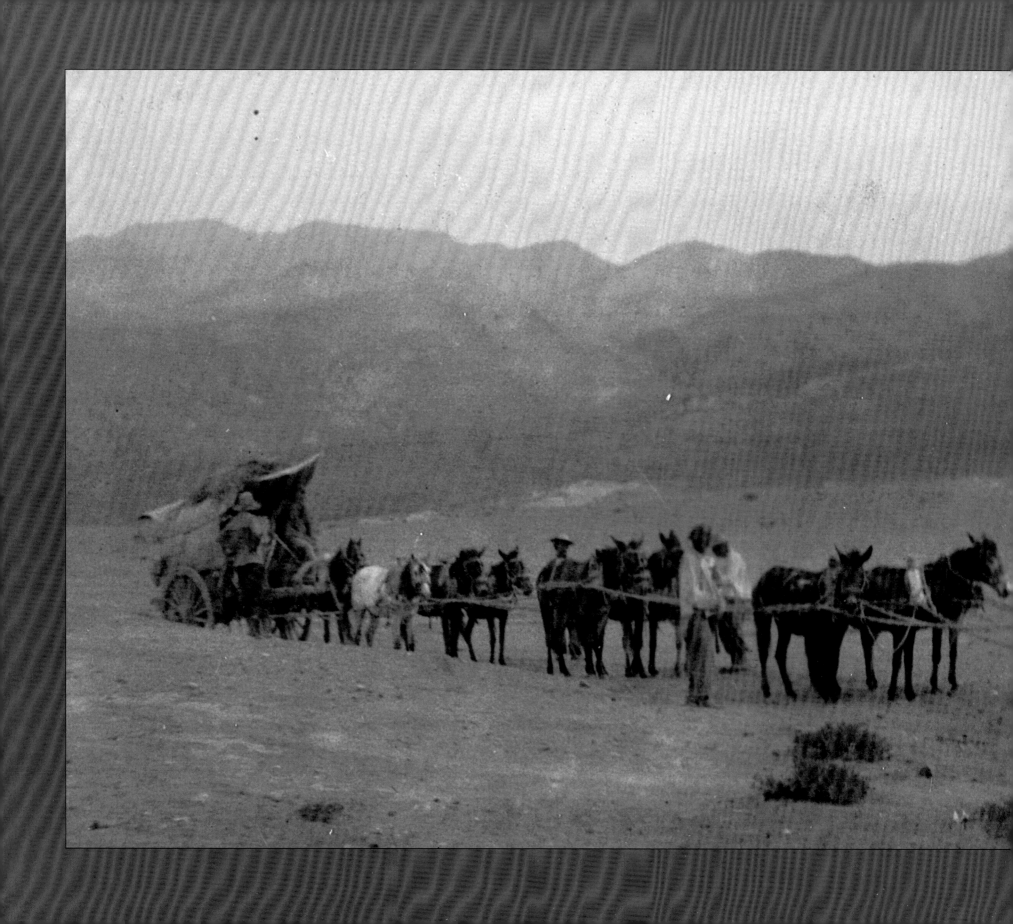

The Wulsin caravan proceeding through northern Shansi towards Tatungfu.
"One mule will be between the shafts as wheel horse for turning, while two or three others, mules or donkeys or sometimes oxen, pull through ropes which ran from their collars to the bed of the cart or axle." —F.R.W., October 1921

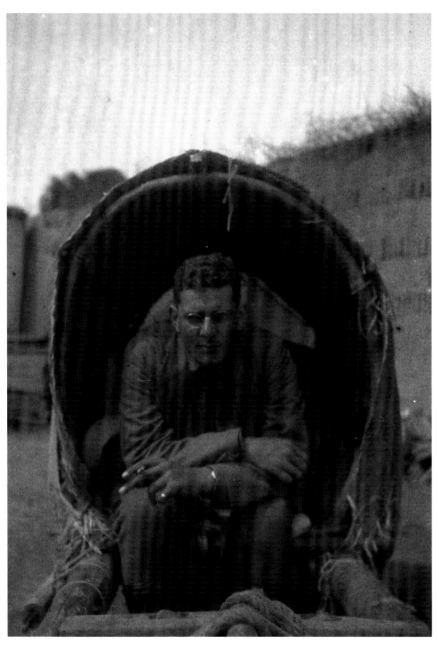

Frederick seated in Janet's mule litter, Taiyuanfu, Shansi. *To the Chinese a mule litter is the last word in luxurious travel.* —F.R.W., August 1921

courtyard was alive with men, boxes, and the squeals of mules. After several hours, the chaos subsided and the caravan lurched slowly out of the gates of the mission.

Janet climbed into her *dja-wher* or mule litter, which had been well padded with numerous cushions. The cook, Aristotle, Bill, and the other servants perched atop the mounds of baggage, looking very uneasy. Frederick, Mr. Wu, and Mr. Ho rode their horses. According to Janet, Frederick was so excited that he looked "positively gray."[18] Janet's shining blue enamel chamber pot, lashed to the top of the highest load, gleamed like a beacon light. The day was glorious, clear and warm, and spirits were high.

This was Janet's first time in a Chinese mule litter. Although they forded the river "constantly . . . my *'dja-wher'* [mule litter] was always dry."[19] This was the customary mode of transportation for many travelers in the rural areas. The litter was built on a frame of poles shaped like a hospital stretcher, with one mule in front and another behind, while the mule driver ran alongside. The top was made of bowed wooden slats covered with matting and Chinese oilcloth to keep out the rain, open at the front but closed at the rear and sides. Once Janet had crawled in from the front and installed herself on the cushions, four men would first lift the back poles of the litter onto one mule, then hoist the two other poles onto the front mule.[20] Janet sat on this "and surveyed the countryside, or lay feet foremost looking over her toes, at a patch of sky beyond, which danced as the mules jogged along."[21] "Perched in my *dja-wher* clad in khaki and black sailor, I felt like a queen travelling through unknown parts of her kingdom," she declared.[22]

Janet was apprehensive, however, when the time came to ford her first river in the mule litter. The water rose over the mule's shoulders. "I felt a bit timid at the thought, as I perched on my *dja-wher*, but an army of Chinese Adams, clad like our first ancestors (only minus the fig leaf) led my mules over safely, while my muleteer, with his baggy trousers tied around his neck, and his shoes tucked into one of the mule's pack saddles, waded over."[23]

Mules and carts were the mainstay of travel in Western China. The Wulsin expedition used mules for bad mountain roads, and carts for better ones; they had two types of carts, both without springs and almost impossible to destroy, even if

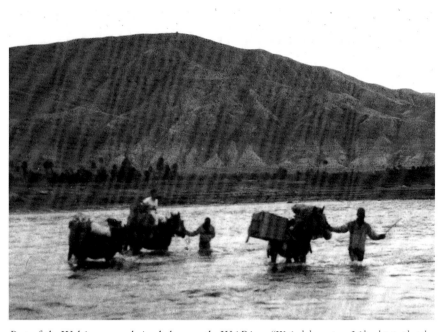

Part of the Wulsin caravan being led across the Wei River. *"We forded one river. I felt a bit timid at the thought, as I perched in my 'dja-wher' but an army of Chinese Adams, clad like our first ancestors, (only minus the fig leaf) led our mules over safely, while my muleteer, with his baggy trousers tied around his neck, and his shoes tucked into one of the mule's pack saddles, waded over."* —J.E.W., September 1921

they toppled from a high bank or bumped over boulders. The stylish Peking cart, a small-bodied two-wheeled carriage with a hooded top and a baggage rack behind, was used as a taxicab in the towns and for the weddings or funerals of important people in the countryside. The larger two-wheeled wooden carts, without hoods, were used for carrying baggage and freight. One mule would be positioned between the shafts, while two or three others, mules, donkeys, or occasionally oxen, pulled through ropes which ran from their collars to the bed of the cart or axle. "One sees a cloud of dust, then one of these great road ships rocking along over ruts and through quagmires, every animal straining when the driver cracks his whip," wrote Frederick. "One wonders if such a enormous load will ever reach the next town, but it always seems to, and the next day it goes on over awful roads for another twenty or twenty-five miles."[24]

However, even the hardiest of Chinese carts could not travel everywhere. Many mountain trails were only three feet wide, with steep rocks rising on one side and a sheer drop on the other (see page 43). To travel roads like this, the expedition hired additional mules in nearby villages and then loaded its supplies onto mule trains. Each mule would be loaded with up to two hundred pounds of baggage, with a driver for every three or four animals.

These mule drivers generally worked for local innkeepers. Travelers hired the transportation by specifying the destination, the number of days it would take to get there, the marches and halting places along the road, the weight of the baggage, and the number of animals and carts required. After much negotiation, a price was agreed upon and the sum paid in advance, with the innkeeper held liable for the contract's execution. The Wulsins' servants continued to ride either on top of the mule packs, precariously balancing themselves amid the stacked baggage, or else perched along the shafts of the more stable mule carts.[25]

GINZA: AT HOME IN A TEMPLE

After a long, bumpy first day of travel, Janet, Frederick, and Mr. Wu arrived at the small town of Ginza, twelve miles outside Taiyuanfu. By the time the rest of the group finally straggled in at dusk, they had set up camp in the courtyard of a local inn.

"Everything is like the Bible days, and the people seem much like those we read of in the New Testament. They are always amiable, and kind, *and* curious. Many of them have asked whether we were Japanese, as they have never seen Americans and some have never heard of Americans," Janet wrote to her family.[26]

The expedition party was constantly on the move. Each day at lunchtime they stopped for a hot meal prepared by their cook. They slept mostly in their own tents, but occasionally stopped at roadside inns. Even then, Janet and Frederick considered most of them excessively noisy and dirty. They often set up tents inside the inn courtyards to sleep in their own linens, amid chickens, pigs, and dogs,

praying that no wandering mule or camel would trip over the tent's ropes and bring it crashing down upon them. In bad weather they put their cots on top of the inn's *kangs*, or raised wooden beds, placing strips of Chinese oilcloth on the floor to protect themselves from fleas.

The inns had a universal plan of a great courtyard with stalls and mangers along two sides for the animals, and a few bare small rooms for travelers. Inside one inn, Janet and Frederick found a dark, low-ceilinged common kitchen and dining room with a large brick cooking stove in the middle and chipped black benches and tables at the sides. "A perspiring inn-keeper presided, bowing and flourishing a napkin, bawling at his minions, counting coppers, directing the serving of food and directing the flow of traffic," wrote Frederick.[27] "The air was thick with clouds of acrid smoke above and a layer of vermin below."[28] The Wulsins preferred to have their own chef prepare their Chinese meals with Western additions of jams, fried eggs, and biscuits, and usually dined outside on tables and chairs that the servants had unloaded from the mule packs. The Chinese staff ate inside, where they exchanged gossip and information with the locals and learned about the next day's marches.

Throughout their travels, the Wulsins preferred to stay at temples wherever possible. These country Buddhist shrines resembled medieval monasteries, with a few monks who welcomed travelers. The temples usually consisted of several buildings that faced tree-filled courtyards, allowing a peaceful resting place. The temples varied greatly from the splendid to the derelict, ruined by neglect and weather. Often, inside the central building, facing the gate, there were mythological paintings on the walls and statues of gods in bright red, blue, and white plaster.

Temples served as community centers. Janet and Frederick surmised that they were supported through some sort of community subscription. Occasionally, the temple bells would sound alarms for fires or even civic disputes, which had to be resolved by a gathering of the townsfolk. The Wulsins often slept in the small temple schoolrooms. At one temple they met an old schoolmaster whose pupils were hard at work studying primers of classical Chinese, squatting on the raised schoolroom *kangs* and wearing blue caps copied from European sailor's hats.

Janet was often an object of curiosity for the local villagers who had never seen a Western woman before. In several small villages Janet gave sewing demonstrations while the local women crowded around to peer and smile, always courteous, interested in Janet's clothes as much as her needle and thimble. One woman gave her a Shansi thimble, a big brass ring worn on the second joint of the third finger for greater leverage with heavy twine and thick cloth.[29]

In late August the caravan climbed into the hills. "We lunched at a little hill town called Dungshen [sic], where no whites had ever been seen before," wrote Janet.

There was a lovely little temple up on the hill where we walked while lunch was being cooked. The old priest very courteously gave us tea while a crowd stared at me. At the inn, we were surrounded by the entire village, until finally we had to send them out and shut the gate while we ate in peace. Even then they waited and peered through the cracks and climbed on nearby roofs to look at the white tai-tai [lady or wife].[30]

HUNG DJEN DJUN

Their journey continued along the Wen Shui River, through steep gorges up to high alpine meadows, passing through flocks of wild black sheep, goats, and carpets of blue and yellow wildflowers. When heavy rains made the river impassable, they paused in the mountain village of Whey Li Tsum, where Janet "took my first tub in our folding tub, and a good one it was."[31]

The frequent torrential rains often forced them to run for shelter under the overhanging roofs of the village gates and seek refuge in small temples along the way. The river was now so swollen that the party was forced to camp for several days, as there were no bridges.

Fording rivers was a constant challenge. Frederick described the scene on their way to Hung Djen Djun the next day: "The back mule of Janet's litter fell in midstream at the crossing, and she had to crawl out onto the shoulders of a passing Chinaman who chivalrously carried her ashore. Then she waded in again and held the front mule while her Sir Galahad and the muleteer got the back mule

onto his feet again. Other mules had been falling too, with trunks and boxes." According the Frederick the weaker ones were beginning to show up.

> *The Boys were riding the mules, perched on their hams on top of the packs. The cook grinned cheerfully and kicked his mule in the neck when it stumbled; Bill wore a doleful countenance, as if he expected to be drowned that day without fail; the local coolie (his name was Leu, meaning laughter) always looked hopeful and entirely unworried, though his mule was the worse submarine of the lot, and Wu's servant, an ex-soldier, had improvised reins and was riding like an accomplished cavalryman. Ho's assistant, with his pleasant face and slightly gray hair, rode soberly and gently along, with no sign to show that he had been pitched off twice on his head.[32]*

By early September Frederick was anxious to move still higher into the mountains to search for wild boar, deer, and lynx. They proceeded on to a small lumber town on the north bank of the south fork of the Wen Shui River at nine thousand feet. "Here we are in the middle, or near it, of North China, in the little village of Hung Djen Djun, living very comfortably in an old temple, and with 3 servants to wait on us, feeling much like feudal lords of old," proclaimed Janet to her family.[33]

One day Janet and Frederick were given a sheep they named "Berenice." Aristotle tried to lead her along the road, but she rebelled and would not move; bracing all four feet, she struggled and protested loudly. She finally lay down flat and had to be dragged. A crowd gathered around the resolute Berenice, offering advice, but she remained on strike, absolute and unmovable. Finally, in desperation, Aristotle picked her up, ran along the road, and packed her, with all four feet tied in the air, in the back of Janet's mule litter, where she would occasionally bleat from behind the cushions. Later, she was allowed to nibble grass between the temple courtyard stones. When that supply was exhausted, she was marked with an identifying ink stain on her forehead and left with a local shepherd to wander with companions and get fat.[34]

At Hung Djen Djun their serious mountain hunting began. Throughout the journey Mr. Ho had put up signs in Chinese offering to purchase wild animals. The country people responded enthusiastically, bringing birds, snakes, toads, frogs, deer, and some small mammals. The animals were usually presented dead. Janet

and Frederick then measured the specimens and recorded them in several canvas-bound collection logbooks. Most of the specimens would be preserved in arsenic or arsenic salt and alum. Capturing birds proved to be a challenge, as they were skittish. Wild pigs, deer, and lynx could only be found higher up in the mountains. Each evening Frederick and his young groom hunted birds, and they often dined on extra pheasants. Janet served as the "tracker" and found both wild boar and leopard tracks for the hunters to pursue.

Hung Djen Djun offered minimal accommodations. After the muleteers were paid off, the horses were stabled at the local inn with Mr. Ho, Mr. Wu, and the rest of the staff. Janet and Frederick set up camp in a small, peaceful temple nearby. "We have much Chinese oilcloth on our floor, our two cots, our own chairs and table," wrote Janet from her new temple home.[35] As the temple rapidly became a dispensary, Janet wrote, "the people of the neighborhood think we can cure any disease and every morning they come to us. We do what we can, but most of them are incurables or need surgical attention. I am keeping a careful history of each case for a record."[36]

Fortunately, she had carefully packed a broad range of Western medicines in case of emergency, including alum, calomel, permangate, quinine, tubes of Ichthyol, and opium, as well as bandages, adhesive plaster, and elemental surgical tools. Frederick, too, was affected by their visitors' needs:

> *Every morning the sick came to us and kept us busy all morning. They leave us weary and depressed as many of them are beyond our help. Many have chronic diseases or wounds that can only be cured by prolonged treatment and good nursing or the use of the knife. Except for a few with fresh cuts, constipation, or sore eyes, we can give little help. These people seem to doctor themselves until they get too sick for the traveler to do anything, then they come to him. We had one blind man brought to us twice. Fortunately, no one brought a corpse to be resurrected.[37]*

THE HUNT THAT FAILED

Camp life was never dull. One night Frederick was routed out of bed by a local farmer who whispered loudly, "*san jew*" (three pigs). With groans of sleepiness,

The loaded mules clinging to the cliffs on the high, narrow mountain pass back to Taiyuanfu, Shansi, 1921.

Frederick, Mr. Wu, and the farmer disappeared into the black night, across the river and high up onto a mountainside field, where other farmers were watching for wild boars. The boars habitually descended from the high mountains to eat the crops at night. The party waited and listened for hours, only to hear a faint trotting sound in the distance.

The expedition thrived on deer—and the occasional wild pig—which Frederick shot. They ate deer liver, deer chops, deer steaks, and deer stew, and Janet was proud that her hunting husband had actually provided their food. "We asked Mr. Wu to dine with us and eat some more deer," Janet recounted, "and there we three sat, inside our snug little tent, talking and understanding Chinese, and discussing, with much laughter, the American game of poker and the Chinese game of Ma-jan."[18]

Their daily routine began at dawn, when Bill brought hot tea to them in their tent. After breakfast, the cook appeared under the canvas awning of their tent with his account book of his purchases the day before, and to be given orders for the day. Chickens cost anywhere from nine to fifteen cents. Vegetables, such as string beans, eggplant, parsnips, and cabbage, could be bought for a few coppers. Later, when the thermometer plunged, they found that bouillon cubes and malted milk were constant lifesavers, as they could be quickly prepared with boiling water and were a pleasant change from the usual tea. At the end of their stay, with much regret, Berenice was eventually served at their table.

They spent their mornings labeling, measuring, and writing full descriptions of their latest specimens. The weight, dimensions, and color of each one had to be recorded in the collections books. By noon, when the noonday sun had warmed their tent, the couple bathed in a collapsible canvas tub. In the late afternoon they set off to visit their traps and hunt. The evenings were spent in Chinese lessons with Mr. Wu, and all except Frederick were in bed by nine; he often stayed up late writing in his journals and reading scientific texts. It was a peaceful routine broken by occasional moments of drama.

Janet rejoiced in camp life and the wonder of the countryside. The profusion of wildflowers reminded her of those she had seen in Yellowstone with her

The mafu (groom) serving tea outside the tent at Pa Shui Ko, Shansi. *"Outside our front door we have a canvas fly, and under that we have our table, chairs, folding wash basin, and a clothes rack (made of two poles with a cross piece nailed on top). Here we sit and eat and wash—and ever before us is that wonderful wide view."* —J.E.W., September 1921

father. The autumnal skies were brilliant, but the nights were growing colder. Despite the faint heat of her oil camp stove, Janet slept in an orange wool sweater with a goatskin under her mattress and numerous army and camp blankets piled over her.[39] There were few sounds but the music of birds, the insects, the wind, and the wild creatures. Occasionally a Chinese chant, let forth by a farmer as he plowed, broke the silence.

During one quiet lunch in the tent, Janet heard a loud voice. Suddenly the cook appeared, crying "Missi come see." Janet emerged from the tent to face a local farmer grasping a snake five feet long and quite fat. The creature was still alive, and fearing he could be poisonous, Janet immediately grabbed it and dumped it into the large alcohol tank. In a combination of Chinese, French, and English, she began to interrogate the farmer to glean scientific information, with the cook serving as translator. Janet recorded the facts, paid the farmer, and settled down to finish lunch and read. A woman with an infected tooth soon interrupted her peaceful interval. Janet operated as best she could with her forceps, swabbing cotton and disinfectant without any anesthetic. Once the surgery was completed, the woman rose, smiled, and disappeared on her way.[40]

Although Frederick had been tracking eagles for many hours one day, he, Janet, and Mr. Wu decided to stalk wild boar that same night. The band started off, Mr. Wu in a long European-style raincoat and high felt hat and Bill in a long padded Chinese gown of gray cotton, which he lifted up like an old-fashioned lady when crossing a muddy street. Mr. Wu's assistant, dressed in old soldier's clothes, followed behind Frederick, a towering giant in mackinaw coat, high hunting boots, and wool pants. Janet brought up the rear in her many sweaters, pink leather coat, and four-dollar tweed hat from Peking. Under the full moonlight they crossed the fields and hills and finally came to a field surrounded by three wooded gullies. Here they stationed themselves, armed and poised with guns ready. They waited for hours. The Shansi guide curled up like a dog and slept soundly. Every shadow seemed a boar. Finally, after sitting for hours without moving, the party cursed loudly, and marched silently back home.[41]

Ice was beginning to form on the ground in the mornings. It was time to return to Taiyuanfu and to explore further north. Janet sent a glowing report home. "The collection has gone very well. We received a letter from Glover Allen, the mammalogist at the Harvard Museum, and apparently we have gotten just the specimens he wants. F. [Frederick] is thriving and slim like an Apollo, though his face is like a brown Indian."[42] Their efforts had paid off, and the growing lists of specimens were dispatched regularly back to the museum at Harvard. Their team was working well, and Janet and Frederick were glowing with happiness in their success, far from the constraints of urban life. She wrote home, "I love the trips, for one seems so free and all of life seems joyous. It is in the cities that problems come up."[43]

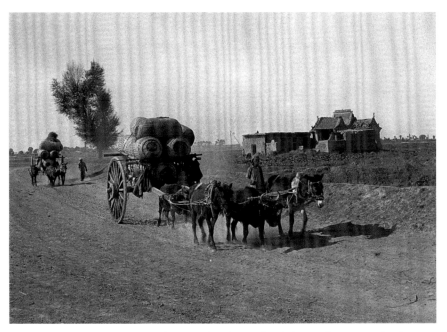

Shansi vinegar in large wooden casks covered with straw headed to market, Taiyuanfu, Shansi, October 1921.

RETURN TO TAIYUANFU

On their return to Taiyuanfu, Janet's *dja-wher* again slipped off the mules with a crash. This time, however, she was on hard level ground, and there was no excuse save the sloppiness of the muleteers. Frederick believed that Janet had narrowly escaped breaking her bones. Furious, Janet stalked along the narrow path for the next thirteen miles to the village, more secure on her own feet than in the capricious litter.

The following morning, Frederick and Mr. Wu rode ahead of the procession, out the ancient gate in the heart of the town, across an open courtyard with children playing, and onto a terrace with a view of trees, temples, and the valleys far below. Marble bridges and balustrades, which led to the nearby houses of priests, gleamed in the morning sunshine. The locals recognized Janet and Frederick along the return route, and greeted them with bows, smiles, and occasionally bouquets of flowers.[44]

Exhausted and ravenously hungry, they hailed a passing cart. Frederick crawled into the back and rolled into a ball, while Janet and Mr. Wu rode on the shafts and the driver ran alongside the mule. They bounced through the deserted moonlit streets, and finally found on the outskirts of the town a small restaurant that was still open.

To their amazement, the restaurant offered them a Chinese banquet that began with hors d'oeuvres of Chinese sausage, tiny pieces of cold chicken, and shrimp with herbs and mushrooms. These were followed by main dishes that included a steaming fish with a delicate sauce, hot roast mutton and potatoes, a pork soup, flour cakes filled with jam, and for dessert, bowls of rice mixed with sugar. Their meal was frequently punctuated by a young boy passing bath towels dipped in hot water as communal napkins. They drank two kinds of warm yellow Chinese wine, as well as innumerable cups of tea. Janet struggled with her chopsticks, two-pronged forks, and round bowl spoon. At the conclusion of the feast, cups of water were passed around and the guests rinsed their mouths before spitting into one of many spittoons. The Wulsins and Mr. Wu staggered out into the cool winter air, rode home, and collapsed onto their cots. They had not eaten so well, or so much, in months.[45]

Now, back in Taiyuanfu, they began to hear news of the Chinese Civil War. In October 1921, General Sun Yat-sen had organized an army of several divisions in Canton and had proceeded to march on Peking. The growing war raised alarms throughout China, but Janet and Frederick were determined to continue on to new hunting grounds. They were energized by the success of the expedition, and the promised rewards in the high mountains. Although most people considered Shansi to be relatively safe, the expedition was now traveling through uncertain regions where no one could afford to take safety for granted, and foreigners were not exempt from the spreading terror.

With civic unrest in the south now penetrating into the north, the provincial *hsien goen*, or governor, of the county provided them with a military escort to the next county seat. They felt uncomfortably " 'swank' being led by this khaki-clad individual, with his cotton shoes, for both fighting and riding."[46] Nonetheless, Janet was somewhat relieved by his minimal protection.

Bundles of mail filled with news from home greeted them back at the mission in Taiyuanfu. Janet's parents had summered in Southampton; Katharine Wulsin had vacationed in an English country estate in Yorkshire with her sister, and was returning to Paris after motoring through Scotland. Family babies were being born, aunts had the flu, and brothers were traveling. The family news seemed very far away to the young explorers on the other side of the earth. They devoured every scrap, and Janet read all the latest journals. Pleased letters from Glover Allen at the Harvard Museum provided great encouragement and further incentive for the explorers to continue the search and enrich the collection with still more exotic specimens.

On October 9, after ten days at the mission spent repacking the collection and skinning a large collection of birds caught by Mr. Ho, they departed for their northern journey. Janet settled into her mule litter, glad to be back on the road again. Three horses drew a large cart for the heavy baggage followed by two smaller carts for the servants, the food, cooking utensils, and bedding. Janet often broke the steep journey by walking two or three hours beside her litter. Their route north followed a high road with deep ruts through the loess region, a strange geological formation that reminded Janet of the Dakota Badlands. At times the road sunk from fifty to one hundred feet below the bank, and they traveled for hours through narrow canyons between the sandy cliffs.[47]

A week later, they followed the rocky bed of a dried stream, with the cart ponies straining over every bolder. At dusk, after a steep mountainside ascent, they stood on one of the old watchtowers of the Great Wall of China, built centuries before to keep out the northern hordes.

Near the sea in the east, the Great Wall was tremendously impressive—a monster serpent of masonry with towers that followed the mountain crests as far as the eye could see. In this western outer region, however, the Great Wall had sadly fallen from its early grandeur. An ancient, massive gate still blocked the road and the pass, but on either side the hills were bare, with only an occasional watchtower pointing towards the sky to remind the traveler that the Great Wall had once defined the landscape. "Beside this gate," wrote Janet, "is a charming old

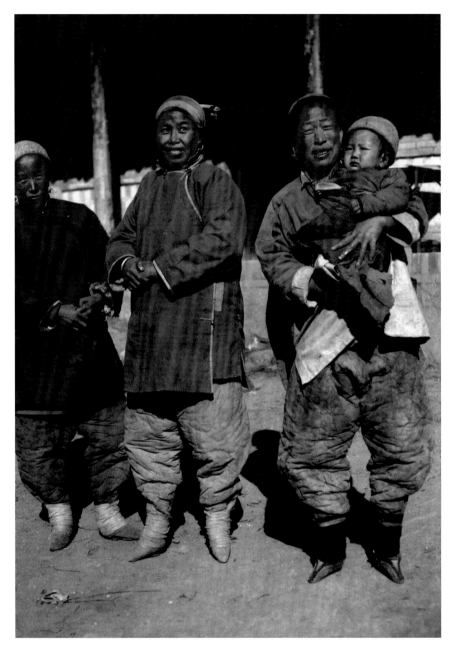

Dung Shen, Shansi. *"Their women with their poor little bound feet can't travel quick enough to get out of the house.... They had never seen a white woman before."*—J.E.W., September 1921

Janet in fur hat and sheepskin-lined coat purchased in Kweiwhating, October 1921.

monastery, where the old Buddhist priest showed us about. The inner temple was most interesting with its pictures of the most horrible creatures, and its great gold sensual Buddha, gazing down upon the offerings before him. These consisted of fruit and grains, and the all important money."[48] Despite the decay, the scene was deeply moving to Janet and Frederick. "There is still a sort of spiritual identity, for once through that gate there is a feeling of Mongolia's open spaces, an absence of that surrounding protection of the Wall which one feels inside China."[49]

Leaving the Great Wall, the small caravan rode for three more days, crossing a vast plain until they finally arrived at Tatungfu in the pouring rain. They had already traveled 215 miles of steady marching, averaging twenty-six miles a day: "a pretty stiff pace, tiring to men and animals," according to Frederick.[50]

On their journey north the landscape changed dramatically. Outside the Great Wall camel trains grew more numerous across the prairies, and the expedition met solitary Mongols in their grease-smeared finery riding great shaggy camels. The Chinese camel drivers walked and led their animals; the Mongols rode, often at a trot, and slept in the saddle, with their arms clasped around their camel's hump.

Janet was dismayed to find the people in these outlying villages "unspeakably filthy, men and women dressing much alike, tho' the women's feet are the smallest we have seen, many of them can't be more than 2 inches long."[51]

BEYOND THE GREAT WALL— KWEIWHATING

Outside the Great Wall the Chinese were spreading fast, and taking their civilization with them into the new frontier. Janet now saw a blending of cultures and civilizations. The temples began to show strong Mongol and Tibetan influences in both their decoration and their unusual two-storied buildings. The streets were filled with Mongols on foot and on camels. The railroad from the east ended near Kweiwhating, and Janet sensed the frontier in the bustling, heavy traffic. Men just in from an eighty-day march across the Gobi Desert from Turkistan passed black-turbaned

Muslim soldiers from Kansu. Merchants who came to buy wool could be found three days later in their stores on the coast in Tientsin, surrounded by the ships of a dozen nations. Trading and commerce were in the air. The plain beyond, dotted with prosperous Chinese villages, was surrounded by high, bare mountains.

In the sprawling suburbs, the caravans loaded and started out over the desert. Camel trains passed continually, as this was the road to the Gobi Desert and countries beyond. One large caravan, headed for Urga, five weeks away, included 140 camels. Because of the troubles on the Kalgau road to the south, much of the traffic was rerouted to this heavily traveled road that wound through the dramatic, eroded cliff formations.

In busy Kweiwhating the stores were full of foreign goods, cigarettes, whiskey, and the ever-useful enamel basins. Here, where civilization and desert met, the merchants thronged to buy furs, wool, and horses. The Mongols came to spend their money and refit for their long journeys. The town's whole spirit was vibrant, expansive, and slightly lawless. On their arrival there Janet and Frederick spent several hours in a merchant's back room inspecting winter coats made of sheepskin with woolen linings. The shop was famous for the curing of skins. Visitors crowded in while the Wulsins sat on the *kang* with elbows on a low table, drinking tea, smoking, and exchanging the compliments of the season while they viewed the coats brought in for display. It was an old-fashioned Chinese office, unchanged since the days of Marco Polo. An old scribe hovered near a high desk and from time to time wet his brush in the flat dish of ink to draw characters in his account book. The shopkeeper and local visitors, courteous and substantial merchants, stood about in their long gowns driving bargains, bowing, spitting on the floor, and emitting clouds of smoke from their long pipes. The only modern touches were a clock upon the wall that had stopped and a few cigarette posters. Janet purchased a short goatskin coat and hat, fur-lined gloves, and coarse, woolen undergarments "an inch thick" to prepare for the arctic weather ahead. Frederick bought a long, fur-lined Chinese gown for twenty-eight Mexican dollars.

November beckoned the winter in, and Frederick was anxious to push north quickly in search of the rare, elusive Shansi wild sheep that would be a prize for his collection and the Harvard Museum. He and Mr. Wu led the group on their white ponies while Janet walked beside her *dja-wher* as it was too cold to sit.

West of Kweiwhating, the steep, narrow ravines eventually opened into a wide rolling valley with high snow-capped jagged mountains on all sides. Ice appeared in the streams, and snow banked in the shaded areas. There were no trees and little cultivation in this bleak landscape. But partridges were feeding in the fields and on the slopes, and eventually, one of the team spotted a wild sheep in the distance. As they ascended they entered a different world, scarcely inhabited, with occasional poor hamlets huddled in the valleys and clinging to the slopes. Everyone wore sheepskin garments or padded coats as a shield against the bitter cold.

The mountains became steeper and there were few trails over the high passes. The expedition was forced to follow a circuitous route along the ridge. They spent the first night in a village of two mud houses at the base of the steep mountain. One house called itself an inn. Inside were two huge *kangs* with a mud stove—also used for cooking—in one corner. One *kang* was already partially occupied by smoking and sleeping mountain travelers. Janet and Frederick chose to spend the night in their tent outside, despite the bitter cold. One traveler had his opium pipe and a little lamp to cook the opium. Opium was smoked frequently, as the region was renowned as a smuggling route from the interior to the coast. Frederick told the team that he would do nothing to help them if they were ever caught smuggling.[52]

YIRGO: WINTER COMES TO THE MOUNTAINS

On a cold afternoon the expedition finally reached the primitive hamlet of Yirgo, perched 5,240 feet above sea level. There Mr. Wu, Mr. Ho, and the groom were

A small temple in Yirgo, Shansi, where the Wulsins stayed, November 1921. *"Here, under the gaze of the Golden Buddha we eat, write, read etc. . . So there you have the meeting of the East and the West in a Chinese temple on the borders of Mongolia."*—J.E.W., November 1, 1921

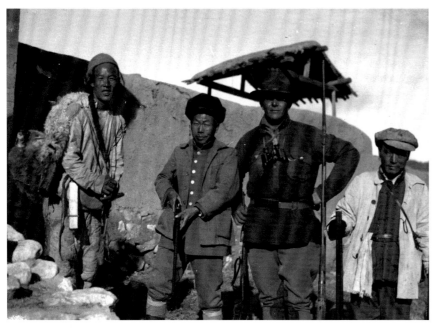

Members of the hunting party in search of mountain sheep—a local hunter, Mr. Ho the taxidermist, Frederick, and Mr. Wu—Yirgo, Shansi, November 1921.

billeted in farmhouses, and the staff took up residence in a mud house that also served as a kitchen. Janet and Frederick lodged in the dilapidated main temple nearby. On either side of the main door were Chinese windows covered with red and white paper, casting an eerie light, punctured with holes through which sparrows flew. Papier-mâché Buddhas, some grimacing and some beatific, lined the altars on the walls; the main Buddha had a golden face and long, black mustachios cascading around his ears. The Wulsins placed their cots at one end of the temple, and here, under the gaze of the Golden Buddha, they ate, wrote, read, and measured their specimens (see page 49).[53]

The strong northwest wind blew snow flurries into the village, and despite the valiant efforts of the Perfection oil stove the temple's temperature never climbed above forty-two degrees in ten days. Bundled in sweaters and Chinese fur-lined coats, with goatskins wrapped around their feet, Janet and Frederick

remained warm, if clumsy. Janet felt "square" in her new ankle-length Chinese coat, but it defied the cold and she remained comfortable despite the increasing chill in the air.[54]

"The country is much like Montana," wrote Janet, "and the Cascade Mtns... rolling valleys, herds of sheep, cows and ponies grazing on the mountain slopes, and then the steep mountains, ridge on ridge."[55] The bitter cold made hunting difficult. Nonetheless, the zoological collection grew daily. Each dawn Frederick and Janet set out with their guide, in his long black queue and baggy cotton-padded trousers, keeping well ahead of the eight other hunters who chatted away, scaring all wildlife within a mile. The Chinese considered hunting to be a convivial outing—like a picnic. Frederick and Janet would often escape with the guide into a side valley to stalk their prey in quiet.

CAPTURING THE GREAT RAM

On November 4, Frederick and his guide took a slightly different route. They kept marching for miles over the uplands and the tops of ridges without sighting sheep. Discouraged and frustrated, they stopped for a quick lunch of four "Shansi sinkers" (lumps of steamed bread), which the guide had produced from the space between his shirt and his hide, and morsels of chocolate offered by Frederick. They discussed the situation, each understanding little of what the other had said, as the local dialect was incomprehensible to Frederick.[56]

After lunch they spotted a small herd of ewes and young with one magnificent ram in the lead. Cautiously, the excited hunters continued to stalk the enormous ram, detouring the valley to cut the ram off. He continued to lead them up steep cliffs, only to disappear into ravines on the other side. The arduous chase took several hours, the ram sliding down a snow-covered cliff, with Frederick tumbling behind him and breaking his favorite corncob pipe from New York on the rocks. The ram raced up the opposite ridge where they spotted him over a mile to the south. Then they stalked him along a sunken road

Frederick with the ram's head (now in the collection of the Smithsonian Institution), Yirgo, Shansi, November 1921.

that led to a village. There, Frederick waited in the dirt on his stomach for the ram to move from the underbrush. Gradually the great ram came into sight, fled up the hill a little way and stopped. The first three shots made him move and the fourth shot knocked him dead. All in all twenty-four shots had been fired, but the prize was worth it.[57]

Frederick and his guide performed an elated war dance as they started for the carcass, while a young cowherd wakened the villagers nearby with his shouts that a big ram had been hit. The ram seemed to Frederick "a big brute, almost the size of a pony." He was impossible to move. When Frederick tried to turn him over by the horns, both hunter and prey slid together down the steep cliff.[58]

Eventually, they commandeered a small donkey to help move the enormous carcass. It took two hours to skin the great beast, and finally, at dusk, the procession headed home. As they forded a half-frozen river in the dark, the donkey stumbled and fell midstream, losing its cargo in the river. They dragged and pushed the ram ashore and loaded him onto the donkey once again by the light of the thin moon.[59] After another hour of rough going up a steep rocky cliff, they spotted a familiar tree and votive stone pile marking the north pass of their valley. The lantern Janet had set out was shining in the distance. At nine o'clock the small procession finally reached Yirgo, where Janet, the rest of the team, and the villagers greeted them enthusiastically.[60]

After their triumph, illness plagued the hunters. Frederick became so dizzy and shaky that his treasured shotgun slipped from his hands and slid down a steep hillside into a pool. Janet became the nurse and ordered him to bed with all of his clothes on. She then piled all of her own extra clothes on top of the bedding, tucked two hot water bottles under the covers, and administered a shot of strong brandy. Frederick was still chilled and weak, but after "roasting" for a day, his symptoms seemed to disappear, and he was able to continue. Mr. Ho suffered a different malady, and was treated with bleeding and Chinese herbal medicines. Frederick also gave him brandy, cough drops, and *balme analgésique*.[61]

The numbing cold of winter paralyzed the travelers. It was difficult to write any of the inventories or measure the specimens or cure the sheepskins

properly, for the preservatives froze on the surface. To everyone's relief, Frederick decided to head for a fresh hunting ground at lower altitudes with a warmer climate.

RETURN TO KWEIWHATING
AND PEKING

On their final night in Yirgo, a howling gale shook the little temple and blew snow in through all the windows. The next morning, their caravan assembled— a motley collection of three camels, three mules, eight donkeys, and the ever-faithful Oatenmeal and Talachey, the two white ponies. Under a brilliant blue sky, the entire village of Yirgo turned out in the clear, shivering cold to see them off. Their caravan reminded Janet of a traveling circus, and she felt certain that they had left the villagers as mystified as they were impressed.

For their return they decided to take the shorter, though much more difficult, trail over the mountains. All eyes were fixed on the narrow path, often only two feet wide, which led them back. Finally, from atop the last and highest mountain the expedition had a stupendous view out over the Suiyuan plain, with the ancient walled city of Suiyuan beside its more modern sister city of Kweiwhating. To the west stood range upon range of bare, majestic mountains with the purple shadows of the setting sun upon them.

During the descent, Janet headed the procession on her donkey. Frederick rejoiced in the spectacle: "Jan on her donkey was delicious to behold—leaning back in her green leather coat and an orange scarf on a little beast the size of a jackrabbit. She yelled at him in approved Chinese fashion, tugged at his halter, beat his hindquarters with her stick. All she needed was sails and a rudder to pose for the apotheosis of transportation."[62]

Janet insisted that they keep moving until they finally arrived in the dimly lit streets of Kweiwhating. At the best Chinese inn in town they were startled to discover a modern office with a large foreign clock on the wall, a telephone, and a clerk sitting at a semi-modern desk. They were back in civilization.

The expedition now divided, one group headed north and Frederick, Janet, Mr. Wu, the groom, and Bill headed south. The wind blew bitterly as the Wulsins set out across the plain toward the mountains. Although they had three carts and two horses, it was too cold to sit, so the entire group walked twenty miles to the next village, Shiu Ussutu.

While they camped, Janet wrote a reflective letter to her mother on her twenty-eighth birthday.

> F. [Frederick] is tremendously interested in his work, and in China and all her problems. His mind is of a scholarly turn and all the problems here open up fascinating avenues for him. I think he can make quite a career for himself out here, but the problem comes up about me. At present this life is fun and interesting, but I don't want it forever.... How can both be worked out? I love F. and I understand his talents, and ambitions, tho' they may not be entirely mine. ... There will be a solution in time, and in the meantime our life is very interesting and I know that many women would envy me.[63]

She admonished her mother not to share this introspective note with the rest of the family, and ended her letter by cheerfully saying that they were both "flourishing" and the next day heading thirty-five miles into the northern mountains where there was abundant game. She never mentioned her misgivings to Frederick, but added, "I think often of these things."[64]

But Janet's enthusiasm for the journey continued, and only after two more weeks of poor hunting did the party finally head back to Peking. It was bitterly cold as they bounced over the rough road to the station at Kweiwhating. Janet expected her feet to "just drop off into the road as two lumps of ice."[65] Late the next evening the train pulled into the Peking station. Janet and Frederick plunged through the excited throng as coolies pushed and shoved, relatives shouted greetings to each other, and the team struggled to assemble the scattered baggage. Susanne Emery was there to meet them and whisked them away in her grand car. Seeing an automobile for the first time in five months gave Janet a start—she realized just how long and far she had traveled.[66]

Janet on her donkey descending from Yirgo, Shansi, November 1921.

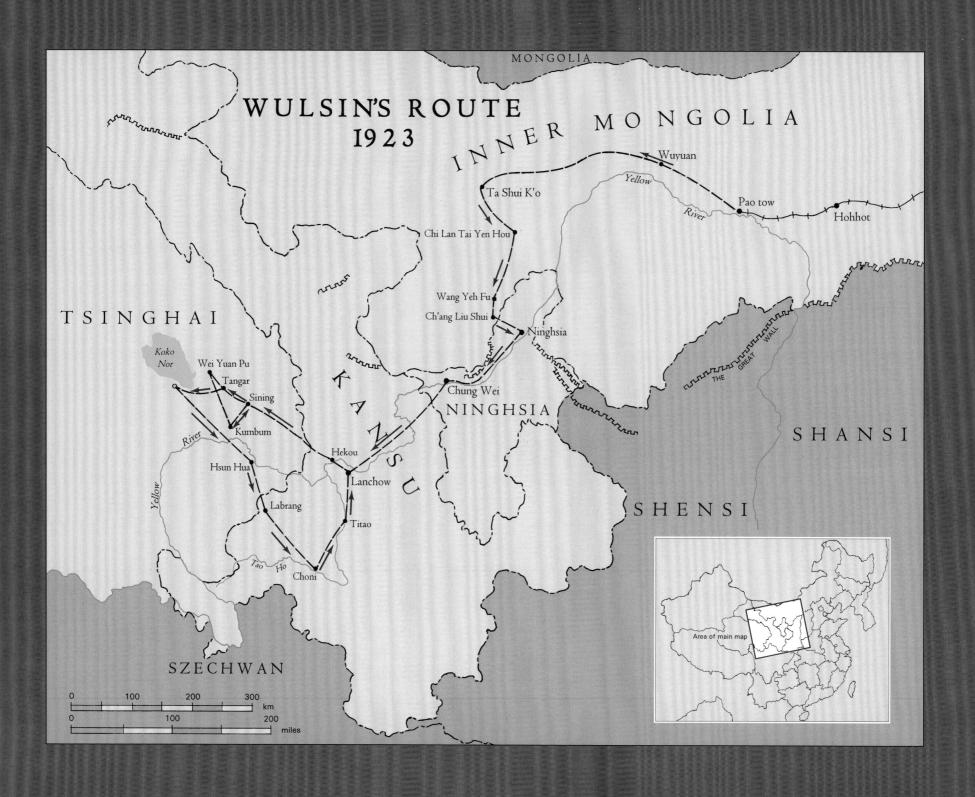

WULSIN'S ROUTE
1923

MONGOLIA

INNER MONGOLIA

Wuyuan

Ta Shui K'o

Yellow

River

Pao tow

Hohhot

Chi Lan Tai Yen Hou

TSINGHAI

Koko Nor

Wei Yuan Pu

Tangar

Sining

Kumbum

Wang Yeh Fu

Ch'ang Liu Shui

Ninghsia

KANSU

Hekou

Chung Wei

NINGHSIA

SHANSI

River

Yellow

Hsun Hua

Lanchow

Labrang

Titao

THE GREAT WALL

SHENSI

Tao Ho

Choni

SZECHWAN

Area of main map

0	100	200	300

km

0	100	200

miles

BOOK III

~ THE GREAT TREK THROUGH THE ALASHAN DESERT~

PEKING, 1922

News of the Wulsins' return quickly spread through Peking's international community. Friends, scientists, and other explorers gave them an enthusiastic welcome back to the city. In their first expedition, Frederick and Janet had traveled 525 miles in five months, camped in twenty-nine different places, and marched the entire length of the province of Shansi, venturing well outside the Great Wall of China.[1] In less than a year they had managed to establish themselves as serious explorers with a real purpose. Frederick was thirty-one and Janet was twenty-eight.

After carefully repacking their delicate zoological specimens, they shipped the impressive collection back to the Agassiz Museum at Harvard. These included some last-minute additions from Mr. Ho, who had "arrived a few weeks later from the Yangtze with a bully collection, including four rare river dolphins and 11 or 12 Yangtze alligators ... and a fine series of birds and some monkeys and frogs."[2] Harvard received the collection with enthusiasm. This recognition, too, strengthened Frederick's reputation in the field.

Their great success came at a price, however, for Frederick had contracted amoebic dysentery in Shansi. His dysentery was followed by a bout of "Gerruld's catarrh,"[3] a serious intestinal ailment suffered by many explorers in the region. As a result, Frederick spent most of the winter and spring of 1922 quietly recuperat-

ing in their new house at 34 Shui Mo Hutung. There, in his small study, he wrote up a report of the Shansi expedition and continued his daily four hours of Chinese lessons with Mr. Wu. He and Janet also labeled and cataloged the hundreds of photographs and specimens from the expedition.

Meanwhile, Janet turned to Katharine for advice. Her sense of alienation and concern puzzled and worried her. Her cry for help took two months to reach Paris:

... so with two sick people, in a climate where nerves are proverbially on edge, we have said and thought things, more from physical irritation, I hope than from anything else. I must think that, for we cannot allow bickerings and difference in taste to make a gulf between us. At bottom I know we love each other intensely but we are so different. I want so to help F. [Frederick] but how? My talents, if I have any only seem to annoy him. ...

I have a good mind, but I'm not an intellectual person, alas, and when I might help F. by bringing intellectual people into our house, or making the surroundings agreeable and easy, he slinks into his study—it is a sad realization to love a person passionately, and, at the same time feel totally incapable of giving him those things that he craves.

But I know we will work out our problem—a love as big as ours can't be flung away. Maybe you can help me see where I have fallen down.[4]

Frederick's recovery was slow. With his energies spent and his future uncertain, his mood became increasingly somber. His finances dwindled as the Baldwin Company cut its dividends due to the recession in America. Despite increasing

financial pressures, however, he remained determined to keep exploring. He defended his decision to his father-in-law, who had urged him to return to the stability of a business career.

Frederick explained,

Business opportunities… are poor now, for business in China is as poor as everywhere else…. scientific opportunities abound [in this] immense and varied country. Comparatively little research has been attempted, and I have gotten much interested in the movements of peoples out here. There are a number of non-Chinese tribes in the country, some of which have not adopted Chinese civilization. Most of them are in the South Western China, where zoological work will take me.[5]

He continued,

I feel that if I can make a good study of these tribes when I go that region for zoology, it will bring me a great deal of credit in the academic world, and probably the offer of a job in the Harvard Museum. My own feeling is that Janet and I will both be happier, and I a good deal more useful to the world, if I am a scientist and eventually a teacher, with politics as an activity if it comes my way than if I am a business man.[6]

Janet, too, clarified the situation to her worried father.

F. [Frederick] has definitely decided once and for all that he is never going back into business. I may not be entirely in sympathy with his point of view, but that is his decision…. He wants a scientific, academic life, with China as his field of study, and after his years of research out here to devote himself to writing. If our present income fails, then he will try to teach or become a curator or something.[7]

As he convalesced, Frederick dreamed of a more extensive journey into the Kweichow region of southwestern China. He drew up plans for several expeditions, combining zoology and anthropological research among tribes of non-Chinese natives, hoping the Harvard Museum of Zoology and the Smithsonian Institution might find them appealing. He estimated that these trips would cost between five and ten thousand dollars. Sponsorship by a well-funded institution would be crucial. Frederick realized that he should return to the United States to raise the necessary funds himself, as Roy Chapman Andrews had done. His poor health was a further incentive to return home and undergo a complete medical evaluation.

While Frederick recovered, Janet turned her energies to fixing up their new house and reading extensively in preparation for future expeditions. She and Susanne Emery took daily excursions through the streets of Peking, hunting for furniture and fabrics in tiny shops. Susanne, who had a "genius" for decorating, had become recognized as the preeminent interior designer in Peking's foreign community. Their excursions led them through a maze of back streets and narrow *hutungs*, or alleys, where the two women bargained with vendors in a mixture of sign language and Chinese. She explored the *hutungs* in the section of the city that the foreign residents called "Piccadilly." She described the market street and its smells of roasted chestnuts and sweet potatoes, the displays of "all parts" of roasted pigs, and "many little cakes rolled out on tables that art dealers would sell for thousands in Fifth Avenue." In the evenings, silk merchants came to the Wulsins' house and spread out their magical materials: shimmering fabrics for curtains, bright-colored silks for cushions, and pieces of old embroidery for the dining room. "The riot of color makes me mad," wrote Janet. "I want it all."[8]

Maintaining the house was a challenge. They had no electricity or running water, and a special bed had to be built to accommodate Frederick's lengthy frame. Janet also ordered extensive carpentry and papering to ensure that their walls would protect them against the bone-chilling cold of the Peking winter. Even the cold was not as bothersome as the violent windstorms that swept across the city, carrying silt from the Gobi Desert miles away all the way to Shanghai. The fine sandy film seeped through every crack, covering every surface in the house, and the servants spent hours gently dusting it away.

Janet retained the same team of servants that had accompanied the expedition to Shansi. Although they were willing to learn, the "boys" had been raised and trained in the country and knew nothing of the traditions of service in cosmopolitan Peking. They dropped dishes during dinner parties and rattled the teacups in their saucers. Janet also found the cook, while good in the field, woefully inadequate when compared to the fine chefs of the city. She eventually replaced him with a cook trained at the British legation, who served up "such morsels as I never tasted."[9]

Although she was adventurous, Janet always created a comfortable home for a "base camp." "Now we are all settled in a charming little Chinese house with its courtyards and thoroughly enjoying the comforts and luxuries of a civilized existence…" she wrote, "We have no modern plumbing, but with coolies galore, I know we are far more comfortable than our [New England] great-grandparents. As I write, the sunshine is pouring in from the courtyard, and my Chinese living room with its many potted plants, its dark Chinese furniture, bright cushions and brocades is delicious."[10] On Christmas day, she further described her surroundings.

> I am writing at my Chinese desk with its quaint all-brass handles, dipping my pen into an old Chinese lacquer inkstand. Hanging on the wall above the desk is a gorgeous red silk banner, with picturesque Chinese characters, made of gold paper and pinned on the silk. They mean good luck, health and prosperity to the new house. Mr. Wu and Mr. Ho sent us the banner the day we moved in. We have a nice Chinese rug, some lovely Chinese chairs… a nice comfy sofa, small tables, everywhere potted flowering plants, and brass candlesticks. [Oil] lamps and candles give our only light at night.[11]

Janet hoped that the peaceful environment would speed Frederick's recovery and lift his spirits. She inspected the kitchen and pantry daily, insisting on the constant use of boiling water and Lysol to fight bacteria, and vowed that the smell of Lysol would "equal any hospital."[12] One of the few joys of their difficult winter was a puppy named Marco Polo, given to them by Susanne Emery. The house was becoming a menagerie, observed Janet: "Now… we have fish, fowl and beast. 6 gold fish in the dining room, Ferdinand the parrot in his cage in the living room and Marco everywhere."[13] The puppy also served as a hot water bottle, perching on Frederick's stomach as he read hour after hour.

While Frederick rested at home, Janet dipped into Peking's swirling social life. She attended lavish *tiffins*—Chinese luncheons of innumerable courses—at foreign legations and palatial private homes. She attended the lectures of noted international scholars such as Sir Oswald Siren, the great Swedish authority on Chinese art, who passed through Peking frequently. Though she often felt underdressed, Janet's charm and her fluency in French enabled her to be included everywhere, and she enjoyed listening to Peking's scorching gossip. One prominent scandal concerned the Italian Minister's wife, who had walked into a room at the Wagon Lits Hotel one night and "beat up another Italian lady within an inch of her life," using both a carving knife and the butt of a revolver. As a result of the fracas, one of the secretaries at the Italian legation committed suicide, and the minister and his wife were immediately deported back to Italy.[14] The general attitude among the more cosmopolitan set, observed Janet, was "when husband can't amuse or adore, there is always the 'lap-dog' (official name for lovers out here)."[15] In this exotic atmosphere, far from home, liaisons and love affairs flourished and were openly discussed.

There was, however, a more serious side to Janet's life in Peking. Famine was spreading throughout southern China. Although it had not yet infected Peking, and much of the foreign community remained blind to its existence, many of the churches and missionaries had established relief agencies within the city to collect money, clothing, and food to send to the hungry. Janet and Susanne were active volunteers in this effort, and spent part of each day helping the relief work.

The tableau of daily life on Peking's streets struck foreigners as both exotic and fascinating. "It is these daily incidents which make life out here so infinitely full of both interest and profound human sympathy," observed Harry Emery.

> One time it will be a gorgeous wedding procession or the barbaric trappings of some great man's funeral filling a long stretch of a street. But the best of it all are the little country scenes which seem to transport one back through the centuries to biblical or classical day, the daily sight of the little threshing floors, and the grinding of the corn in the open by hand or by a little blindfolded donkey. The big funerals are interesting, but tend to be humorous, whereas while the little country funerals… go rumbling through one's heart. In them there is nothing ludicrous—nothing but beauty and faith. Also out on some dusty road in the country one sees the familiar sight of a mother with her baby on a little donkey, and the father trudging along by the side, going on to some distant destination. It is the Flight into Egypt over again, and I have seen it so often in a coloring and setting which makes one think it is a Tintoretto come to life.[16]

To help Frederick recover his strength, he and Janet traveled out to a small hillside temple, Tung Wau Tang, that they rented in the Western Hills. By April, their courtyard was ablaze with peach blossoms. For several weeks, they led an idyllic country life, reading, walking the hills, and investigating the surrounding temples, monasteries, and ancient cemeteries. Frederick retreated to secluded spots in the hills, where he stripped to the waist and took long sunbaths.

After six months, Frederick's health finally returned. He had lost fifty pounds, and remained weak, but now was well enough to travel. On May 22, 1922, they boarded the S.S. *Che Foo Mara* to Yokohama, changing to the S.S. *Empire State* in Yokohama and continuing on to San Francisco.

RETURN TO THE UNITED STATES: NEGOTIATIONS WITH THE NATIONAL GEOGRAPHIC SOCIETY

After landing in San Francisco in June, Janet and Frederick continued on to New York. They spent the summer and early fall preparing expedition proposals for submission to the National Geographic Society and to Harvard. In early November Frederick traveled to Washington, where he met the National Geographic Society president, Gilbert Grosvenor, and presented his plans for an extended expedition into the Kweichow region of southwest China. This was a crucial moment in the Wulsins' careers as explorers. Their fate rested in the autocratic hands of one powerful but difficult man.

Protracted negotiations with Grosvenor ensued over several months. Frederick sent additional proposals, calculated a series of budgets, and carefully wrote and rewrote lists of the equipment and supplies that he would require. The National Geographic Society formed a special committee to review his proposals and drew up their requirements for sponsoring the expedition. Finally, in December 1922, the society agreed to sponsor an expedition to be known as the National Geographic Central China Expedition. Frederick, as the

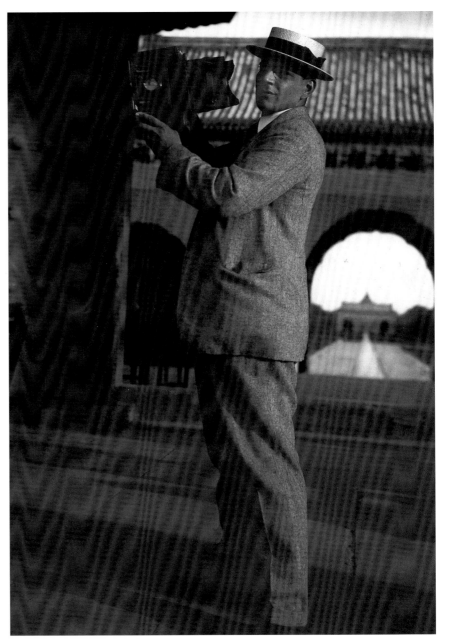

Frederick with his Graflex camera at the entrance of the Temple of Heaven, Peking, July 1921.

nominal leader, would receive eight thousand dollars a year for two years, beginning on January 1, 1923. The Wulsins' responsibilities would include making zoological, botanical, and ethnological collections, taking pictures, and writing articles for *National Geographic* magazine. The National Geographic Society claimed the right to approve all personnel, as well as all museums where the collections would ultimately reside. The society also retained the exclusive option of publishing in its magazine every article, book, or map based on work done by the expedition. All equipment purchased from the National Geographic Society's funds remained the property of the Society, and would have to be returned to Washington or disposed of at the discretion of the director. Finally, Grosvenor insisted that the Wulsins take out their own life insurance policies, for the National Geographic Society would not be responsible for its explorers or their safety.

The budget would be strained as this would be a much more ambitious expedition than originally projected. The National Geographic kept its explorers on a tight leash, and their auditing procedures were stringent. Each audit would have to receive the personal approval of Gilbert Grosvenor before funds for the expedition could be transferred to the Central Trust Company in Cincinnati. The Wulsins would need to provide detailed and explicit justification for every expense, no matter how trivial.

Much of the eight thousand dollar grant would go toward paying the expedition's team. Immediately upon their return to Peking, Frederick would need to hire a team of qualified scientists to help him gather and catalog the botanical and zoological collection. "My old Chinese crew [from the Shansi trip] will do much of the zoology for me," he wrote. "I am to hire a Chinese botanical collector. The ethnology, photographing and writing fall wholly to me."[17] The National Geographic Research Committee stipulated that only upon receipt of the expedition's first season's work would it consider the assignment of additional scientists to the fieldwork of the expedition. The Wulsins would need to continually substantiate each step taken in order to ensure financial support for their scientific team.

PEKING, 1923: ASSEMBLING THE TEAM

The National Geographic Society was committed to keeping its membership high by making the magazine attractive to the general public, "primarily through publishing beautiful pictures."[18] Frederick was well aware of the challenge before him. "He [Grosvenor] cares more for the pictures I am to send him than for any other fruit of the expedition, and it behooves me to send him very fine ones if I want to keep his support," he wrote to Katharine.[19]

> I am going to make photography my very first business, as it is certainly my most important activity if the expedition is to continue. The grant is made for two years, but it is subject to renewal after that and everybody concerned hopes that the expedition's success will justify frequent renewals. So, if all goes well, I may have the beginning of a life's job before me. Mr. Grosvenor has emphasized to me again and again that the pictures are his prime concern. Apparently the articles worry him less, for an article can always be patched while a picture cannot.[20]

The Wulsins, neither of whom had much experience with photography, would be competing against some of the finest photographers in the world, and they were nervous about meeting the challenge.

Frederick asked his mother to dispatch the latest photographic equipment from London and Paris. He spent $443 in one afternoon at Hathaway Dunn in New York, buying items ranging from tripods to the latest filters. His total photographic bill amounted to over $1,300, a sum considered astronomical at the time. He read the latest photographic manuals, and Janet trained herself in current developing techniques.

Throughout their months in the United States, Janet and Frederick remained focused on their return to China. "Except for one short trip to Washington to talk botany, the rest of my time was spent in New York," Frederick reported to his mother. "We both worked like beavers, and got all our shopping and packing done. The NGS paid for much of my equipment, praises be; but there were other parts that I had to pay for, so I am not rich. That will correct itself as soon as I get into the field, where my expenses, out-

side of what the fund pays for, should be very low."[21] They were eager to return to China.

In January 1923, the Wulsins set sail for China once again. On arriving in Peking they returned to their beloved house at 34 Shui Mo Hutung, where their domestic staff set to work unpacking their trunks. Janet was thrilled to be back in Peking. "Here I am writing at my own desk surrounded by the lovely familiar Chinese things that I had such fun in acquiring and I must say that there is an air of *home* around me," she told her parents. "And the house! Even a Dutch housekeeper (I believe they are the most particular) would have been thrilled over it. The place fairly shone, brasses glistening, stoves blackened to shimmering, and over all the soft light of candles and lamps."[22]

Peking was as enchanting as ever, but the political situation in China had deteriorated even further during the Wulsins' absence. Janet and Frederick were stunned to find a human head impaled on a fencepost by their gate—a grim reminder of the chaos surrounding them. Justice was swift and brutal to robbers and brigands who were captured. Rumors of kidnappings swirled through Peking dinner parties, and on several occasions the foreign community fled to the temples of the Western Hills when the city gates were closed against invasion.

In May 1922, brigands hijacked the Tientsin-Peking train and took several foreign hostages. A more dramatic threat would occur only a few months later, when robbers attacked another train and seized forty Americans as hostages—including John D. Rockefeller's sister-in-law. As Janet's friend Julia Deane exclaimed in a letter home:

> Isn't it extraordinary to live in a country where such things happen all the time? It
> has created the most awful excitement out here. It is just as if brigands had held up
> the Boston-New York train and removed everybody, shooting a few people for luck
> on the way... I think this will bring home to the Americans better than anything else
> could do the state that China is in. As long as there had to be a holdup, we are all
> cheering out here that Rockefeller's sister-in-law was among the ones who got held
> up because there is likely to be more reaction if an important person is involved. She
> was rather lucky and got a bandit who treated her well. She buried some of her

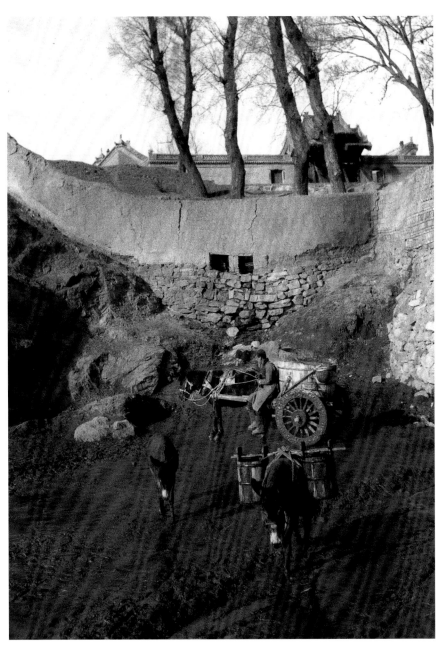

Mongols and their mules on the outskirts of Paotow loading water in preparation for their trek into the desert, Shansi, March 1923.

jewelry under a rock and now we all wonder if she will ever be able to find that rock again.[23]

The warlord demanded a ransom of twenty-five thousand dollars, and eventually the American government paid it, over the protests of the French that the Americans had allowed the ransom bar to be set too high.

The region south of Peking, too, had grown politically tense—and increasingly dangerous. Many territories were overrun by civil wars. It quickly became apparent that the Kweichow expedition, which Janet and Frederick had so carefully planned, would be far too dangerous to undertake. "Conditions in the South and Southwest of China are unusually bad," wrote Frederick. "There are a number of wandering armies in the field which live as they can, largely as brigands. Occasionally they capture a large town and then clamor for recognition as a political faction and incorporation in the regular forces with pay and food."[24]

They decided to change the expedition's route to a more peaceful region: Kansu province. "South China is in turmoil this year, so it is out of the question," Janet told her parents. "Therefore we shall go to Kansu, a long way off, but a peaceful Province and full of game and vegetation."[25] On February 24, Frederick wrote to Gilbert Grosvenor to tell him of the change in plans. He was careful to emphasize that Kansu, like Kweichow, would produce a photographic record worthy of *National Geographic*. "Remembering what you told me, I considered first what photographs we could get by going to Kansu," he reassured Mr. Grosvenor.

Kansu is the meeting ground of Tibetans from the regions south of Kokonor, Turkish peoples of Central Asia, Mongols, and Chinese. As a result there are a lot of interesting types. Kansu is also the chief seat of Mohammedans in China, and contains Kumbum and Labrang, two famous Buddhist monasteries, with gorgeous and impressive buildings which rise in wild solitudes... Altogether I think it should afford better photographic material than Kweichow, and more of it, with more propitious conditions for producing good negatives and keeping them without deterioration after they are developed.[26]

Aside from photographs, Janet and Frederick recognized that the success of the expedition rested heavily on attracting good scientists. This was not an easy task, for Western-trained botanists, zoologists, and geologists were difficult to

I feel as if we might be going to Mars — with just as much probability of return — The Emenys are with us, making a total of four foreigners and 10 Chinese
Mr. Wu - transport manager, gentleman & teacher
Mr. Ching - Botanist
Chang - Taxidermist
Liu - Taxidermist
Sun - Photographer - assistant and hunter taxidermist
Fu, the cook
Pu, our personal servant
Wang, the Emeny's personal servant
Sun - the mafu (groom for ponies)
A Chinese servant for Mrs. Wu -
Baggage by the ton; but an extra 500 lbs. worries F. as little as an extra handkerchief worries us common mortals — so we are loaded for every clime and every emergency — F. is carrying a travelling

A page from a letter from Janet to her mother-in-law describing the Chinese expedition team, Paotow, March 24, 1923.

find, and scientists who were willing to travel into remote areas for over six months harder still.

Frederick retained his longtime Chinese teacher, Mr. Wu, to again serve as the transport manager and boss of the Chinese part of the team. Mr. Wu had proven himself indispensable during the Shansi trip, and Frederick's admiration for him was unbounded. "Mr. Wu himself is a corker, not only a charming gentleman of the old Chinese type, but a practical traveler and caravan head of the first order," he wrote. "If I have any success it will be due primarily to him."[27]

Janet also relied heavily on Mr. Wu. She and Susanne enjoyed watching him about the courtyard in his long fur-lined black *I-shang* coat, "smoking his long Chinese pipe with a green jade mouthpiece as he inspects his horses. His face is so wise and so kindly and so humorous. And in his foreign riding clothes, mounted on one of the new ponies for a ride, he is equally delightful."[28] Together, Frederick and Mr. Wu began recruiting a team of three personal servants, taxidermists, botanist, *mafus* for the horses, and a cook. They would hire camel drivers later, when the expedition reached its departure city of Paotow on the Mongolian border.

Frederick had great difficulty finding a Chinese botanist who spoke both English and Mandarin and would agree to accompany him into the field. He contacted the Canton Christian College, Nanking University, and National Southeastern University, as well as the Arnold Arboretum in Boston and the Edinburgh Botanical Garden. Finally, his search was rewarded when he contacted a botanist named Mr. Ching. "I was lucky enough to find a botanist who will probably be the ideal man for our work," he reported.

> He is a graduate student of botany in Nanking University who has already done field work in Hupeh, and who is very anxious to make botany his life's work. He is a big, strong man, well educated, who speaks and writes English fluently. Consequently he will be able to write first-class labels and descriptive matter on the plants that he collects. I have arranged for Mr. Ching to join me on March 1st and make the trip with me as botanist.[29]

As an avid hunter and gun collector, Frederick was especially eager to find an expert zoologist to join him on the expedition. He finally settled on Mr. Lin and Mr. Chang, two skilled taxidermists, along with Jow, "a boy who has done much hunting and some skinning for me in the past, and whom I have sent down to Shanghai for further instruction before we start."[30]

In preparation for the extensive anthropological fieldwork that they planned to undertake in Kansu, Frederick and Janet spent much of the winter of 1923 researching the tribes of Inner Mongolia and Tibet. Much of their work would focus on measuring and photographing the native people whom they encountered in the field, in accordance with the anthropological methods of the day. "This season's work in anthropology will consist in getting photographs of the many different racial types which appear in Kansu," Frederick explained. "There are Tibetans, Mongolians, Turks, Chinese and, I believe, occasionally villages of 'aborigines.' Actually this ought to give better material for the magazine than would be obtained in Kweichow. It has a bearing on the question of the non-Chinese races, and is a piece of work which would have to be done sooner or later."[31]

Between assembling their team of Chinese assistants, gathering supplies for the expedition, planning their route, and preparing their equipment, Frederick and Janet were inundated with work. Their house was never still as they hurried to prepare for the departure from Peking, scheduled for the end of March. "For the last month I have led such an insane life that it has been impossible to write you," an exhausted Frederick told his mother.[32]

In addition to their preparations, Frederick and Janet faced another difficulty: their close friend Harry Emery had lapsed into a deep depression, accompanied by a ferocious bout of drinking. "On arrival here I found that Harry had been drinking like a fish," wrote Frederick. "It is an old failing of his. He had straightened out since he married nearly five years ago, but had begun to relapse last spring. Since they got back to Peking last fall he had gone from bad to worse, completely saturated most of the time, and going at such a pace that he must kill himself if it continued many months more."[33]

This state, which Harry called "the enemy" in his letters and journals, made Susanne frantic with worry (years later, she would edit out all references to Harry's condition in their letters in heavy black India ink). She was unable to control Harry when he drank, and once he had begun a binge her efforts to keep him away from alcohol were futile. During Harry's lapse the previous spring, Janet and Frederick had offered Susanne their support, and she had never forgotten it. In March 1922, after Harry had begun to recover, Susanne sent a long letter to Frederick.

> I started this letter really to tell you how awfully grateful I am to you, Freddie, not only for all you've done, but for your wonderful patience and sympathy and understanding. I could never have pulled through without you, and I don't know another person anywhere who could have done what you've done. Thank you from the bottom of my heart.[34]

The worst was over, she believed, and she hoped that "the enemy" would remain at bay: "I feel quite encouraged about Harry. I think he's coming on all right."[35]

Unfortunately, Harry's grip on sobriety proved to be tenuous. By the time Janet and Frederick returned to Peking from the United States, he had plunged into another binge. He would disappear into the smoky labyrinth of Peking bars and opium dens, not to resurface for days, when Susanne would discover him in a hopeless state on their front steps. He had resigned his position at the Asia Bank on January 1, 1923, and the lease on the house that Susanne had so carefully restored was up on the first of March. "The situation was pretty desperate," wrote Frederick. "They must either go home, get another house in Peking—which simply meant more drink—or take some radical step which offered a chance of curing him."[36]

Susanne was distraught, and once again, she approached the Wulsins for help. "The only hope seemed to lie in getting Harry far out into the country, where he cannot get anything to drink, and where the out-of-door life will build him up," Frederick continued. "Consequently, Susanne was most anxious to start with us on our next collecting journey."[37] If she and Harry paid their own way, she appealed, would Frederick allow them to join the expedition as guests?

Frederick, already overwhelmed by the daunting task of organizing a large expedition under the National Geographic Society's watchful eye, consented nonetheless. "Naturally I agreed to do all I could for them, but stipulated that once we started I was to be dictator, and that I would use any degree of violence that might be necessary to restrain him in case there was any danger of a relapse. They both agreed to this."[38]

Deeply grateful, Susanne hurried to prepare for the long expedition ahead. Harry vowed sobriety, but was unable to keep his promise. "We had him in the hospital, in a hotel where two good solid German men took care of him, at home, and everywhere else we could think of," wrote Frederick. "He would sneak out when nobody was looking, buy a bottle of gin in a Chinese shop, and drink all of it on the spot."[39] Consequently, "the whole of the past month has been a struggle to keep Harry Emery from drinking himself to death."[40]

By mid-March, Janet and Frederick were eager to depart. Their preparations for the journey had been exhaustive—and exhausting. They quizzed everyone they could find who had ever gone to Kansu, and heard advice ranging from "use only mules, wear Chinese clothes, live off the country," to "take only a case of jams… never wear Chinese clothes." Still others insisted that they "be sure to take your own food; food is scarce on the way out, have Chinese padded clothes."[41] Janet was continually advised not to undertake such a dangerous journey. No wives of other explorers ventured into such unknown territories during these dangerous times; even Roy Chapman Andrews's wife always remained safely behind in Peking while her husband explored the wilds. Undaunted, Janet persevered. She and Frederick pieced the conflicting opinions together as best they could. "All month I have been preparing and packing for the expedition, keeping the social engagements that J. [Janet] makes, and helping out the E. [Emery] family," Frederick wrote Katharine. "Whenever I saw a little light in one of these activities the other two would work up a crisis, so that for five weeks, I have been at it literally every day from 8 a.m. to midnight."[42]

PAOTOW

At last, on March 9, 1923, Frederick dispatched an advance party to Paotow, a bustling city on the Mongolian border, where the expedition team would load the equipment onto camels before setting out for the desert. The Emerys and their servant left by train, accompanied by the two "solid Germans," Mr. Heiss and Mr. Karius, who had come along in order to "keep Harry in order for the first few days."[43] Mr. Wu; Mr. Ching, the botanist; Lin and Chang, the two taxidermists; Sun, the *mafu*; and one horse made up the rest of the first party.

As the Emerys' party settled in Paotow, Janet and Frederick prepared last-minute supplies. The night before they left Peking, Janet saw to one last necessity: a haircut that would be practical in the field. "I have taken a radical step, *in tears*—my hair is bobbed!" she told her parents. "And I have Chinese wadded

trousers. Can you picture me? Of course the hair is for sanitary reasons—but when I brought home my little knot I felt as tho' Janet Elliott had gone forever."[44]

On the morning of March 14, Janet and Frederick set out for Paotow with the rest of the Chinese team—their personal servant, Pu, the cook, Fu; and the "hunting boy," Jow. They stopped at Kweiwha for a day to pay their respects to General Ma Feng Hsien—the leader of the Chinese Mohammedans, whom Janet described as a powerful figure in Kansu—and receive the general's advice about Kansu travel, and some guarantee for their safe passage through his territories. The next morning they set out for Paotow, a day's journey from Kweiwha by rail. "We traveled up comfortably in a steel baggage car with various Chinese country-men, soldiers, and merchants, all most interested in an American woman with bobbed hair, viciously eating hard-boiled eggs and knitting socks," Janet reported to her family in Manhattan. "That was your once 'delicately nurtured' Janet—now a wild prairie flower."[45]

The Emerys' party met them at the Paotow railroad station and helped them unload their "tons of stuff," including "food, guns, ammunition, tents, camp fur-niture, clothes for every clime, medicines, cameras, traps, rubber bans, ink, and soap."[46] At their inn, a one-story building with an enormous courtyard, they were relieved to find fine, clean rooms and roaring coal fires. Coal was so rare in Peking that the fires delighted the travelers, who considered them a great luxury.

In a letter to her mother-in-law, Janet searched for the words to describe her exotic new surroundings.

We are up here in this frontier town (on the border of Mongolia and near the Yellow River) of 150,000 inhabitants the western terminus of the Peking-Suiyuan R.R., and on Monday we start on a 24 day camel trip into space. Our ultimate destination is the royal palace of the Prince of Alashan. I feel as if we might be going to Mars—with just as much probability of return.[47]

The spring thaw had arrived and the world seemed made of mud, thought Janet, with "mud walls, mud houses, muddy streets and mud hills, no trees except for scattered rows of willows."[48] Brilliant sunshine flooded the brown plain, which dipped into a low valley. It was festival time, the second day

Rug factory with wool drying in courtyard, Paotow. *"The wool is hung up ready for dyeing. In the right hand corner are great blocks of famous Shansi coal."*—F.R.W., March 1921

of the second moon, and Paotow's muddy streets were jammed as revelers flooded into town to attend the puppet theatres. Mongols, in their big boots and tall fur caps, filled the marketplaces. The shops were full of exotic peasant goods—bright cloths, shoes, brasses, and copper pots—and crowded with Mongol and Chinese shoppers, who bargained loudly with the merchants. "Carts of Chinese girls in bright red coats, well-greased hair, and smaller feet than I have ever seen" streamed in from the countryside. Shaggy ponies, with their brightly colored saddles and bridles, were surrounded by excited specta-tors, all standing against a background of long strips of dyed blue cotton cloth, hung out to dry in the sun. In the evenings, "stilt walkers in fantastic costumes" and "little children dressed as Chinese fairies" danced by candlelight at the inn. Janet was captivated by her first glimpse of the Mongols in Paotow "in all their barbaric splendor."[49]

Each day Janet strolled through the narrow, muddy streets in her high Italian leather boots, looking for opportunities to photograph the crowds. She was fascinated by the Mongol women with their brilliant orange and magenta robes, luxurious fur hats, and elaborate headdresses of coral beads and heavy silver that veiled their faces with a jeweled fringe. She and Susanne discovered a perch over the west gate of the city, and Frederick joined them to lie in wait to photograph the passing procession of townspeople and revelers. Camels, ox carts, donkeys, nomads, merchants, and puppeteers all passed in the noisy traffic of daily life.[50]

One day Janet witnessed the funeral of an important merchant.

Two bandmasters, clad in white gowns, led the cortège's orchestra of red-robed musicians playing trumpets, bugles, flutes, and a large kettledrum suspended on a pole, beaten by three musicians simultaneously. A powerful man striking cymbals brought up the rear. The procession wove through the muddy streets under red flags, eight enormous lanterns on poles, huge green fans, large parasols, and fluttering blue banners. Along the side a man distributed paper money from a sack.[51]

Janet was dazzled by the pageantry of the scenes before her. "It has all been very gay, and colorful," she wrote. "F. [Frederick] has photographed copiously and I hope with success—for pictures of excellent quality mean more funds for later expeditions."[52]

Meanwhile Mr. Wu negotiated for the numerous camels, horses, and camel drivers that the expedition required. Since the Wulsins and Emerys would spend much of their time on horseback, it was essential that they find strong, dependable horses—qualities that all of the horse dealers promised, but few could actually provide. Mr. Wu worked tirelessly, and the bargaining was fierce. "We bought ponies, little strong Mongol animals capable of much endurance," wrote Janet, "and we engaged our camel caravan with much palaver and queer contacts."[53]

Before leaving Peking, Frederick had sent a preliminary expense account to the National Geographic Society for photographic equipment, arms and ammunition, scientific instruments, and "gifts to natives"—including tin cups, hairpins, bandages, and other trinkets—at a total cost of $1,311.26.[54] A tireless list-maker, he

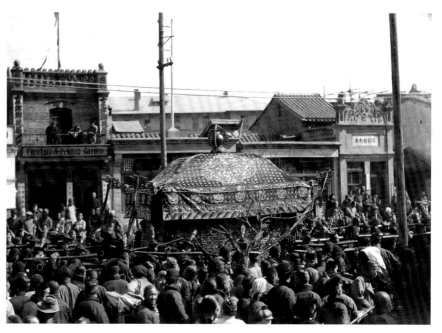
Funeral procession for a leading merchant, Paotow, March 1923.

now spent hours packing and repacking, checking and rechecking the equipment. The lists of necessities that he drew up were endless: an iron stove, a primus stove and a supply of oil, a large water can and dipper, and Mongol copper pots; hatchets, picks, and shovels for digging wells and fire pits and pitching tents; candle lanterns, oil lanterns, and flashlights. Janet prepared a large supply of medicines, and the Emerys dragged along an entire trunk filled with books. Frederick also urged each member of the party to carry an individual stash of "essentials," which would include, at minimum, a sheath knife, a revolver, a box of cartridges, a roll of emergency rations, a large tin cup, a can of Sterno to light the portable stove, matches, a compass, a barometer, a notebook, a thermometer, a candle, a lantern, pen, raincoat, camera, extra film, snake bite needle, field glasses, a shotgun, and a rifle strapped to the saddle.[55]

Janet was amazed at the amount of equipment that Frederick insisted on packing for the journey. She dryly reported to her mother-in-law that they had

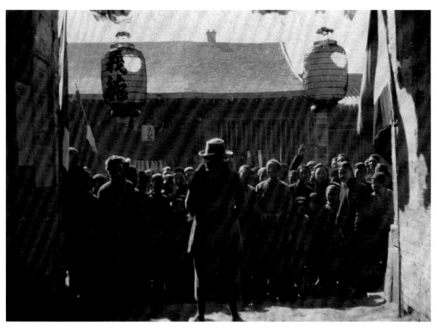

Janet restraining an inquisitive crowd while the camel caravan is loaded in the inn courtyard, Paotow, Shansi, March 26, 1923.

FINAL PREPARATIONS: THE *CHIAO TZU*

The *chiao tzu* was an ingenious Chinese invention for desert travel. These large canvas "poodle baskets,"[57] as Frederick called them, were built on a wooden frame, the bottom woven with ropes and the whole covered inside and out with heavy blue Chinese cloth "and suspended on either side of the camel."[58] In case of high winds, a dust storm, or fatigue, travelers could climb into their *chiao tzu* and ride in comfort, protected from the elements. Frederick ordered two *chiao tzu* custom-made for the expedition. Skilled carpenters spent several days constructing them in the inn courtyard at Paotow. The frames had to be perfectly balanced across the camel's backs, so at the final fitting, the carpenter told Janet and Susanne crawl to into their *chiao tzu*, then forced the camel to rise so that he could adjust the balance. A loud chorus of yells and kicks accompanied this quest for precision. Janet and Susanne spent days decorating their two *chiao tzus*. Janet concluded that "ours were the most elaborate, I feel sure, that ever crossed inner Mongolia." They installed windows made of thin Chinese gauze, curtains to hang down in front and roll up, countless pockets, cushions, and fat straw mattresses for comfort. When they were finished, wrote Janet, "Any small girl would have loved them for a doll's house."[59]

Frederick had designated Janet as the expedition's "*commissaire*," and she worked hard to gather several weeks' worth of tinned goods and essential Western supplies such as coffee and chocolate—as well as "whip the fat cook Fu into shape," as she put it.[60] For camp rations, Fu packed large bags of rice and *hsiao* (Chinese yellow millet) to be used as gruel, mush, or little cakes. The heavy crates of food were strapped onto camels and mules. They included marmalade from Fortnum and Mason, syrup, bacon, hardtack, dehydrated vegetables, malted milk, and even canned baked beans. To supplement the diet of canned and dried Western foods, Frederick hoped to shoot birds and antelope and buy sheep, chickens, and eggs. On their final days in Paotow, Janet scoured the markets for fresh fruits and vegetables.

Guns were a particular passion with Frederick. He had shot in Europe and Africa, and was an expert on firearms. In letters home he justified the guns as crucial for the zoological collection. In reality, he was also keenly aware of the dangers of civil war in the south, and knew that the warlords were penetrating Kansu. The guns would not only be necessary for hunting game and shooting zoological specimens—they would be crucial to the expedition's safety while traveling through China's war-torn countryside.

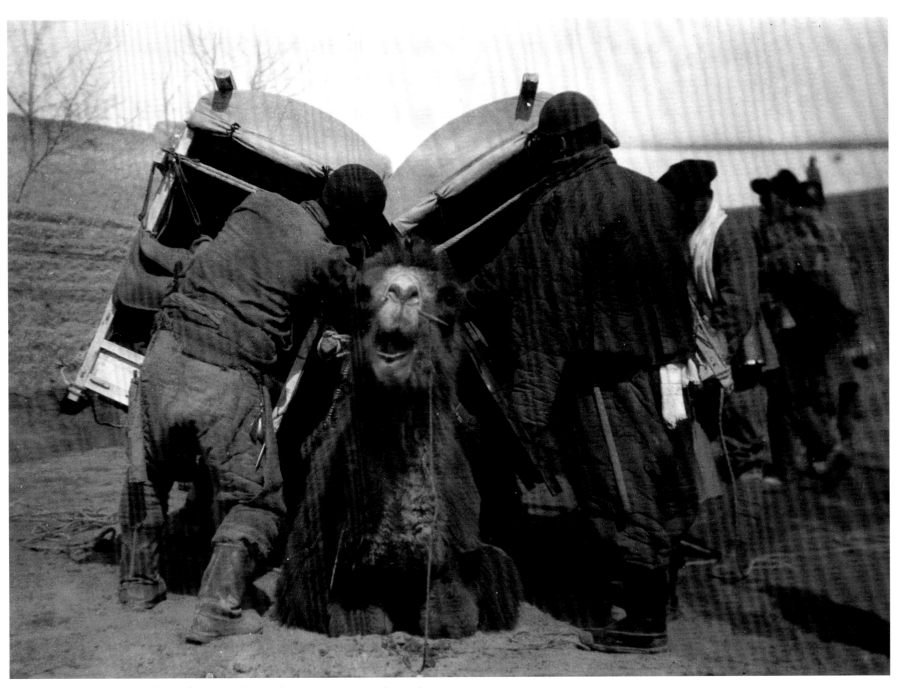

Loading *chiao tzus*, Paotow, March 1923. *"They fastened the two chiao tzus to a grinning squealing camel, on a good deal of a slant, and then [encouraged] Janet and me to get in. We did with fear and trembling, and then the camel got up with grunts and slants and jerks, accompanied by screams from Jan and me and giggles from the surrounding multitude."*—Susanne Emery, March 27, 1923

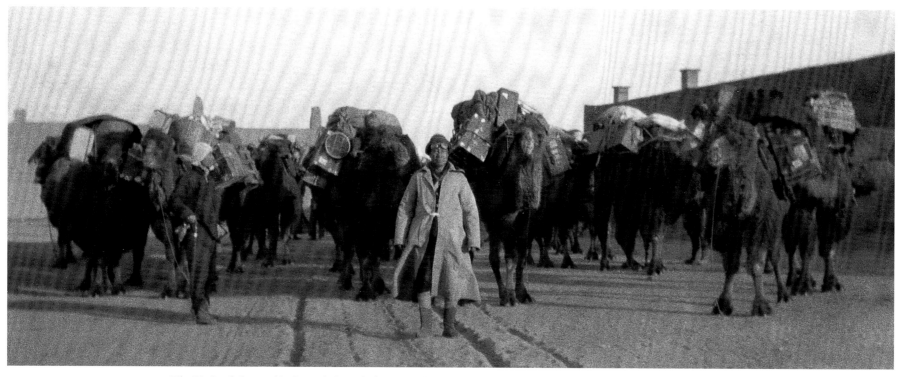

The National Geographic Society's Central China Expedition heads into the desert from Paotow to Alashan, March 26, 1923.

The days of preparations, wrote Janet, were "a mass of confusion." Frederick, so nervous and excited that he could hardly sit still, directed his assistants as they crated up guns and ammunition, personal belongings, and a towering pile of delicate scientific equipment—including botanical presses, taxidermy instruments, and of course thousands of dollars' worth of cameras and film. Excitement was everywhere. Janet stood guard at the inn's entrance gate to keep the crowd of curious Chinese onlookers from engulfing the courtyard (see page 66).

The final packing was a circus. The twenty-seven camels, scheduled to arrive from the camel dealer at dawn on the morning of March 26, did not appear until the middle of the afternoon. Rushing to beat nightfall, the expedition party sprang into action, and soon the courtyard of the inn reverberated with the sounds of packing, shouting, and the braying of camels. The camels were prodded, with squeals and grunts of displeasure, to kneel down to be loaded. Under Frederick's anxious direction, the Chinese team carefully balanced forty-three heavy wooden crates upon the backs of the kneeling camels. The loading went smoothly until Frederick realized that an extra camel would be necessary for the cook's equipment. Mr. Wu rushed back to the camel seller, made a hasty deal, and returned, breathless, with one more camel. Janet dashed off a last quick letter to her family in New York, reassuring them that, "we are very well, excited and happy…. I will try to get off letters from every P. O. but they are few and far between so you mustn't worry," she reassured them.[61]

After months of preparation, negotiations, cables, and bureaucratic stalling, the camels finally rose to their feet at 6:15 p.m. on March 26, 1923. The sun began to set, casting long golden shadows over Paotow. "You can't imagine what a momentous occasion it was," Janet wrote. "F. [Frederick] dashed about on his small prancing Mongolian pony, equipped for battle in khaki, campaign hat, two guns; the servants were perched on top of various camels looking very ill at ease, but knowing that they had to do it."[62] A dust storm was rising, so the camel driver strapped on the *chiao tzu*, and motioned for Janet and Susanne to climb aboard. "We did, with fear and trembling," wrote Susanne, "and then the camel got up with grunts and slants and jerks, accompanied by screams from Jan and me and giggles from the surrounding multitude."[63] Janet explained further. "You climb in while the camel is on the ground and then he rises, or rather unfolds, lurches forward, then back, and is up. But what an arising! The drop in a huge elevator is as nothing compared to it."[64]

Mr. Wu led the caravan triumphantly through the gate of the high walls of Paotow and out toward the Ordos Desert. In addition to the Wulsins and Emerys, the caravan now included twenty-eight camels, four camel drivers, six horses, ten Chinese from Peking, and ten Chinese from Paotow. "The flight of the children of Israel from Egypt had nothing on us," recalled Janet.[65] The great plateau of Han Hai, ancient Chinese for "rolling like the boundless ocean,"[66] lay before them—and an adventure that would change all of their lives.

INTO THE ORDOS DESERT

The great Gobi Desert lay just to the northwest of them, serving as a barrier between the northern nomads and the more settled lands to the south. In 1923 it was a void skirted by Silk Road merchants as they drove their camel trains between east and west, a remote and hideously inaccessible area—yet crossed often, though with great hardship, by conquerors from Attila to Genghis Khan. Many had traveled the historic trade routes from Baghdad, Ulaanbaatar, and

Chinese Turkistan, their caravans laden with wool, hides, gunpowder, textiles, and spices. The Gobi—a Mongolian word meaning "watering place" or "gravel desert"—is the northernmost and least populated desert on the planet, covering more than half a million square miles and receiving fewer than three inches of rainfall per year. In the heart of this rocky, wind-scoured desert, in the far reaches of northern China, lay the Alashan plateau, the expedition's first destination.[67] Crossing this vast wasteland was the first of many challenges that the Wulsin expedition would face during its trek to Tibet.

Their route followed the course of the Yellow River northwest to the Ho Lan Shan mountain range. After they became accustomed to the lurching motion of their camel, Janet and Susanne sank into the cushions of their *chiao tzu* and relaxed, watching the horses and camels plod along ahead of them. "Camel travel is peaceful *and* slow and delightful," wrote Janet.[68] "We bobbled along many a mile while the camel ogled us with his great supercilious eyes."[69] They had everything at hand in their wall pockets, and spent many hours as "prairie flowers" rolling through the desert. Their camel had a way of expanding his stomach at intervals against the sides of the *chiao tzu*, which was disconcerting at first, but became almost comforting once they accustomed themselves the sudden heaving motion. Susanne's tin washbasin, strapped to the top of one of the camel's loads, caught the moonbeams as night fell. From Janet's cozy perch in her *chiao tzu*, it looked to her like a glittering planet across the sands.

After their first moonlit march, during which they passed "endless caravans, often over two miles long traveling… in never-ending lines in the moonlight noiselessly, but for the clink of the camel bell… hung on the last camel of each string," the caravan spent the night at a Chinese farm.[70] The farmers welcomed them as visiting royalty, and accorded the Wulsins the wedding chamber of a newlywed couple, where they slept in their bedrolls on a *kang*, or wooden platform. The following day they forded a branch of the river, with the camels slipping and stumbling over the rocks. Frederick and Harry dismounted and hunted antelope until dusk.

Sketches of numerical hands signals used by Mongols in the Alashan Desert by Frederick R. Wulsin in his journal, Li Dja Sha Wo, Inner Mongolia, September 1923. *Above:* The expedition's camp at Tsai Yuanze in the Ordos Desert northwest of Paotow next to a Mongol trading post. *"For days we slept four in a tent and spent some wild nights while the Mongolian winds shrieked around us, and shook the tent as thought it was made of paper...."*—J.E.W., August 6, 1923

After a few days' march, they arrived at low flat plain that stretched to the Lan Ho Shan mountains in the west. Occasionally they passed a Mongol yurt or crumbled temple, but for the most part the distance spread before them like a calm sea. On April 3, at a small trading post called Tsai Yuan Tzu, they met a "picturesque" Mongol crowd who were fascinated by Janet's brushes and combs, and watched with suspicion as Frederick and Susanne wrote in their journals. The Mongols loved to barter, and Janet exchanged a small tool kit for a gold ring from one of the nomads' fingers. These negotiations were conducted in "the language of the desert": pidgin Chinese mixed with Mongolian and much sign language of hands and face.[71]

On the night of April 3 they camped at Wu La Ku Tu, a ruined Mongol temple. Mr. Wu rode into a nearby town for supplies and returned with reports of danger: a group of Chinese cavalry deserters had united to form a robber band, and were marauding in the nearby hills and trading posts. Soon a group of soldiers arrived to warn the expedition about the brigands. They presented Frederick with their captain's card to use as a pass in case of an attack, and he tucked it safely away. Luckily, the robbers fled to the southeast as the caravan headed north, narrowly avoiding danger. Frederick, immensely relieved but still on edge, stored the card just in case. Two days later the expedition passed a ransacked farm where Mongol soldiers

had captured two of the robbers. Their severed heads swung from wooden poles as a warning to all who passed.

Danger averted, the caravan continued slowly across the countryside, moving at the camels' lazy pace, camping in ruined temples and abandoned farms. The vast prairies spread endlessly about them in all directions. After many days they camped by the Chia Ho River. Here the expedition discovered a marshland full of exotic birds on one side of the river and big game in the mountains on the other. The oasis was a welcome relief from the endless monotony of the desert, and offered an ideal area for collecting specimens. They camped for five days, hunted and shot a variety of birds, two Mongolian antelope, and two rock goats.[72]

Sandstorms often funneled across the skies, engulfing the caravan in a blinding cloud of dust and debris. These storms brought two enemies—sand and robbers. One day a sandstorm blew ferociously among the camels and horses, causing the horses to bolt and blinding anyone who could not shield their eyes. Human voices arose out of the noise as a clattering, galloping band of bandits rode by. They did not seem interested in the Wulsins' caravan, but at the next watering hole, the party was told that the robbers had beheaded a man for his silver and ridden on. Later they passed a robber's head suspended in a wooden cage. Justice was swift and final in the desert.

The caravan's daily routine was dictated by the needs of the camels. As Janet wrote, "We had to change our habits of life quite a little, as the camels wouldn't change theirs. They insist upon grazing on stubble or stones or any other trash from 4 a.m. until noon, then marching from noon until dark or later."[73] Their march began at 1 p.m. and continued through the afternoon until dark, when they pitched camp. The travelers had a big brunch (or "munch") at 11 a.m. and dinner at 9 p.m. after they had set up camp. Their servants prepared an afternoon "tea" en route that included cocoa, ham, and occasionally even eggs. The camels rested during the night and then grazed from dawn until 11:30 a.m., when the drivers then brought them in and gave them another feed from nosebags while the arduous reloading of trunks and boxes went on.

Justice was swift in the desert. Ordos Desert, April 1923.

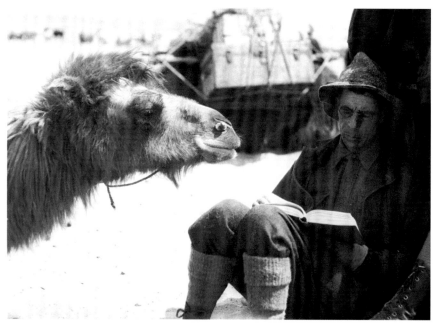

Harry Emery with camel, Ordos Desert on the route to Alashan, April 1923.

The Chinese camel drivers worked their camels all year long, noted Frederick, unlike the Mongols who let theirs graze for six months of the year. Consequently the Wulsins' camels had to be "fed and watered every day. They had no big stores of fat to draw on," and they could only travel fifteen to eighteen miles a day, which was slow in comparison to the progress they had been able to make in Shansi a year before. Occasionally they were able to travel faster, but only under pressure. They always paid for it "by doing less than usual in the next two days."[74] Frederick asked his drivers whether they could not march early in the day, and let the camels feed before dark. He was told that the camels fed best only after they had rested. The caravan often met other caravans traveling at all hours of the day, but their contract specified 1 p.m. for starting. Frederick felt that their camels required all the favoring he could give them, and said nothing more.[75] The stubborn beasts ruled their days.

Janet, for her part, enjoyed the camels once she got used to living on their schedule. "Camels are frightfully funny creatures—they are so like people," she wrote home to her family. "Every night when we got unloaded they would form in a circle, sit down and begin munching the leftover lunch. We called them the sewing circle and there was Mrs. Cabot and Mrs. Lowell and Mrs. Sears who always munched and gossiped together in the most supercilious way."[76]

THE GREAT MONGOLIAN PLATEAU

The Great Mongolian plateau, with its grasslands, flocks of sheep and goats, and an occasional herd of cows, spread out before them day after day. The expedition often traveled well into the night. A full or waxing moon transformed the desert in its silver light, and made the mud-walled farms appear like Arabian palaces. Night marching was glorious.

Frederick originally assumed that the caravan would be able to cross the Yellow river on the ice. He had, therefore, not anticipated a Mongolian journey. Thus, accommodations across the desert were crowded. Frederick brought only three tents: one for Mr. Wu, Mr. Ching, the groom, and the saddles; one for the cook, his works, and the other five servants; and one for the four Americans. Frederick admitted that the tent was "pretty crowded" for use day after day. He and Harry had to take great pains to allow their wives even a small degree of privacy. The two men would smoke outside the tent until Janet and Susanne were in bed, then crawl in themselves; in the morning, they would rise first and leave the ladies alone to dress. As Frederick said later, "As a result I lost a lot of time that could have been used for sleep, writing or reading if we had had separate tents, to say nothing of the obvious charms of privacy."[77] Frederick vowed to take more tents next time. Even at the inns and trading posts, space was limited. "We usually slept four in a room, and the boys were very careful to put the two wives next to each other with each husband beside his lawful wife," Janet wrote.

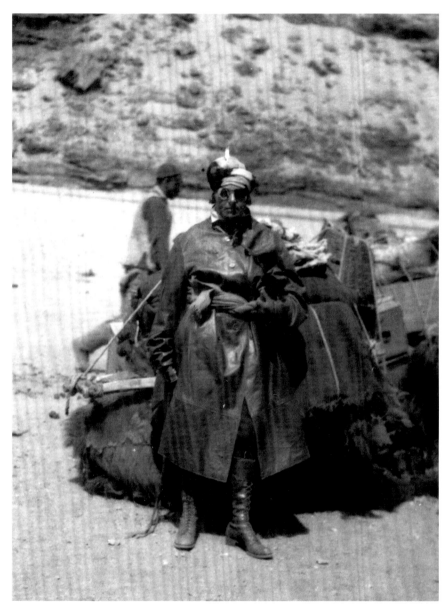

Janet bundled against the desert winds, Ta Shui K'o trading post, April 20, 1923. *"The days in the Alashan Desert were something we were glad we did, but don't want to repeat. Ten hours of steady marching, and then a hole in the sand of such brackish water that even the horses won't touch, it is no fun. But those days are memories now, and I am glad to have seen those acres and acres of sand, rolling sand and weird dwarfed trees like a forest bewitched."*—J.E.W., August 6, 1923

Many were our nightly companions—puppies, cats that insisted on trying to use my head for a pillow, 6 little piggies whose owner told us were motherless, a setting hen slept close to Susanne one night without uttering a sound and then in the morning burst forth into torrents of abuse; [one room was] a butcher shop where legs of lamb, dried hearts, livers, hung over our heads like "Swords of Damocles." For days we slept four in a tent and spent some wild nights while the Mongolian winds shrieked around us, and shook the tent as tho' it were made of paper.[78]

Trading posts were important refuges for caravans in the desert. These isolated trading posts existed about ten miles apart. They were often huge enclosures with many rooms and courtyards, run by individual Chinese merchants who bought hides and wool from the Mongols and sold tea, boots and hardware in return.[79] As the Mongols did not trade, manufacture, or till, the Chinese settlers ran the shops. Some of their inn enclosures were two hundred yards square, with chief accommodation for the livestock (small herds of cattle and many sheep and goats) that "were the chief possession of the Mongols and governed their lives." There was also sufficient room for some families to have separate rooms, which seemed luxurious to the travelers.[80] In the inns weary travelers would spread out their bedrolls on wooden bed platforms or in the courtyards. Frederick described one inn as a "barnyard": "Both sleeping platforms were crowded with camel-drivers, peasants, and travelers. One look at this squalor, and we set up out tent in the courtyard, among pigs, donkeys, and oxen."[81]

As they moved further into the stony desert, the expedition spent five or six days traveling without seeing a trading post or habitation. "For days we never saw a human soul, maybe in the distance a Mongol with his camels silently moving across the landscape, or a few Mongols with their flocks and herds," wrote Janet. "They are picturesque smiling people of great filth and huge feet."[82]

One day they passed a great caravan of nearly five hundred camels laden with wool and hides coming from Kansu or Chinese Turkistan, an eighty-day march. The great caravan was a wonderful sight. The camels were festooned with robes of brilliant purple, red, and yellow cloth. One had a red fringe around his

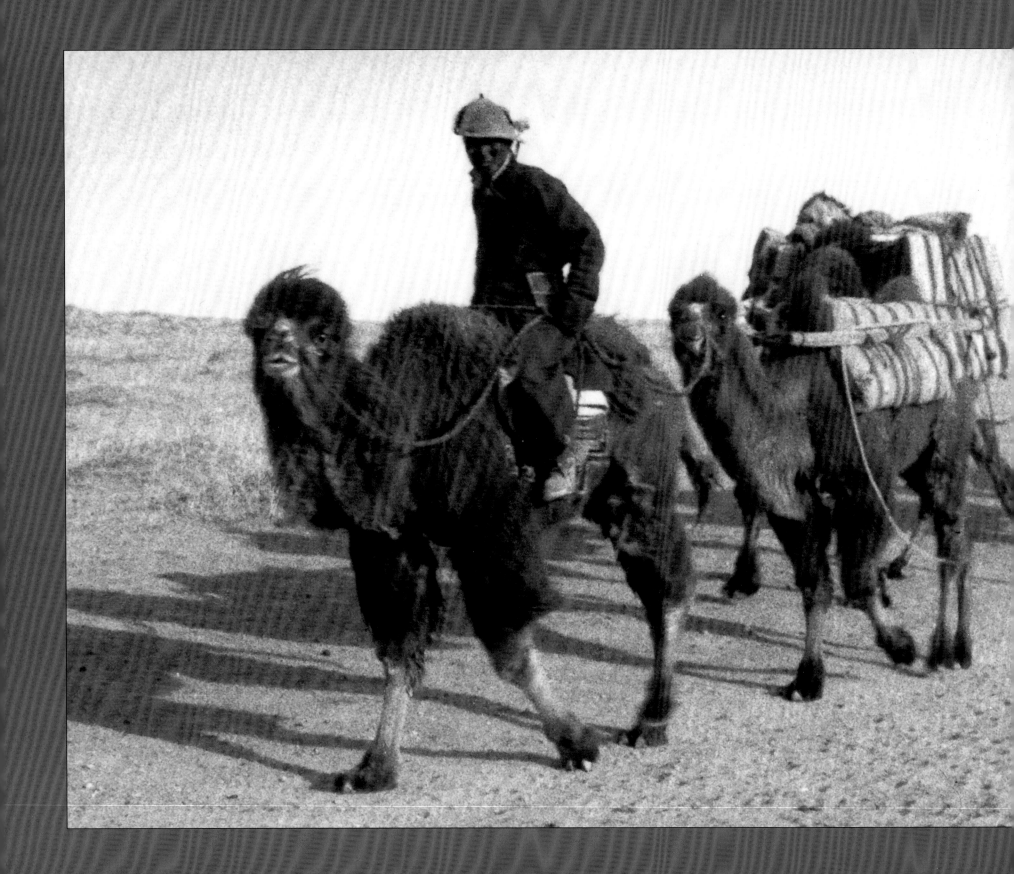

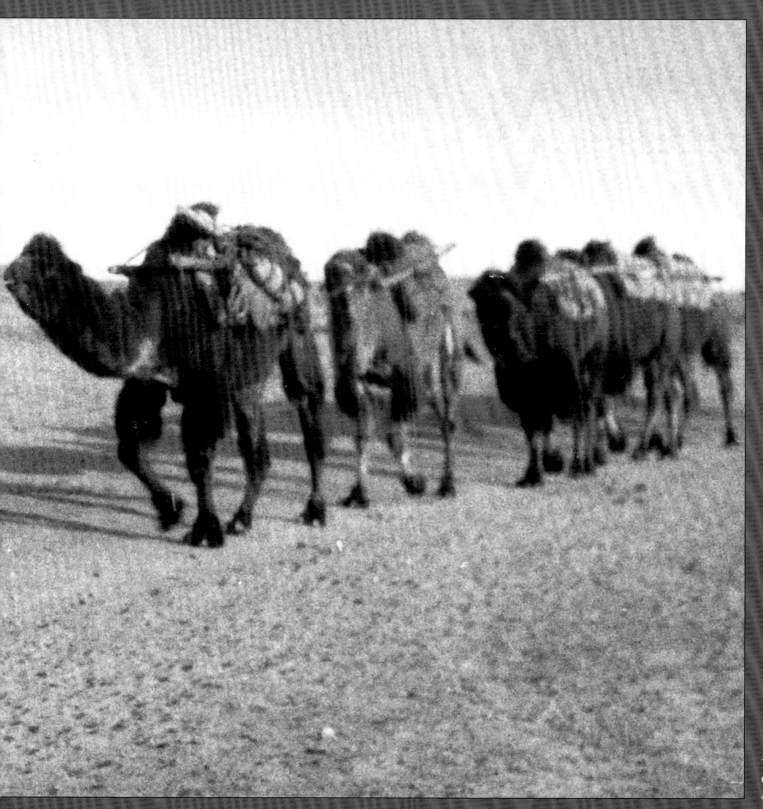

The National Geographic Society
Central China Expedition camel caravan
crossing the Alashan Desert, April 1923.

hump and a framed picture propped in front of his hump. Behind him on a white horse was seated a boy of eight or nine wearing regal yellow robes. He was the newly incarnated Living Buddha, or *Hut'ukt'u*, the Mongol word for "one who returns." "The Living Buddha at Lhasa is called Hut'ukt'u," noted Susanne, and "now most Mongol monasteries have their own living Buddha or avatar."[83] Two riders in red quilted robes, leather boots and fur caps, and a lama in brilliant yellow towing a camel followed him.

The caravan continued mile after mile, watching camels graze over the vast panorama spread out before them. Mongol camel drivers often strapped newborn camels to their mothers' backs or slung them in a bag for travel. They were carried all day long for their first month, and did not begin to go the full day's march until they were three months old. Janet described them as "the softest little gawky things with their fuzzy two humps that hadn't hardened enough to stand up."[84]

THE SEARCH FOR WATER

A month after their departure from Paotow, the expedition party was out of water. They entered a magnificent gorge surrounded by Mongol shrines with sacred piles of sticks and stones called obos and spotted camels and a few Mongol tents, but no spring. They stumbled on through the dark, holding lanterns, until they saw a campfire flickering in the distance. They pressed on to find a startled Mongol and his camels. Scowling suspiciously, the lama grunted that there was water a little way to the west, retreated into his tent, and "slammed the door so to speak," wrote Susanne. "After urging him in vain to guide us we stumbled on in the dark."[85] Finally, in the darkness, they found a small spring in the sand. Janet and Susanne crawled on their hands and knees in the darkness, searching for fuel, and returned to the camp with Janet's leather coat full of dried camel dung. At last they built a fire and relaxed over a cup of cocoa under the stars. They christened the tiny spring "Sour Lama Camp" in honor of the surly lama who had refused to help them.[86]

From then on, the quest for water was incessant. The next day they were told that there was "dead water" ahead, which meant that the wells they found might be dry. The camels were tired as the grazing was poor, and they refused to travel long distances. The team filled every possible container, including four hot water bottles, which Janet packed in the pockets of her *chiao tzu*. The next Mongol trading post was forty miles ahead. There they would surely find a reliable spring—and, Frederick hoped, a guide to lead them through the last leg of their desert trek toward Wang Yeh Fu.

On April 20, after several tense days of searching for water, they met a knowledgeable Mongol who agreed to serve as a guide. Frederick was immensely relieved. "Just as we were leaving the Lord provided a guide—a wall-eyed individual traveling alone on a white donkey," he wrote in his journal. "He lives in these parts and knows of abundant water en route."[87] Their new guide wore ragged white trousers, a purple waistcoat, a violet turban, and a long sheepskin coat. His native language was Mongol, but he spoke a half-Chinese jargon that everyone seemed to understand. Walking beside the lead camel driver, the new guide set out to lead the party safely to the water that they so desperately needed.

The following day they heard a dog barking near several yurts, and found more nomads, but little water. The days grew hotter and hotter. Dust blew into the eyes, mouths, ears and nostrils of the travelers. Everyone wore goggles and covered their faces as much as possible, but there was no escaping the broiling sun as it rose overhead. They stopped for lunch under a canvas awning, but the shade did little to cool them. Finally, late in the afternoon, they discovered a muddy trickle on the sandy ground. Cautiously, they followed it into the mouth of a gorgeous ravine with high red sandstone cliffs—a place known locally as Ta Shui K'o, or "Great Water Gorge." Within the canyon, the trickle became a gurgling brook: water at last! In jubilation, the weary travelers kicked off their boots and plunged their tired feet into the water. The women followed the stream up to the second waterfall, pulled off their shoes and stockings, and rejoiced as they waded. Safe at last, they prayed that the worst part of the desert crossing was now behind them. That night they camped in the wide

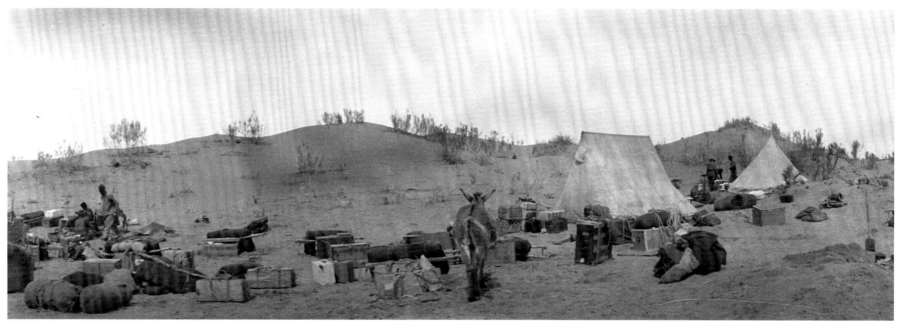

The Sour Lama Camp, where the expedition stayed during the long search for water, April 1923.

circular alcove, surrounded by cliffs of red sandstone, on a flat sandy floor cut by the stream of ice-cold water.

MONGOLS IN THE RED GORGE

The gorge proved to be a meeting ground, with a steady procession of lamas, shepherds, and merchants who stopped to water their animals. The next morning a long Chinese caravan of 140 camels passed, carrying hides and wool to the railroad in Paotow. A blond camel, with beautiful saddle blankets, inlaid stirrups, and great brass watering cans gleaming in the sunlight, lumbered in for a drink. The Mongol driver followed, clad in brightly colored robes and a tall peaked fur hat with a turned-up brim. More muted were the Buddhist lamas, who wore the

traditional dull red or yellow cloaks. "All the Mongols we meet are friendly in the extreme," Frederick noted in his journal.[88]

"As sun was getting low, and we were coming over the crest of the plain," wrote Harry, "we met… A family of Mongols, men, women and children, each on their magnificent, shaggy camels, in their colorful costumes. They smiled broadly and wiggled their thumbs at the Americans."[89] "The Mongol greeting, we learned, is to wiggle your thumbs," wrote Susanne, "and now that we do that and smile on all occasions we get on better."[90] Some of the children tumbled off their camels in such haste that they fell flat, but no one noticed. All of them found the cameras fascinating. The old lady, "a frolicsome old dame" who stood about four feet high, wore a shiny gray-green gown that had once been purple, a yellow peaked bonnet, goggles of horsehair netting, and a yellow cloth strapped over her mouth to keep out the wind (see page 79). Her great leather embossed Mongol boots were as

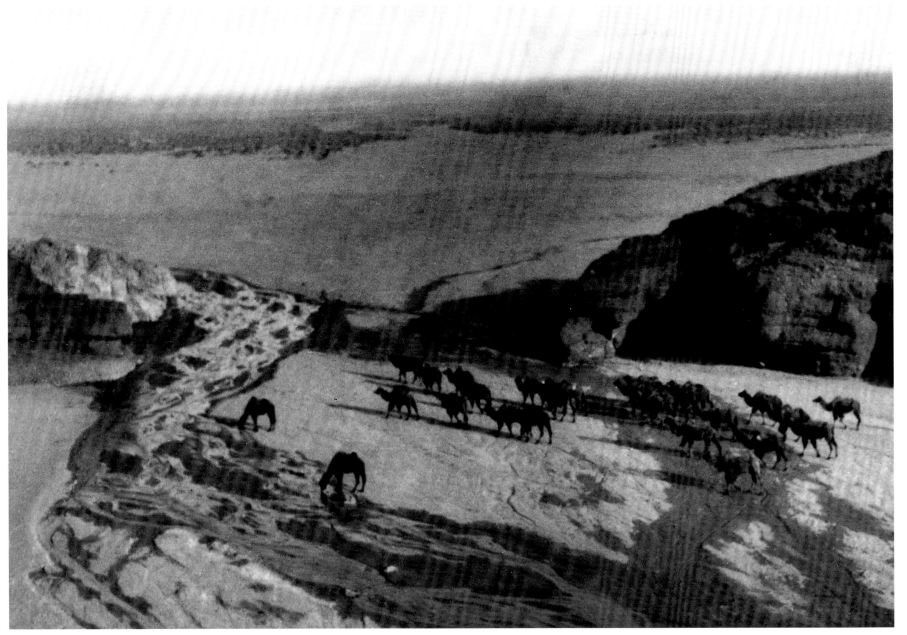

The camels stroll towards water and grazing lands on the hillsides after the desert crossing, Ta Shui K'o oasis, Inner Mongolia, April 1923.

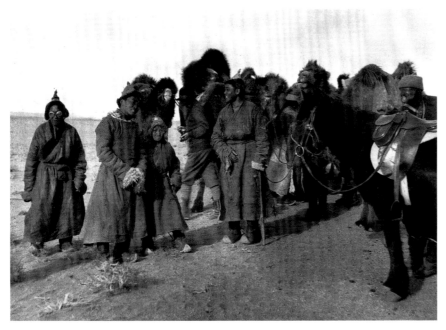

A Mongol family with camels, Ta Shui K'o oasis, Inner Mongolia, April 22, 1923.

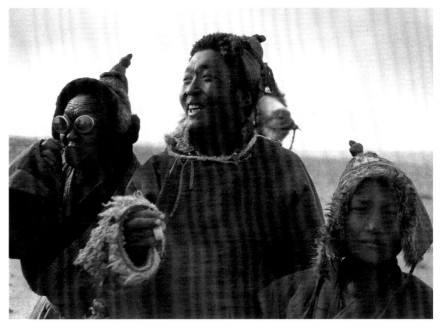

A Mongol grandmother in her goggles with her daughter-in-law and grandchild, Ta Shui K'o oasis, Inner Mongolia, April 22, 1923.

large as Frederick's, and she gleefully played a game of comparing foot size with him, stamping delightedly on his feet with roars of laughter. She was intrigued by the women—the first Western women she had ever seen, and felt them up and down to make certain of their sex. She rode the largest and most magnificent camel they had ever seen, with fat, stiff humps and thick fur as a testament to his health.[91] "Grandma," as she was affectionately nicknamed, wiggled her thumbs excitedly and proceeded to charm the party. She danced around Janet's small donkey, feigning fear and laughing all the time. At eighty years old she was considered a lama in her own right.[92] After the Mongols had directed the travelers to the next well, the two parties separated with friendly greetings and shouts across the desert. Everyone felt that they had met "the Mongolian of the Mongols."[93]

For the next few days, their one-eyed Mongol guide on his white donkey successfully led them to another great water gorge and, eventually, across several long stretches of dry, sandy desert. "Though his estimates of distance were vague in the extreme, he always found water for us at night," wrote Frederick in relief.[94] For two days they crossed high sand dunes thickly studded with dry, gnarled, miniature trees, so stunted by their harsh environment that they grew only a few feet tall.

One night, however, it became clear that even the guide had lost his way. At ten o'clock one of the camels fell and refused to get up. Frederick sent Mr. Wu and the camel driver ahead to look for water. An hour later Mr. Wu fired a rifle shot from the distance to signal that he had found water at last, and as midnight approached, the Chinese "army" hurried to set up camp at the well. Fu, the cook, prepared a satisfying late-night meal, and Janet and Frederick were eager to crawl into their tent for the night. After dinner, Frederick bid Mr. Wu goodnight with his usual Chinese salutation of *"Nin cherla miao* (Have you eaten)?" Mr. Wu said nothing. Frederick pressed the point, and discovered that none of the staff had eaten dinner: apparently the well water was too salty for even camels to drink. The horses had sniffed the water and refused to touch it, and the servants were unable to use it

for cooking. Mr. Wu and the others were going to bed hungry and thirsty after having served the Americans a dinner of soup and cool water from the previous night's well. Janet and Frederick, touched by their staff's quiet generosity, gave Mr. Wu and the others cans of soup and the last few cups of water from their canteens.

It appeared that the expedition's water bags had remained mistakenly unfilled from the last watering hole. Such carelessness resulted in much finger-pointing and blame despite the fact that Frederick had been warned that the area was full of alkali wells. Nerves were on edge. Finally the guide found a well some five miles away. With water, the Mongolian desert was a place of vast, harsh beauty; without water, the expedition learned, it could quickly become deadly.

Harry, meanwhile, was impatient to keep going. He had regained his health and physical stamina, and bragged that, although fifty, he was in better shape than any of the younger men. Each day he rose early, started the fires, walked a few miles out into the desert, and returned to rouse the rest of the party. He felt that the expedition lacked order, and shared his thoughts with Susanne and his sister far away in Providence, Rhode Island. As an economist and business leader, he was used to precision and order. Life in the desert offered neither. Frederick coped as best he could with his "team," the camels, the collections, and the unexpected demands of the journey. Harry's determination to beat his "enemy" had paid off, however, and Frederick was relieved to report that Harry had "straightened out completely and is a charming and considerate companion."[95] Frederick complained to his mother, however, that "two women in a party are four times as much trouble as one, and one is more trouble than four men."[96] He planned to go alone on his next expedition.

After over a month of hard travel, the expedition grew weary. Mr. Wu was tired of negotiating the constant conflicts that arose between the camel drivers, grooms, guides, and Fu, the temperamental cook. His choice of cook, a tinker whom he had hired in Peking, had proved a poor one, as he was argumentative and moody. As Frederick complained, "Chinese cooks are plenty in Kansu, and this man will have a chance to walk home unless he reforms very soon."[97]

Nonetheless, all agreed that there would be no rupture for fear that he might desert them. The motto became, "Once aboard the camel the cook is ours."[98]

On the night of April 24 they made camp at a spot they called "Mud Well Camp," where the team desperately dug a makeshift well. The water was so muddy that it was barely fit for the animals to drink. They lined the well with a tin can and waited overnight for the mud to settle. Despite a fierce desert wind that raged all night, shaking the walls of the tents and howling across the dunes, the well water settled enough by dawn for the expedition party to fill their canteens. Janet figured that a little more mud wouldn't hurt her.

The morning of April 25 dawned gray and dreary, and by afternoon the expedition was caught in a nasty hailstorm. They stood with their backs to the wind for an hour, and finally pushed forward when the icy gusts subsided. As they sky cleared, they beheld a waterlike sheen in the distance each time they came to the top of a rise. They pressed on toward the shimmering lake, hoping it would prove to be more than a mirage. The desert had many illusionary tricks, and the weary travelers had learned to suspect their first impressions.

THE SALT WORKS

At three in the afternoon, after crossing a series of dunes but never encountering the lake, they came to a large stone-lined well next to a well-built Chinese house. The caravan had finally arrived at the trading post of Gi Lan Tai Yen Yen Hou—the Salt House—where they found an excellent well, a well-kept road, and good grazing for the animals as well as a beautiful campsite. This trading post, on the edge of high sand dunes, was surrounded by vast salt fields. Salt was the most highly valued natural resource of the desert, and the only source of wealth. Salt administrators were always powerful and rich men, and control of salt wells was fiercely contested and often led to bloodshed. Here Janet and Frederick met several armed soldiers in the small community that worked the salt wells.

As the weary travelers soon discovered, saltwater pools were wonderful for bathing. They disappeared out into the desert until they found a good deep pit, stripped off their clothes, and plunged in. The water was so salty that they floated or swam in any position. Suzanne posed with her arms, her feet, and her head all raised without sinking. The temperature was cool enough to be refreshing. When they came out and dried in the sun they all looked as if they had been rolled in flour, and had to peel the salt from their bodies in layers.[99]

The expedition now began to sense that their desert crossing was drawing to a close. They relaxed for a few days, watered their animals and let them graze on the stubby desert grass, and explored the neighboring sandy hill. Janet and Susanne hiked to the top of a secluded dune where they sunbathed and watched a convoy of black beetles crisscrossing the sand. With water and some rest, tempers were restored and high spirits returned.

At the Salt House the expedition's faithful one-eyed guide, with his fleece coat of many colors, his purple turban, and his white donkey, bid farewell and returned to his territory. Their new guide was a tall, slender Chinese man, with a long queue hanging down from under his black velvet bonnet. He wore blue cotton Chinese trousers, black leather Mongol boots with green trimming, and a gray cotton shirt with a high standing collar and long sleeves piped with black. Around his waist were tied various colored scarves with silver and embroidery. He often stood motionless smoking his long pipe with its green jade mouthpiece clamped in his teeth.[100] He was originally from Paotow, but had grown up in this region and worked in the salt works. Frederick paid him five dollars to guide the caravan to Wang Yeh Fu, with a one-dollar bonus if he guided them safely out of the desert.

After the Salt Well Camp the caravan came to a parting of the trails, one leading southwest to western Kansu, and the other south to Wang Yeh Fu, a hundred miles away. The following two days the party "ate bitterness" again as they stumbled along poor trails and searched for hidden wells. High winds blew and filled their eyes with sand. The camels grew increasingly weak, and at times the drivers had to flog them onwards. Skeletons of dead animals littered the sands surrounding the wells. Camels lacked the spirit of horses and men, the camel drivers

explained; once worn out and discouraged, they lie down with their loads on their backs, and refuse water and food until they die—sometimes only feet from the wells.[101] The expedition struggled on.

The markers in the desert now changed from piles of stones to high stacks of twisted branches and roots called *obos*, which marked the trails. Each time a caravan passed, the travelers would deposit a branch on top of the pile. These large obos dotted the landscape and gave the guide mysterious directions, obscure to the foreign travelers. The branches proclaimed the availability of trees, and where there were trees, there was water. The caravan lumbered on.

THE FINAL OASIS

More sand dunes rose ahead. The camels strode on undaunted, but every man on the team had to push and pull the carts through the deep sand. This slowed the journey down and they crawled through the heavy dunes from Hato Kutuga, with its small trading post, to U Djor Tau Li. Finally, the countryside flattened. At Cha Hor Lei they camped at the site of a ruined trading post near a large, clear spring. Here they met a caravan of one of the local lords, Ta Tung Kung, who arrived with Mongol soldiers as escorts. A beautiful Mongol girl was also at the well with her camels. Janet and Susanne were a novelty to the Mongol girl, and she showed off her beautiful earrings and elaborate coiffure. Janet, in turn, displayed her watch, bug lights, and sewing kit. She gave the girl a needle and some chocolate, concluding that they had been able to express themselves "in the universal language of womanhood."[102]

The next morning the caravan was awakened by a group of stallions, mares, and colts that arrived at the well for a drink. Later, more caravans arrived. Dawn brought a group of Mongol women with she-camels and their young, a flock of baby camels of all ages and colors, including a pair of pure white three-month-olds. The oasis grew busier as the morning progressed with flocks of goats and sheep, camels and horses, some fierce Mongol dogs and mules. There was a continual circus performing for the expedition as they sat happily in silence on the grass.

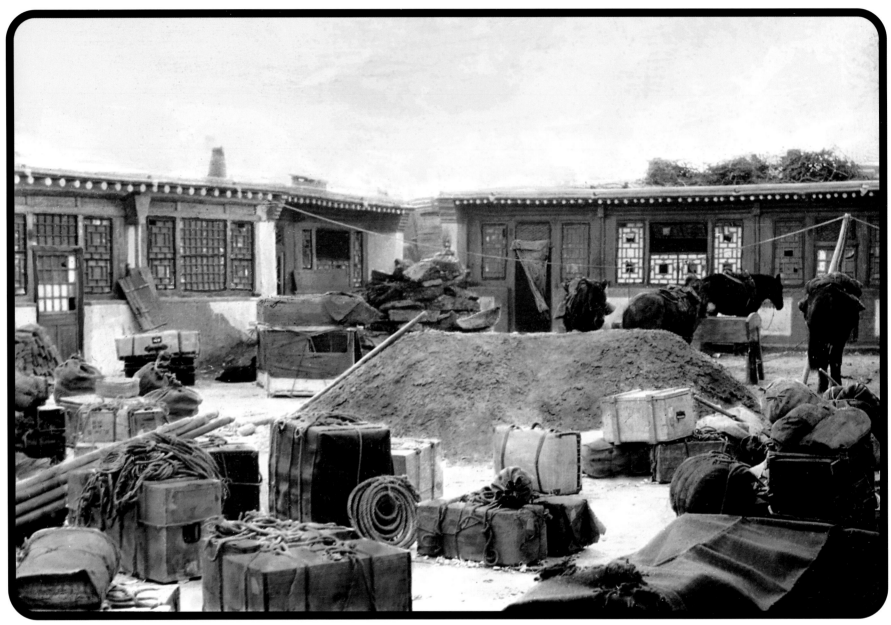

The caravan unloaded for the night, trading post yard, Ch-ang Fan Ch-uan, Inner Mongolia, April 7, 1923.

Right: *Chiao tzus* rising with Janet inside (left), March 26, 1923. These large "poodle baskets," as Frederick called them, were built on wooden frames, the bottoms woven with ropes, and covered inside and out with heavy blue Chinese cloth. The frames had to be perfectly balanced across the camel's back.

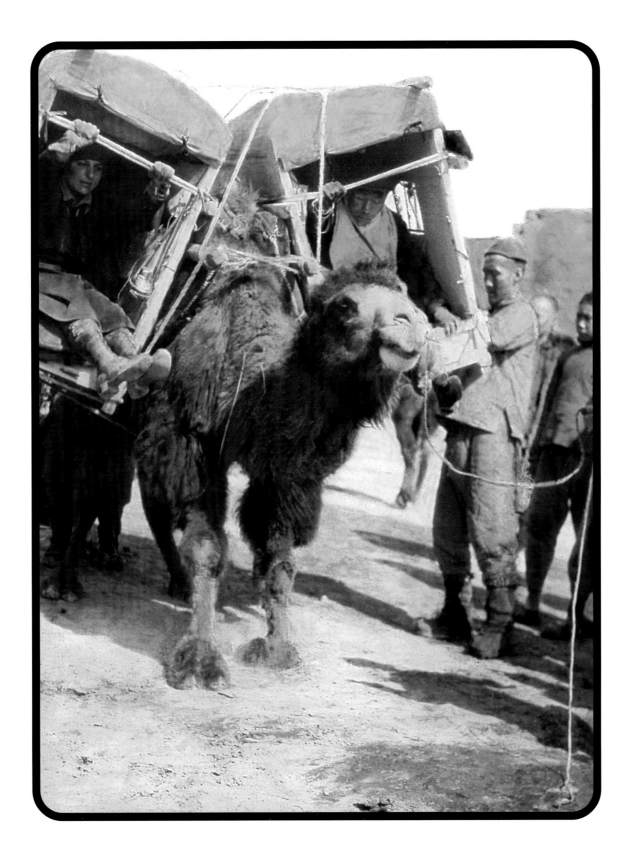

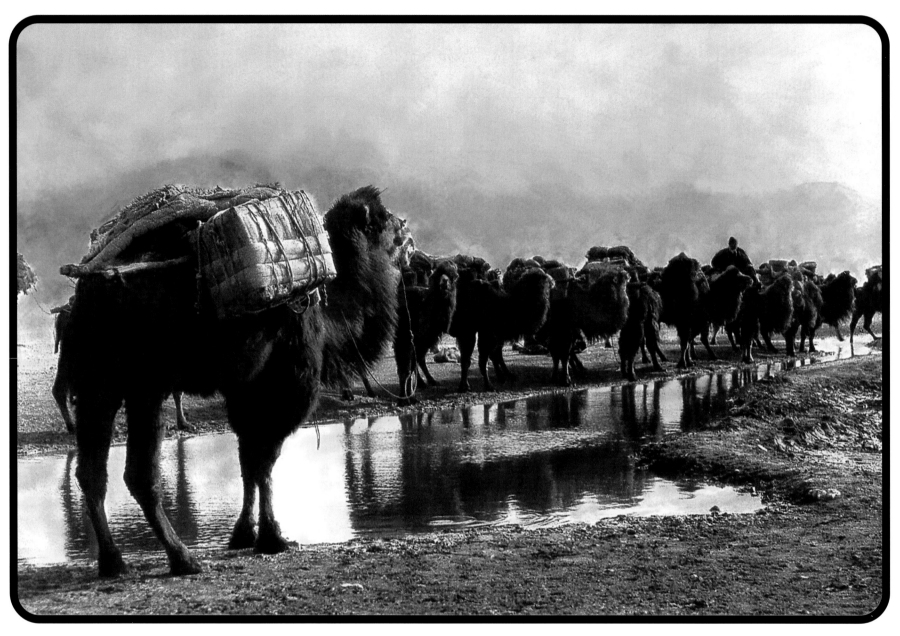

Camels reflected in an oasis pool in the Alashan desert, Inner Mongolia, April 1923.

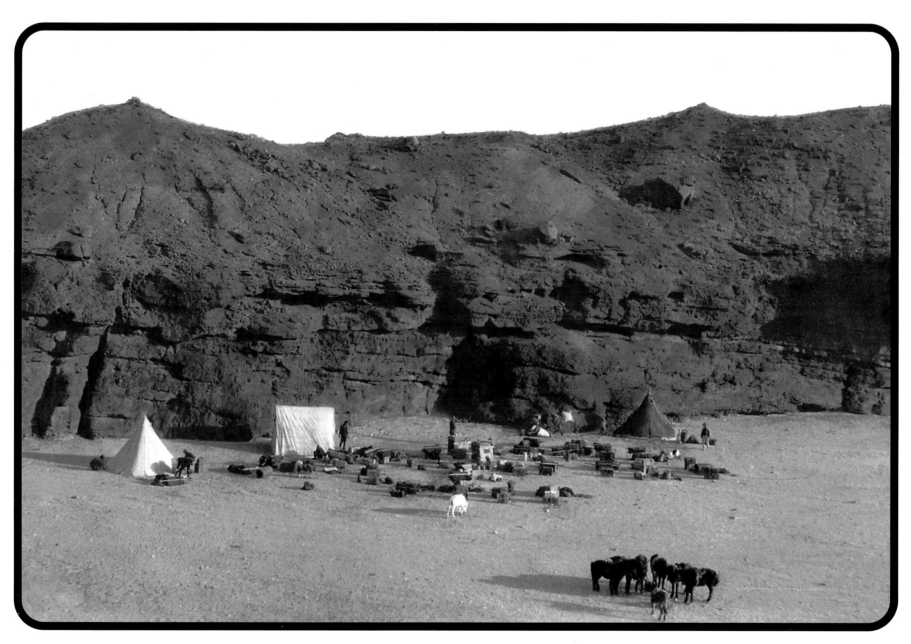

Camping at the Ta Shui K'o oasis on the edge of the Alashan Desert, a favorite watering place for Mongol caravans at the west end of the Ho Lan Shan Mountains, April 20, 1923.

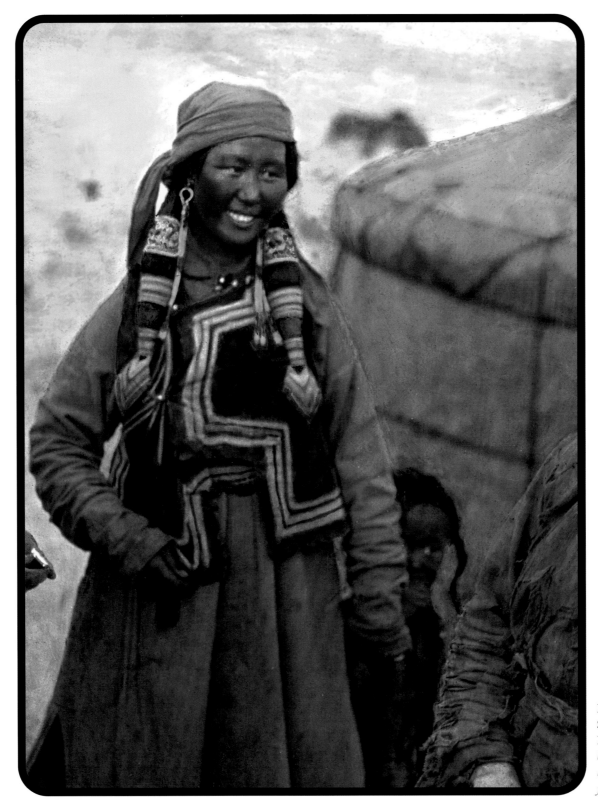

Mongolian girl in a blue dress, Ta Shui K'o, Alashan Desert, Inner Mongolia. *"The costume is a mass of colors, but dirty and greasy. Her main occupation is drawing water from the desert wells for the family animals."* —F.R.W., April 22, 1923

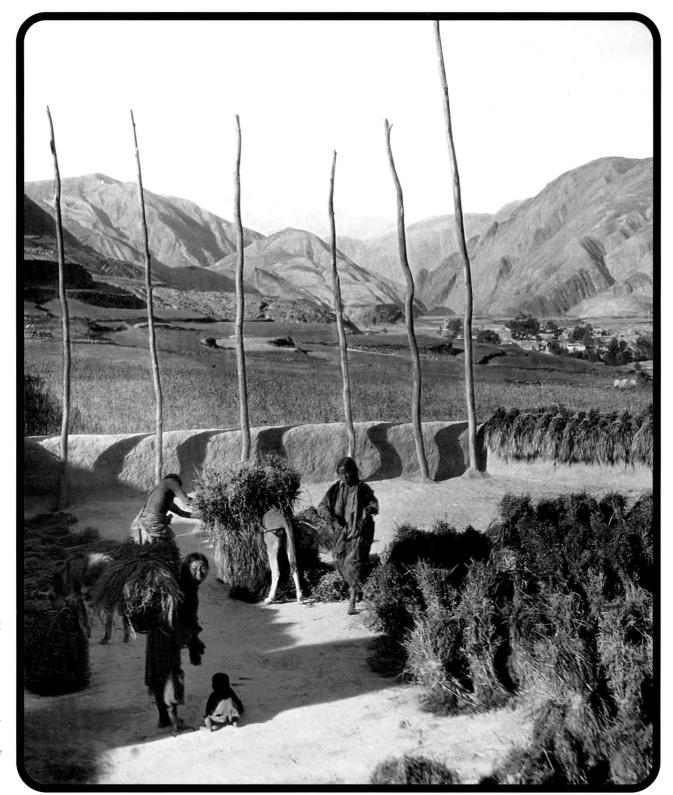

Tibetan women threshing and storing grain. *"They store grain on high frames or poles where it hangs like a perpendicular thatch to dry. Whole villages are adorned with these on house roofs and near threshing floors. From a distance, it makes them look as if they were all poles."* —F.R.W., September 1923

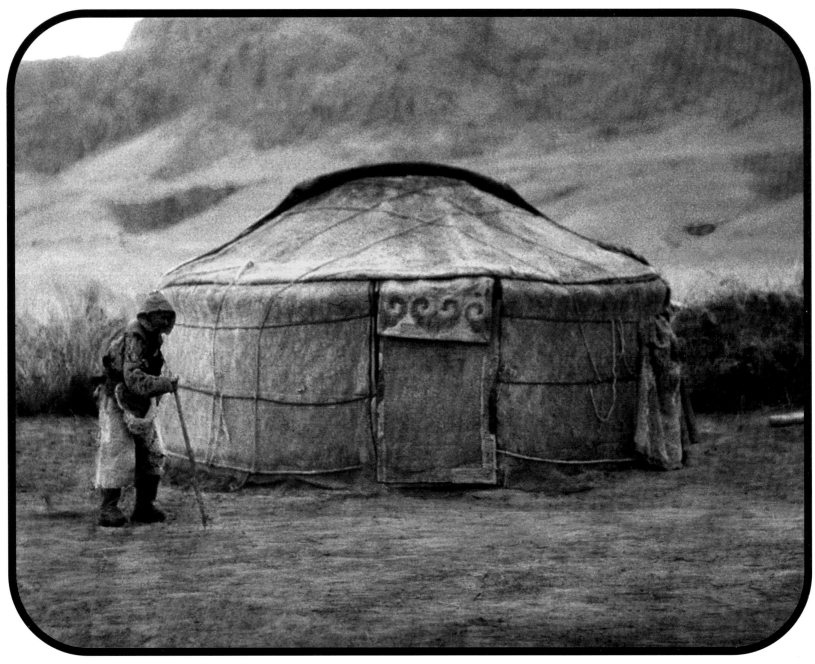

Man in front of Mongolian yurt, Alashan desert. *"These circular nomad dwellings are made of felt stretched over wooden frames. A fire is built on the ground in the center. They can be set up or taken down in a few hours."*—F.R.W., April 22, 1923

Right: Rural Tibetan kitchen with brass, pewter, and copper cooking utensils, Archuen, September 1923.

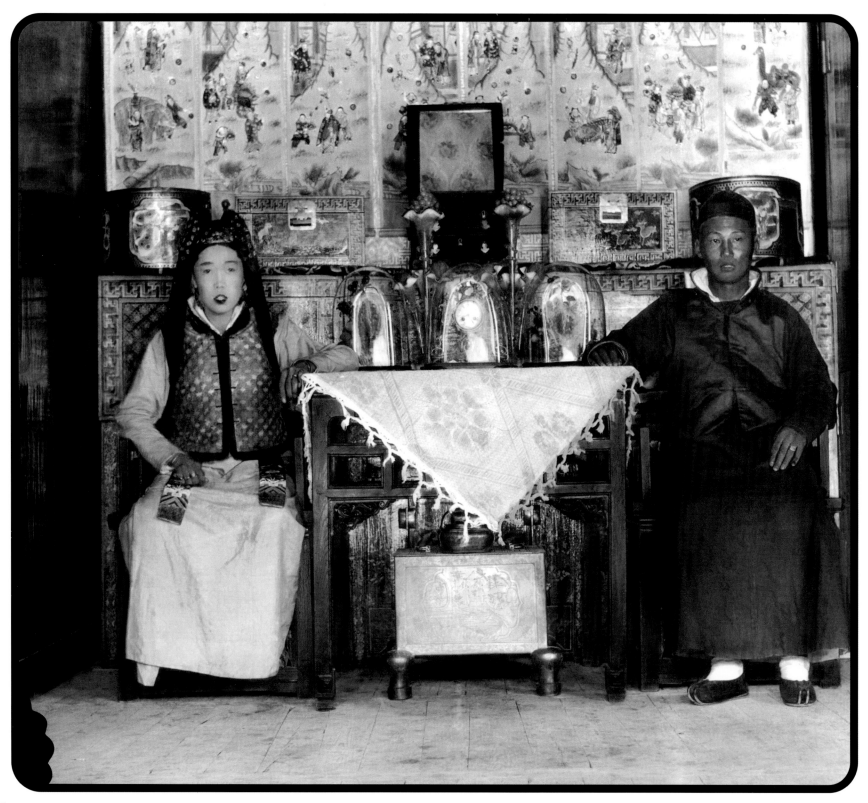

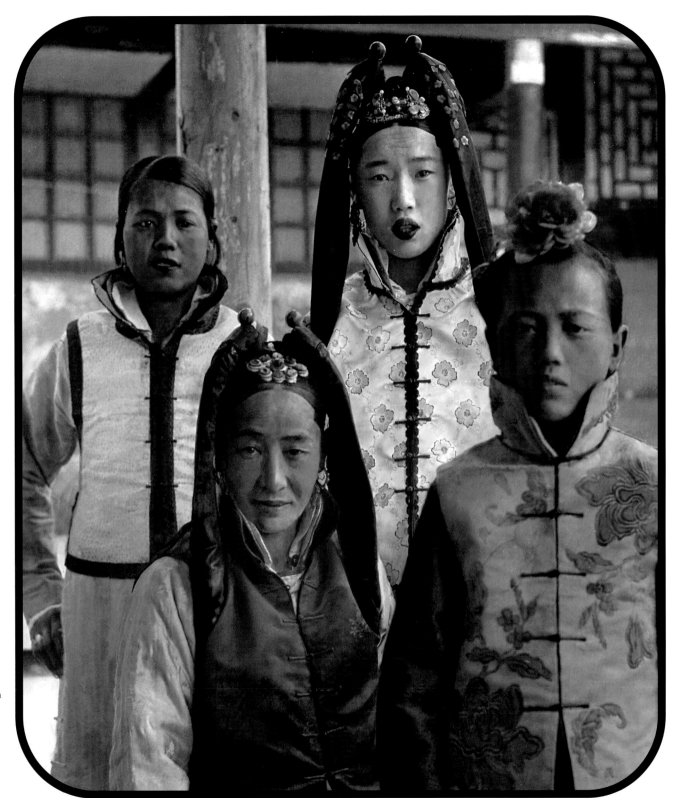

A wealthy Mongol bridal couple posing for their wedding picture, Wang Yeh Fu, May 1923.

Right: A Mongol family in their finery pose for their first family portrait, Wang Yeh Fu, May 1923.

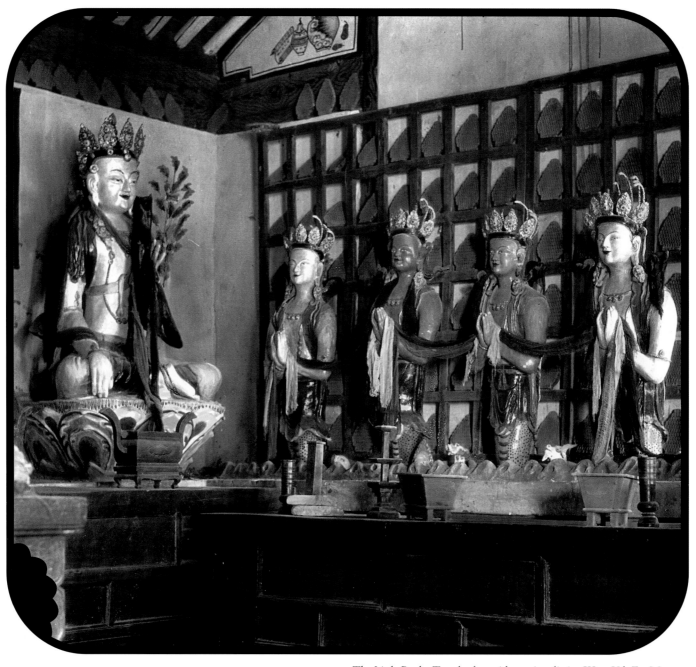

The Little Poplar Temple altar with praying dieties, Wang Yeh Fu, May 1923.

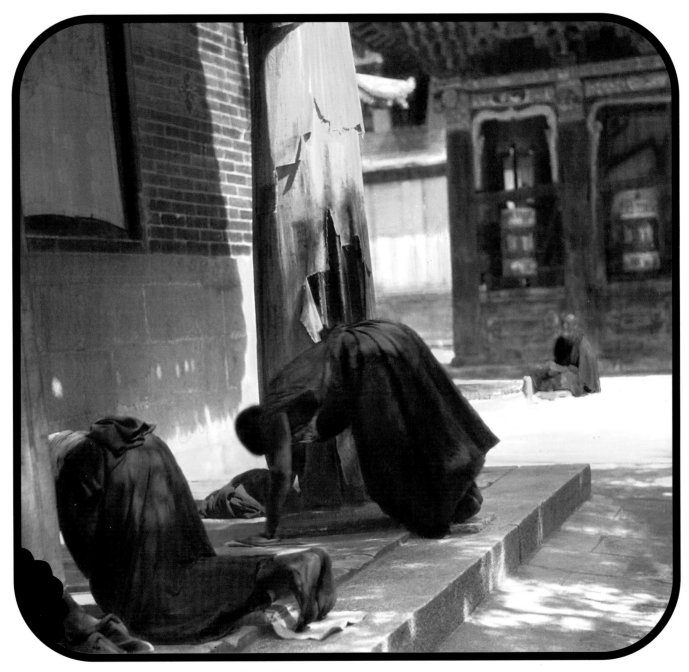

Monks prostrate in front of the Great Chanting Hall, Kumbum,
August 1923. *"On the porch of the Golden Temple, pilgrims prostrate themselves one
hundred times, and the boards are worn into grooves where their feet and hands touch."*
—J.E.W., August 1–3, 1923

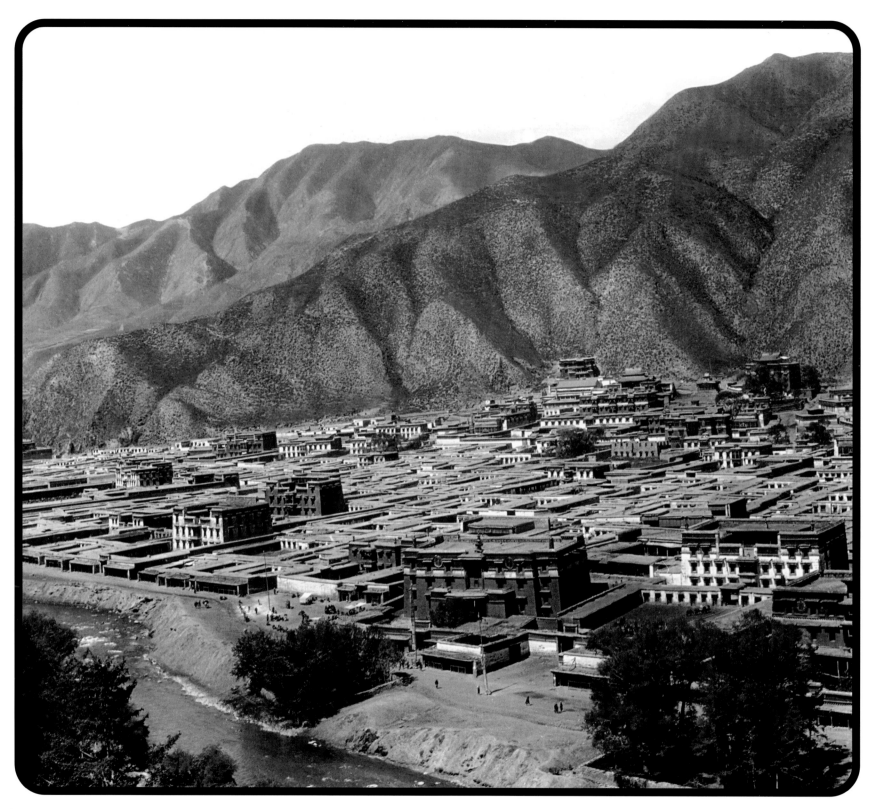

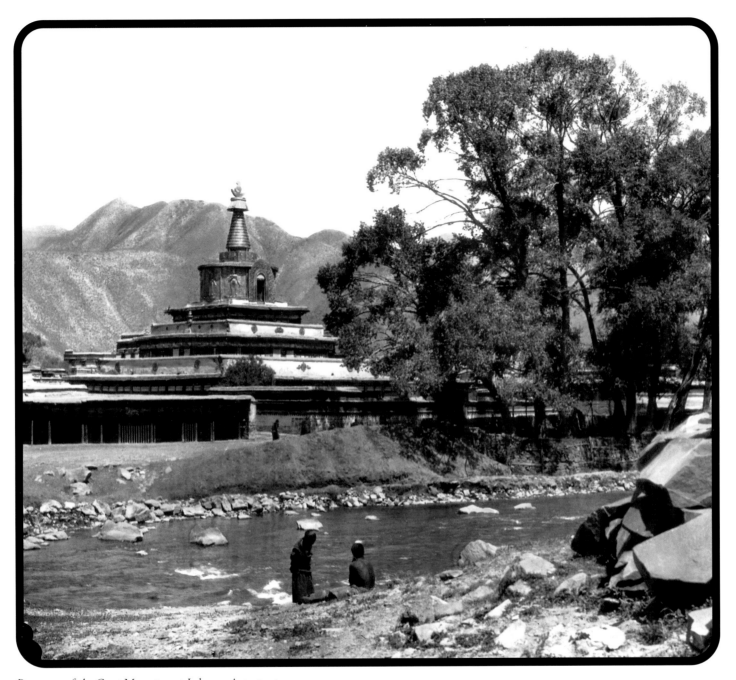

Panorama of the Great Monastery at Labrang, August 1923.

Above: The golden stupa at Labrang, Tibet, seen from across the river, August 1923.

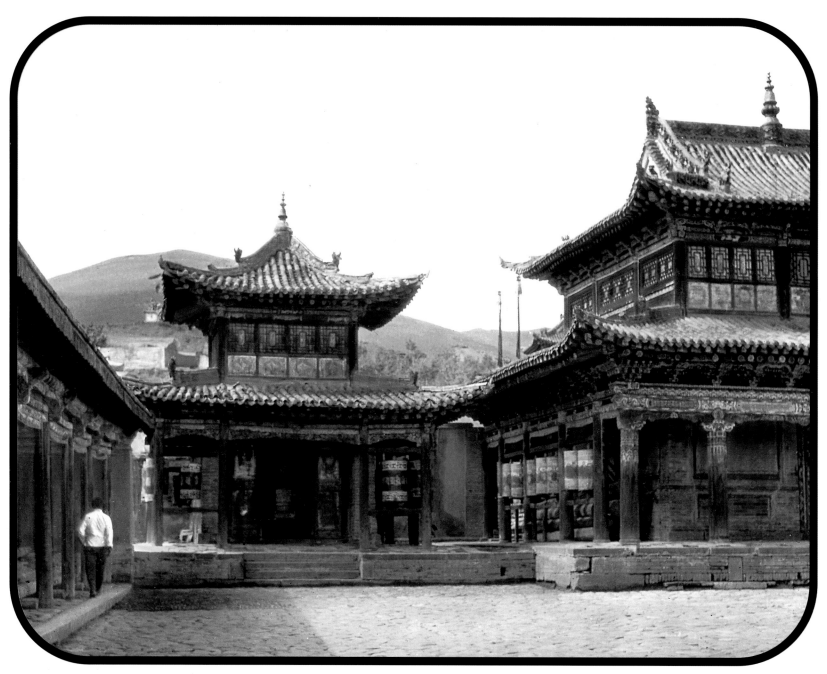

Temple courtyards in pure Tibetan style, the Great Monastery at Kumbum, Qinghai, September 1923.

Right: Prayer wheels in the courtyard of the monastery at Kumbum, Qinghai, September 1923.

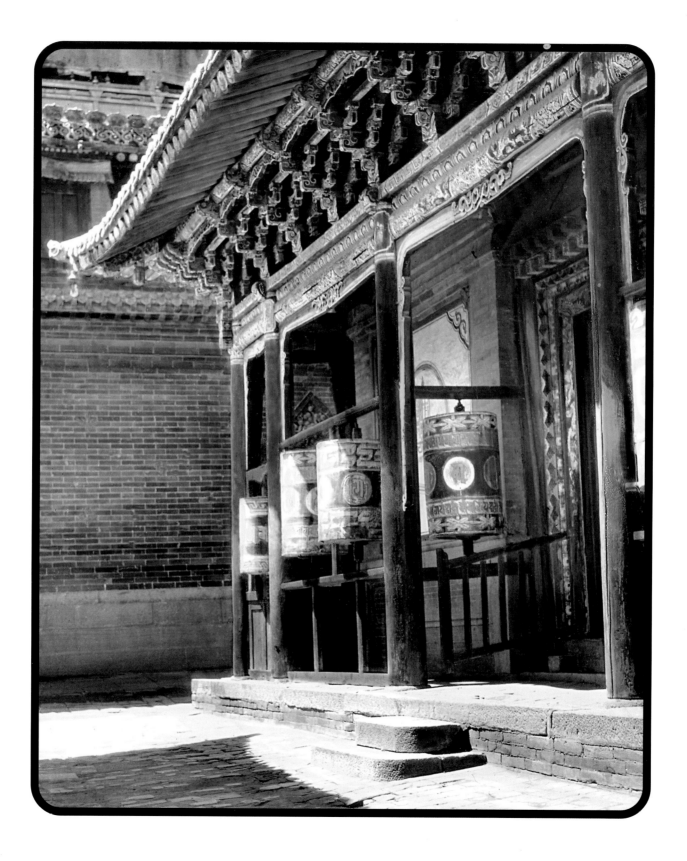

Monks on temple stairs, Kumbum, Qinghai, August 1923.

Above: Courtyard near the Golden Temple: The Temple of the Thousand Buddhas, Kumbum, Qinghai, August 1923. *". . . Hundreds of lamas were there. . . . As they clapped, they screamed a jargon of sound. They were praying. It was one of the most extraordinary sights and sounds that I ever saw or heard."*—J.E.W., August 1–3, 1923

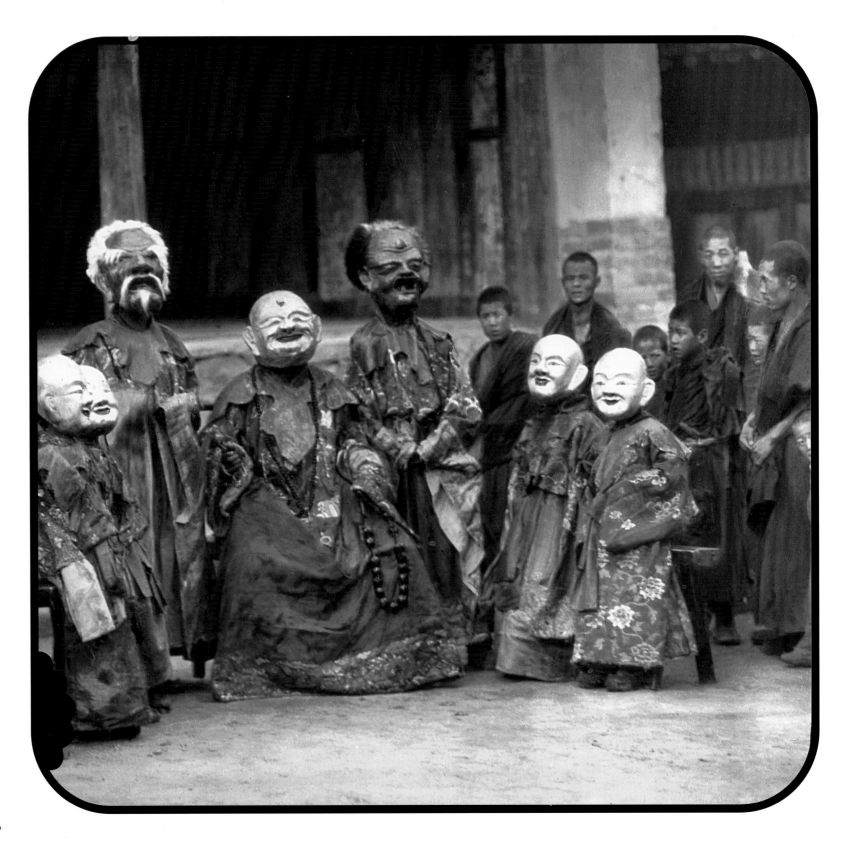

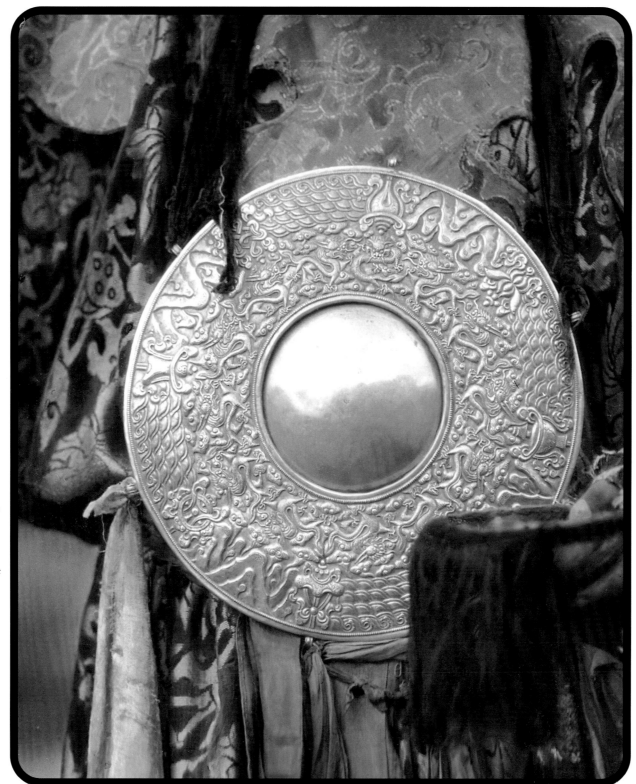

Lamas in festival dress, Choni, Kansu, September 1923. The masks, made of papier-mâché, weighed ten pounds each, and were finely painted and decorated with a full range of expressions. Before putting on their masks, the lamas pulled on padded woolen caps that covered their foreheads, their necks, and the sides of their faces.

Right: The silver breastplate, inscribed with astrological figures, worn by a dancer in the great Cham-ngyon-wa festival at the lamasery at Choni, September 1923.

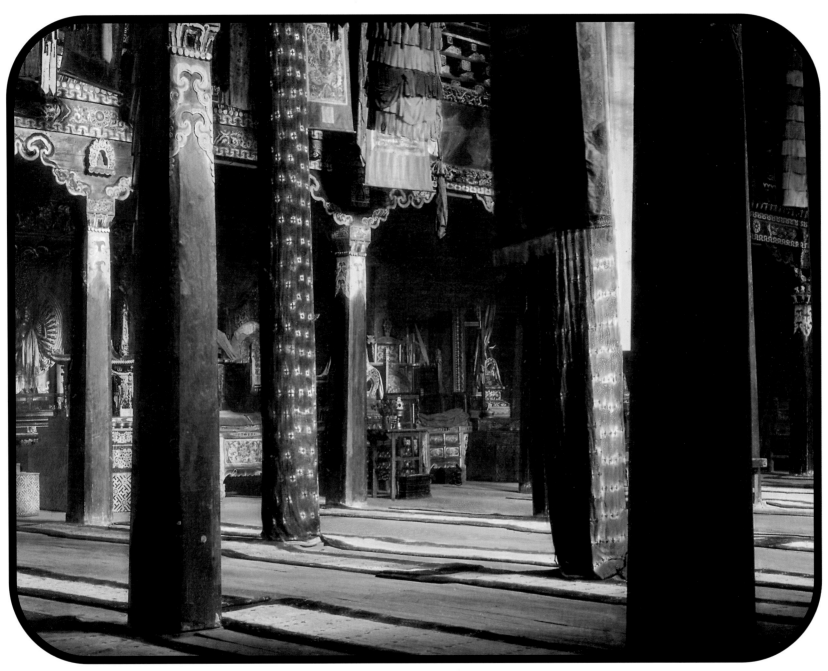

The Interior of the Great Chanting Hall at the Lamasery at Choni. *"On festival days, the hall was decorated with brocades and long ceremonial umbrellas suspended from the ceiling. The pillars were covered with vibrant hand-woven carpets, a present from the King of Alashan."*—F.R.W., September 1923.

Right: Altar in Great Chanting Hall, Choni, August 1923.

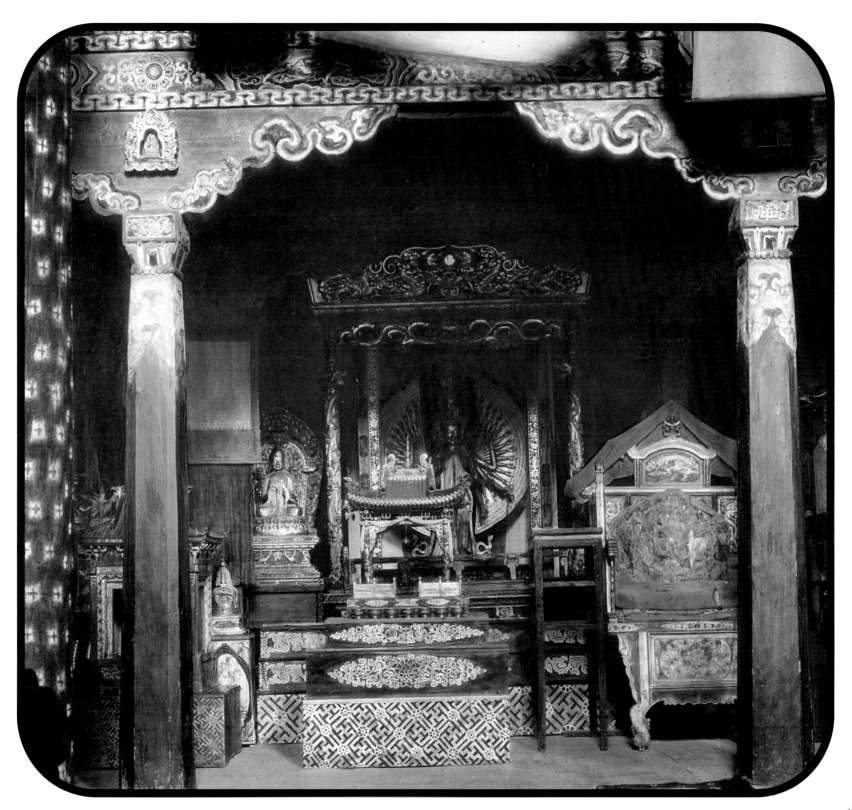

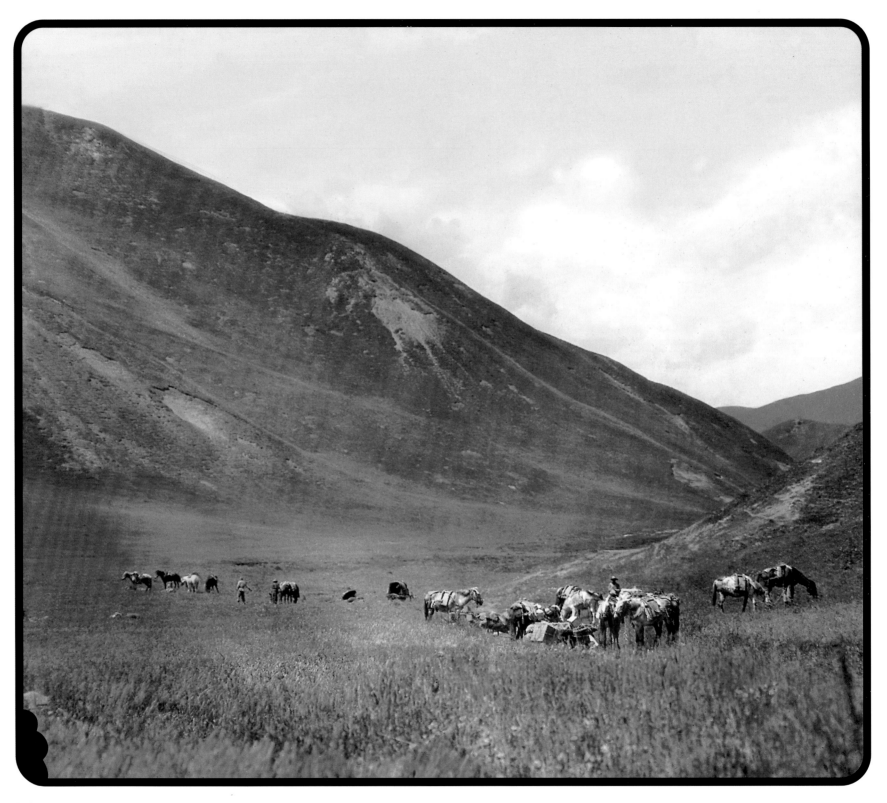

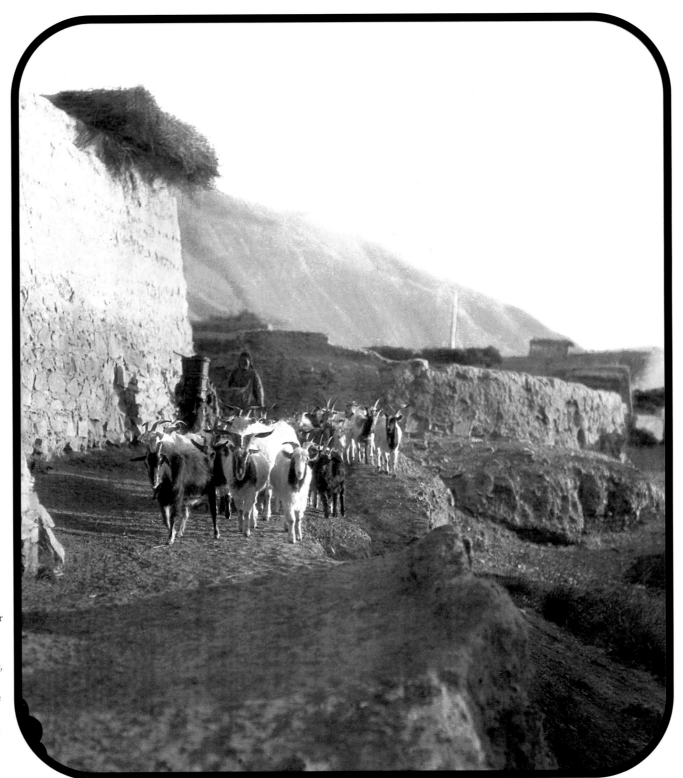

The expedition pauses in the Tibetan grasslands, Qinghai, September 1923.

Right: T'o Run villagers returning home with their goats, Wei Yuan Pu, Kansu. *"On the way we met family after family of T'o Run, but when they saw the camera, they fled. Finally, we lay down in wait behind walls, and F. [Frederick] laid concealed in the grass, and I think we got some pictures."*—J.E.W., September 1923.

A typical black Tibetan tent made of yak hair, Qinghai, September 1923.

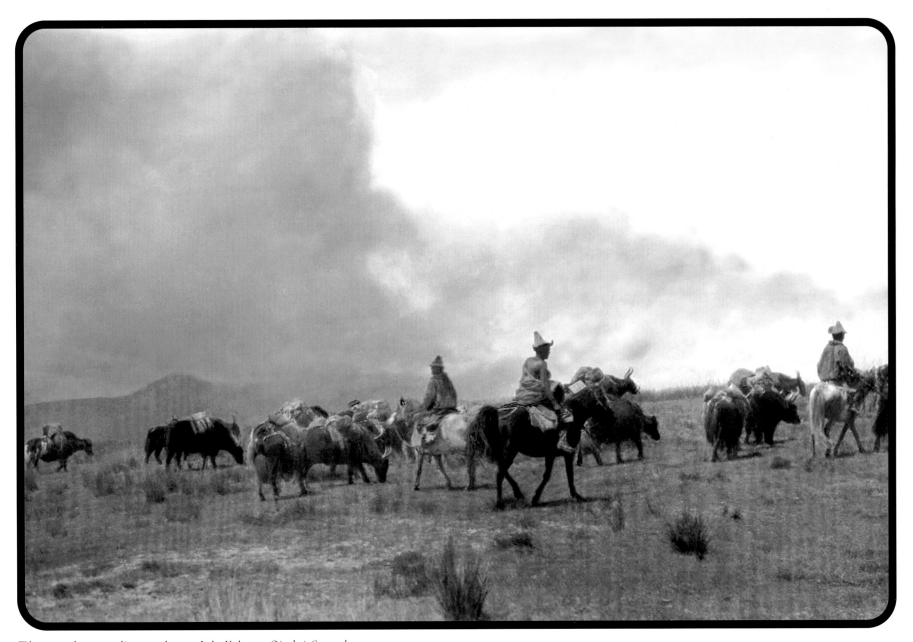

Tibetan cowboys rounding up yaks near Lake Kokonor, Qinghai, September 1923.

The Yellow River with the high walls of Lanchow in the distance,
where the Wulsin expedition raft was loaded, October 1923.

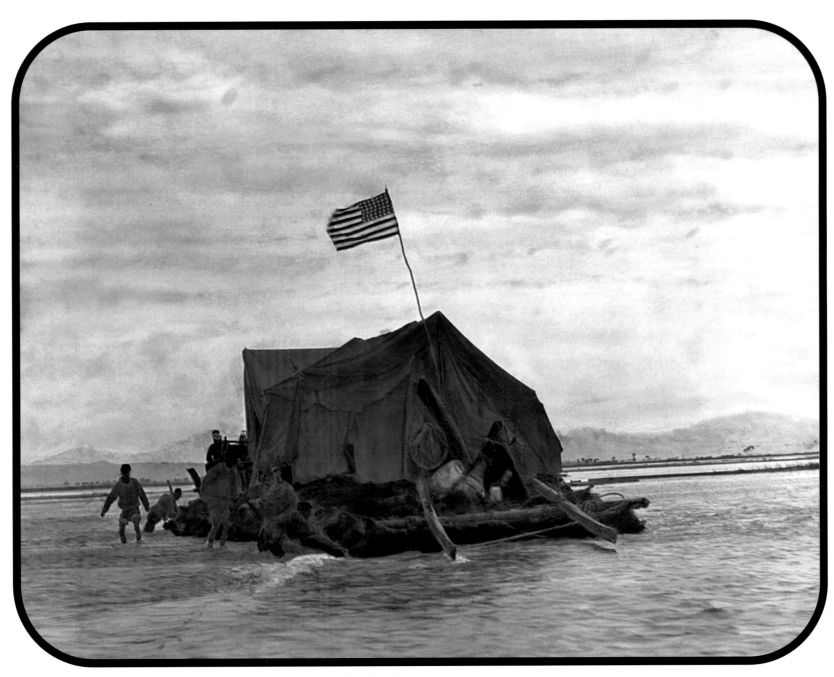

The National Geographic Central China Expedition floating down the Yellow River from Lanchow to Paotow on their return from their journey of nine months, October 1923.

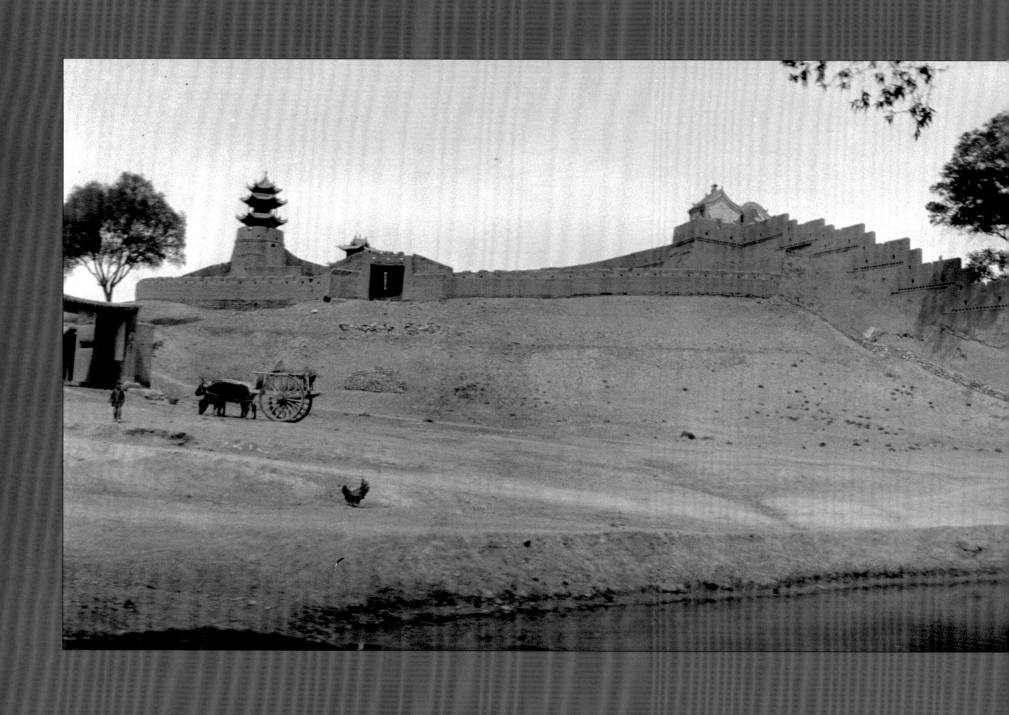

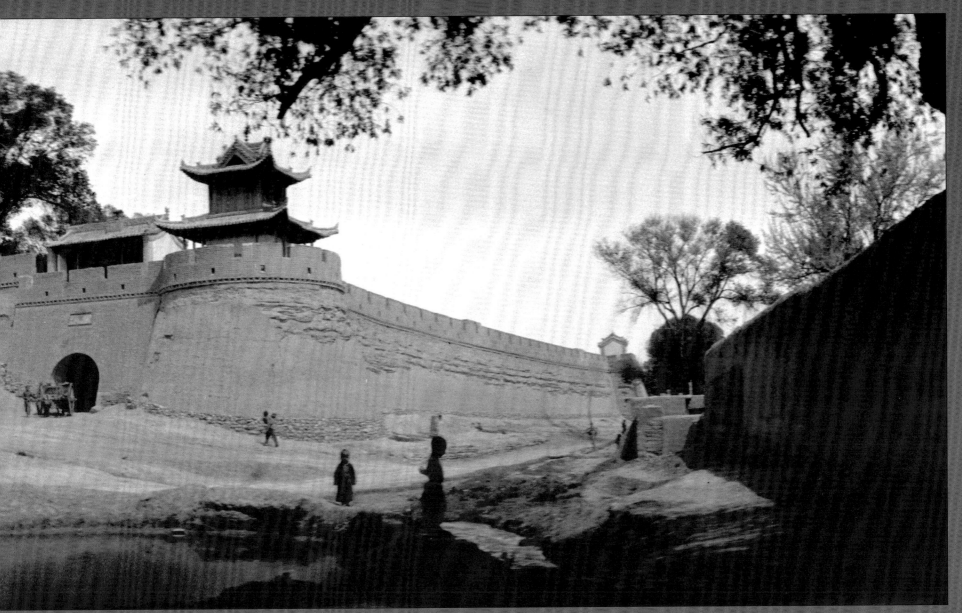

The East gates of Wang Yeh Fu, Alashan, Inner Mongolia, May 1923. *"It is a fairy city with its towers, and pagoda, its fresh green trees that our eyes devoured, and its old lama temple of brilliant colors and peaceful courtyards."*—J.E.W., August 6, 1923

THE KINGDOM OF WANG YEH FU

The expedition had now finally reached the end of its long camel journey across the desert. They had traversed 450 miles over arid, desolate plains, marching for twenty-nine days and pausing for ten to collect specimens, rest, and shelter themselves against violent dust storms.[103] They were tired and dirty, but exhilarated to find themselves in a verdant landscape.[104]

At sunset, six days from the Salt House, Janet was overjoyed to glimpse a farmhouse with trees and a brook in the distance. They rode on, and soon green fields with lush grass and a roaring stream welcomed them from the desert. That night they camped by the stream. Janet listened to the animals grazing and the stream flowing as she fell asleep.

On the following morning, May 3, 1923, the caravan rode on, catching glimpses through an occasional gap in the hills of the medieval walls and towers of Wang Yeh Fu, capital of the Mongolian state of Alashan. At last the meandering city wall came into view, "a fairy city with its towers, and pagoda, its fresh green trees that our eyes devoured, and its old lama temple of brilliant colors and peaceful courtyards."[105] All was silhouetted against the snow-capped, ragged crests of the Ho Lan Shan Mountains on the far horizon while Mongol caravans passed slowly in the distance.

As they proceeded through the outskirts of the town, they passed busy farms with trees, lively brooks, and large cultivated gardens. Suddenly, from a small rise, Janet saw the full panorama spread out before her. Ancient adobe brick walls surrounded the town in a long oval. High, pagoda-like watchtowers perched above the wall, reminding Janet of those in oriental manuscripts. On each side of the walls she saw large open gardens, and low houses, more spacious than those she had seen elsewhere in Mongolia. The walled town was surrounded by green hills with dense forests on all sides, which added to the weary travelers' sensation that they had finally stumbled onto Shangri-La.[106]

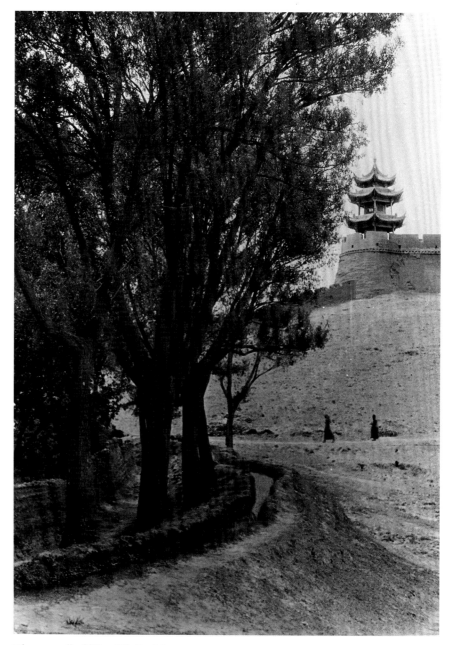

The east wall of Wang Yeh Fu, May 1923.

Janet reflected:

The days in the Alashan Desert were something we were glad we did, but don't want to repeat. Ten hours of steady marching and then a hole in the sand of such brackish water that even the horses won't touch it, is no fun. But those days are memories now, and I am glad to have seen those acres and acres of sand, rolling sand, and weird dwarfed trees, like a forest bewitched.[107]

The kingdom of Alashan stretched for about three hundred miles from east to west, with its southern edge resting on the Great Wall of China and its northern border lost in the Gobi Desert. It had been established in 1760, when the Eleuth Mongols defeated the Kholkeit Mongols from the Tibetan region of Kokonor. The victorious tribe then sought recognition from the emperor of China, who granted them the lands and ordained the new territory of Alashan under Chinese administration. The province eventually included a mixed population of approximately three hundred thousand Mongols, Manchus, and Chinese. The walls of Wang Yeh Fu still bore a Chinese inscription to commemorate the city's founding.

The people of Alashan were primarily nomadic herdsmen, although there was something of an official court in Wang Yeh Fu. The kings of Alashan had become popular with the emperors of the late Manchu dynasties, and they married several daughters of the Imperial family. Consequently, a few rich Manchu families still remained in this remote kingdom. The present government was a monarchy under old Mongol laws. The king derived his wealth from the export of salt, the equivalent of gold in the desert. The salt was shipped from Tongkow, the other small city in Alashan, down the Yellow River to Peking by raft. These salt revenues served to finance the kingdom.

The king himself lived in Peking and left the administration to his younger brother, the regent of Alashan, who soon became a great friend of the Wulsins. However, the real power lay with the Chinese magistrate at the Chinese garrison nearby, as Alashan shared the fate of other principalities of Inner Mongolia—the gradual encroachment by Chinese settlers onto agricultural lands. It was evident to Janet and Frederick that soon most of the lands of Inner Mongolia would become Chinese *hsiens*, or boroughs.

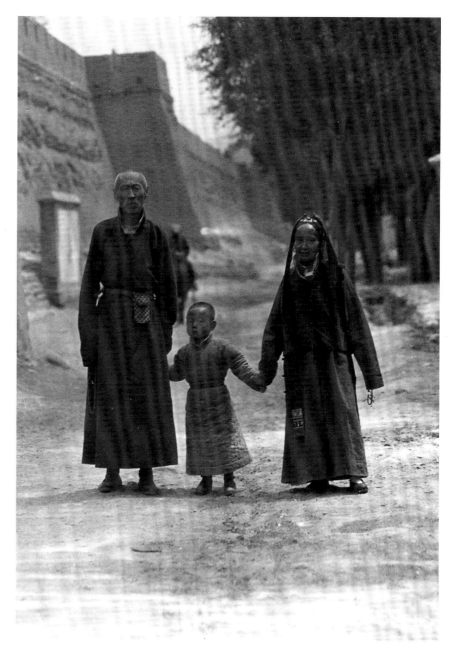

A Mongol family strolling along the walls of Wang Yeh Fu, May 1923.

Wang Yeh Fu was separated from the Chinese valley of the Yellow River by the high, narrow range of mountains, the Ho Lan Shan, which towered up ten thousand feet. The town encompassed one *amin lama* temple, in half-Tibetan style; the King's semi-modern house, set behind a large garden; the *yamen* or government office, a row of plain brick buildings behind an ornamental arch; and the homes of many lamas and rich Mongols, who lived in spacious houses with fine furnishings.[108]

As soon as the caravan traversed the dirt road over a wooden bridge with mud parapets into the town, they happily paid off the camel drivers, and were rather unceremoniously dumped in the muddy courtyard of a rundown Chinese inn with low rooms opening onto the courtyard. Janet described the scene: "The roof has just leaked onto my bed, and we are in one of the filthiest holes imaginable. I am huddled in a fur [sheepskin] coat with my feet encased in huge boots, which are resting on the table to keep them off the damp, mud floor."[109]

Over the next three days, Janet and Frederick were objects of fascination for crowds of curious townspeople who came to have a good look at the unusual strangers. The crowd gathered around the doors and windows to stare inside and wandered into the rooms the moment Janet and Frederick turned their backs. For three days, they could find no privacy. "When we closed the door of our room the more curious would squeeze close to the window, block out all the light, and poke holes through the paper windowpanes with their fingers,"[110] wrote Frederick. In desperation, he and Janet washed their hands and flung the suds and water into the courtyard, causing a shower that allowed them a temporary reprieve from prying eyes. When all else failed, they resorted to climbing onto the roof and pulling the ladder up behind them.

They finally found comfortable new quarters in the house of Mr. Mung, the postmaster, whom Janet described as "a shrewd Chinese who has become almost a Mongol, but tho' suave in manner he is a rascal in reality."[111] Mr. Mung was a prominent citizen who ran the grain and feed store, the wine shop, and the post office. On the lower level of his grain shop was a donkey-powered flour mill. Wearing a long black pigtail and richly brocaded robes, he served as the party's guide throughout their month-long stay (see page 116).

The Wulsins' house, on "East Wall Street" near the main gates, was quiet and beautiful, with a kitchen, a taxidermy room, and wooden lattice shutters welcoming the cool breeze from the surrounding hills. Janet and Frederick rented six rooms to share with the Emerys, for which they paid the equivalent of a dime a day per room. The staff stayed in the inn, nearby. As a protection against lice they had the rooms whitewashed, then proceeded to set up their camp cots, stack their books in a corner, and install themselves in relative comfort after their long desert journey.[112]

Janet settled into her new home with pleasure. "The weather was perfect, food was plentiful and if you ever saw joy radiate from humans you ought to have seen us when we ate our first spinach. We hadn't tasted a green thing for weeks," she wrote.[113] She commissioned the village carpenter to create a few pieces of office furniture for Frederick and large work tables for the taxidermists to work on their specimens. From the rooftop, Janet could see Wang Yeh Fu spread out around her, the walled city rising to the north and the flat roofs shaded by groves of trees. Three mud forts on the northern wall broke the skyline. Each evening she watched the town trumpeters sound the daily retreat from their medieval towers.[114]

On her frequent strolls along the city walls, Janet passed lamas in their deep red robes, soldiers off duty, officials who still wore the colored caps with buttons of former Manchu times, and rich Manchu ladies in fine silks who strolled with dignity on tiny feet. Wang Yeh Fu was a special oasis for Janet. There she and Frederick found privacy and united in their efforts to document the fascinating life of the town.

Janet and Frederick's days were busy, as they created a makeshift darkroom in their house and roamed Wang Yeh Fu, taking photographs that they printed in their darkroom late at night. Janet helped develop all of the film, and carefully inventoried each negative in small negative binders that survive to this day.[115]

The long street of blacksmiths, coppersmiths, and carpenters became their favorite photographic hunting ground. The carpenters used logs that had been

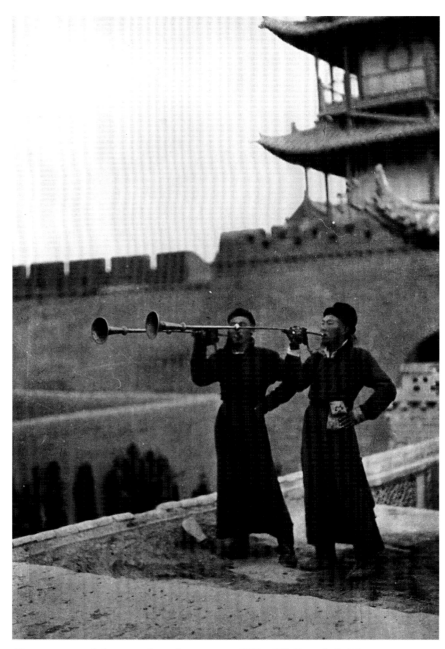

Trumpeters sound the retreat from the ramparts of Wang Yeh Fu at dusk, May 1923.

transported by donkeys down from the mountains, sawing them with large old-fashioned Chinese double saws. They built frameworks and low doorways for yurts, small portable cupboards, chests and boxes, watering troughs, and wooden linings for desert wells.[116] Nearby, coppersmiths hammered out large circular water casks, nearly two feet in diameter, to be hung from camel packsaddles. They also forged pots for tea and small cooking pots.

Most of the commerce flourished on the shady side streets that opened onto the main street of the town. A merchant usually stood behind his counter with his wares piled on shelves behind him. His apprentices, in long blue gowns, dashed back and forth to tend the stove or bring goods from the back room. The smaller merchants set up awnings in the street and spread their wares out on the ground. The blacksmiths set up their anvils and forges before a client's house under an awning, and worked right on the street. Dyers hung long strips of dripping blue cotton cloth to dry in sequestered nooks throughout the town. Down in the stony streams, half-naked young men set sheepskins and goatskins to soak, then beat and scraped them for market.

On the main street, the big trading companies established themselves behind imposing Chinese gateways in large courtyards. Here large camel caravans unloaded their wares. In the quiet side rooms off the courtyard, merchants sipped tea while bargaining ruthlessly. Most goods came to the town by caravan. One day the town would be flooded with stamped tin washbasins, and the next week none could be found. The Mongols from the region came into town to shop, leading their camels from booth to booth. Once loaded, they returned to the desert.[117]

Janet and Frederick were fascinated by the short, stocky Alashan Mongols, with their round faces and weather-beaten bronzed skin, who were different from the Mongols they had encountered in the desert. Their eyes were dark brown and their hair was black and straight, rarely worn long. In nearby Urga, the women wore their hair in great horns created by filling the hair with glue and letting it dry in that shape. Janet tried to photograph them, but they were too skittish. The Mongol farmers who came to town wore enormous hobnailed boots with flat, stiff soles that required them to trudge with their shoulders forward, their heavy

feet set down as if stumps.[118] The local population was varied and inspired the photographers.

Janet and Frederick now had new insights on field developing. Frederick described their challenges:

I find that the open tank system of developing cut film works very well. There are only two real difficulties; that one must work at night, and sometimes very late, for lack of a dark room, and that it is very difficult to get enough wash water. North China is quite a dry country, and Mongolia is very dry indeed. Water is carried to our house in town in buckets, and stored in big earthenware jars. To wash eight or nine dozen 4 x 5 cut films, using a siphon, you need nearly two jars of water, and two more jars for it to run into. Often you cannot raise that many. So you have to have a coolie falling in through the door all the time with buckets.[119]

To avoid this clumsy performance, Frederick asked his brother, Lucien, to send him an Abercrombie & Fitch portable darkroom. These were made to order and would take months to arrive in China. Nonetheless, Frederick wanted a solution to the darkroom problem—no matter how long it took.[120]

He continued, "The National Geographic Society persuaded me to buy a 4 x 5 view camera, fit only for tripod work. I have found that it is no better than the Graflex for tripod work—less convenient, in fact—and very much below the Graflex for everything else…. Altogether, I think it is a lemon!"[121]

The cameras survived the desert crossing, but Frederick's guns were in serious disrepair. A rifle sight was broken, as well as a shotgun stock, and the Parker 12 was so full of sand that it had to be dismantled entirely. There was also a revolver out of order. A remarkable gunsmith from the Shanghai arsenal, who mended the local soldiers' rifles and worked on the side for special clients, repaired the guns. Frederick had never seen better work in either New York or Paris.[122]

The urban Mongols of Wang Yeh Fu were relatively rich. They owned prosperous farms with irrigated fruit and vegetable gardens adjoining their houses on the edge of the town, but their gardeners were usually Chinese. In general, Chinese staffs administered most of the work and trading for the largely Mongol

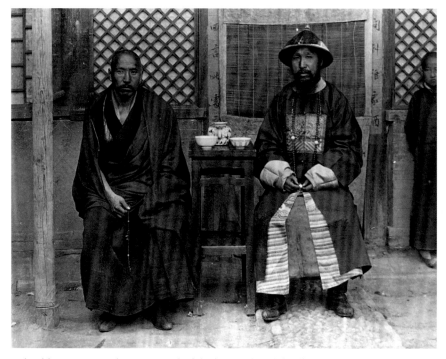

A local lama sitting with Mr. Mung (right), the expedition's landlord and guide throughout their stay in Wang Yeh Fu, May 1923.

population. One member of the Wulsin party asked Mr. Wu what a certain man did for a living. He replied, "Oh, he's a Mongol and he just lives there."[123] Most of the local Mongols were traders or minor government officials who followed localized forms of Chinese customs.

An introduction to the royal family allowed Janet and Frederick to pass through a special portal of local life rarely seen by foreigners. The regent of Alashan, the younger brother of the king, remained in Wang Yeh Fu by royal command. He was half Mongol and half Manchu, and spoke both Mongol and Chinese. He was intelligent, somewhat traveled, and stuck in what Frederick described as "this hole" with "nothing to do, and scarcely a shadow of power."[124] Slim and elegant in his black silk long Chinese gown, he was fascinated by Frederick's cameras and guns, and did not hesitate to drop in at their compound

at odd hours of the day or evening. One day he interrupted Frederick having a haircut, but, undeterred, continued his friendly questioning. He and Frederick became great friends. The regent quizzed him endlessly about machinery, customs, and politics. He inquired if false moustaches were much used in America. He viewed this as a serious question, and insisted on a serious answer.[125]

Janet became friendly with the local women. The dowager mother took a fancy to her, and greatly admired her hair and her simple Western clothes. Janet described her as "a dear old Manchu lady who had married the former Mongol Prince"[126] who "urged us to smoke her water pipe and admired [my] bobbed hair and stroked [my] hands."[127]

One evening the prince entertained them at a "ghastly Mongol feast of fearful greasy, dirty dough cakes galore."[128] They, in turn, invited the royal family to dine several times at their compound, serving them canned foreign food and cigars. Despite "the awful, greasy concoction *tsamba* [barley mush]" frequently offered to her, Janet found this new friendship "delightful," and she spent happy hours with the women of the regent's family. Some of the women had traveled to Peking and were far more cosmopolitan in their dress and customs than the local Mongols. They were very small and delicate and smiled only with their eyes cast down. The spirited dowager mother, however, dressed in the fashions of the late empress dowager, Tsu-Hsi, in silks and brocades, wore elaborate headdresses, and looked Janet straight in the eye. Although she smoked often, she tried to conceal her water pipe from Janet's camera.[129] She was, in true Chinese fashion, the power behind the throne, and ran the household as the mother of the prince (see page 119).

Aside from photography, Janet busied herself with chronicling the growing inventory of mammals, birds, flora, and fauna that the team was collecting from the high mountain gorges nearby. Mr. Wu had posted big red placards in Chinese throughout the town offering to purchase any animals. Soon a steady stream of people invaded their courtyard, from old men with a few eagle feathers to small boys with very active mice held by the tail. Mr. Wu, Mr. Ching, the botanist, and the taxidermists did the more serious collecting by scouring the nearby mountains

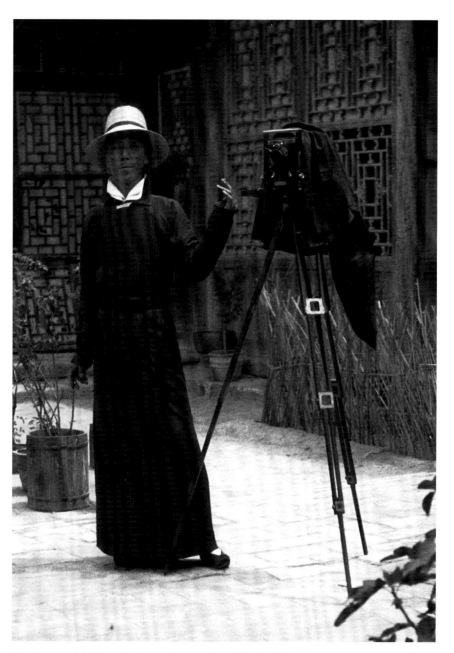

The Regent of Alashan in the royal courtyard with Frederick's Graflex camera on a tripod, Wang Yeh Fu, May 1923.

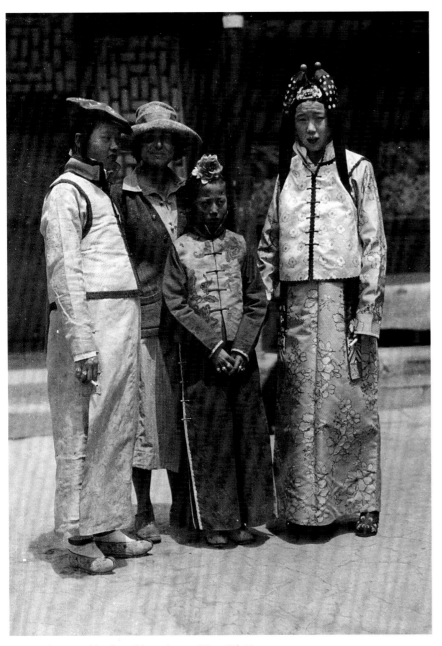

Janet with Mongol bride and her relatives, Wang Yeh Fu, 1923.

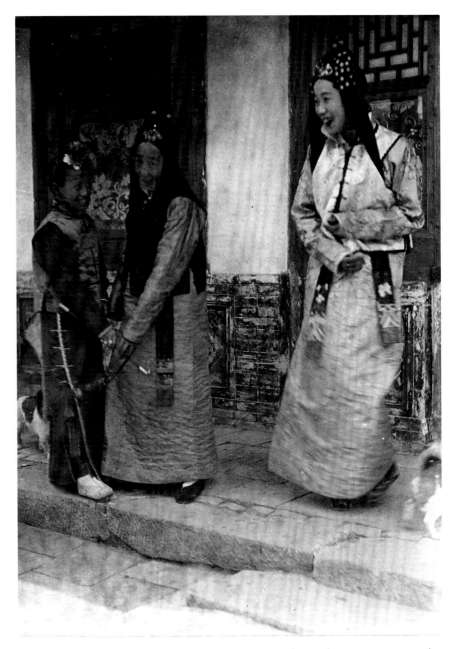

A Mongol bride (right) laughs with her mother and sister as her mother attempts to conceal her pipe from Janet's camera, Wang Yeh Fu, 1923.

and the high plateau for specimens.[130] The desert offered little in comparison with this lush countryside.

As in Shansi, Janet and Frederick again gained reputations as healers, and their courtyard again became the center of a primitive clinic. Janet administered as best she could to the ills of the population. She now had a wider range of medicines than in Shansi, and could, at times, clean infections and bind wounds effectively. The people were, by and large, healthy, but smallpox was a scourge. Unfortunately, Janet had no inoculation serum with her. Often the locals had their own medical solutions. One herdsman came to the clinic with a high fever, and was given quinine and ordered rest and a light diet. The following day, Janet saw him outside the chief Buddhist temple, engaged in a long series of prayers and prostrations that had been prescribed by a lama as an infallible remedy for fever.[131]

In between adding to the collections, processing photographs, and cataloging new specimens, Janet and Frederick led a growing social life. Although the townspeople of Wang Yeh Fu had initially viewed them with a mixture of suspicion and curiosity, their warm reception by the regent of Alashan and his family encouraged the rest of the community. Once the royal family had given their permission to be photographed, word went out throughout the town, and soon "all the great and powerful of the town came to F. [Frederick] to be photographed or doctored."[132] With royal approval, Janet and Frederick photographed the wedding of the daughter of a rich local merchant. In their wedding portrait the young couple is seated on either side of a table in typical Wang Yeh Fu headdresses with their prized wedding gift, a clock, displayed between them. The wedding's hosts "tried to get us drunk on all sorts of evil-tasting drinks. This is a favorite Mongol joke,"[133] wrote Janet. The foreigners were gradually becoming an accepted part of the life of the town.

The Wulsins were entertained often by their new friends, who included a Manchu family that lived in the southwest suburb, the local sculptor, a wandering Mongol named Yang, the town jeweler, and Mr. Pa, the king's representative. Mr. Wu, who spoke both Mongolian and Chinese, often translated during these social occasions, enabling the conversation to move more easily.

The mother of the Prince of Alashan with her daughter and grandchildren in the royal pavilion, Wang Yeh Fu, May 1923.

Their growing circle of friends also included the "High Lama Priest," who had been to Lhasa, the greatest holy lamasery in Tibet. He allowed Janet to attend the services in the lovely old temple, which was half Tibetan and half Chinese in architecture—a singular honor, rarely accorded to women. She described the service as "barbaric in sound, great drums, gongs, trumpets six feet long, small bells and the weird chanting of the 'sutras.'"[134]

Frederick's first impulse was to be skeptical of the lamas. However, as time went by, he admitted,

as one gets to know individual lamas better, one's impression changes. Many are sensible, kind and devout men. Their religion offers no more violent insult to the human intellect than some others…Its effect on the Mongols has been excellent from the Chinese point of view, for it has moderated the Mongol thirst for gore and given harmless employment to the more active-minded, besides moderating the growth of the population. [135]

The courtyard of the temple in Wang Yeh Fu, May 1923.

Outside of the town was a smaller country temple referred to as "the Little Poplar Tree Temple"(see pages 92 and 121). This was a favorite haunt of the Wulsins'. They made friends with the two lamas and were allowed to photograph them as well as the altar of the temple itself with its gilded Buddhas and flower offerings.

After three weeks of processing and labeling their film, Janet and Frederick carefully dispatched more than three hundred photographs back across the desert to Peking—and eventually to Mr. Grosvenor at the National Geographic Society. Janet thought some of them were unusually lovely and prayed that Mr. Grosvenor would agree.[136]

During her stay in Wang Yeh Fu, Janet sensed that she had communicated with the people around her. She felt settled, and she had reestablished her relationship with Frederick after their grueling passage across the desert. During their stay, Frederick wrote a brief note to the Elliotts saying that they had a "swell daughter,"[137] which conveyed much about his own happiness. Little wonder that

Janet was reluctant to leave the tranquility of Wang Yeh Fu after what she called a "perfect month."[138]

Their departure was delayed by an important religious festival, traditionally held on the first fifteen days of the fourth month. There were noisy services, of "much banging of gongs and blowing of horns and firing off of powder," according to Frederick.[139] Their departure was further delayed for six days by the late arrival of the carts for the next leg of their journey. Mr. Mung, who was in charge of their transport, seemed pleased that the delay would earn him another week's worth of rent. Janet's assessment of him was correct: he was, indeed, a shrewd businessman.

At last the six carts arrived, two for the Emerys and four for the Wulsins and their staff, at a cost of $108 each for the journey of twenty days. They were large enough to each sleep two passengers comfortably under their hooded roofs of matting tied to wooden frames. Janet christened the carts "prairie schooners" because they reminded her of the American "buckboards" as they rolled along the Mongolian countryside over their large wooden wheels, five feet in diameter.[140] Loading the carts was a monumental task that took an entire afternoon and most of the next morning. Everyone had purchased at least one of the colorful wooden boxes made in Wang Yeh Fu; Mr. Ching purchased six for his botanical specimens, and Mr. Lin purchased four. Frederick, a bit of a scavenger himself, nonetheless managed to eliminate several hundred pounds of coal from the cook's supplies, as well as two enormous wooden packing boxes from Mr. Ching's horde.[141]

Finally, on May 31, the caravan was assembled with "six huge carts drawn by four mules each, like our U.S. prairie schooners, our six ponies, and 'Dung Pi,' the donkey."[142] After reluctant farewells, and a "big Chinese feast . . . with sixty to one hundred dishes" hosted by the regent, the explorers were back on their trail of adventures.[143] "We were the first Americans to go there [Wang Yeh Fu], and the first scientific expedition since the Russian explorer, Kossof, I think, in 1900 or 1901," wrote Janet.[144]

Their journey took them south through irrigated farmlands with the distant Ho Lan Shan mountains to the west and the sandy desert to the east. Janet could

see the amber glow of the desert's heat in the distance. They traveled all day and well into the evening under a full moon. The "prairie schooners" were on a smooth sea for the time being, and the caravan found a safe resting place at a comfortable inn late that night. The following night the party chose out of loyalty to stay at another inn owned by Mr. Mung in a small trading post. At the inn they met Dr. Enoch Anderson from the Swedish American Mission. He was the first Westerner they had seen for over two months. At dawn the "schooners" creaked out of the courtyard and headed for a pass through the Ho Lan Shan Mountains. They passed broad valleys with Mongol shepherds tending large flocks of sheep and goats, and an occasional farmer with carts of grain. Gradually they climbed up the twisting, turning cart road. Janet glimpsed the walls and towers of Wang Yeh Fu disappearing in the distance far below.

NINGHSIA

During the days that followed Janet rode her pony, finding it "great fun, and much more restful than a cart without springs."[145] Whenever she rode a camel, she became dizzy and preferred to walk. The caravan finally reached Ninghsia, a big, prosperous, sprawling city. The city had high walls, ornamental silos, and a bank, where Janet and Frederick drew money to pay their staff and buy supplies for the next leg of the journey. Their finances were complicated as the local bank only dealt in Ninghsia *taels* that had to be transferred into Lanchow *taels*. These were finally exchanged into silver Mexican dollars. A businessman's daughter, Janet understood the elements of currency exchange, and oversaw the transactions carefully. Their funds were beginning to run low, as the expedition was costing more than Frederick had anticipated. Nonetheless, Janet and Frederick managed to pay off their debts and the crew, using their letter of credit in Peking.[146]

Basic supplies were plentiful in Ninghsia. In the shops they found kerosene, strong cigarettes, matches, candles, mirrors, and enameled cups. Canned food offered a challenge. They purchased three cans of pineapples. The first one was

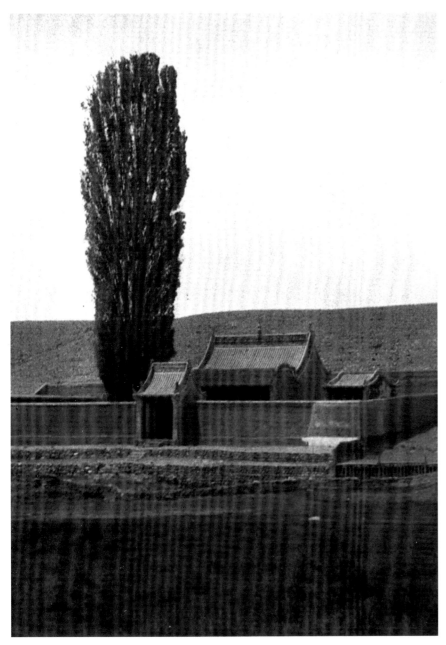

"The Little Poplar Temple," where the lamas permitted the Wulsins to photograph the interior altar adorned with offerings and flowers, Wang Yeh Fu, May 1923.

delicious, the second contained pears, and the third was full of peaches. One took one's chances, despite the labels.[147]

During their brief visit to Ninghsia, Janet heard talk of streams of Russian refugees who were fleeing the Revolution and its aftermath, making their arduous way across to Peking without a dime to their names. Many died on their flight. Occasionally Janet and Frederick found inscriptions in Russian on the walls of their Chinese inns.[148] As the temperature now reached one hundred degrees by noon, Janet and Frederick decided to rise daily at 2:30 a.m., load the caravan, and depart no later than 4:30 a.m. to avoid the heat. The caravan then rested at mid-day and traveled from dusk well into the evening, often by moonlight, stopping late at night to sleep around a campfire under the stars. One afternoon, Frederick spotted a herd of antelope, and spent the rest of the afternoon hunting one for the collection. He also caught a fish a foot long that was swimming down the road in water an inch deep, with half of its back out of the water. It too was stored in the collection boxes.[149]

Mr. Ching's collection had now swollen into many more large wooden crates. This required another total reorganization of the luggage. Frederick described the challenge,

> Just about so much bulk can be piled on and squeezed in, and we already have reached the limit. I have four carts altogether. Mr. Ching's collections take up most of one cart. The stores of zoological collections take up another. The baggage of the "Chinese army" takes up a third, and Janet's bedding, baggage and mine, plus five trunks, two boxes of photographic equipment, and one desk take up the fourth.[150]

The expedition still had many months of traveling ahead of them, some of it over rough, steep terrain.

Night after night, week after week, the Wulsins and Emerys shared meals, campfires, and the same tent. Janet reported home that she found the Emerys "delightful companions, but the academic mind at times too persistent….The atmosphere is a little too exalted for me at times. But it is fun to have another couple along."[151] In Harry's determined battle against "the enemy" he became rigidly disciplined, and somewhat controlling of the program and his interpretation of

their experiences. Janet liked him, and pitied him, but he was not a relaxed traveler. Susanne, on the other hand, was easier, full of curiosity, and spoke even better Chinese than Janet. The two women often explored the towns together. Although it was never mentioned, there was an unspoken understanding between them about Harry's condition. Each kept a watchful eye on him. So far, all went well.

CHUNGWEI

Despite the heat and the early hours, Janet found the trip from Ninghsia to Chungwei extraordinarily beautiful. "I don't know when I have enjoyed a trip more," she claimed. The carts passed through rich, fertile valleys, ingeniously irrigated by a complicated system of dikes and canals. The new crops painted a vivid green expanse dotted with white fields of opium poppies along the roadsides. Small villages with whitewashed mud walls nestled in groves of lush trees. Scantily clad children of all ages played in the fields near their mothers and their fathers. Many of the farms had high walls with lookout towers and large arched gateways, where grandparents sat to welcome their families home after a long day's work.[152]

"At one time the country was full of robbers," wrote Janet, causing the farmers to fortify their farms. "Now [the province of] Kansu is *ding ping* (very peaceful), and the bandits carry on their operations in more eastern provinces." As the caravan progressed Janet saw swamps full of "lovely water birds, ducks, cranes, herons, gulls, and great trumpeting swans, all of which were added to the collection." Two live baby cranes were captured and placed in a basket under Janet's cart, where they swung for twenty days. She was amazed that they survived the journey to Lanchow.[153]

After four days of travel through the irrigated countryside, the caravan began a slow climb to the top of a vast plateau, broken only by a small temple and a few flocks of sheep. As they descended on the other side, Janet could see the Yellow River winding its way through the cultivated plains far below. A patchwork of canals and irrigation ditches marked the division between the sandy

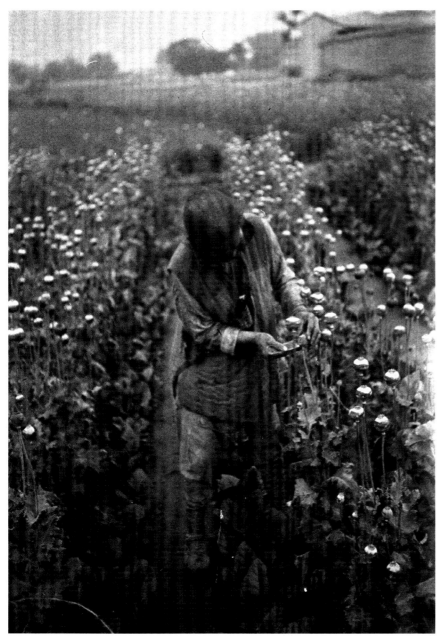
Woman harvesting opium poppies in a field along the roadside outside Ninghsia, June 1923.

desert country and the lush fields, often winding into the desert as if seeking to help irrigate the sand. The high wooden wheels of the "schooner" carts became essential. Without them cargoes would have been flooded whenever the carts crossed the marshy fields.

Late on the afternoon of June 10, they arrived at city of Chungwei with its busy main street full of shops. Two American Baptist missionaries, Mr. and Mrs. Elliott, welcomed Janet and Frederick. Janet questioned Mr. Elliott about the profusion of opium poppies being cultivated along the roadsides. In response, he described the local opium trade, known as the "opium squeeze," in operation. There were three men in Chungwei from Anwei, he told her, two of them officials who worked together. One distributed printed proclamations that prohibited the planting of poppies while verbally encouraging the farmers to plant it, saying, "proclamations are for form only." The second official then fined the farmers for planting the poppies, and the third man acted as a go-between. All three got rich in the process. Mr. Wu added that one row of opium could be taxed or fined thirty dollars a year, but that the crop would sell for two hundred dollars; a farmer who planted an equal amount of grain would earn just thirty dollars. Despite the scofflaws, everyone agreed that there was much less opium smoked than before, because of the government's strict, though unevenly enforced, new restrictions.[154]

Although Janet found many of the missionaries, whom she called the "mishs," a bit unsophisticated, she grew to appreciate their hospitality and respect their deep knowledge of the customs, history, and terrains of the regions they served. "The missionaries in my experience are always kind, and turn themselves inside out to give the traveler everything that they have—often times going without themselves."[155] She found their "Lord will provide—Manna from Heaven idea" a bit too fundamental for her taste, but after weeks on the move, it was a relief to come to a welcoming mission, bathe, read the mail and newspapers, no matter how out of date, and touch base with the Western world.[156]

The expedition abandoned their carts in Chungwei and continued by horseback and hired mule litters. The party had now expanded to four mules, six sad-

Temple in Chungwei, Kansu. *"Here the desert of Mongolia comes down into the Province of Kansu to touch the Yellow River. In the foreground is the beginning of one of the canals which water the Ninghsia plain."* —F.R.W., June 1923

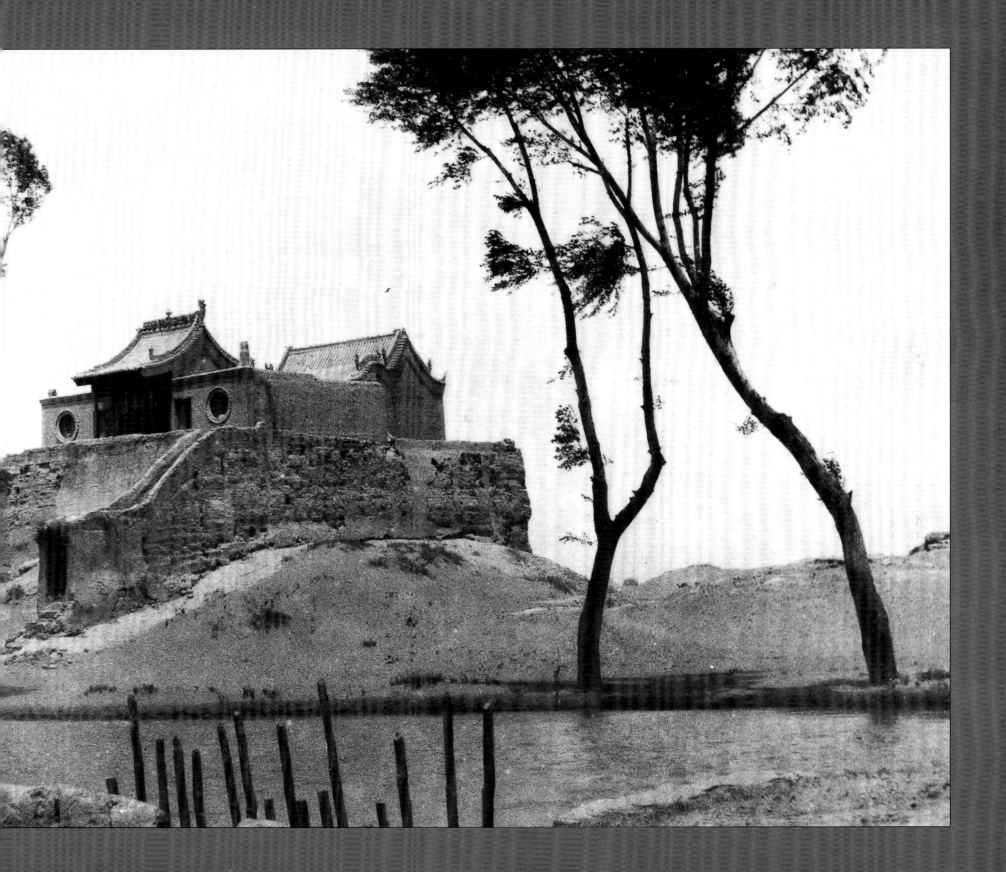

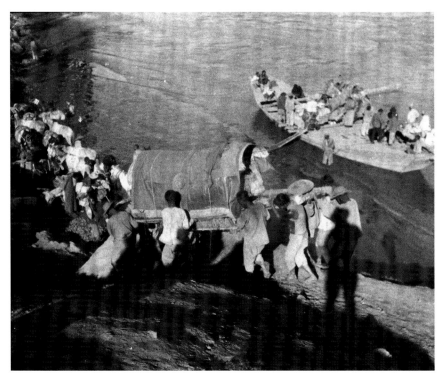

Crossing the Yellow River by ferry—Janet's mule litter is hoisted up the steep embankment, Ho Ts'ui Tze, July 1923.

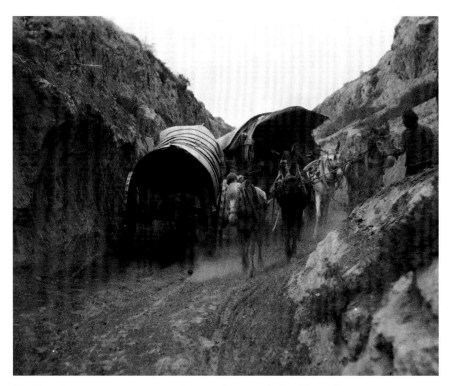

The Expedition carts on a narrow trail in very heavy sand, Gan Tangze, June 14, 1923.

dle horses, and twenty-eight people, including four soldier escorts. Large bales of fodder for the horses were packed on top of the smaller wagons, causing them to tilt on the uneven ground.

The new countryside differed dramatically. Gone were the lush fields, the swamps full of birds, and the hillsides of bounding antelope. Now they marched for days over an arid, unpopulated plain that gradually became a sandy desert. "The road was '*hung kow*'—very bitter," wrote Janet. "Bitter to the Chinese traveler because the inns are poor, and food supply very, very meager. Bitter to us was just monotony, for we had plenty of our own food and fuel."[157]

Janet watched with envy as a large raft floated quickly past her down the Yellow River. Initially, it seemed an ideal way to travel. Later, however, she

glimpsed the raft stuck far out on a sand bar where it remained marooned for the rest of the day.

THE GREAT SANDSTORM

Crossing the Yellow River by ferry the next day proved an arduous process. It took two and a half hours to go upstream in the big boat of rough boards, hauled by six men, and about the same time to return. At six the next morning, three of the carts were loaded onto the boat. When the boat returned at eleven a heated debate about price broke out between Pu and the boatmen, causing an

Sand Mountain above the Yellow River, Sha Ba T'ao, June 1923.
"We crossed a sand mountain, straight up four hundred feet of fathomless sand. The carts had to be put on boats and were pulled around the foot of the mountain by coolies…the horses went up over the mountain, two of them lost their footing and slid the whole way down, rolling over and over."—J.E.W., July 19, 1923

hour's delay. Finally, at noon, the last three carts were loaded. The second trip, however, hit a rock in the channel, causing another delay. Meanwhile Frederick, Mr. Wu, the two grooms, and Mr. Ching's local guide led the cart horses up the steep, sandy incline over the mountain. Janet described the experience: "We crossed a sand mountain, straight up 400 feet of fathomless sand. The carts had to be put on boats and were pulled around the foot of the mountain by coolies… the horses went up over the mountain, two of them lost their footing and slid the whole way down, rolling over and over."[158]

Meanwhile, Janet and Susanne traveled around the mountain in their mule litters, following the shoreline of the Yellow River. Janet was terrified as she watched the horses plunge down the four-hundred-foot sandy cliff above her. She wondered whether she too would land in the river. Susanne's litter did tip over later in the afternoon, but not on the sandy slope of the mountain.[159]

Exhausted, the team finally reassembled at the top of the treacherous cliffs. As they proceeded across the crest, a ferocious sandstorm arose, blinding the travelers and the animals. All eyes quickly filled with sand, despite goggles. The blinded party groped its way forward. The wind whisked sand in long hissing streams from the tops of the dunes, whipping it across their faces with a burn. More sand howled up from below, flew along the edge of a dune, and sailed straight up in a plume, scattering sand far and wide. Frederick yearned to film the spectacle, but feared that the sand would ruin his cameras.[160]

As Janet lurched forward, clutching her goggles against the wind, she pitied the mule men who were struggling to control their terrified animals. The wild-eyed beasts were ready to stampede over the cliffs to their peril. When the winds subsided the party stumbled into a small temple to take shelter behind the walls. There, a hospitable caretaker brought bowl after bowl of strong Mongol tea to the weary travelers. This was the last habitation they saw for the rest of the day.

Thinking that the storm had subsided, the caravan set out again. The wind had now shifted from the south to the north, however, and began howling again in cold gusts. The trail was blown from view, and visibility dwindled to a few feet. Suddenly, a torrential rainstorm poured down on the windswept band, scaring the animals once more. Soaked and caked with sand, the caravan crawled along the ledge. At the end of the narrow trail Frederick spotted fossils of sandstone lying exposed in the yellow sand. One seemed to be of an elk horn, others of plant stems. The tired group gathered as many as possible, stuffing them into their saddlebags and shirts. These fossils were an unexpected reward at the end of a hazardous day. They were later considered one of the prizes of the collection.[161]

As they crossed the dry countryside of lizards and hard earth, water was again in short supply. At the small village of Ing Pan Shwei, they sent six donkeys seven miles into the mountains twice a day to fetch potable water, as the local water was undrinkable. Remembering their shortages back in the Alashan desert, everyone dutifully filled their water bottles from the donkeys when they returned from the mountains.

THE BRIGANDS ARRIVE

The desert was never quiet for long. Outside the village, their journey was suddenly interrupted when a group of eight men on horseback in Chinese army uniforms clattered past them. Several were armed with two rifles each. Janet noticed that two other men had been riding ahead of them, each with a lead horse. They were traveling fast and gave Frederick a perfunctory salute as they disappeared into the desert. Moments later, a detachment of twenty soldiers rode by in hot pursuit. They informed Janet and Frederick that the men were brigands who had attacked a salt storehouse two nights before, killing a few guards and stealing their rifles. The troops hurried on. Janet breathed a sigh of relief that their caravan had not been the target for the robbers. She had recently read the gruesome tale of a young missionary, Dr. Susie C. Rijnhart, who had traveled across the mountains from Szechuan with her husband and young son in 1895. Robbers murdered her husband and son, and the young widow was forced to proceed, starving and barefoot, to the holy city of Lhasa. Although Kansu was considered safe, brigands roamed widely throughout the territory, and Janet heard many blood-curdling tales during her travels.

The following day Janet and Frederick stopped at the salt warehouse, where a guard of twenty soldiers greeted them. One man was barely alive, but recounted the story of the massacre in halting gasps. Two members of the guard had enabled the robbers to enter the warehouse while the soldiers slept with their guns lined against the wall. The invaders shot and wounded the soldiers, seized their guns and several thousand rounds of ammunition, and fled.

Frederick and Janet tended the wounded as best they could. The men, lying naked under blankets on the straw-covered floor of a dark stable, were courageous and uncomplaining. Two had been shot in the chest. Janet thought they would recover, with the exception of one man who had been paralyzed by a shot through his spine. The scene reminded Janet of her time in France tending soldiers during World War I. These men, however, were not so lucky, for there was no medical help for miles.

Janet and Frederick departed reluctantly after doing all they could for the wounded men. They pressed on towards a new landscape. After a torrential rainstorm cleared the air, the caravan approached giant cliffs of yellow loess that rose from the sandy valley floor. The canyons were a hundred feet deep and more than a mile long, with sheer walls of earth rising on both sides. In one place a cart road ran right over the brink at the head of the chasm. The cliffs looked as if they had been sliced with a sharp knife. Janet was amazed to see entire families

living in "queer little caves, with wooden doors and wooden windows" cut into the face of the cliffs.[162] Traveling through the loess country posed serious problems for carts. Their wide wooden wheels sank into the thick sand, and they could not move. Only by hitching all the mules and the horses to each cart, one at a time, could they be dragged to the edge of the sand. It took two long days for the entire caravan to weave its way through the cliff to hard ground.

At sunset, the mule-filled courtyard of their ramshackle inn commanded a magnificent view back over the sandy bluffs, with their deep gullies and the green fields beyond. Far off, a tiny village perched perilously on the edge of the cliff in the mist (see page 137).

LANCHOW

On June 20, "after many windings through what seemed never-ending, bare, yellow hills, we saw again the Yellow River and Lanchow in the distance. What a lovely sight—a green plain full of ripening crops and gorgeous trees, and Lanchow with its thick, irregular walls, its great gate towers, its temple roofs and the towers of many mosques, for this is a city of many Chinese Mohammedans, lay before us," she wrote.[163] This was the expedition's first encounter with the large Chinese Muslim population on the frontier.

After weeks in the desert sands, the bustle of Lanchow dazzled the expedition. *We crossed the famous American built steel bridge over the Yellow River, along the cobble stoned street through the north gate, and wound through many narrow streets crowded with shops, with farmers, merchants, gentry and children galore, until we reached our inn.*

Just as we got off our ponies, a breezy voice cried out, "How do you do?" There was Mr. Andrews, the missionary, a six foot two Englishman, under forty, dressed in Chinese clothes, behind a cart with Mrs. Andrews and Mervyn, aged six. Mr. Andrews piloted the men of the party into the dank, narrow courtyard of the inn, and before we knew it, Susanne and I were put in the Andrews' cart, and off we all started for the Andrews' house, which is outside the south gate of the city. . . . They gave us a huge British tea with luscious

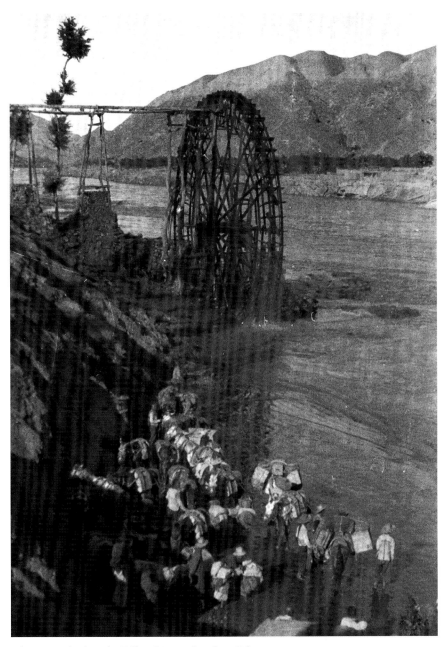

The water wheel on the Yellow River at Lanchow, July 1923.

A man carrying water down a rural road outside the city walls of Lanchow near the Wulsins' house, July 1923.

cakes galore, yak's milk (the first milk we had tasted in months) and apricots that one could eat raw. We ate as though we had never seen food.[164]

Finding lodgings soon became their primary concern.

Mr. Andrews had a friend, Mr. Ma Yea, a Chinese Mohammedan, who had a house for rent....so off we trooped... through wheat fields and fields of opium poppys [sic], with the beautiful masses of white blossoms. Into a little courtyard with flowering pants in pots, and great bowls of gold fish. [We] found Mr. Ma Yea at his evening prayer (called the li-li). (The Mohammedans worship five times daily, and this was his sunset worship. The "li-li" over, he was willing to talk business....

[The house] had a lovely upstairs room with round moon windows, but it was crowded with furniture and curios: too many things. But he had another house not far away. So we started off, and had another half hour's walk through the fields, across little streams, past lovely pinkish temples, and we came to Fung Djai Lo. There is an old garden, now a mass of vegetables, but redeemed by the poppy blossoms and many trees, and the house itself has two stories and the big upper room overlooks every direction to the Yellow Hills and graves, and the group of temples at the north, across fields and lanes and farms to the walls and towers of Lanchow on the south, and to the east more fields and rows of willow trees, and the hills across the Yellow River—and the west, the never-ending grave mounds of the long-forgotten dead and always the sunsets.

We agreed to take both houses. The first one for F.'s [Frederick's] "army," the taxidermists, Mr. Wu, the collections, and an office for F. The second house was for the Ah-Wu (the Wulsins and the Emerys) and the living establishment—"home" for a month at least. Sixty Mexican dollars a month covered the rest for the two houses.[165]

They had traveled eighty-six days from Paotow and twenty-one from Wang Yeh Fu, surviving drought, sandstorms, and brigands.

Mr. and Mrs. George Findley Andrews ran the China Inland Mission in Lanchow, comprised of a church, a school, and a hospital. Their reputation stemmed, however, from the role Dr. Andrews had played after the devastating earthquake of 1920 when he took charge of the agricultural chaos and organized flood control projects throughout the region. His role in civic affairs was as strong as his role in the church. "Their hospitality overwhelmed us," Janet wrote.[166]

The Wulsin house in Lanchow, with Frederick on the balcony and the garden of opium poppies below, July 1923.

In a short time Janet and Frederick were engulfed in a microcosmic foreign community.

Social activities began with a whirl. The Andrews must have us meet all the local "lights." So hardly had we brushed the dust off our clothes, before there were luncheon parties, tea parties, dinner parties, and Chinese feasts....[At one dinner] there were nine foreigners, a beautifully set table, flowers, good local wine, and it seemed hard to realize that we were near the borders of Tibet.... I longed so to shed [my] camp clothes that [I] bought two old Chinese coats of gay colors, and they were [my] dinner gowns.

We stayed with the Andrews until June 26th, and we were busy, having a Chinese tailor make us Chinese clothes for summer, buying and bargaining for a little furniture for our new house, and doing the social act full tilt. Mr. Chun, the Postal Commissioner, gave us an elaborate semi-foreign dinner, and his queer little Cantonese wife received the guests with him—quite an advance from old China. The Tuchen [sic] gave F. [Frederick] and Harry a feast with all the local officials, and F. sat next to him and had a fine time. The Civil Governor called in his chair with an escort of eighteen soldiers who quite filled up the Andrew's [sic] garden. He was an affable man who continually pulled his wispy moustaches. Even Mr. Ma gave us a feast—your landlord feasting you—in one of the lovely temples at "On Chuan" (five springs) on the hills just a mile or two south of the city. Father Van Dyke, a Belgian priest, and a relative of the great painter, who has been in Lanchow for twenty years, reveled in talking French with F., and above all in discussing photography. He takes beautiful pictures, and F. has him enthusiastic about photographing for the National Geographic....[167]

The Wulsins reciprocated the hospitality.

We were a novelty to the little foreign community here, and they loved to come and see us, and they did come, and stayed for hours.

On July Fourth, as the only Americans in Lanchow, we staged a "blow out"— a buffet supper—the house full of flowers and lanterns; lanterns on the upper porch, and lovely fireworks, which Pu operated in the garden after dark....

Like all true July 4ths, it rained in torrents. We had our water-proof tent put up in the yard for the children, and they ate at a little table inside and loved it. They had our small Tibetan dog to play with, a present from Mr. Ma. Inside the grown-ups guzzled food, and

for once our dirty old cook did himself proud, with an ice cream made with yak's milk.
Susanne cut out a paper donkey of blue paper, and we pasted it on a sheet and pinned red
tails on it. It made a great hit, and Mr. Chun won. There were also spraying fountains, and
all sorts of elaborate things that the Chinese make so well. The rain stopped a little for the
fireworks, which [were] really lovely.[168]

Frederick's thirty-second birthday provided an excuse for another celebration.
…we had a surprise birthday dinner…. It was very jolly—a big cake with thirty-two
candles, ice cream again and many amusing stories. The Andrews sent F. [Frederick] a gor-
geous bunch of dahlias which greeted him at breakfast. [One of the nurses] brought him a
birthday cake. I gave him a pair of local Lanchow-made camel hair blankets, not bad ones.
The Ahs [Emerys] gave him a chopstick set and some little brass bowls. The servants present-
ed him with a straw hat and two fans and a gracefully written note in Chinese. F. was
much pleased.[169]

In a short time, Janet had managed to create a life for herself and Frederick
in this distant city.

Despite their busy social life, Janet and Frederick had much serious work to
do. The zoological collection needed repacking and overhauling after twenty days
of bumping over rutted roads in the wooden carts. Skins prepared en route had
to be done over, for many had been only superficially cured for lack of time.
There were inventories to revise, three months of mail to read, and correspon-
dence to the outer world to be finished before they could move on.

The Wulsins found Lanchow a fascinating city. Located on the banks of the
Yellow River, the city rested within oblong walls, surrounded by Muslim suburbs.
The big iron bridge, engineered by Harry Emery's friend Mr. Karius in 1907, cov-
ered the river on the north bank, supporting caravans from the Turkistan road.
Inside the town of seventy-five thousand inhabitants were inns, shops, *yamens*
(civic offices), and temples—all the important elements for the life of the city.
There were few local industries of any importance, and the Lanchow plain,
blooming with opium, was large enough to support only a small city. For the first
time during their travels Janet and Frederick sensed ethnic and religious tension
among the local population. While for the most part there was a somewhat

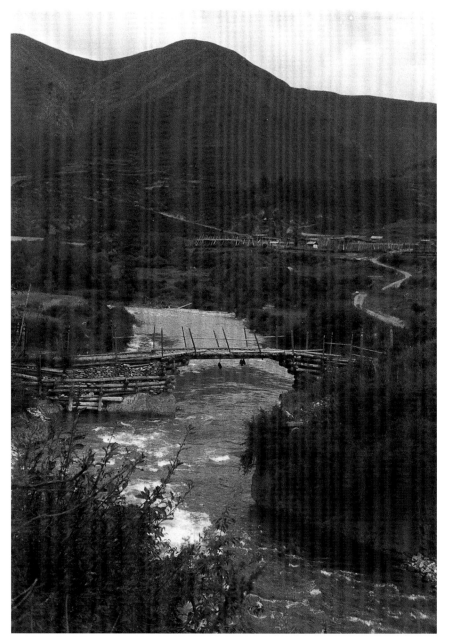

Crossing a rural bridge outside of old Taochow in the river valley leading to Choni,
September 1923.

strained civil order, the Muslims and Chinese fought freely on occasion, usually stabbing frays that arose from small quarrels.[170]

After two weeks, the Emerys, accompanied by the Andrewses, departed to visit the Prince of Choni, who reigned in southwest Kansu on the Tao River. The prince, a great friend of Mr. Andrews, was a Tibetan who ruled forty-eight wild tribes that inhabited the Tibetan borderlands. Andrews wished to inspect the construction of a new bridge over the Tao River that was being built in case of trouble with China. The prince believed that the growing civil war in the south might warrant a hasty retreat to his Tibetan stronghold in Choni, where he lived on the Chinese side of the river. As history would prove, his fears were well founded.

It was a nine-day journey through the mountains. Mr. Lin, one of the taxidermists, accompanied the party, and planned to collect for two months in the region under the prince's protection. He took two mules, the three-barreled gun, one thousand assorted cartridges, and two hundred dollars in cash. He was given strict instructions not to travel outside the prince's territory and protection.[171]

Meanwhile, as Janet and Frederick remained working in Lanchow, the rest of the team scattered. Mr. Ching was dispatched to "botanize" the countryside between Lanchow and Sining, and the zoologists rode south with their two mules and their guns to collect birds and mammals. Bad weather hindered them, but they nonetheless managed to collect a substantial collection of rare species.

Lanchow seemed a paradise to Janet.

Lanchow is a beautiful city of 80,000 people—a delicious climate, good food, meat, vegetables, milk, delicious fruits, lots of foreign goods for sale, though prices are naturally high. Marco Polo came here and many travelers since. It has never been captured, and is in good repair and quite clean. In many ways I should like to spend the winter here, for it is a virgin field for many of the scientific undertakings that F. [Frederick] loves and the province is peaceful so that work can be carried on.[172]

She concluded her letter saying, "I will have to go now and blow up the cook, and get the packing started for Sining."[173]

Despite her own happiness, she wrote her family that Frederick "is rather discouraged about things and I hope his mother will come out, for she seems to

be the one person who can help him."[174] Clearly, Frederick's commitment to explore Kweichow weighed heavily on his mind. As Janet continued,

F.[Frederick] talks of going to Hong Kong, Canton and Manila in January 1924, and then going to Kweichow in the spring of 1924.... If F. goes into Kweichow, I will go up the Yangtze River with him, see the gorges, start with him into Kweichow, then return down the river to Shanghai and sail for America. But, of course, no plans can be made so far ahead.[175]

With Frederick nothing was certain. He continued to have doubts that he would measure up to the rigorous standards set by the National Geographic, and was worried that the expedition was already over budget.

THE ROAD TO SINING:
MR. WU'S TRAVAILS

Days of torrential rains prevented Janet and Frederick from departing on schedule. Finally, the caravan—consisting of ten mules carrying the baggage, the mule litter, Pu, the cook, Jow, two grooms, six mule drivers, four horses, Janet's treasured donkey, Dung Pi, and Mr. Wu—departed Lanchow for Sining. "As usual there was delay and more delay," wrote Janet.

Grumbling at the loads, lame mules, one excuse after another, trying to substitute a donkey for a mule when our contract called for ten baggage mules and two mules to carry my litter.

At last all our belongings were loaded. The others stored in the Lanchow house were locked up. "Aro," the Tibetan puppy was given a last hug, and an extra dollar bestowed on the caretaker with the hope that the little dog would be well fed in our absence, and we were off....

There were two roads to Sining, one a cart road that takes eight days, and the other a mule trail taking six days. Because of the heavy rain, we thought it best to go by the big road. So we crossed the river on the big steel bridge and went west for 40 li [fifteen miles] skirting the Yellow River with the high, yellow hills of loess to our north.[176]

Mr. Wu "seemed to be utterly exhausted and looked very ill."[177] He told Frederick it was nothing, simply a stomach upset, but at noon, he collapsed. After sleeping for a while, he seemed to grow weaker and feel increasingly sick. Janet

found his temperature to be a little below normal. Frederick and Janet finally placed him in her mule litter, and the party turned back to Lanchow. Besides Mr. Wu, Frederick was concerned about the mules. There were six bad ones in the lot, some of them very lame and scarcely able to hobble. Three of the mules had been falling all morning. Once back in the city, Janet escorted Mr. Wu to the hospital, while Frederick upbraided Mr. Ma, their old landlord, who had arranged for the mules. Janet learned that, "though intelligent above the average, [Mr. Wu] had a fear of foreign medicine, and he was most reluctant to be left at the hospital. However, I insisted and Dr. King said that he would make a careful observation for two or three days and then he could follow us to Sining."[178]

After leaving the hospital Janet rode around the city walls, as all the gates were closed, to Mr. Ma's house, which was in the Muslim suburb.

F. [Frederick] with the aid of Pu was busy reviling Mr. Ma, threatening him, screaming at him, which is most effective with an Oriental—and the upshot was that if Mr. Ma did not produce twelve good mules for us by nine the next morning, F. would take him to the Yamen. At eleven p.m., after a fruitless day of 80 li [30 miles], and many difficulties we fell asleep....[179]

The following day,

No chances were taken this morning about the mules. We got up at six a.m., so that Mr. Ma could not blame us for any delay. He was rather perturbed as he hustled his men with the loading. When all were loaded, we made each mule walk around the stable yard in order to see the condition of his legs and feet. Two we refused to take, and then the torrents of sound that issued from Mr. Ma! I was glad we couldn't understand. Two new mules were forthcoming, an extra clause was added to the contract that stated if the mules ever delayed us for a day, we need not pay for that day.[180]

Mr. Wu, however, remained behind in Lanchow with his servant and personal baggage. Anxious to hear the medical diagnosis, Janet and Frederick came to visit him in the hospital on their way out of the city. The doctor assured them that Mr. Wu would be well in a few days, but it would be three weeks before they saw him again. When they learned the true cause of Mr. Wu's illness, acute opium addiction, Janet and Frederick were dismayed and angry. Although he accompanied them throughout the rest of the expedition, Mr.

Wu's addiction became more and more apparent each day, and by the time they reached Peking he was no longer a competent manager. Opium was easily available everywhere in China, and could be purchased out of sight of foreign eyes. In contrast to the situation with alcohol, a quiet opium underground operated throughout the countryside, and Mr. Wu and the "team" had little trouble in buying it wherever they stopped along the route. The Wulsins were surprised that Mr. Wu had managed to operate efficiently for as long as he had without their detection.

After leaving the hospital, they continued down the road to Sining. Janet wrote: *The trail follows the Sining River, which flows into the Yellow River. The country is uninteresting, bare loess hills with here and there cliffs of red sandstone, narrow valleys with fields covered with small stones (said to keep the moisture in), where luscious melons are grown. We ate four different kinds, cantaloupe, watermelons, and two others tasting like honeydew, but smaller. They were most refreshing in the heat of the day, and it gave me quite a thrill to buy raw fruit off the vine in China, and eat it without being boiled.*[181]

"We had an exciting day the second day out crossing the Yellow River. This time the trips took only ten minutes," wrote Janet.[182] Frederick described the scene: *The ferry was a big, ugly, flat-bottomed boat of rough boards, handled by two sweeps [oars] near the bow and a third at the stern, each with several men to work it. They carried loads onto decked portions of the boat, unsaddled the animals, and made them jump on board in shallow water. Some balked in spite of yells and cries behind them. Then, each front foot was caught in a rope and hoisted separately over the gunnels. The hind feet had, perforce, to follow. On the way across some of the animals shied at the swirling waters and rocked the boat. The swift current carried us down several hundred yards. The horses jumped out, and clambered up a steep bank. The passage for the whole caravan was $4.30.*[183]

After the crossing the caravan marched all day. Later, by moonlight, they passed the three great water wheels of Lanchow, and continued into the village of Hsin Ching where they spent the night at the inn.

Their route took them through an isolated rural village where the women had amazingly small feet, only two or three inches long. The little girls three or four years old already had their feet wound tightly in bindings.[184]

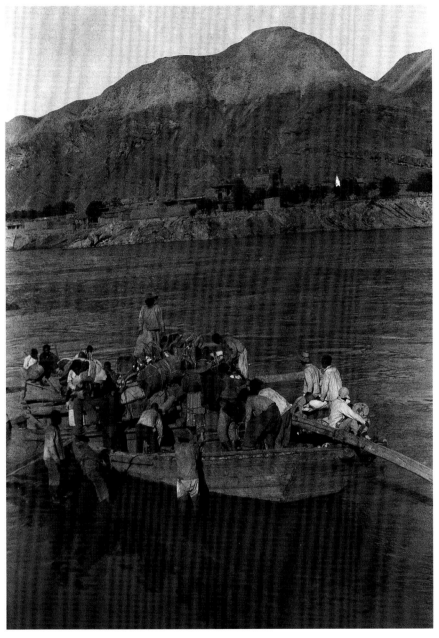

Crossing the Yellow River by ferry, Ho Ts'ui Tze, July 1923.

Further along the trail, the faces of the people they met looked different. They saw "a good many men with brown or blond beards" and observed that "coal black hair was by no means universal."[185] Feet were no longer so severely bound. Many of the locals seemed to be Chinese in color and costume, but their features were different. "Their faces now seemed more square, the front part of the chin broader, and the eyes more horizontal than the Chinese." They also began to see locals "with copper-colored skin, broad noses, heavy mouths and chins."[186]

Janet became fascinated by the tumultuous past of the region.

The road to Sinning [sic] is very historic as the scene of much fighting during the Mohammedan Rebellion of 1895. There were many ruined villages, forts and towers, but as we drew nearer to Sinning [sic] (one of the Mohammedan strongholds of China), the villages seemed very prosperous, many new buildings, good crops, lovely gardens and orchards and everywhere the "Hwei-hwei" (what the Muslims are called in China), with their little black or white cotton caps.[187]

SINING

Just outside of Sining, Janet and Frederick were delighted to meet up with Mr. Ching, who had collected 430 new species of plants in the mountains along the To Tung River. Despite the constant rain, which had made it difficult for him to dry his specimens, he had achieved splendid results.

Upon their arrival in Sining, after a journey of six days and 143 miles, the Wulsins called on the China Inland Missionaries, Mr. Learner and Mr. Harris. "They have a large compound, two Chinese houses, a school compound, chapel, stables, vegetable garden, gate-house, all in Chinese style," wrote Janet.[188]

Their interiors are comfortable, but in atrocious style—golden oak furniture, antimacassars, terrible photos all over the walls.... I never can understand why the missionaries cannot use some sort of the outward signs of beauty that the Chinese have so abundantly. I shouldn't think it would injure their inner Christian life. But they would a great deal rather own an

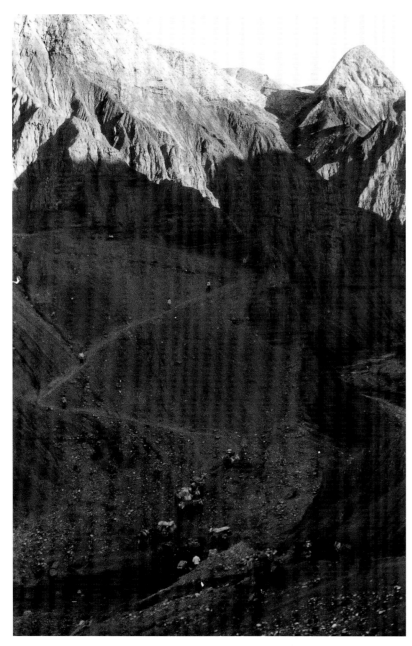

The Wulsin caravan's dramatic ascent from Pai Yuan Jung to Gantu over a mountain pass at 10,250 feet elevation. August 1923.

awful chiffonier from Montgomery Ward, than a charming red lacquer cupboard made in China.[189]

Janet found Sining wonderful:

You feel Tibet in the high winds and the bare hills and high plateau all around. Sinning [sic] has an altitude of 7000 feet, a delicious dry climate, a real tonic in the air, cold winters, sometimes 12 degrees below zero, but very little snow. It is a great trade center for all sorts of manufactured articles going to Tibet, and a market for wool and skins and famous Chinese medicines going into China. The city is well built, the wall in excellent repair, and, though the streets are dirtier and more smelly than any Chinese city we have been in, there is an air of bustle and frontier life everywhere. The mixture of peoples is amazing. Here is a real Asiatic melting pot, Mongols, Tibetans from the Kokonor, Tauguts, Chinese, Chinese Mohammedans and a few strange aboriginal peoples that F. [Frederick] is keen to study. Occasionally, one sees central Asiatics from Turkestan [sic], with their curly beards, their high leather shoes, and Russian refugees, whose tales must be heartrending if we only understood them. Several Russians we hear, are trying to get a start in the wool business here.

Sining played an important part in recent history. In the Mohammedan rebellion of 1895 there were terrible massacres here of the "Hwei-Hwei" and the accounts of the siege of Sining and the bloodshed and destruction of the east suburb where all the "Hwei-Hwei" are required to live, is ghastly tho' thrilling reading.[190]

The mixed ethnic population of Sining was in great contrast to the pure Mongols of Alashan and the Chinese in the east, observed Frederick.

The Chinese Mohammedans are an interesting study. It is not definitely established from whence they came, some may have come from Arabia, some from Sammarcand, and some are pure Mongolian type. One third of the population of Kansu is Mohammedan. They are a shrewd, fearless people, great fighters, large in size and quite insolent as compared with the gentle, courteous ways of the Chinese. Each time they rebel they think they can gain complete control of China. The Chinese fear them, but respect them, and because the Kansu Chinese fear them, Kansu is peaceful. For if the Chinese in Kansu join the general upheaval of the rest of China, it will be an opportune moment for the "Hwei-Hwei" to rise, and then the Kansu Chinese has

Following the narrow cliff trail high above the Yellow River gorge at Hsing T'ong, July 1923. Frederick considered this to be the first "bad cliff day" of many. The caravan progressed slowly and cautiously.

Loess canyons with rutted cart roads and a small village on the cliff, I Wan Chuonze. *"With the high winds of spring, and the downpours of rain which come in the summer, erosion is rapid, so that a road may change its surface appearance in a few hours; the general bed remains, but its looks are altered completely."* —F.R.W., June 1923

lost more than he has gained. The Tuchun of Kansu, a pure Chinese, has very little power in the province for nine big Mohammedan leaders hold the real control.[191]

Janet found it interesting to discuss "the Mohammedan question" with different missionaries.

Some think that soon there will be another rebellion, and when China is in utter chaos, the "Hwei-Hwei" will fight and win. Others say that the Mohammedans hold all the important posts they want, that it is they who hold the peace in Kansu and on the N.W. Chinese border—Tibetan border, and tho' few foreigners like them, they think on the whole they are a good element. Many of the Mohammedan women here wear green or white or blue cloth hoods with a long cape-like piece hanging down their backs, but none are veiled as their sisters further west.[192]

KUMBUM: THE GREAT MONASTERY

Janet and Frederick decided to take a detour to Lusar, a village close to the famous lamasery of Kumbum, only a short day's journey from Sining. As Janet described their visit,

This great Lamasery ranks second to Lhasa, and we could not leave Sining without making a pilgrimage to it. We started at 7:45 a.m. yesterday morning, the road deep in mud after a downpour during the night, and followed a rushing stream for about fifteen miles to Lusar. The road, which was nothing but a trail, wandered through groves of trees, ripening fields and hills, emerald green, with soft grass where many horses were grazing. I haven't seen green anywhere in China and it was a joy to the eyes.[193]

The great French explorer Alexandra David-Neel had spent more than two years in the celebrated monastery at Kumbum translating Tibetan books just before the Wulsins arrived. She described the magical setting of Kumbum as a

configuration of the surrounding mountain ranges [that] arrested the passage of the clouds, and forced them to turn around the rocky summit which supported the gompa forming a sea of white mist, with its waves beating silently against the cells of the monks, wreathing the wooded slopes and creating a thousand fanciful landscapes as they rolled by. Terrible hail-storms would often break over the monastery, due, said the country folk, to the malignity of the demon who sought to disturb the peace of the saintly monks.[194]

Janet wrote,

We passed lamas on their way to the village in their red and yellow robes.... When we got to the temple two of F.'s [Frederick's] visiting cards were sent somewhere and a lama more intelligent looking than most, came out, bowed, and appointed a young lama to be our guide around the temple. The Lamasery is situated on the two sides of a little valley, with a soft winding stream flowing behind the hillsides. The houses and living quarters of the priests are in the hillside, and the temples in the valley are on the opposite hillside.

We were taken first to the great kitchens where priests were brewing Tibetan tea in great copper caldrons ten feet in diameter, beautifully chased with the Buddhist symbols. The stoves were the usual mud affairs and the fuel nothing but straw, which younger lamas continually fed to the fire.

From the kitchens, we went to the great Gold Temple of Tsong Kaba. Tsong Kaba was born on the site of Kumbum. He was a famous Buddhist reformer who lived in the four-teenth century, founded the Yellow sect of lamas, and made many changes in the forms of Buddhist worship. Many are the legends about him. He is thought to have learned from a western saint whom many believe to have been one of the early Roman Catholic fathers. The "Golden Tiled Temple" is revered throughout Tibet and Mongolia. It is a small building with a roof of pure gold plate. Inside, it is full of wonderful relics, great banners of silk brocade called "katas" (tankas), wonderful lamps of gold and silver, thousands of small vessels burn-ing butter, a colossal figure of Tsong Kaba, said to be made of gold. All is in semi-darkness which adds to the mystical effect, and the gleam from the butter lamps throw into relief some beautifully wrought temple vessels, or the queer blank face of some saintly Buddhist image.

Everywhere the smell of rancid butter! Everywhere butter is burned, is placed in dishes for sacrifice, and the priests even rub it on their filthy, never washed, bodies.

On the porch of the Golden Temple, pilgrims prostrate themselves one hundred times, and the boards are worn into grooves where their feet and hands touch. Near the Temple, is a huge stone-paved courtyard, surrounded by temples in pure Tibetan style, huge prayer wheels with the ever-recurring inscription, "Om mani padme hum" (Oh! Lotus flower, Amen). When we came into this courtyard, hundreds of lamas were there, playing a game, I thought. Some were seated with their great red capes on, and their yellow hats. Others were standing laughing at their seated companions, and clapping their hands. You never heard such a noise. As they clapped, they screamed a jargon of sound. They were praying. It was one of the most extraordinary sights and sounds that I ever saw or heard—quite hypnotic in its effect, and we found it hard to move away [see page 99].

We were taken into one great temple capable of seating twenty-five hundred priests. The great pillars were covered with brilliantly woven rugs, skins of animals and the bright "pulo" cloth of the Tibetans. It was a mass of brilliant, garish colors and to my mind would have been wonderful in a more subdued light. Lamas were polishing various altar vessels, and seeing to the many butter lamps. The smell was most horrid. We were allowed on the roof of this temple, and got a fine panorama of the whole Lamasery.[195]

The mystical scene had also captivated Alexandra David-Neel:

In the vast edifice scarcely lighted by the lamps placed before the magnificent tombs and gilded statues of defunct lamas, the monks were seated motionless, attired in dark crimson togas. They were chanting in deep tones solemn sentences of mystic import or transcendental philoso-phy, which raised the mind above captivating illusions.[196]

Janet described their introduction to the living Buddha:

We had brought gifts for the living Buddha, and now we were to be allowed to see him. We crossed a bridge over the little stream, climbed the hill to a house painted red on the outside instead of the usual white wash of the majority of the lamas' houses. A lama, looking like a Chinese Malvolio, with thin curling moustaches, a wicked looking eye, led us into a courtyard typically Chinese in appearance where we waited.

Soon a nice old lama appeared, beckoned to us, and led us into another courtyard, where pansies, asters and many flowers were growing up between the flagstones. I wondered

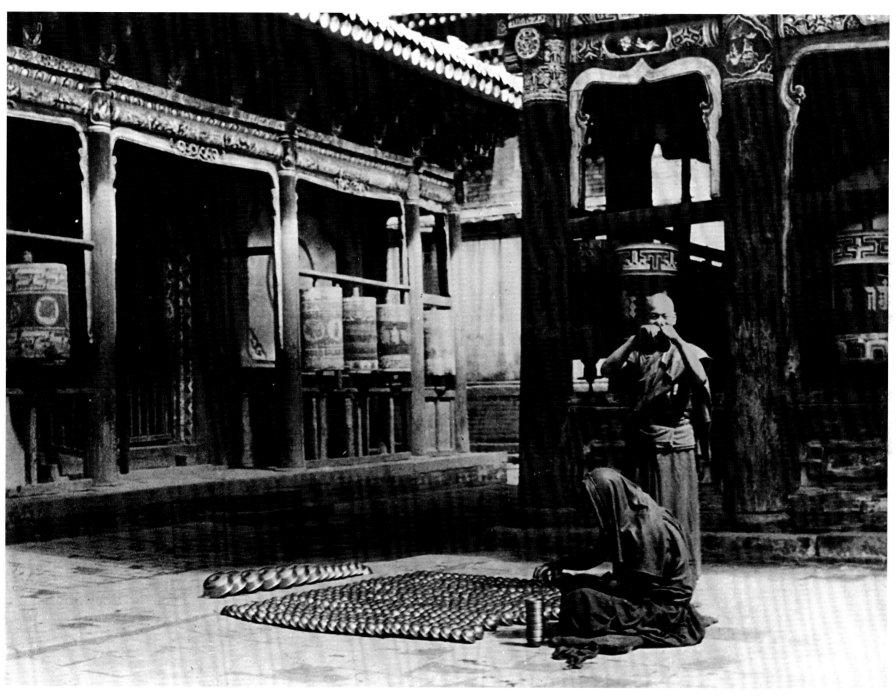

Polishing brass lamps in the courtyard of the monastery at Kumbum, Kansu. *"Countless little brass lamps, whose fuel is melted butter, burn in front of the holy images in the temples."*—F.R.W., August 1923

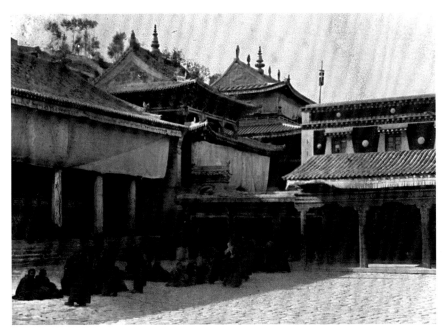

The courtyard of the Great Chanting Hall, Kumbum monastery, Kansu, August 1923.

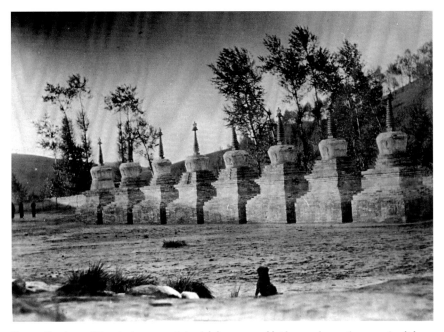

Graves, Kumbum. *"Opposite the entrance of the whole lamasery stand bright, great chortens (monuments), which mark the graves of eight famous lamas who were all beheaded at once. We had feared that the lamas would object to our photographing, but, on the contrary, they paid no attention to it."*—J.E.W., August 1–3, 1923

if they might have been lamas in a previous existence! Soon, another old lama with an exceedingly smart face, and speaking good Chinese, came and led us into the presence of the poor little "Hulcutukuto," or living Buddha. The present incumbent is a small Chinese boy of thirteen years, with soft, frightened brown eyes, and a timid expression. He stood up to receive us, and was dressed in the usual red robe, perhaps a little cleaner than the average lama's. We presented our gifts, an Ingersoll watch, which shines at night, a compass, some loaf sugar and a pale blue "kata," the silken scarf that the Tibetans always give with presents. The gifts were seized by the three old lamas, and I think the poor little Buddha will have small chance of ever enjoying his Ingersoll.[197]

Janet was puzzled by the concept of transfiguration.

One of the old lamas told us that the little Buddha had been to Peking, and died there, and he had then returned to Kumbum. All was said perfectly sincerely. It was queer to have this

Buddhist doctrine of transmigration so naively expounded. F. [Frederick] made some polite remarks to the Little Buddha, through Pu, and the poor child looked even more bewildered. Then we left. It is quite a thing to be received by a Buddhist divinity, and I guess not many of the Junior League girls of New York can boast of it.[198]

She continued,

On the way back to our house, we saw more temples, one full of relics, old guns, stuffed animals, whose skins were covered with sticky butter, and coins. Opposite the entrance of the whole Lamasery stand bright, great chortens (monuments), which mark the graves of eight famous lamas who were all beheaded at once. We had feared that the lamas would object to our photographing, but, on the contrary, they paid no attention to it. . . .

Certainly this spot is full of beauty, and the followers of Buddha could have selected no more peaceful and heavenly surroundings for their meditations. . . . One wonders if this

outer beauty does, in any slight degree, add any beauty to their souls. There are over three thousand lamas, some little boys of seven, others aged men nearing the end of life.[199]

Janet added, "You may find Kumbum on your map, under Ta Er Szu. It means the Temple of the Ten Thousand Buddhas."[200]

She became increasingly infatuated with Tibet.

If Kansu were not so far away, it would be the most perfect place to come every summer. The climate is perfect, excellent food, plenty of milk and honey, and, according to the hymn that blesses the land, delicious fruits… lots of interests to study along every line of science, and from the art viewpoint, the great lamaseries, and the ruins in N.W. Kansu, a territory we can't even peep at this year. It has been an altogether delightful summer, and I only hope the results will please those who grant the funds. F. [Frederick] has over 700 zoological specimens and over 600 botanical specimens.[201]

On their return from Kumbum, Janet and Frederick developed their ninety-six photographs of the lamasery. To their despair, only fifty-three of the negatives were worth keeping, as most of the interiors were hopelessly underexposed.[202] Those that survived were later transformed into hand-painted colored lantern slides in Peking (see pages 93–99).

INTO KANSU: SINING AND THE TO RUN

Meanwhile, Mr. Ching had informed Frederick of the existence of an aboriginal tribe, the To Run, only thirty miles northeast of Sining. The tribe of approximately two hundred families, also known as the Tu Jeu, and as the T'an Bun or "earth men," was supposedly descended from a conqueror of the Sung dynasty (A.D. 960–1279). Janet and Frederick decided to spend time exploring Wei Yuan Pu, the To Run village, to document and photograph the vanishing tribe. Photography, however, would be extremely difficult, as the To Run were reputed to be shy and apprehensive. Nonetheless, this was a cultural anthropologist's dream, as the tribe had yet to be studied by Westerners. The To Run were simple rural farmers—unable over the generations to compete against the more efficient, competitive Chinese. They had gradually retreated into their isolated villages, as their population diminished.

Wei Yuan Pu turned out to be a walled village with an outpost of soldiers in the middle of a fertile valley. The Wulsins had to wait for two days of torrential rains to cease before they could wade through the mud to a small compound of farmhouses inhabited by To Run families. Their first encounter was with a barefoot young woman with long black hair and a decorative headband of wide blue cloth across her forehead who fled down the street at the sight of Janet's camera. At the next farm, Janet and Frederick were more discreet and passed the time, while Pu translated, discussing the weather with the To Run villagers. Finally they bought a pair of shoes and a scarf and Frederick was able to get ten pictures.[203]

Janet described photographing at random in the isolated village. "On the way we met family after family of Tu Jeu, but when they saw the camera, they fled. Finally, we lay down in wait behind walls, and F. [Frederick] laid concealed in the grass, and we *think* we got some pictures."[204] They were eventually able to take many pictures of the To Run as they returned home in the brilliant sun. However, taking pictures without the To Run knowing it was, according to Frederick, "a real sniper's job."[205]

To Run families were scattered in several locations throughout the region. Some were governed from Sining, others from Taochow by the reigning Loo family who had ruled the To Run for nineteen generations. The current prince was only sixteen, so his mother ruled for him. She was the daughter of the current prince of Alashan. For six generations wives of the Loo family had come from the royal house of Alashan. The Loo family judged cases, collected taxes, and raised a small brigade of twelve hundred soldiers who could be called upon by the Chinese authority. Neither armed nor drilled, Janet wondered how they could be effective in times of battle.[206]

The To Run had no written language, but spoke a unique blend of Chinese, Mongol, and Tibetan, a language that was similar to Chinese in structure, but lacked tonal variations. Most of the words were unisyllabic. As many of the To

Run had intermarried with Chinese, they spoke fluent Chinese for business, but used their own language at home.

The majority of the To Run farmed. Their chief crop was *ching ko*, a cold-weather wheat. They tended yak and hunted deer with old *gingals* (bows). The women were rarely seen without a narrow Chinese or Tibetan bladder hatchet at the back of their belts for collecting firewood. Both men and women spun heavy woolen thread for homemade cloth. They smoked tobacco, not opium.

Their houses were low log cabins, chinked with mud, with roofs of sticks and dirt, built around an enclosure facing a central court. Several generations lived together in one house, with their animals stabled next door. They slept on earthen *kangs* under woolen blankets, but there were no shrines or musical instruments. They cooked in large iron kettles, like the Chinese, with the smoke escaping through a chimney on the roof, shaped like a little mud volcano.

The To Run men were of medium stature and wore jackets of coarse cream-colored woolen homespun that was durable and resisted the wet. Their shoes were of a style worn in China several generations earlier. The women wore unusual and distinctive headdresses. Both men and women wore black or green rimless hats of cotton decorated with a green star on top, and a large button of green cord on top of their black, wavy hair.[207] Unmarried girls dressed their hair in twenty to thirty tight braids that hung down all around their heads, and painted large patches of red on their cheeks. The married women did their hair in a small knot at the back of their heads, covered with a little brass cap that was held in place by a harness of red or black cloth. In contrast, the Chinese women of the region oiled their hair and brushed it into stiff, formal shapes or knotted it through huge disks of cotton cloth.

Their diet was based on wheat, and they cooked steamed bread from the black wheat flour. Yak milk provided butter and cheese, and they also ate an occasional chicken. They drank dark Mongol "brick" tea, which they broke off in chunks and mixed with water. Overall, the Wulsins concluded, the To Run were "poor farmers, no equal for the Chinese," and barely maintained a subsistence-level existence.[207] Mr. Ching described them as "just wanting to eat."[208]

A sketch by Frederick of the typical To Run woman's headdress, Wei Yuan Pu, Kansu, August 1923. *Right:* Clipping from *The New York Times* inaccurately describing the To Run tribe, August 1923.

FINDS BLOND WOMEN 'AGELESS' IN CHINA

Explorer Reports Years Don't Count Among Toguns of Kansu, but Hair Does.

WASHINGTON, May 14.—Blond Chinese with curly yellow hair and women who keep no account of their ages have been found by an expedition of the National Geographic Society sent into the unmapped Kansu region of Asia.

Reporting to the society's headquarters here, Frederick R. Wulsin, leader of the expedition, told of a trip on the Yellow River on a raft made of seventy-two yak skins. The "Toguns," meaning "earth men," were the most interesting people encountered, he said, and it was among these that the question of age had no importance. He added that the unmarried women wore from twenty to thirty braids of hair.

TO TANGAR

Just before their departure Janet wrote a letter to Frederick's brother Lucien about the possibility of their mother, Katharine Wulsin, visiting them in China.

We are crazy to have her [Katharine], and I think it will help F. [Frederick] a lot. She helps him more than anyone in the world, and he needs help to unscramble some of his weird problems....F. has been very well, so far during the entire trip, in fact I have never seen him in better shape. He gets a bit discouraged sometimes about the results of the expedition and the lack of response from those at home. So far the expedition has over seven hundred zoological specimens, and over six hundred botanical specimens. August, of course, is a rich month for the botanist and we ought to have at least one thousand specimens before we leave Kansu. F. seems to realize that if people at home know nothing of your work, you are forgotten. The National Geographic Society before he left Washington took special data for a series of publicity articles, and Mr. Grosvenor told F. that there was to be a notice of the expedition in

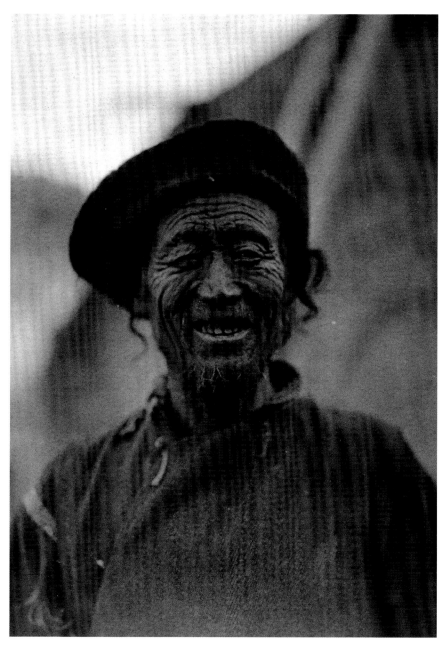

A To Run man, Wei Yuan Pu, Kansu, August 1923.

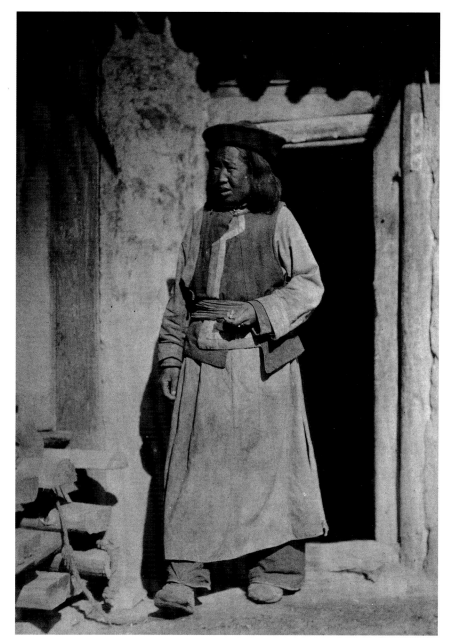

A To Run woman in her doorway, Kansu, August 1923.

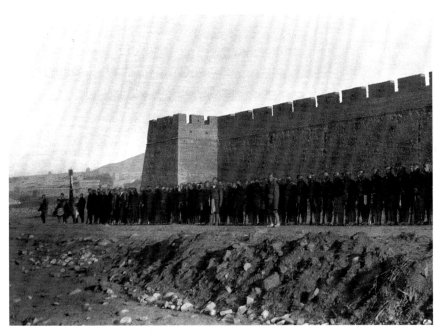

Garrison of soldiers, Ing Pan Shui, June 1923.

the February or March Geographic. So far there has been nothing, and it is as if "out of sight, out of mind." F. has sent reports to Grosvenor, and other members of the Committee; a large consignment of tea was sent to Sheldon in March, and never a line. It does seem a pity that some little interest cannot be shown F. as a means of encouragement when other China expeditions are so well advertised at home. We have just gotten the Harvard Bulletin of May 10th, and have read with great interest of the Harvard Explorations in China, under Langdon Warner. Every other scientific American expedition in China but F.'s is mentioned in the article. Here is F., a Harvard graduate, doing scientific work, and getting no recognition.There is very little that I can do to tell the powers that be, of the good work that he is doing, but maybe [you], Lucien, who sees many people in Washington, New York and Boston can see how the wind is blowing, and why they seem to want to forget F. I guess Grosvenor is a very self-absorbed person, but I should think that some of the committee would write some time.[209]

Janet would later be amazed to read a short, inaccurate mention of Frederick's discovery of the To Run people in the *New York Times*, months later. It wasn't much, but it was something. She had observed that other explorers, such as Roy Chapman Andrews and Joseph Rock, were blatant self-promoters. Although this was contrary to her upbringing, she realized that success in this field required a certain amount of initiative for public recognition and funding of future expeditions.

On August 11, the expedition team reunited to prepare for their departure for Tangar and ultimately Lake Kokonor. "The Emerys had returned from their southern trip the night before, and we were glad to see them," wrote Janet. "Such a talking and comparing of notes as we did yesterday afternoon, while the rain came down in sheets outside."[210] Traveling continuously with the Emerys was a strain, as they became increasingly critical of the organization of the journey. The couples took occasional breaks for side expeditions that allowed them time alone. After these absences, however, they were pleased to be reunited and share their experiences for a few days.[211]

Mr. Wu had also returned, along with Mr. Chow and Mr. Chang, from collecting in various areas. The party now consisted of three grooms, the indispensable "boy," Pu, the cook, two soldiers provided by the local warlord, Ma Chi, as escorts, a Tibetan interpreter named Mr. Ma, ten muleteers, twenty mules, eleven horses, and a donkey, for a total of twenty-seven people and thirty-two animals. [212]

The caravan left Sining the next morning.

The first day was a nice trip, between 25 and 30 miles. The first part of the road was rather monotonous, red clay hills, the usual farms and fields of grain. Then we got into a rocky gorge with the Sining River, a rushing, mountain torrent beside us, and high partly wooded hills above us. We followed the river all the way to Tangar, the little border city between this part of China and Tibet. It is much more picturesque than Sining, built on the side of a hill with its winding walls, many Tibetan houses with their flat roofs, and always Tibetans coming and going on the unevenly stone-paved streets.[213]

Janet wrote to her parents:

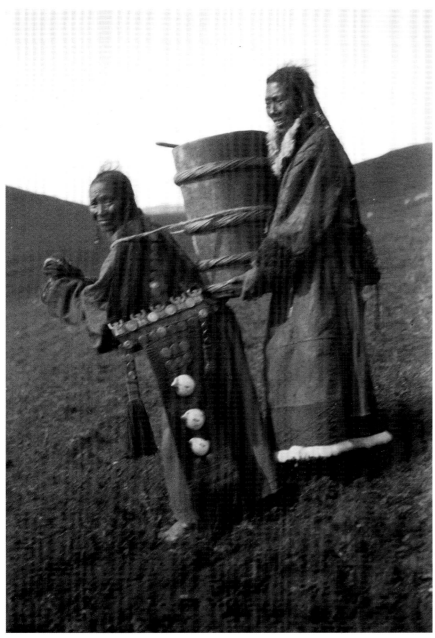

Tibetan girls wearing traditional coats and long braids carry water to the village of Choni, September 1923.

We spent the night at the Salt Office....We had big, spacious quarters, separated into various rooms by long, white curtains, very like hospital wards. Everything was clean and comfortable, and the Chinese in charge were most courteous—in fact, too much so, for they wanted to drink tea and pass the time of day for hours, when we wanted to go to bed.[214]

Gradually the landscape changed.

On Sunday morning early we left Tangar. We had an escort of two Mohammedan soldiers and a Chinese-Tibetan interpreter, all from the yamen [provincial governor] at Sining. ... We traveled due west in real Tibetan grass lands, bare green hills with herds of yak, sheep and goats feeding high up on the hills. We saw a few Tibetans, but not many. At this season they are feeding their animals farther west.[215]

LAKE KOKONOR: THE AZURE LAKE

Just before the sun set, we had reached the pass over the "Sun and Moon" mountains and off to the west we got our first glimpse of the sacred Lake Kokonor—a great sheet of pale blue water, flooded with the silvery rays of the setting sun. We all felt quite a thrill. Even my dja-wher man cried, "Tai-tai ding how can," "Lady! Wonderful to see." We were then about fifteen miles from the lake, but from the pass the land slopes gently to the lake shore.

On Monday we were all up early, anxious, if possible, to reach the lake by one o'clock. The trail led us to the southeast corner of the lake where there is a good mountain stream of clear water for man and beast. As soon as we reached the lake we all ran onto the pebbly beach. No one was anywhere around, not a house, not a sail in sight, and, as we looked out on this great blue sea, we felt as if we were the original discoverers. The impulse to get into it soon gripped us. F. [Frederick] and the "Ahs" (the Emerys) at different ends of the beach, plunged in, and had a good salt bath, and then a sunbath afterwards. There are quantities of birds on the lake, great gulls, geese, loons etc., and the Chinese [taxidermists] were busy adding to the collection. Our tents were pitched about one quarter of a mile back form the lake, on a

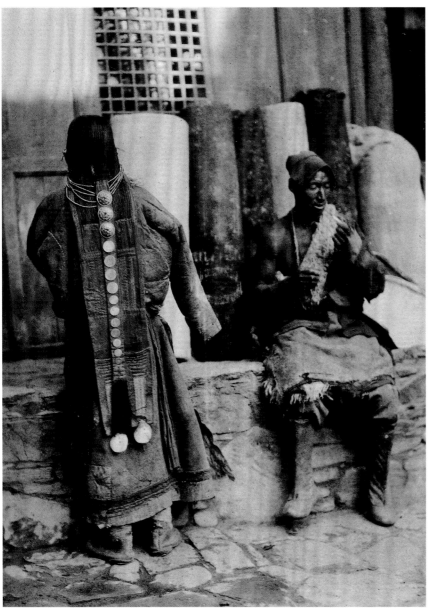

Tibetans in traditional dress, Hsuan Hua, Kansu. "*[The women's] hair is done in a great number of long, slender braids, which hang down the back to the waist, pieced out with cord, if need be. These many pigtails are caught in a frame of red cloth, nearly a foot wide, decorated with shells and disks of silver and brass, which hangs down a couple of feet further, almost to the ground.*"—F.R.W., August 1923

grassy spot that was a mass of wild flowers. It was a glory of yellow, blue and white. Never have I seen flowers in such profusion, nor so vivid in color....

That night, two caravans camped near us, one Tibetan with their flocks, the other Chinese traders bound for Tangar with wool they had bought from the Tibetans. The latter had yak. I wish you could see a yak caravan, for it is amusing—great awkward creatures, sort of a cross between a cow and a buffalo. They graze as they travel; in consequence move slowly, and are driven by stones thrown by men behind them. They are very strong, can swim any river, and can live entirely on grass—where horses or mules have to eat some fodder. They are most practical for Tibetan travel. I tried to catch one to ride, but was unsuccessful.

That night our mule man, new to camp life, had a huge dung fire (dung is the only fuel the country affords, we had brought wood) the soldiers and the interpreter another, and our camp was a picturesque sight. We spent the next day at the lake, had another swim, read, talked and thoroughly enjoyed the beautiful scenery. The Chinese and F. got numbers of birds, but no large game.[216]

Lake Kokonor, or Ching Hai, proved as magical to Janet as it was in local mythology,

Lake Kokonor is very sacred to the Mongols and the Tibetans, and many are the legends about it. Long ago there was no lake, only a grassy depression in the land. There was an attempt made to build a great temple at Lhasa, but without success. So a lama was sent throughout Tibet to consult all the wise men. He eventually came to the tent of a blind sage in the Kokonor country, and learned from him that there was a subterranean river running from Lhasa to the Kokonor, and if any lama from Lhasa knew that, the river would overflow the Kokonor country. The Lhasa lama did not disclose his identity until later. Kokonor Lake was thus formed, and one of the three islands in the lake is the stopper, which keeps the underground river from doing further damage. On this island live a dozen hermit lamas. They visit the mainland only in winter when the lake is frozen. There are no boats on the lake. The lake has a circumference of 230 miles, and is probably sixty miles across at its widest point. With its grassy hills, and distant snow-covered mountains, its green and flowered shores, its blue waters with hundreds of birds, it is, indeed, a lovely sight.[217]

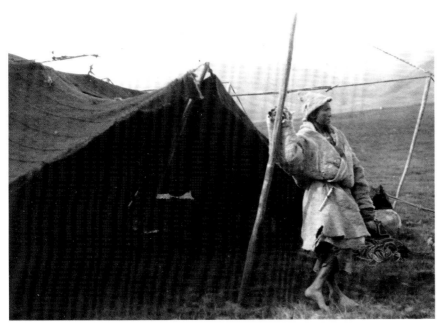

A Tibetan nomad stands in front of his tent, Lake Kokonor region, August 1923.

The hills around Lake Kokonor were full of game as well as birds. Frederick and his team were busy from dawn to dusk adding to the collection. That night, he wrote,

We slept soundly, perhaps too soundly, as the Kokonor people have a reputation for stealing horses. I turned out at midnight to find the horse guards sleeping profoundly... Later Harry found them awake. My remonstrances must have had some effect. I was told that shod horses and mules are fairly safe from thieves, as they are too easy to track. We had no trouble with thieves... in fact, we saw few tents for the nomads were all up in the mountains with their flocks, and would stay there until the rains were over and the ground near the lake had dried off.[218]

The next morning, wrote Frederick, they encountered

a herd of yaks loaded with baggage, in bales and leather sacks, coming down to meet us. Three horsemen in fleece-lined gowns, with bare shoulders, and swords in their belts, were herding them along pell-mell. Mr. Ma hailed them as "aro" (brother), and while we talked with them

I hopped from stone to stone taking pictures. These were men of the Djekwur tribe, on their way home with grain, for which they had traded wool at Tangar.

Later we came to flocks feeding, and saw black tents scattered in several side valleys where none had been three days before. We rode up to one group of three tents, where a young man tied up the dog and smilingly received us.[219]

The Tibetan tents fascinated Janet and Frederick.

The tents were about twenty-two and a half feet square of course black homespun in strips sewn together. Inside, two rows of poles prop up the cloth. Outside, are other rows of poles, and ropes and stakes. These tents have no proper ridge or point; they are simply a great cloth lifted away from the ground over all its central part. In the center was a long, mud fireplace, reaching back under the roof crack, which served as a chimney; in front of it stood great wooden tubs for water, milk and butter; behind it, a great pile of dried dung. Around the sides of the tent stood a neat, double row of bales, sacks and decorated wooden chests, containing the worldly goods of the tent owners. On the grass floor, lay a straight, heavy sword, and a long, old-fashioned gun with its prong [see page 106].[220]

Frederick was also captivated by the magic of Tibet. "In Tibetan country we met wild cowboys on horseback, in sheepskin robes and pointed hats, with long guns and swords, driving herds of yak, loaded with baggage, and tent dwellers with their big black tents. Tibet has a marvelous fascination as you draw close to it, and I am beginning to understand why it has cast a spell over so many travelers."[221]

On their arrival back in Sining, the innkeeper presented Janet with a large watermelon. "This is our fourth arrival in Sining, and I guess he feels we are old and valuable customers. First, we came from the east, Lanchow, next from the south, Kumbum, next from the north, Wei Yuan Pu, and now from the west, Tangar."[222]

Despite her joy in the vast borderlands of Tibet, Janet had not completely forgotten the outside world. On her departure from Sining she wrote home,

We haven't had letters from you for a long time, but then the roads have been washed out up this way, and mails have been fearfully irregular, coming from Lanchow, which is the main distributing point for the provinces. ...I hope you all have had as nice a summer as we have.

If only you were going to be in Peking to see us when we wander in with our "traps" [*sacks*] *in blue and red cloth, leather and straw suitcases, and hear all the first accounts, and be the first to see all of the pictures—some of them are splendid.*[223]

In Sining the Wulsins bid farewell to the Emerys, who departed for a separate journey south over the mountains to Szechuan, down the Yangtze River, and eventually back to Peking. As Frederick noted to his mother, "Having them with us has worked out very well, and we shall part even better friends than when we started, but a big party is hard to handle, and for really difficult stretches a very small one is better."[224]

Loading and unloading the crates and baggage was once again required for the next part of their journey. The Chinese packsaddles would now be lifted off at night with their loads still lashed in place. The cook packed wooden boxes for cooking utensils, dishes, and food for the Chinese staff. Baskets of live chickens swung from the carts beside baskets of firewood, bread, and vegetables. Only these and the bedding would be unpacked each night.[225]

During their journey the expedition's horses had become their trusted friends. Frederick rode "The Centipede," so named "because both he and I are full of feet." Janet rode "Bill Brown", the "best and toughest of the lot." The others included "The Yellow Goat," a mean but tough little horse from Paotow; "Nijinsky", the big, black horse ridden by Mr. Wu; "Wulashan"—durable, but ugly—for the groom; and a little white Tibetan pony. Janet was sad to leave her little donkey "Dung Pi" behind at Sining, for he had faithfully carried her across thirty-nine days of the desert and many treacherous trails.[226]

In Sining they also parted ways with their interpreter, and their two escort soldiers. The provincial governor replaced them with "three lazy, half-baked individuals, ignorant of travel, who caused us more swearing than pleasure throughout the trip," wrote Frederick. "These worthies lied about the stages when it suited them, loafed on the job, lay abed late, and complained bitterly over the hardship of camping out, besides helping themselves to the best we had without much scruple over payment." Frederick "drove them without mercy, and fired them thankfully at Labrang."[227]

Janet explained that "the last few weeks have been so full of impressions; Tibetan border life, new scenery, missionaries galore, with their strange ideas, and their bound[less] hospitality, collections coming in, photographs developed by the hundreds, that we have been too busy hardly to think."[228]

THE GREAT MONASTERY OF LABRANG

The route from Sining to Labrang took ten arduous days over rough terrain. They first passed through the high, lush, Tibetan meadows—the "Desert of Grass," as Alexandra David-Neel called it—and then turned south through a series of mountain ranges. "Up hill and down dale inadequately describes our route," wrote Janet. "It was picturesque in the extreme, lovely valleys, where the natives were bringing in the harvest, high green grass-covered mountains (no trees) with temples or mosques perched on top."[229] They eventually climbed high mountain divides, some over eleven thousand feet.

Another night we stopped in our first real Tibetan village where we were lodged in the house of the herdsman, who, with much ceremony, presented us with a sheep. [His wife] wore a huge sheepskin garment (only one garment) with one sleeve always out, and a shriveled breast hanging out. She was fascinated by me, and when F. [Frederick] gave her an empty shaving soap tin, her enthusiasm was delightful.[230]

They thanked the herdsman, ate the sheep, and slept well.

They continued on through the rain for several days. The going became difficult and slow. There was a "most wearisome descent over thick red clay for miles and miles, through a perfect labyrinth of conical earthen mountains, beyond which we could see the distant Yellow River gleaming, and more mountains beyond. The slopes were too steep to ride, and great cakes of red mud clung to our shoes at every step," wrote Frederick.[231]

The next day, as they were finishing their picnic lunch, there was a commotion. Two soldiers pushed their way through the crowd, brandishing a flaming red umbrella and what Frederick described as two "prehistoric Spencer car-

View of the city and monastery of Labrang, Kansu, with the Great White Stupa, and surrounding mountains ten thousand feet high, August 1923.

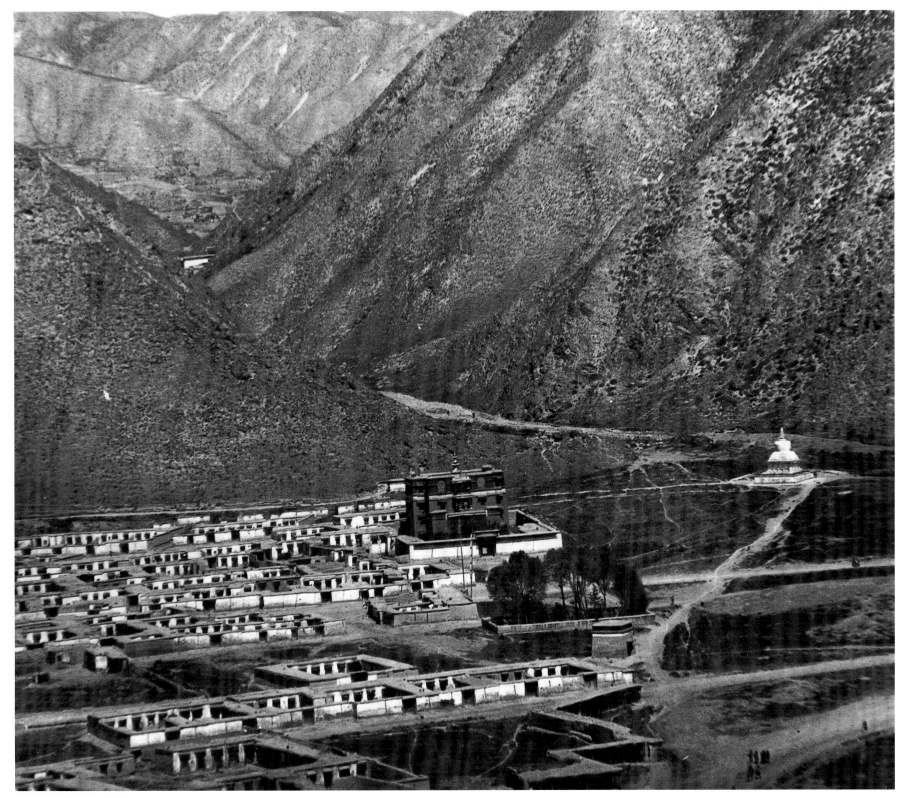

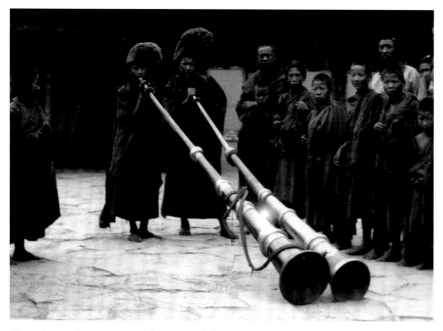

Young lamas playing ceremonial trumpets, Labrang Monastery, August 1923.

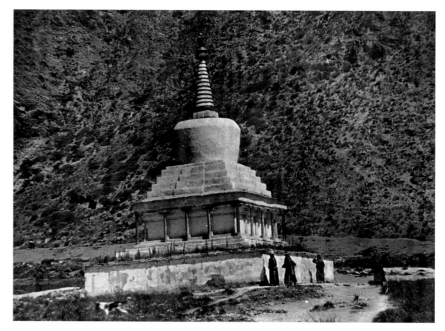

The Great White Stupa, Labrang Monastery, August 1923.

bines." Four sweating porters then arrived, struggling under a blue cloth-covered chair. The local magistrate had come to call on Janet and Frederick. He turned out to be a polished, intelligent man of about fifty, who had been born near Shanghai, but had lived in Kansu since he was eighteen. He told them about his district. The region was peopled by the Salars, a Muslim agricultural tribe from Sinkiang who still spoke a Turkish dialect; the Fantzu Tibetans, nomad or settled; and the Chinese traders, who had just recently arrived. He pointed with pride to the region's big sheep and tall men, but admitted, with regret, that some of the men were very wild, especially to the south—"as wild as they could be."[232]

On the whole, Janet and Frederick found the people "cheerful and friendly," *less curious and given to staring than the Chinese villagers, but far more vivacious and responsive. In the small village of Shi Shan K'o the villagers beamed and talked, took us*

around to see the town, and ended by bringing us gifts in the evening. The head man started with a khata, or scarf of greeting, and I [Frederick] replied with a pocket tool roll which cost nineteen cents in Cincinnati. The head man then answered with a great burst of friendship, by giving me a sheep, and I was forced to fall back on coined silver to properly express my esteem. We parted in the morning with expressions of lifelong affection.[233]

After ten days of rugged but fascinating travel the expedition arrived in Labrang. Janet's first impression was not positive. "It is the filthiest village I have ever seen, dead animals in all stages of decay, and filth unimaginable," she wrote.[234] Frederick agreed.

The village is a dirty little place, half Chinese, half Tibetan. Its architecture has no charm, but its populations has; a medley of lamas, wild tribesmen, Chinese fur buyers, Mohammedan soldiers, and richly dressed Tibetan women with magnificent straight figures,

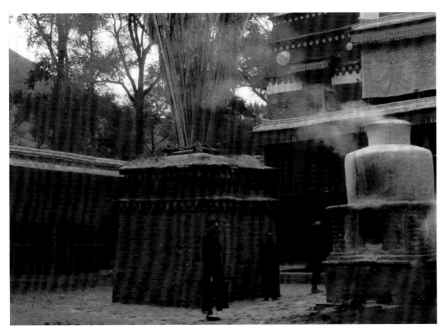

Monks tending the great copper caldrons in the monastery kitchen in Labrang, August 1923.

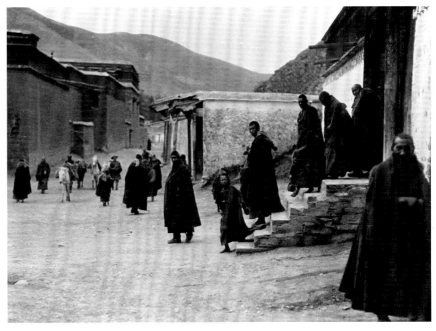

A group of young lamas leaving a service in one of the temples at the monastery at Labrang, August 1923.

and white sheep skin hats. Many live by their charms. It is a sight to see others, in never-ending processions, bring up tall wooden buckets of water from the river on their backs.[235]

Janet and Frederick spent several days exploring Labrang. They photographed, took copious notes, drew diagrams and sketches, followed detailed maps, and compiled their notes into a long entry in Frederick's expedition journal:

Labrang naturally falls into two parts, the monastery full of monks, and the village full of merchants, and the Mohammedan garrison. The monastery is half a mile up the valley, west of the village. The immediate space is broad and fairly level. It gives one a fine view of massive buildings, with gold roofs rising here and there, above a regular city of low dwelling in which the lamas live. To the right, as one looks from the village, is a fine white stupa, or t'a around which pilgrims ceaselessly perambulate. It stands at the mouth of a small side valley where dead lamas' remains are devoutly fed to the vultures. The stupa was put there, they say, to prevent floods from rushing down this valley into the temple.

A road leads from the village to the temple beyond. On it there is a ceaseless stream of lamas, pilgrims, hucksters, townsmen, idlers, soldiers, and peasants. One comes first to long sheds filled with prayer wheels that pilgrims spin as they pass. These sheds surround the whole monastery, a circuit, they say, of ten li [three miles], and great is the merit of the devout one who makes the entire circuit of these spiritual fortifications, turning each prayer wheel he comes to.

The morning market is a fascinating place to shop, for here the belongings of dead lamas, and all manner of odd wares, are likely to come for sale. I bought a prayer drum made of two [human] skulls for a few hundred cash. Another stall had finely mounted eating knives, each with a set of ivory chopsticks in the same scabbard. Another had little temple bells of bronze. Another had some wooden rifle cartridges, stolen or smuggled, and others still brass teapots, wooden tea bowls and cloth. Each merchant spreads his wares under a big umbrella, and squats beside them. Most of the buyers are lamas, in greasy red

Residence of the Living Buddha, Labrang Monastery, August 1923. *"Labrang is the most important Lamasery in N.E. Tibet, and it is a magnificent group of buildings in pure Tibetan style."*
—J.E.W., September 1923

gowns which reek of rancid butter, but there is a fair sprinkling of townspeople among them. At the hillock at the edge of the crowd stood a few wild nomads holding a horse, but whether they came to sell or stare, I could not tell. The language one hears on all sides is DrocWa Tibetan, and he who knows only Chinese feels a stranger in a strange land.

From the market one turns in through the city of lamas. Low mud-walled dwellings hide the view on either side. One comes at last to a big, open space, on which face the massive buildings, which are the heart of Labrang [see page 151]. First among these is a great gold-roofed chanting hall. Outside it is an imposing Tibetan structure, with a pillared courtyard, golden hinds on the roof, and richly painted doorways. Inside a glowing blaze of softened light plays on red wood pillars, silken streamers, and yellow patterned cushions for five thousand crouching lamas. The light streams in from the windows on a gallery above, and underneath this gallery, in almost total shadow, stands a row of golden images, each with its burning butter lamps and other signs of worship.

Next to the great chanting hall are the kitchens, with copper kettles ten feet across for the lamas' tea. The cooking arrangements are those of a Tibetan house, but magnified in size; wooden lidded cauldrons of copper, half-round on the bottom, are let into an oven of brick, stone or clay, where the fire is built. Like all Chinese, Mongols or Tibetans, these lamas are famous consumers of tea, and carry their taste so far that they even drink it at services. They make it in the Tibetan style with milk, that is none too fresh, and may perfect the brew by adding large lumps of rancid butter. This buttered tea, with barley meal, is the principal food of the northern Tibetans. One mixes the meal into the liquid with one's fingers, kneads a brown lump, and swallows it. This is the famous "tsamba," a nourishing food, and a good one if the materials happen to be clean.

Every temple of some standing has a Living Buddha of its own, and Labrang is no exception. The transmigration of souls is a cardinal doctrine of northern Buddhism. The Living Buddha is a monk, but one of great sanctity, for in him the spirit of Buddha is supposed to dwell. When he shuffles off his mortal coil, he is said not to die, but to transmigrate, and his new incarnation is looked for among children conceived at the time of his last transmigration. The child is recognized by its ability to pick out the late Buddha's possessions from a great heap of similar objects, when five or six years old. Then it is escorted, with state and pomp, to the monastery, there, through his lifetime to incarnate the Divine.

Practical affairs are dealt with through advisors, old experienced monks, who surround the little Buddha. It has been noted that these incarnations rarely remain very long in one body, as a rule. In fact, the little Buddha transmigrates at eighteen or twenty, when his personal character might begin to assert itself to the cost of those who surround him....

At Labrang the present incarnation is nine years old. On State occasions, he appears in public. We asked whether he had been to Peking, and was told, "Oh yes, before he died the last time." West of the great Chanting Hall and the kitchen lies a paved open space with a high platform where the Living Buddha sometimes sits enthroned. Next comes the house where he dwells. There are many more temples at Labrang, all of the same general type: Tibetan exterior, carved doorways and capitols,

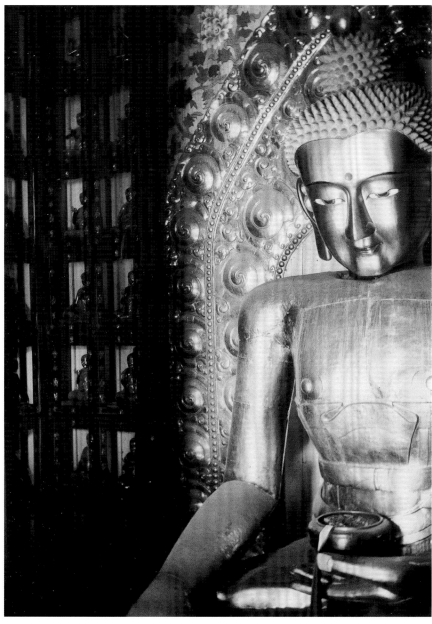

The Great Golden Buddha, Labrang, August 1923. The statue was more than fifty feet high and surrounded by rows of smaller Buddhas recessed in niches and illuminated by many candles.

sacred images on silk or gold, and little lamps of shining brass filled with melted butter. One building contains statuettes of the Gods in glass cases, another, sacred books.

Still another has a museum in it, horrible, rather than attractive. Badly stuffed wild beasts loom up in semi-darkness between pillars on which hang old Tibetan guns. A live lynx moves nimbly among them. Butter lamps drip endlessly on beasts and rugs and the floor. Sulky lamas opened the door against their will for us, driven and threatened by our Muslim guide, a great bearded veteran of the Mohammedan rebellion, long exiled among the Tibetans, and now supremely powerful over their fate in the Labrang region, because of his post as official interpreter at the mayor's office in the town.

Generally, the lamas are indifferent enough, as far as visitors are concerned, though a few years ago, they almost murdered a missionary who tried to photograph the Temple. This praiseworthy change of heart dates from a thrashing administered by the Mohammedan general at Sining, who rules this whole border. Thanks to his vigor, peace reigns as far west as the Tsaidam. A strong Muslim garrison has stayed at Labrang. The garrison is now about three hundred strong, and has been further reinforced at the time of our visit. A Mohammedan official made the lamas keep quiet while we photographed the great Chanting Hall, and forced an entrance for us into the museum [see page 10].[236]

At the conclusion of their visit Janet wrote to her mother,

The village is always alive with Tibetans, and the color of their costumes would delight you. The women's headdresses are gorgeous, with silver, amber and coral ornaments. They are all so full of merriment, and the peals of laughter from the square as the women bargain and sell their milk, butter or firewood, are delicious to hear—quite a contrast to the subdued Chinese women. We were very comfortable in the Mission house with two young married couples, Americans, and very nice. The officials in the town were most courteous to Freddie, and had all sorts of places specially opened in the temples for him to photograph. His pictures are splendid. Labrang is the most important Lamasery in N.E. Tibet, and it is a magnificent group of buildings in pure Tibetan style. Only no photograph can give you any idea of their picturesqueness.[237]

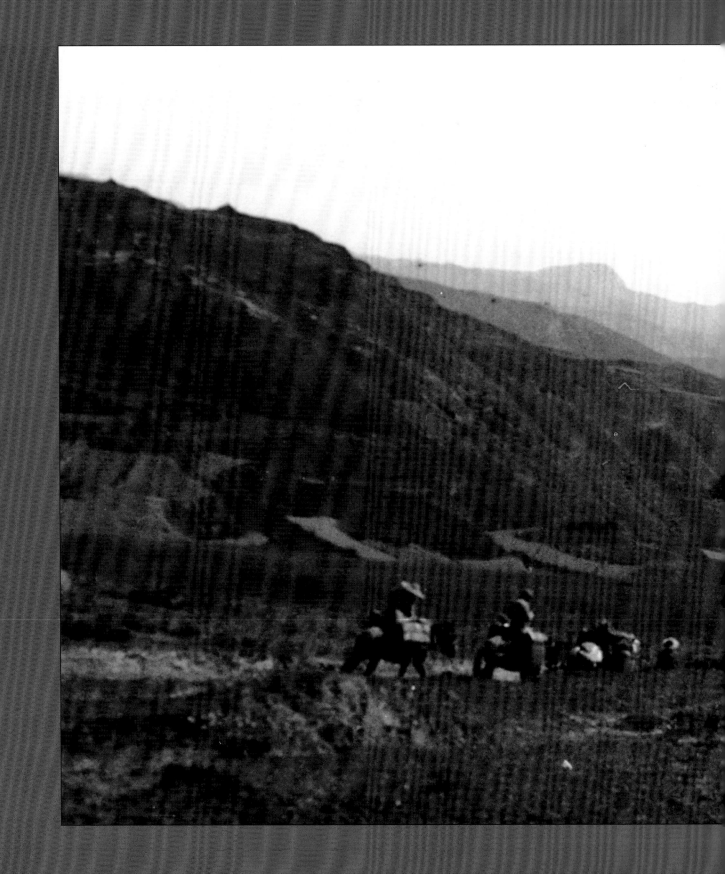

The road from Old Taochow to Choni.
*"From Labrang we traveled through more Tibetan country,
great grassy plateaux alive with flowers, until we reached
the Chinese border city of old Taochow... Taochow is...
very flat after the romance of the Tibetan country."*
—J.E.W., September 1923

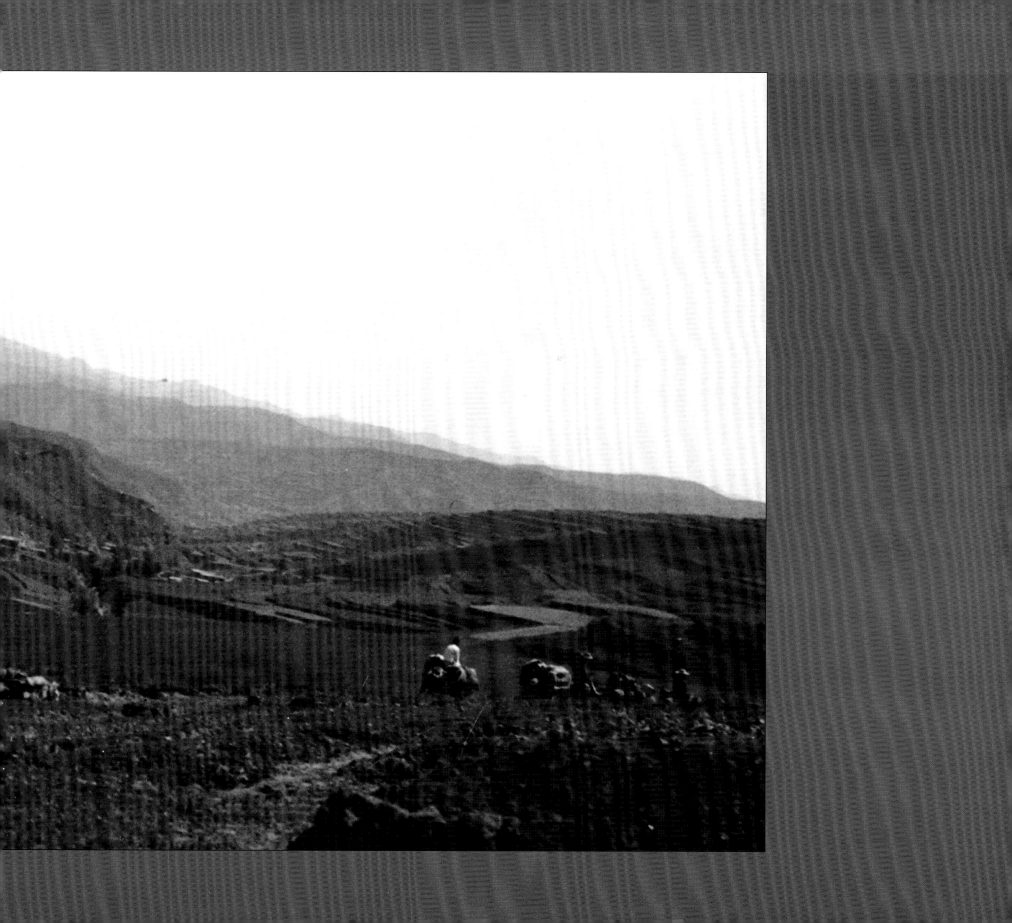

A Tibetan girl harvesting near Pai U Djio Sse, Kansu, August 1923.

After their days discovering Labrang, Janet and Frederick continued south towards the old city of Taochow.

> Soon we came to Tibetans working in the fields—pretty girls with magnificent head-dresses, often with their gowns dropped down to leave bare shoulders and breast bare. The hair is done in a great number of long slender braids, which hang down the back to the waist, pieced out with cord if need be. These many pigtails are caught in a frame of red cloth, nearly a foot wide, decorated with shells and disks of silver and brass, which hangs down a couple of feet further, almost to the ground. . . .²³⁸

The harvest scene fascinated Janet and Frederick. Janet wrote,

> Tibetans stuck their tongues out at us (the sign of great admiration), and lovely Tibetan girls flirted and laughed at Freddie. They are most stunning, beautiful, straight figures, high color, jet-black hair done in hundreds of little braids and great silver ornaments, faces full of life and merriment. . . . But I must not dilate any further on the Tibetans. We loved them, we want to go live with them.²³⁹

"Reapers worked near Sining late in July and near Taochow early in September," reported Frederick.

> They gather a handful of grain and cut it with a short sickle, stooping over, then rise, and bind the sheaf with a fast, twisting motion. . . . They store grain on high frames of poles, where it hangs like a perpendicular thatch to dry. Whole villages are adorned with these on house roofs and near threshing floors. From a distance it makes them look as if they were all poles. We saw no flails in action, only light stonerollers with six or eight sides, which animals drew over the grain [see page 87].²⁴⁰

Frederick was also fascinated by the native costumes.

> The townswomen also wear boots or shoes with soft leather feet, and cloth leggings tied below the knee. The country people are generally barefoot. The men wear short cotton breeches, and a knee-length, fleece-lined coat. . . . Both sexes are likely to appear in conical sheepskin hats, the brim turned high to show the white fleece inside. No traveling Tibetan man is complete without a single clumsy sword stuck in his girdle.²⁴¹

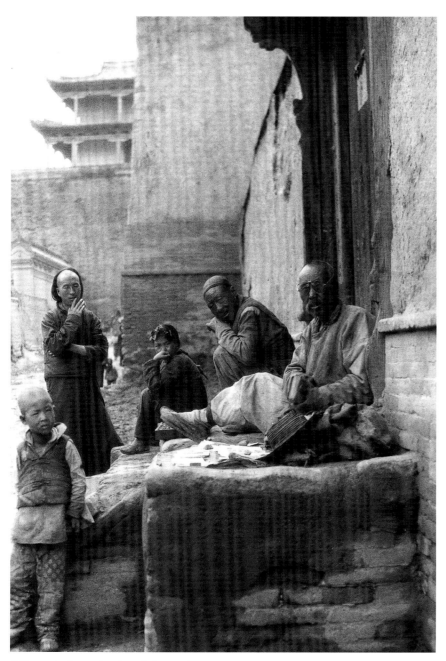

Villagers in the marketplace, Labrang, August 1923.

"From Labrang we traveled through more Tibetan country, great grassy plateaux alive with wild flowers, until we reached the Chinese border city of Old Taochow," wrote Janet. "It was a three day journey. From the top of high passes we caught glimpses of the Min Shan Mountains to the south, that great stone range that separates Kansu and Szechwan, and is the divide of the Yangtze and Yellow River water sheds."[242]

THE GREAT LAMASERY AT CHONI

They soon reached Taochow. "Taochow is a Mohammedan stronghold, and seemed very flat after the rolling Tibetan countryside," explained Janet.

> We stayed one night at the mission where we were overfed on luscious food, and the next day we came fifteen miles over the hills to this perfectly charming little mountain village of Choni. It nestles in the bend of the Tao River, a rushing crystal stream, and the high wooded mountains (our first real woods in all our travels in north China) tower all about it. Choni is a little Tibetan village with a most charming native Prince, quite like a fairy tale, who rules over forty-eight Tibetan clans.[243]

The village contained approximately four hundred Tibetan families and had changed very little since its founding six centuries before. Although the Tibetans, unlike the Chinese, kept no written records, legend claimed that Choni was founded by Chinese warriors who had migrated across the mountains from Szechuan in 1404, conquering the tribes as they went. The current prince, Yang Chi-Ching, was twenty-second in line of succession. His ancestors had been made hereditary chiefs of Choni by the Chinese emperor, Yung Lo, and given the Chinese name of "Yang" along with an imperial seal.[244]

The prince administered his territory from a palace on the north bank of the Tao River. His tribesmen were wild, disobedient, and given to raiding and stealing, but the Prince kept them in check and occasionally ran punitive raids against them. Janet and Frederick found him to be a polite, cultivated Chinese gentleman of about forty, tall, clean, and intelligent. He showed them his guns

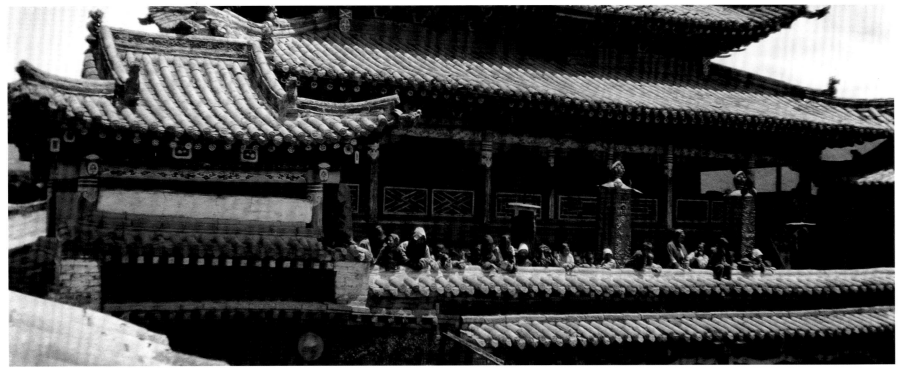

Spectators on the balcony of the lamasery at Choni viewing the ancient festival of Cham-ngyon-wa being performed in the courtyard below, September 1923.

and his camera, a Graflex, with which he had photographed the Devil Dancers of Choni a few weeks before.[244] In 1928, Prince Yang Ta Run was relieved of his hereditary title and military rank by the conquering Chinese general, Feng Yu Shiang. The prince became a mere commissioner, and was subject to removal at the will of the Lanchow government.[246] The fairytale kingdom was on its way to obliteration.

When Janet and Frederick arrived in 1923, the great lamasery at Choni had miraculously survived many earthquakes over the centuries. Its gate bore an inscription "Bestowed by Imperial command, Temple of Tranquility" composed in 1710 by the great Emperor Kang Hsi as a favor to a local lama who had paid him a visit. The lama is reputed to have returned from Peking with three thou-

sand taels of silver, an enormous fortune at that time, which he contributed toward the building of the temples and chanting halls of the monastery. Within the walls lay 172 buildings, including ten chanting halls. At one time the monastery had thirty-eight hundred monks, but the population had now dwindled to only seven hundred. For several days, Janet and Frederick wandered through the labyrinth of narrow streets and courtyards, taking notes and photographs.[247]

The largest chanting hall, tucked behind the main square, was two hundred years old and could accommodate four hundred monks. Eighty large wooden pillars of red lacquered wood supported the tiled roof. One day, in the course of their wanderings, Janet and Frederick came across a service in the temple and stopped to watch. The lamas, mostly young boys, sat cross-legged in six rows as

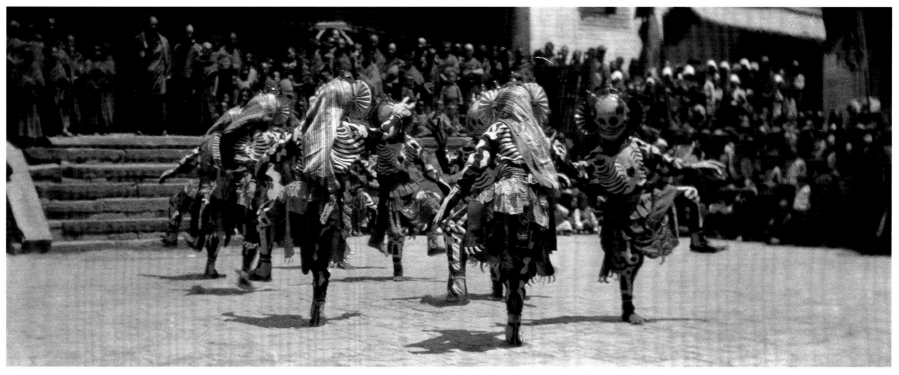

The Cham-ngyon-wa festival dancers perform the dance of the departed spirits (or Dance of Death) in the courtyard of the Lamasery at Choni, September 1923.

an old lama stalked up and down the rows, cracking a whip in the air to keep order. Two thrones for the High Lamas or Buddhas took the place of an altar. The service was musical, and everyone chanted or played a musical instrument. For festivals, the hall was decorated with brocades and long ceremonial umbrellas suspended from the ceiling. The pillars were covered with vibrant hand-woven carpets, a present from the king of Alashan.

On the festival day Janet and Frederick managed to climb onto the roof of the temple. There the lamas, playing fifteen-foot-long trumpets, were summoning the throng for the *Cham-ngyon-wa* (devil dances) pantomime in the great courtyard below. The long echoes of these ancient horns could be heard far away in the mountains.[248]

NOTE: The famous explorer Joseph Rock arrived in Choni six months after the Wulsins departed, and stayed for two years, copiously photographing the city and the ritual dances first documented by the Wulsins. In his article, published in 1928, he claimed to have been the first foreigner ever to photograph Choni and the Devil Dances. The National Geographic Society never refuted his claim.

Inside the oldest of Choni's chanting halls, dating back five hundred years, Janet and Frederick discovered the enormous gilded figure of Tsongkapa with his two disciples. Legend had it that Tsongkapa had appeared on the stone altar of his monastery in 1714, and, after addressing the crowd on the greatness of his church, became transfigured and ascended into heaven. He founded the Yellow, or Reformed, sect, and established the church of Tibet.[249]

To the left of the main chanting hall was a large octagonal prayer cylinder of wood. Inside was a complete set of the *Kandjur* and *Tandjur*, the great Tibetan classics, comprising 317 volumes. With each turn of the two-storied prayer wheel, a pilgrim would earn the merit of saying 317 volumes of prayers.

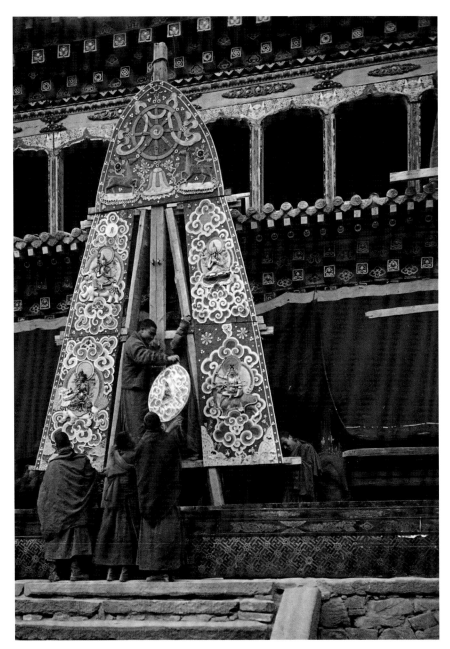

Lamas making final preparations for the great butter panels after a month of artistic creation before the festival of Cham-ngyon-wa, Choni, September 1924. Photograph by Joseph Rock.

THE FESTIVAL AT CHONI

On the sixth day of the sixth moon, Janet and Frederick witnessed the extraordinary *Cham-ngyon-wa*, the "Old Dance." The square in front of the chanting hall was packed. Lamas armed with long birch whips reached over the heads of the crowd and dealt gentle blows to the heads of the onlookers. Those in the first rows would duck to avoid the blows, but those further back were in direct range of the assaults. All were good-natured and suffered the ritualistic punishment as a matter of course. Thousands of spectators had gathered. Women with tiny babies, both half naked, braved the crowds. The nomad women kept one shoulder and half of their breast bare, as Janet had so often seen in the fields, and the rest of their bodies wrapped in their traditional sheepskin coats.[250]

Now the chief lamas gathered before the butter images in the center of the courtyard, bearing the boy god Tsemoling. This four-year-old peasant boy, dressed in yellow silk, had been declared the incarnation of the Tibetan king by the Dalai Lama. The huge crowd pressed forward.

Before the ceremonies began, the Choni prince, escorted by his soldiers who parted the throng for him, strode onto the courtyard, and, prostrating himself three times upon a carpet, bowed to the enormous butter images. Janet and Frederick joined him later in the gallery. The sea of humanity below caused a nauseating odor of rancid butter to rise to the gallery in waves. The prince tried to neutralize the stench by sniffing mothballs. Janet merely held her handkerchief before her nose. Little of the fresh water from the Tao River was used for personal hygiene. As a result, the monks reeked of rancid butter and grease, and their skins were black from the years of accumulation of filth. Their priestly garments of red Lhasa cloth were never washed, since few of them had more than one robe.

Twenty feet above the courtyard, wires had been stretched from side to side. A miniature temple of wooden and colored paper was balanced on the wires over the exact center of the courtyard, illuminated by butter lamps. The heat of the lamps

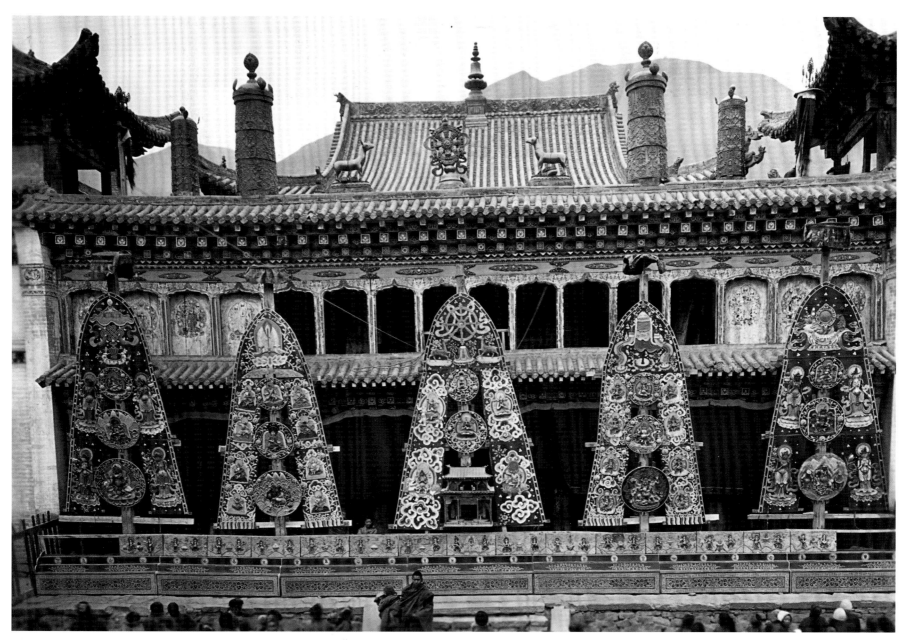

The five great butter panels at the festival of Cham-ngyon-wa at the lamasery at Choni, September 1923. The towering panels, featuring astrological and mythological deities, take months to prepare from chilled yak butter. At night hundreds of yak butter candles illuminate the panels. Photograph by Joseph Rock.

rotated the little prayer wheel of the temple, inscribed by the traditional prayer, *Om Mani Padme Hum*–"Oh! lotus flower, Amen." It all seemed to float on air. At a blare of the trumpets, two baskets resembling lotus flowers, each supported by a great paper butterfly, were sent along the high wires next to the wooden temple. In these baskets, controlled by strings held by the lamas below, were strange dolls, resembling Buddhist deities. The marionettes pivoted and spun far above the heads of the crowd. Baskets of them followed, one after another, to delight the crowd.[251]

The lamas had prepared the butter panel display the day before. Towering posts, supporting five wooden frames, had been erected in front of the old chanting hall. Yak butter panels, brought out from the cold storerooms, were secured to five enormous panels by small ropes. Artistic monks had worked for months to prepare the beautiful panels, sculpted from more that thirteen hundred pounds of yak butter that had been donated by rich patrons of the monastery. The best molders were in great demand, and rivalry for their services had developed among the lamaseries. The challenge of creating the images on the panels took place in the cold of winter, in freezing rooms. The butter was first mixed with twenty different brilliant colors. The monks dipped their fingers in icy water before touching the butter, which they then sculpted into intricately detailed panels representing the many Tibetan Buddhist deities. The figures were then adhered to the pyramid-shaped scaffolding in front of the main shrines.[252]

By the time these panels were in place, night had fallen. The monks then arranged hundreds of lit butter lamps on shelves before the images, shedding a brilliant white light on the deities.

The dancers' ceremonial costumes, dating from the Manchu dynasties, were richly embroidered in vibrant colors. Frederick was told that they cost up to five thousand *taels* each. The masks, made of papier-mâché, weighed ten pounds each, and were finely painted and decorated with a full range of expressions. Before putting on their masks, the lamas pulled on padded woolen caps that covered their foreheads, their necks, and the sides of their faces. These caps were secured by scarves, passed under the chin, and tied on the top of the head. The masks

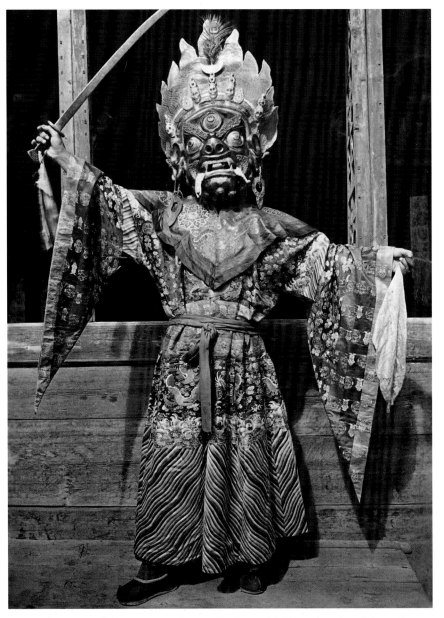

Masur Lhamo, one of the twenty-one Bowas who dance with Yama, the ruler of the underworld, in the Cham-ngyon-wa festival, makes his grand entrance. His mask of papier-mâché weighs over twenty pounds and takes hours to adjust onto his head. Choni, September 1924. Photograph by Joseph Rock.

were then placed over the caps and adjusted so that the lama could see out through the openings for the eyes.

The dance began the following day at noon under the blazing sun. The crowd gathered and surrounded the courtyard. Janet and Frederick were allowed seats of honor in the gallery near the prince. The walls and roofs were packed with people of various Tibetan tribes, and some Kansu Chinese (see page 160).

Earlier, Frederick and Janet had received special permission from the prince to photograph some of the costumes. They marched off one day to a special temple on the bluff above the town where they drank tea, and ate sweetmeats with the lama and took pictures, and were shown the entire building.[253]

The orchestra included large circular drums held erect by staffs fastened to the rims with sickle-shaped rods as drumsticks. Bronze trumpets ten to fifteen feet long blared, as well as small trumpets in the forms of dolphins. The main courtyard served as the stage for the pantomime, and no words were spoken—merely an occasional outcry by one of the performers. With a flourish of trumpet, gong, cymbal, and drum, the large doors of the chanting hall opened, and four boys made their appearance in the square. Clad in striped silk shirts and red jackets, they represented the demons or *tegong*. Their masks resembled Hindu faces with prominent noses, surmounted by conical hats with red, fuzzy knobs on top. These young boys danced in pairs, jumping into the air and spinning with a gesture of the hand.

Next came the Devil Dancers, who were not Buddhists, but an outgrowth of shamanism and sorcery. They were dressed to strike terror in the hearts of the spectators, and represented assistants of Showa the Deer, messenger of Yama. They danced to drive away evil spirits, represented by a hellish band of eight living skeletons representing departed spirits. These spirited performers of the Cham-ngyon-wa, representing departed spirits who aided in punishing the wicked, were dressed in tight-fitting garments with strips of brilliant red cloth cut to resemble the bones of the skeleton. Over these they wore skirts of imitation tiger skin, sleeves ending in gloves with fingers tipped with huge claws, and ivory-white skulls with red eye sockets. The young dancers were very agile, and cavorted furiously over the whole courtyard, keeping time with the drums.[254]

Janet and Frederick watched, fascinated, as scene after scene passed below them. At the top of the steps of the chanting hall, directly opposite her, Janet saw the enormous figure of Yama, the grim ruler of the nether world, a magnificent figure arrayed in a gorgeous garment embroidered with gold dragon rising from the sea. A rich brocade collar hung over his shoulders. His terrifying headdress, painted to represent a bull with golden horns, was painted a brilliant blue with a scarlet nose, and five human skulls adorning the forehead. In his right hand he held the scepter of death, crowned with a skull, and in his left a skull cup with red fringe. The strange figure gyrated slowly to the measured beat of the drums and cymbals before descending to the courtyard. This was the oldest of the Choni mystery plays. The monks restrained the eager crowd with difficulty.[255]

The twenty-one Lords of Hell, Yama's attendants, then arrived and joined him in a whirling dance called the *Bowa*. The fiendish Balden Lhamo led the dancers with a miniature corpse of her son, whom she had supposedly devoured, dangling from her mouth. In a bag by her side, she carried diseases that she released over man and beast when angered. The Dalai Lama of Lhasa had pronounced Queen Victoria the reincarnation of this demon years before.[256]

One of Janet's favorite figures was that of Nantain and his guards. Nantain represented a Chinese monk who had come from China to Tibet in the eighth century to dispute with the Tibetan lamas. He lost the debate and became an object of ridicule. It was one of the few pantomimes of political propaganda that emphasized the superiority of the lamas over the Chinese, whom they thoroughly disliked, and it brought down the house. The fat and fatuous Nantain entered the great courtyard on the arm of an old man and an old woman. Then the eight Devil Dancers arrived with a wooden tray. They danced around the tray with Nantain and his four tiny disciples, who wore masks and costumes similar to that of the ridiculous old priest. Much fun was had by all as the Chinese monk was put through a series of ridiculous antics and finally beaten on the head with his necklaces.[257]

Crossing the Tao River by rope, September 1923.

DANGEROUS CROSSINGS

After many days entranced by the pantomimes in the lamasery in Choni, Janet and Frederick found bundles of mail from home and received an unexpected visit from the Emerys, who had stopped on their way to Szechuan. Mr. Lin and Mr. Ching also showed up after a long excursion collecting in the mountains. Mr. Lin had over one hundred new birds to be labeled, and Mr. Ching had added many more specimens to the botanical collection. The compound was humming with activity.

Janet continued to measure and record the recent specimens, and developed two hundred of their latest photographs in the makeshift darkroom. The remodeled Tibetan house, which had once belonged to a Living Buddha from Lhasa, was now was part of the mission, and served as their headquarters in Choni.

The Emerys departed on their way to Szechuan. "I envy the Emerys this journey, and would have gone with them, had it been possible to transport all our gear—nearly one hundred cases—over the mountains. I hope to make the trip someday myself. They will, I think, be the first white people to go over this particular road," wrote Frederick.[258]

Their final week in Choni, Frederick, Mr. Wu, and the hunters departed for few days of hunting in the lush forests surrounding Archuen, a small village high in the nearby mountains. They passed their days hunting for sheep, and hunted bear at night. The local hunters managed to swing their way across the rushing Tao River on high suspended ropes. This was the traditional Tibetan means of crossing the numerous roaring streams that coursed down the valleys.

As Alexandra David-Neel described a similar ordeal,

They [the native guides] passed the . . . rope across [the river]—a real acrobatic feat that requires an uncommon strength in the wrists and a complete absence of giddiness. These men were not towed. . . They scrambled unaided over that sagging and swaying rope at a considerable distance above the rushing waters. When they had reached the opposite bank, the passage of the luggage began [along the ropes].[259]

On their return to Choni, Frederick discovered that two mules had been stolen from Mr. Ching. The drama unfolded in the chambers of the prince as Frederick demanded repayment for the mules stolen in his territory. The prince replied that as Frederick did not have an official escort, he could not hold the prince accountable. This discussion lasted two days. Finally Frederick and the prince each paid fifty *taels* to the owners of the mules. The Taochow guide, who had allowed the mules to be stolen, was turned over to the prince for punishment.[260]

More trouble lay ahead. As the expedition wove its way through the wild, densely forested mountains, they were on the lookout for robbers at all times. "We met one group of hard-looking characters, but apparently we looked even worse to them, at least not a word did they say," wrote Frederick.[261] At dawn the next morning, however, Janet and Frederick were told that thieves had dug a hole in the mud wall of the inn and stolen a packsaddle, a tent, and a suitcase of clothing belonging to Mr. Ching. They cut the straps, took the contents, and left the empty case at the bank of the river. No one was harmed, and fortunately Mr. Ching's crucial botanical records had been stored safely in a strong locked trunk. Frederick promised to replace Mr. Ching's wardrobe.[262]

At noon the expedition crossed the roaring Tao River at Tsing Shwei Chu. This was their quickest river crossing of the whole trip.

A rope ran clear across the river, moored to two rough piers of boulders on either side. A worn wooden sheave on the rope helped guide the ferry, a small, ramshackle boat of rough, thick boards, smaller than usual, and much easier to manage. In five minutes, Jan and I were across, with her litter, two mules and a horse. The other four horses made another load, but they were embarking before we got well clear of the bank. When the turn of our baggage mules came this crossing in teaspoonful took them over two hours.[263]

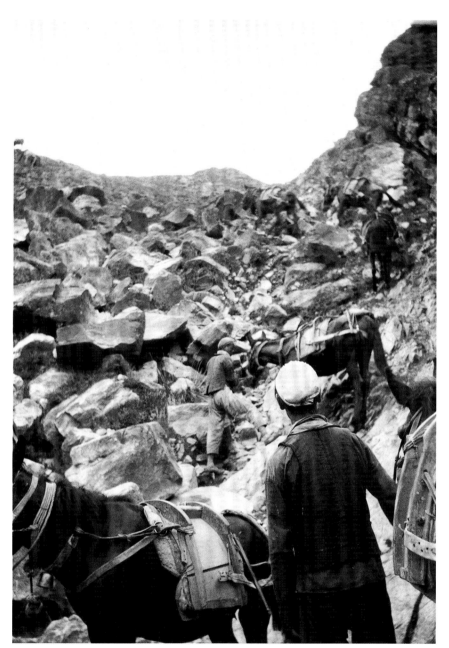

The expedition mules making the steep ascent to Archuen, Tibet, September 9, 1923.

Man inflating one of seventy-six yak skins for construction of the raft for the return down the Yellow River, Lanchow, October 1923.

The expedition was now crawling along the narrow mountain trails as the collections multiplied. The stacks of wooden crates towered above the mules, and hung perilously over the creaking carts.

From the little village of Titao the road to Lanchow was all downhill. Frederick wrote:

> People called it a cart road all the way from Titao, and so it is in two senses: no vehicle on earth but a Chinese cart could negotiate its mountainous boulders and slough of despond without being utterly wrecked; no human being but a Chinese carter could/would take a wheeled vehicle over it without promptly assassinating the officials who ought to see to its upkeep. On horseback, it is quite negotiable, though my stirrups sometimes nearly touched the mud through which my horse was wading.[264]

On September 20, when the expedition returned to Lanchow, Janet discovered that Aro, their "dear Tibetan puppy, had grown into a large-sized awkward, mongrel dog, nothing Tibetan at all. It was quite a shock."[265]

RETURN TO LANCHOW: THE BUILDING OF THE RAFT

On their arrival in Lanchow the mail brought them news of a disastrous earthquake in Japan, as well as the mysterious death of a close woman friend Peking. Janet also discovered that the letters she had written several months before had never reached New York. "I am much disturbed and annoyed that my letters never reach you," she told her family:

> I cannot understand it, and have spoken to the Postal Commissioner. Of course, letters from Lanchow, and south and west Kansu take at least two months to reach home. But you ought to have gotten the June letters by August. I do hope you have gotten more letters lately.... I sent you another cable a few days ago telling you that we were starting for Peking via the Yellow River, due in Peking November first. No doubt all that you read of China is most sensational, and causes you undue anxiety. China is upset—that is true, but Kansu is peaceful beyond words, and for you, who live with telegraph and trains, it is hard to realize

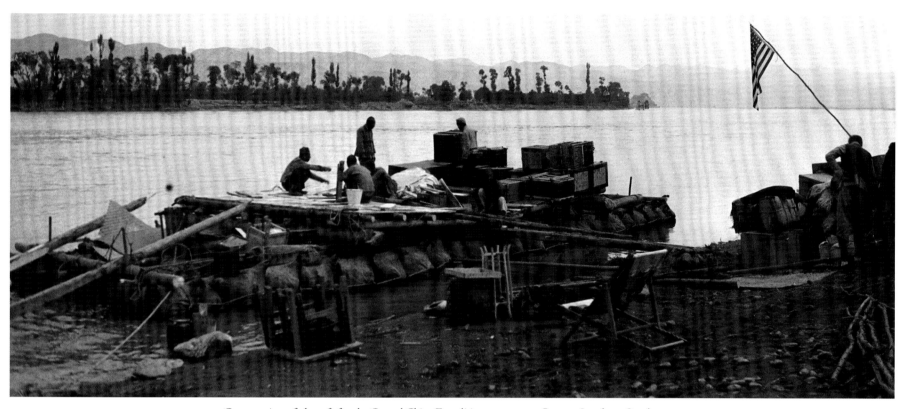

Construction of the raft for the Central China Expedition to return to Paotow, Lanchow, October 1923.

that one part of China can be safe, and others unsafe. But Kansu is as far from Peking as San Francisco is from Chicago, and you can imagine that one could be safe in San Francisco, with terrific fighting in Chicago.[266]

Janet and Frederick expected to leave on their yak-skin raft down the Yellow River soon after their arrival in Lanchow. There were many delays, however, and much work to do before they could depart two weeks later on October 6. The collections had to be completely dried, and everything had to be repacked to fit on the raft before the dangerous journey down the river.

Rafts were a familiar means of transportation up and down the Yellow River. The construction of the Wulsin raft, however, was complicated. It rested on

seventy-two inflated yak skins that had been salted and oiled and stuffed with straw. The openings were then tied tightly with rope, particularly the neck openings. At times the leg stumps of the yaks would stick up in the water grotesquely.

Frederick was intrigued by the engineering required to build the raft. He explained that,

the inflated skins are brought into position—in our case three rows of twenty-four skins each, layered transversely—lashed together with ropes. Then timbers are layed [sic] across at the ends, quarters and center, and ropes made fast to them. The cross timbers at bow and stern carry posts, two each, for the big sweep used in steering. The two end quarters of the boat are reserved for the crew; no deck is put there, but the men sweat back and forth on the bare yak

The group assembled for a final picnic before the expedition left Lanchow: Father Van Dyke, Major Strachan, Mrs. Scoville, Janet, Frederick, Mr. Andrews, Mervyn Andrews, and Mrs. Andrews, October 1923.

hides when they work the sweeps. The center half is used for baggage and passengers. Here there is another layer or two of poles, resting on the center and quarter timbers.[267]

Frederick's training as an engineer allowed him to redesign the raft. He ordered flooring on one end of the raft for his and Janet's tent, and the cook house. The crates of the collection were piled high in the middle for stability. He believed that their quarters were "crowded, but comfortable," although the entire raft measured only twenty-eight by fifteen feet and was to carry thirteen passengers for three weeks.[268]

Rafts were legion in Lanchow, and all along the upper course of the Yellow River little rafts of pigskin, twelve or thirteen skins tied to a flimsy frame, were used for local transport. Big rafts of yak hides, and some of timber, were used to carry merchandise far down the river. The usual cargo was wool or tobacco. The hide rafts were then carried back over land, and made a second trip the same year.

The raft was finished under the careful supervision of both Frederick and Mr. Andrews, who was "very good in making the contract for the raft, paying out the necessary money, and doing a lot of chores for us. He is a 'Prince among

men,'" declared Janet. "I don't know how the foreigners in Lanchow could get anything done without him."[269]

Their final days in Lanchow were frustrating as there was much work to be done while it rained "every day or every night, damp, cold and depressing beyond words," according to Janet.[270]

She continued to describe the preparations for their journey down the river, "All the boxes of plants and animal specimens had to be varnished with pig's blood, which the Chinese swear is waterproof, and which the merchants use on their cargo boxes going by raft."[271]

While awaiting the completion of the raft there was still time to see their friends in Lanchow.

> On the 25th [of September] a party of us took a small skin raft, and went thirteen miles down the river to see a bridge that Mr. Andrews built last year. We took a picnic lunch, and sent the ponies down so that we could ride back. We covered the thirteen miles in an hour and three quarters, and coming back by pony, 'though we followed the river, it took us four hours.[272]

Picnics were not, however, their only entertainment. The governor of Lanchow hosted a feast—which Frederick found boring—and the Andrewses gave a farewell dinner for the Postal Commissioner, "who is leaving Lanchow shortly and expects to make a trip around the world. Our cook and boys helped, and the party went off most successfully. Mr. Chun sang Chinese love songs in a high squeak, with English explanations, and it was hard to keep a straight face."[273]

Finally, after many delays, the Wulsins moved in with the Andrewses—thinking they would depart the next day. Janet reconciled herself to the situation:

> But this is China. What matter if a contract is signed for the raft to be all ready and equipped for October first? What is a day or a week to a Chinese? F. [Frederick], Mr. Wu, Mr. Andrews and the boys have stormed in vain, always some excuse… but yesterday, the third [of October] the man came and told us that the raft would be in a certain spot by noon, and ready to load. Then [came] a rush for carts to take our things to the river bank. On the way out of the city, the carts were taken by soldiers. Another three hours wait, sending of F's cards to the yamen and finally, about one we had some of the things on their way

> to the river. Chinese soldiers seize anything they want without paying, and their insolence is unspeakable. Three cartloads got to the riverbank. No raft. It was two o'clock. They stayed until four, still no raft. So the things were moved into a near-by inn for the night. In the meantime, Mr. Andrews went to the raft people, screamed and yelled, finished off part of the raft himself, got the men on board, and floated down to where we were to land. F. had also gone with the police to either get the raft, or put the men in jail. Both got home weary last night. How one longs at times for a train that leaves at a stated hour, not this shilly-shallying of these infernal Celestials. F. went off at eight this morning to try and load the raft. Now word comes that the river is too high because of the rains, and we will have to wait another day or two. It is exasperating.

> The Andrews [sic] are awfully hospitable, but I know they must tire of us. They are running a big boy's school, and Mr. Andrews has demands on him all the time. Besides, they are not well off, and yet they will not let us pay a cent. I would feel much better if I was a "parlor boarder." All of this delay is, of course, demoralizing the servants and staff. Lin, the taxidermist is always soaked in opium these days, and even Mr. Wu has begun to smoke, so that he can never be depended on. The boys drink a good deal more than is good for them, but we are powerless to do anything.[274]

"My patience is almost exhausted, and I feel these days as if I would like to see all China, especially the Chinese, swallowed up by an earthquake," continued Janet. The trip down the Yellow River loomed as a challenge. "I am trying to get F. [Frederick] to run the raft like a ship, and have regular drills and inspection, etc. It is quite cold now, and some exercise will do the Chinese good. I suppose, if the sun ever comes out I will feel more encouraged."[275]

This was hardly the letter to calm her anxious parents back in Manhattan.

THREE WEEKS ON
THE YELLOW RIVER

After three frustrating weeks the raft was completed and loaded. "Finally after many annoying delays we floated away from the walls of Lanchow at 8 a.m. on

October 6th," wrote Janet. "A dear old Russian refugee, an engineer by profession, with a face like Jesus Christ, was the only one who bid us 'good-bye.' He greatly feared for our safety going through the rapids, and in his Slavic earnestness wished all sorts of blessings upon us."[276]

The yak-skin raft proved to be better than Janet had anticipated.

The raft is very comfortable and most amusing. It lacks only one thing—some place where we can exercise. For after these months of riding twenty to thirty miles a day, to sit all day long is a real hardship and hard on the liver. The raft is made of seventy-two yak skins, stuffed with straw, and inflated with some air. These are tied together with long poles. On top of the poles rests a platform thirty feet long by fifteen feet wide (the width of the raft). On this platform we, and the Chinese "army".... live. On either end of the platform there is a space about ten feet long, just the poles resting on the skins, and here the raft men work the raft, with two long oars, bow and stern, do their sleeping and their cooking. I wish some of our twentieth century New York cooks could see their mud stove resting on two poles with a yak skin for a base, and see the steaming concoctions that come out of their kettle twice a day. On the platform we have our tent, a little shack of matting, for the cook, and a great tarpaulin-covered space for the Chinese to sleep. Under this tarpaulin our cases of specimens, and baggage not in use, are placed flat to make a floor, and the Chinese, sixteen of them, each has his little nook where his bedding is spread, and where he sleeps most of the days and night or talks, volubly, especially the cook and the mafu.[277]

It was hardly the Ritz, but Janet had grown accustomed to strange, crowded lodgings and found the river trip to be an adventure.

The first day out they hired eleven men to guide the raft through the treacherous rapids. Janet was anxious, as

these rapids are spoken of in hushed whispers, and F. [Frederick] and I both thought we must be going through a second Niagara. But they were mild in the extreme, except for a few exciting moments in some whirlpools, when we almost hit the great rocky cliffs that hem the river in. The raft men kept up a continual yelling for the five hours we were in the rapids, a typical Chinese habit whenever a lot of men are working together.[278]

Frederick explained that the rapids ran for twenty miles through the mountains, where the underlying rock had been cut by the river as it roared through the narrows. It was said to be very dangerous at high water, particularly for rafts made of logs. They often raced too fast through the canyons, and were dashed against the cliffs instead of following the current. The Wulsin expedition was blessed that the river was low at this time of year. Once safely through the gorges, Frederick tipped the pilot, and he and the crew returned to Lanchow on foot.[279]

Gradually their life on the raft assumed a daily routine as they floated through the countryside. Janet described their journey,

A day-by-day account of the raft trip would be dull reading, as it is dull traveling. When the raft can travel, we make 200 to 300 li a day, nearly 100 miles. But when there are high winds, we have to tie up to the shore all day and curse. Nothing is so wearing on the nerves as those winds. We have tied up so far two and one half days and, instead of making Ninghsia in 6 days, it has taken us over 8. If we have less wind for the remainder of the trip, we ought to make Paotow in nine or ten days. But quien sabe?

I have read copiously, mostly novels that Julia [Deane] sent me, and some that Langdon Warner passed on to us. They are amusing, and pass the time.

F. [Frederick] takes Chinese lessons every afternoon, and spends the rest of his time in writing articles. His energy and system would astound you. He gets up promptly at seven every morning. We breakfast at 7:30, lunch at 12:30, sup at 6, and I am in bed by 7:30 and sleep eleven hours every night. We travel from dawn, about five a.m. 'til dark, and tie up at nights. The river is too full of sand banks to make night travel safe without a moon.[280]

Their routine was interrupted occasionally by the unexpected. Janet was delighted to recount a challenge on the river, and to photograph it carefully.

One day we stuck on a sand bank for five hours. Finally, the combined effort of all hands, F. [Frederick], our 12 Chinese, and five raft men wading knee-deep in water and tugging at a rope, got the old ark moving. F. had carried me to a neighboring sand bank to watch the performance. It was a scream. I hope the pictures I took will be good [see page 109].[281]

Frederick described the scene in more detail.

All hands waded to a little island, and we had a grand tug of war against the Yellow River, trying to move the raft twenty feet into the channel. It seems impossible to move these things against the current. All one can do is to swing one end 'til the stream catches it. Then the whole raft spins, and very likely breaks loose from the mud bank. When the raft first sticks

Janet in front of her tent on the raft just before the departure to Paotow, October 6, 1923. This final journey took them seven hundred miles down the Yellow River.

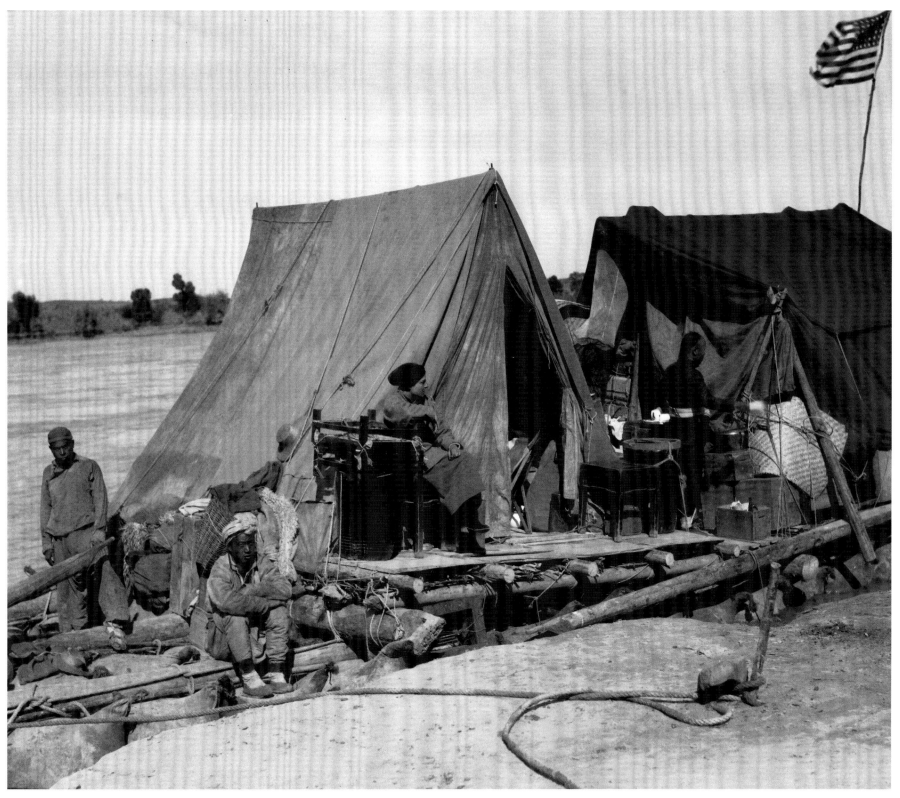

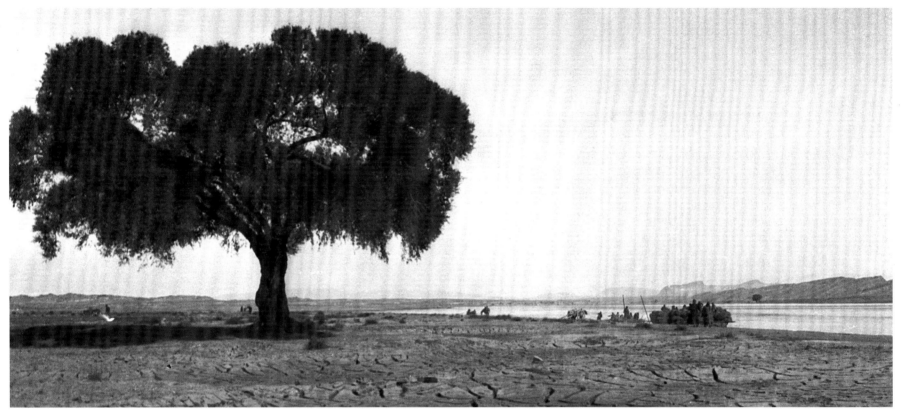

The expedition raft ties up on an uninhabited bank on the Yellow River on its way to Paotow, October 16, 1923.
On their right lay the sandy Ordos Desert, to their left a plain with the Ho Lan Shan Mountains looming over it.
They spent the nights tied to the mud bank. It was often hot when the winds ceased, in contrast to the piercing cold
when the winds lashed the raft. Often when the winds subsided, they ran half the night by moonlight.

fast, the men slave at the sweeps. If that fails, they hop into the water and push. Ice cold, I
found it. That usually moved things. When that fails, they hang a sweep from one side,
moored with rope, to catch the current and help them. The final recourse is unloading. I
preferred to put our men on a rope. It saved us a day, and no end of trouble.[282]

Their days passed without incident when the wind died down. They were
floating through the Ninghsia plain past a few familiar landmarks, but mostly
through farm country with trees and the Ho Lan Shan Mountains in the dis-
tance. One evening four boatloads of tough-looking characters tied up along-
side them. As a precaution, the expedition cast their raft off and dropped a few
miles down the river.

Occasionally the raft would tie up at small riverside towns along the
route. At Ninghsia Frederick wished to visit the eminent Belgian priest, a
renowned Tibetan scholar who had spent ten years in Sining. Janet described
their day:

Yesterday, about nine a.m. we got to Hung Cheng the port of Ninghsia, ruined fort, a
few miserable shanties, and a great flat, muddy plain. That is Hung Cheng. It is forty

li [thirteen miles] from Ninghsia and no carts to be had. We succeeded in hiring a donkey, put some blankets, our washbasin with toilet articles, the lunch box, a pitcher, some extra coats, and, with Pu and Jow, we started off. We had to buy food for the rest of the trip, and Frederick was most anxious to see Father Schram. We walked, and I rode on top of our emigrant bundles for a while. We found a nice clean inn near the Catholic mission. Father Schram welcomed us, and gave us a nice hot coffee, some ham, bread and jam. And I, after my long walk, got sleepier and sleepier, while the good father talked most learnedly in French and smoked his long Flemish pipe. Finally, I got back to the inn.[283]

Father Schram gave Frederick a great deal of valuable information on the ethnographic problems of Kansu, which he was able to incorporate into his report on Kansu. Janet settled into the warm October sunshine in the courtyard of an ancient inn while the two men discussed the history, language, and anthropology of Kansu. As the twilight deepened, Janet described the evening,

We warmed up our tin of baked beans for supper, and then I struggled to make myself comfortable on the hard brick kang [the bed of north China]. F. [Frederick] returned to talk with the Father, and I slept a little off and on. Now, F. is back again with Father Schram going over photographs for the National Geographic Society. In a little while, we return to the raft, and start on again. We hope to reach Peking by November first, but no dates are certain in China.[284]

By October 25 the river had widened into a vast lake that flowed gently. Small boats could be seen in the distance. Although the days were still and warm, the nights became ice-cold, and the water left in the basins overnight was frozen by morning. They cast off early and drifted until long after sunset. On their right lay the sandy Ordos Desert, to their left a plain with the Ho Lan Shan mountains looming above it. They spent the nights tied to the mud bank. It was often hot when the winds ceased, in contrast to the piercing cold when the winds lashed the raft. Often, when the wind died, they ran half the night by the light of the moon.

As their journey drew to a close, they floated eleven hours each day, tying up at the riverbank at night. Gradually they saw more and more farms, closer and closer together, and they knew they were nearing Paotow where their journey had begun nine months ago. On their last day out, Frederick recorded, "Today we can scarcely believe our memories."[285]

Janet lamented their departure from Kansu.

We hate in many ways to leave Kansu. We have had a wonderful summer, and I think F. [Frederick] has done some work of permanent value. It is a beautiful province, almost as big as Texas, with wide stretches of desert in the north, great grazing plateaux in the west along the Tibetan frontier, an agricultural belt in the center of the province, and, in the south-east and in the south-west beautiful forests, mountains, rivers and a good deal of wild game. Compared to the other provinces of China, Kansu is sparsely populated, but there is no great poverty, as food grows easily and the climate is not severe. The most interesting thing in Kansu to me are the different races, and mixture of races and languages—Chinese, Mongol, Turks, Arabs, Tibetans of many tribes and clans, and aborigines whose origin is still uncertain. I cannot imagine a more picturesque and romantic spot in the world today than this Tibetan border.....[286]

Frederick wrote, on the last page of his journal, "Here the journey ended."[287]

The team was gradually disbanded. Mr. Ching and Mr. Chang, the loyal botanists who had amassed such an important collection, went on to Nanking. Mr. Ching stayed on the payroll to go over his botanical specimens and his notes, packing and verifying each carton. These would be then sent on to Manila for further conservation. Frederick gave him his 1A Kodak special as a present to practice his photography. Janet and Frederick paid off the cook and the groom. Mr. Wu and the invaluable Pu remained with the Wulsins as permanent fixtures in their household in Peking. As Frederick wrote on the last line of his journal, "So our party dissolved, to assemble, perhaps, in the spring."[288]

RETURN TO PAOTOW
AFTER NINE MONTHS

Paotow was as bustling as ever. Janet saw signs of expanding businesses everywhere; new shops, inns, trading posts, and warehouses were going up at every station. Their old inn showed signs of prosperity, new paint, some new rooms, and a more impressive gateway. The city seemed a whirlwind of life, after the empty quietness of travel on their raft.

Through the courtesy of the stationmaster, the expedition had an entire forty-foot steel freight car to themselves and their gear. In it they piled "130 pieces of baggage, all the Chinese [team] and ourselves," wrote Janet.

> At Kweiwha we were able to get a first class compartment for F. [Frederick] and me, a bit crowded, but no matter—and at 8:00 A.M. on October 29 the 'Central China Expedition of the National Geographic Society' reached Peking. We have traveled 1850 miles by horseback, 700 by river and 1,000 by train. We have over 500 bird skins, over 150 mammal skins, large and small, about 600 reptile's skins, and well over 1,000 species of plants with about ten specimens to a species. Probably the botanical collection will be the most interesting to science. I think it is the first collection of Kansu flora to go to America.[289]

The plants were restored in the Philippines, and eventually shipped to the Smithsonian along with the zoological specimens. Eighty years later, the collections remain a prize at the Smithsonian Institution.

Eighteen hundred photographs went to the National Geographic Society, of which 350 were selected for their permanent archives. Sadly, however, the National Geographic Society destroyed the original negatives in 1971. The Wulsins gave the remainder of the collection to the Peabody Museum of Archaeology and Ethnology at Harvard, along with the nitrate negatives. Many of these disintegrated with time, but many albums still exist with the original photographs, and copy negatives have been made so that future generations may glimpse the vanished kingdoms of China, Inner Mongolia, and Tibet.

PEKING: WINTER 1923–24

Assembling over 130 crates and mountains of baggage on their arrival at the Peking station took hours, but finally Janet and Frederick returned to their home on Shui Mo Hutung. "The little house never looked prettier," wrote Janet.

> Tung [the house servant] had had new white paper put on all the walls, the courtyard and every room was a mass of lovely, bright-colored chrysanthemums. Every bit of brass and furniture glowed. I never saw such a spick and span little place.... I really felt quite proud to think it was my creation. We sat down to a delicious breakfast, lovely flowers on the table, and our blue glass, and blue and white china looking so nice after months of enamelware. It is wonderful how perfectly one is run in China. Tung got our town clothes out of storage, has unpacked them, is now in the process of cleaning, pressing or having them washed, and not a word has been said. He has rented a little house three doors away for an office for Freddie. A nice, sunny, quiet little courtyard where Freddie can write and develop pictures, and hug his guns to his heart's content. It will give me more room here, either an extra bedroom for a guest, or my study.[290]

On her return from nine months of travel in Inner Mongolia and Tibet, Janet regarded herself as a serious explorer. Frederick no longer referred to her as a "pocket wife." As she wrote home to her family, "I am seriously considering writing of my experiences. Do you think there would be a possibility of publication? I have a lot of things in mind, and am planning some original research, if I can get hold of a good Chinese translator. I want to get at Chinese sources, and as I can't really read the d—- language, must get a reliable person to work with me."[291] She confided her aspirations to Katharine, "I have some literary schemes in the back of my head, and am trying to get together copies of all the letters I wrote on the Kansu trip. I don't want to do anything 'til F.'s [Frederick's] articles are published. Only, I want to work up my material this winter while the experience is still fresh in my mind."[292] Gone were the doubts and fears expressed by Janet two years before in Shansi. Her path with Frederick was now set.

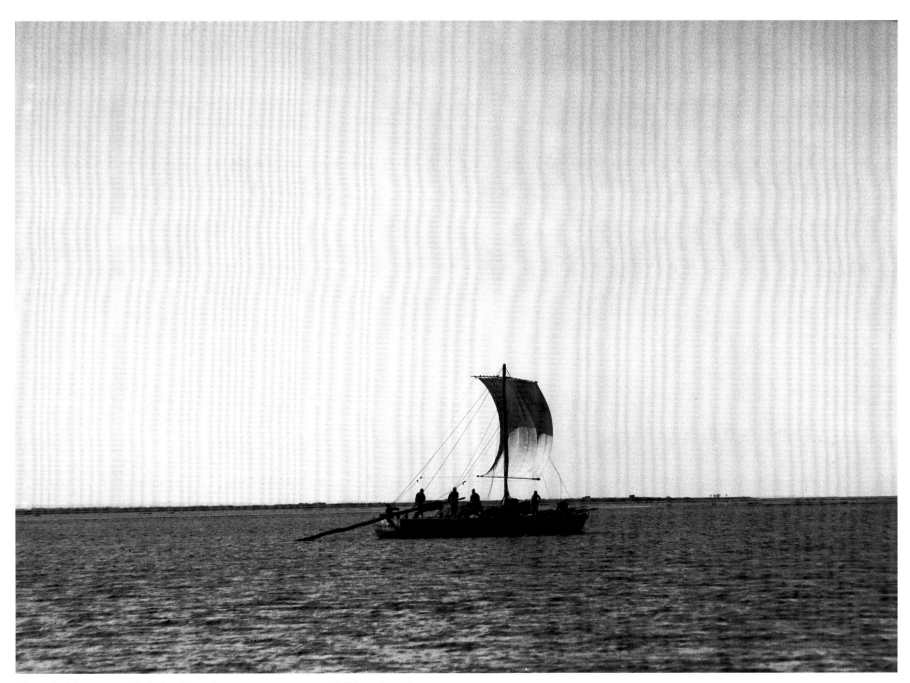

The end of the journey: The Yellow River, the great transport artery of China, widened at
To Chung Tze and large boats of all kinds were seen in the distance transporting goods from
the interior to the coast, October 1923.

Peking had changed in the months since their departure. "The big metropolis kept bursting upon us at every turn," Janet wrote.²⁹³ Many foreigners were leaving the city because the civil war was now threatening Peking. The legation was now staffed with unfamiliar people, and many of the Wulsins' closest friends had departed. "Roy Chapman Andrews has gone home for a four month lecture tour at $35,000, for five lectures a week. So he certainly earns the money. She is here having a baby. Do send me clippings of Andrew's [sic] lectures, and try and hear him. He has achieved great things, and his last summer finds of fossils in Mongolia, are a great feat."²⁹⁴

"Peking is full of famous scientists at present," continued Janet, "even Hedin, the great explorer of Tibet, Dockeray, a [sic] English Marconi man who has seen many far corners of the world, not to mention ourselves."²⁹⁵ Janet now included herself and Frederick among the recognized explorers. Her transformation from the sheltered Red Cross aide who fled to Paris at the close of World War I to a sophisticated woman explorer was complete. For a brief moment in Peking, she had emerged from the shadows. Although later articles—including those authored by her husband—rarely mentioned her, she was a crucial member of the National Geographic Central China Expedition, and the first American woman to explore many regions of Inner Mongolia and the borderlands and lamaseries of Kumbum, Labrang, and Choni. She vowed to return and go to Lhasa.

Janet was not the first Western woman, however, to attempt to pierce the inner kingdoms of Tibet; Annie Royle Taylor, an English missionary's daughter, made her attempt in 1892. Mrs. St. George Littledale tried to reach Lhasa later in 1895. The tragic Susie Rijnhart, a Canadian missionary doctor, lost both her husband and son to brigands in her attempt to reach Lhasa.²⁹⁶ These women and Alexandra David-Neel each held Lhasa as their ultimate goal.

In keeping with her conventional upbringing, Janet continued to put Frederick's career foremost. She proudly told Katharine, "I really feel that the trip is a great foundation stone in F.'s [Frederick's] career, which, if he can carry forward as he plans, must be a most distinguished [one] along some lines of science or an intellectual endeavor. I do feel too that nothing that the future holds should interfere with his work here in China, if humanly possible."²⁹⁷ She added later, "His career seems to be getting a firmer foundation every month, and the continuance of his present work, I feel should not be interrupted."²⁹⁸

Despite the fact that Janet found Peking a little "flat" on their return after their exhilarating expedition into Kansu, she and Frederick passed several contented months that winter.

> We have had a most wonderfully happy winter together, one that we will always remember—pleasant friends, nice parties, lots of congenial work for Freddie, good riding and much laughter and stimulating talk. F. [Frederick] blossoms under it all and is so well and handsome. I simply cannot bear the thought of leaving him, but there is no other solution that we can see.²⁹⁹

Janet was surprised and overjoyed when the doctors in Peking confirmed that she would have a baby the following May. She confided to Katharine, "Of course for me the greatest outcome of the trip is the advent of a baby—the greatest surprise, and the greatest pleasure. I have never felt so well. I do want to stay with F. [Frederick] as long as possible. We do have such wonderful times together planning all sorts of things for 'the Tibetan,' and two more ignorant tho' happy future parents you cannot imagine."³⁰⁰ She continually urged her mother to come to China for the birth, to no avail.

She continued,

> We are leading a most pleasant life....I have been working a lot over F.'s [Frederick's] 1800-odd photographs trying to give a title to each print so that "the nuts" in Washington who have never seen or heard of China will understand what the pictures are really about. For a geographic body their (incorrect) propaganda for F.'s trip seems too ignorant for words. I boil over ...The idea of 'fork-tailed monkeys,' but I suppose that drivel gets the great American public. I will be so glad when some of F.'s articles get into print.³⁰¹

Janet was still furious at the National Geographic for announcing their expedition's route erroneously as to Kweichow instead of to Kansu to the press. The Wulsins' relations with the National Geographic would strain to the breaking point the next year over Frederick's expenses in Indochina, and a controversy

over the final repository of the botanical collection. Mr. Ching wanted to keep a selection of the botanical specimens he had collected for Nanking University in Shanghai, but Frederick was ordered by the National Geographic to ship everything to the United States. He reluctantly complied.

The National Geographic Society published only one of Frederick's articles in 1926, despite the fact that he submitted several others. Frederick's writing tended to be dryly scientific, but Janet helped to enrich his prose by adding vivid descriptions of the cultures, people, and sites encountered on their journey. As relations with Gilbert Grosvenor frayed, several of Frederick's articles were shelved. Space was given to more flamboyant articles by such writers as Joseph Rock. Frederick's scholarly articles seemed less and less enticing to the vast *National Geographic* readership.

Susanne and Harry Emery finally returned to Peking from Szechuan. There they joined the Wulsins for a quiet Christmas day. Later the two couples rode out to their temple in the Western Hills for a final dinner. The Emerys' lovely house in Peking was now closed. Their servants had scattered, and their big car was now driven for the new chairman of the Asia Bank. Yale University offered Harry a post upon his return, but he was not interested. He had begun drinking heavily again and the Emerys' future remained uncertain. The imminent departure of the Emerys saddened Janet, "I can't bear to have them go. I think they are real friends. I think they hate to go too."[302]

In late January Janet wrote to Katharine, "Our friends the Emerys sail for home on February 4th (1924). We shall be sorry to see them go, but home is the best place for them now since H. E. has a violent return of his old 'trouble,' and living here in a hotel is not easy."[303] The Emerys boarded the S.S. *President Lincoln* on February 4, 1924, in Shanghai. That evening Harry Emery disappeared overboard into the vast Bay of Shanghai. A lengthy obituary in the *Peking Times* on February 7, 1924, listed the cause of his death as "pneumonia" and reported that Harry had been buried at sea between Shanghai and Kobe. The mystery was never resolved, but those who knew him well suspected that "the enemy" had finally triumphed. Susanne returned to Providence, Rhode Island, as a widow.

Janet sailed for home on the S. S. *President Cleveland* on March 4, 1924. Her father met her in San Francisco and they went directly to New York, where her son, Frederick Roelker Wulsin, Jr., was born later that spring. She notified Frederick of the birth by cable to Hanoi.

Frederick remained in China and embarked on his final expedition to Kweichow, Laos, and Vietnam later that spring. In a brief cable to Janet he announced, "Starting Kweichow shortly. Due back Peking November. Home December. Washington best location. Wulsin."[304] In a letter to Katharine Frederick admitted, "Jan has changed me, so I don't like big hunks of solitude any more and I miss her here on the ship most awfully. She makes every place she comes to alive."[305] At the request of the National Geographic Society, he returned home to Washington as promised that December, where he met his son for the first time.

Janet had written to Katharine that summer, "I hate to think that our China life is over. I want it again…I long for China every day…"[306]

To her everlasting regret, she never returned.

~*EPILOGUE*~

In the years that followed, the journey that Janet and Frederick had begun together took an unexpected turn. In 1924 they settled in Cambridge, Massachusetts. Frederick worked on his Ph.D. in anthropology at Harvard and made frequent trips to Africa to study the pygmy tribes. They had two more children, Howard Elliott Wulsin and Janet January Wulsin.

In 1929, while on an expedition to Mexico for the Peabody Museum, Frederick obtained a surprise divorce from Janet, citing "absolute incompatibility of temperaments." Janet was stunned and shattered. Frederick, feeling shackled by his domestic life in Cambridge, yearned to return to the "open road." He turned to Susanne Emery, the widow of Harry Emery, as a sympathetic partner with whom he also shared memories of his glorious days in China.

In 1930 Frederick and Susanne were quietly married in Hartford, Connecticut, despite the strong objections of his mother, Katharine.

After his remarriage, Frederick's career faltered. He left Harvard and was appointed curator at the University of Pennsylvania Museum. Years later he became a popular teacher and professor of anthropology at Tufts University, in Medford, Massachusetts.

As divorce was rare at this time among their circle, it caused a scandal in the Boston and New York papers. Disillusioned, Janet withdrew with her three children to a quiet home at the end of a long country road in Concord, Massachusetts.

She remained in seclusion for two years until Julia Deane, her old friend from China, persuaded Janet to buy a new dress, leave her exile, and come to a dinner in Boston. There she was seated next to Richard Bryant Hobart, a banker and eminent collector and scholar of Chinese art, who had traveled in China since 1906. They sat together discussing China long after the other guests had left the table. The bond was formed, but it took Richard many months of constant courting to gain Janet's trust. In 1932 they were married in her aunt's garden in Winter Harbor, Maine. They had one daughter, Mabel.

Janet and Richard spent the rest of their lives following the tumultuous events in China from afar. Janet lamented the disappearance of the China, Mongolia, and Tibet she knew so well as they vanished into history. She and Richard welcomed Chinese refugees who turned up on their doorstep at all hours, day or night, passed on from friends in China.

Surrounded by Chinese art from dynasties past, Janet would occasionally pause before furniture that she had brought back from Peking—remembering her years in China when she had emerged from the shadows as a woman explorer in her own right.

After her death in 1963, when her children were cleaning out Janet's desk, they discovered a faded photograph under the paper lining of the top drawer of a young man and woman sitting on the steps of a Chinese temple—a secret memento of a long lost past that remained with Janet until her journey's end (see page 9).

Janet just before the birth of her son, Frederick R. Wulsin, Jr., New York City, May 1924.

ITINERARIES AND GLOSSARY OF PLACE NAMES

TREK INTO SHANSI, 1921

August 15
Beijing | Peking 北京

August 16
Shijiazhuang | Sherdjindjuong 石家庄
Taiyuan | Taiyuanfu 太原

August 22
Jinci | Ginze 晉祠

August 23
Qingyuan Xiang | Tsungyuanhsian 清源鄉
Jiaocheng Xian | Kiaochunghsien 交城縣

August 24
Dongshe | Dungshen 東社

August 25
Huili Cun | Whey Li Tsum 會立

August 27
Zhaizi Cun | Djai Tzetaun 寨子村

August 28–September 24
Shizhuang | Sherdjuong 市庄

September 25
Huili Cun | Hweili 會立
Dongshe | Dung Shen 東社

September 26
Jiaocheng Xian | Keachunghsien 交城縣

September 27
Qingyuan Xiang | Tsingyuanhsian 清源鄉

September 28
Jinci | Ginza 晉祠

October 9
Taiyuan | Taijnanfu 太原
Yangqu | Yang Chi Hsien 陽曲
Huangtuzhai | Whang to Djen

October 10
Guancheng | Goan Cher 關城
Xin Zhou | Suinchow 忻州

October 11
Jinshan Pu | Gin Shampoo 金山鋪
Yuanping | Yuan Ping 原平

October 12
Guo Xian | Goahsien 崞縣
Yangming Pu | Yuan Ming Pu 陽明堡

October 13
Jiajia Zhuang | Jan Ja Juong 賈家庄

October 14
Daiyue | Dai Yin 岱岳

October 15
Huairen | Whey runhsien 怀仁

October 16
Datong | Tatungfu 大同

October 20
Datong | Tatungfu 大同
Guihua | Kweiwha (Huhehot) 歸化

October 28
Guihua | Kweisha 歸化

October 29–November 8
Yugou | Yirgo 榆溝
Guihua | Kweiwha 歸化

November 16
Guihua | Kweiwha 歸化

November 23
Guihua | Kweiwha 歸化

November 27
Datong | Tatungfu 大同

November 28
Beijing | Peking 北京

THE GREAT TREK: 1923

March 26
E bi hao | Au Pi Hao 鄂必豪

March 28
Ha da men qian shan kou |
Hatamen Tien Shan K'ou 哈達門前山口

March 29
Ha da men hou shan kou |
Hatamen Hou Shan K'ou 哈達門後山口

March 30
Wu la hu tu | Ulahutu 烏拉胡圖

April 1
Da she tai | Shih T'ai 大佘台
Shui quan zi | Shui Ch'uon 水泉子

April 2
Cai yuan zi | Tsai Y'fanze 菜園子

April 3
Wu la hu tu miao |
U Lan Ko Leoto 烏拉胡圖廟

April 5
Zha ge er zhai | Cha Gor Shi Wa 扎格爾齋

April 6
Liu quan zi | Leo Sha Ch'uon 柳泉子

April 7
Zhen fan quan | Ch'ang Fan Ch'uan 鎮番泉

April 13
Dong pi fang | Dung Pi Fang 東皮房

April 14
Lang shan wan | Lang Shan Wan 朗山灣
Tian yi sheng | (name not avail.) 天義生

April 15
La ma sha | La Ma Sha 喇嘛沙
Yi tai kui | (name not avail.) 義泰魁

April 16
Ci wan zi jing | Tze Wanze Gong 磁萬子井

April 17
Na la e bao | Nalaobo 那拉鄂包

April 19
Dian shui | Dean Shui 點水

April 20
Da shui gou | Ta Shui Ko 大水溝

April 21
Gai ji er wu su | Kau Dier Ussu 蓋吉爾烏蘇

April 22
Da shui gou | Ta Shui K'o 大水溝

April 23
Jia gan gou | Dja Gan K'ou
("Salt Well Camp") 架杆溝

April 24
Ba tuo er bu la | Batorbula
("Mud Well Camp") 八托爾卜拉

April 25
Ji lan tai yan hu |
Chi Lan Tai Yen Hou 吉蘭泰鹽湖

April 28
Ha tong hu tu ga |
Hato Kutuga 哈通呼圖嘎

April 29
Wang zu dou tao lin |
U Jou Tauli 玉租兜桃林

April 30
Cha ha la | Cha Hor Lei 茶哈拉

May 1
Gong hu tu ga | Wen Hutuka 公胡圖嘎

May 2
Zha ha wu su | Li Ho Ussu 扎哈烏蘇

May 3
Wang ye fu | Wang Yeh Fu
(Ting-yuan-ying) 王爺府

May 31
Yao ba | Io Ba 姚壩

June 1
Chang liu shui | Ch'ang Liu Shui 長流水

June 2
Ping qiang pu | P'ing Ch'ien P'u 平羌堡

June 3
Ning xia fu | Ninghsia 寧夏府

June 5
Yang he pu | Yang K'ou Pu 陽和堡

June 6
Da ba | Ta Pa 大壩

June 7
Guang wu | Kuang Wu 廣武

June 8
Zao yuan pu |
Tsao Yuan Pu Chuko Pu 棗園堡

June 9
Lei jia sha wo | Li Dja Sha Wo 雷家沙窩

June 10
Zhong wei | Chung Wei 中衛

June 11
Sha ba tou | Sha Ba T'ou 沙壩頭

June 12
Chang liu shui | Chang Liu Shui 長流水

June 13
Yi wo quan zi | I Wan Chuonze 一窩泉子

June 14
Gan tang zi | Gan Tangze 甘塘子

June 15
Ying pan shui | Ing Pan Shui 營盤水

June 16
Yi tiao shan | I T'iao Shan 一條山

June 17
Da la pai | Ta La Pai 大拉排

June 18
Liu dun zi | Leo Dunze

June 19
Shui bai he | Shui Pai Ho 水白河

June 20
Lan zhou fu | Lanchow
(Kao-Lan-Hsien) 蘭州府

June 23
Xin cheng | Hsin Ch'eng 新城

June 24
He zui zi | Ho Ts'ui Tze 河嘴子

June 25
Xiang tang | Hsiang T'ang 享堂

June 26
Gao miao zi | Kaomiaotzu 高廟子

June 27
Zhang jia zhai | Chang Ch'i Chai 張家寨
Zhang lao zhai | (name not avail.) 張老寨

July 28
Xi ning | Sining 西寧

August 2
Ta er si | Kumbum 塔爾寺

August 3
Xi ning | Sining 西寧

August 5
Wei yuan pu | Wei Yuan Pu 衛元堡

August 8
Guo ma si | Go Mung Sse 國馬寺
Yang jia zhai | Yang Cha Chai 楊家寨

August 9
Xi ning | Sining 西寧

August 11
Dan ge er | Tangar 丹葛爾

August 12
Hai shen miao | Hai Shen Meow 海神廟

August 13
Qing hai | Kokonor 青海

August 15
Ha la hu tu | Shalakutu 哈拉胡圖

August 17
Dan ge er | Tangar 丹葛爾

August 18
Xi ning | Sining 西寧

August 22
Xin zhuang | Hsin Chuang 新庄

August 23
Ba yen rong | Pai Yuen Jung 巴燕戎

August 24
Gan du | Gantu 甘都

August 25
Xun hua | Hsun Hua 循化

August 26
Xi chang gou | Shi Shangk'o 西廠溝

August 27
Gan jia tan | Gan Diatan (ruin) 甘家灘

August 28
La bu leng si | Labrang (Xiahe) 拉卜楞寺

August 31
Long wa | Rungwag 隆洼

September 1
Mo wu jiu si | Pai U Djio Sse 陌務舊寺

September 2
Da lu shi | Taloosher 大路石

September 3
Jiu tao zhou | Old Taochow 舊桃州

September 4
Zhuo ni | Choni 桌尼

September 9
A chuan | Archuen (Ah Chuen) 阿川

September 12
Zhuo ni | Choni 桌尼

September 15
Yang sha | Yang Sha 羊沙

September 16
Xian jia tan | Hsein Diajan 線家灘

September 17
Di dao | Titao 狄道

September 19
Shang zhong pu | Shang Djung Pu 上中堡

September 20
Lan zhou | Lanchow 蘭州

NOTES

Editor's note: Unless otherwise noted below, all the letters of Janet E. Wulsin are from the collection of The Peabody Museum of Archaeology and Ethnology, Harvard University Archives, Frederick R. Wulsin Papers, Accession 56-55, box 1.

BOOK I

1. Lesley Blanch, The Wilder Shores of Love (New York: Simon and Schuster, 1954), xi.
2. Milbry Polk and Mary Tiegreen, *Women of Discovery: A Celebration of Intrepid Women Who Explored the World* (New York: Clarkson Potter, 2001), 19.
3. The American Red Cross, "Canteen Service and Hospital Hut Service in France" (pamphlet); Wulsin Family Papers, bMS Am 2069 (21), folder 14 of 16, Houghton Library, Harvard University, Cambridge, Massachusetts.
4. Frederick R. Wulsin to Katharine R. Wulsin, Harvard Club of Boston, 1917, Wulsin Family Papers, bMS Am 2069 (20), Houghton Library.
5. Frederick R. Wulsin to Katharine R. Wulsin, September 8, 1917, Wulsin Family Papers, bMS Am 2069 (20), folder 16, Houghton Library.
6. Ibid.
7. Ibid.
8. Frederick R. Wulsin to Katharine R. Wulsin, Harvard Club of Boston, September 21, 1917, Wulsin Family

Papers, bMS Am 2069 (20), Folder 16, Houghton Library.
9. Ibid.
10. Frederick R. Wulsin to Katharine R. Wulsin, January 5, 1921, Wulsin Family Papers, bMS Am 2069, Folder 24, Houghton Library.
11. Ibid., p. 2.
12. Janet E. Wulsin, to Family, Paris, December 15, 1918, Hobart-Wulsin family archives.
13. The American Red Cross: pamphlet, Wulsin Family Papers, bMS Am 2069 (21), folder 14 of 16, Houghton Library.
14. Janet E. Wulsin, to Father and Mother, Paris, December 15, 1918, Hobart-Wulsin family archives.
15. Ibid.
16. Ibid.
17. Ibid.
18. Janet E. Wulsin to Katharine R. Wulsin, June 15, 1919, Wulsin Family Papers, bMS Am 2069, Houghton Library.
19. Frederick R. Wulsin to Katharine R. Wulsin, June 2, 1919, Wulsin Family Papers, bMS Am 2069, Houghton Library.
20. Ibid.
21. Katharine R. Wulsin to Frederick R. Wulsin, January 2, 1921, Wulsin Family Papers, bMS Am 2069, folder 95, Houghton Library.
22. Frederick R. Wulsin to Katharine R. Wulsin, January 7, 1921, Wulsin Family Papers, bMS Am 2069, folder 95, Houghton Library.
23. Janet E. Wulsin to Family, March 26, 1923, Hobart-Wulsin family archives.

24. Frederick R. Wulsin to Katharine Wulsin, January 10, 1921, Wulsin Family Papers, bMS AM 2069 (24), Houghton Library.
25. Frederick R. Wulsin to Katharine R. Wulsin, March 23, 1921, Wulsin Family Papers, bMS Am 2069 (24), Houghton Library.
26. Katharine R. Wulsin to Frederick R. Wulsin, Paris, April 26, 1921, Wulsin Family Archives, bMS Am 2069 (95), Houghton Library.
27. Katharine R. Wulsin to Frederick R. Wulsin, April 6, 1921, Wulsin Family Papers, bMs Am 2069 (95), Houghton Library.
28. Frederick R. Wulsin to Katharine R. Wulsin, April 25, 1921, Wulsin Family Papers, bMS Am 2069 (24), Houghton Library.
29. Janet E. Wulsin, to Family, Shanghai, May 20, 1921.
30. Frederick R. Wulsin, memorandum to Katharine R. Wulsin, February 22, 1921, Wulsin Family Papers, bMS Am 2069 (24), Houghton Library.
31. Frederick R. Wulsin to Katharine R. Wulsin, Shanghai, May 18, 1921, Wulsin Family Papers, bMS Am 2069 (24), Houghton Library.
32. Ibid.
33. Juliet Bredon, *Peking: A Historical and Intimate Description of Its Chief Places of Interest* (Shanghai: Kelly and Walsh, 1922), 15.
34. Ibid., 73.
35. Ibid., 15.
36. Ibid., 18.
37. Ibid., 53.

38. Frederick R. Wulsin to Katharine R. Wulsin, Shanghai, May 18, 1921, Wulsin Family Archives, bMS Am 2069 (24), Houghton Library.
39. Janet E. Wulsin, to Family, Peking, September 8, 1921.
40. Janet E. Wulsin, to Family, Peking, December 11, 1921.
41. Henry Crosby Emery, diary, p. 240, Henry Crosby Emery Papers, Special Collection and Archives, Bowdoin College Library.
42. Janet E. Wulsin, to Family, Peking, July 23, 1921.
43. Julia Coolidge Deane, letter to Mrs. Coolidge, September 8, 1922, Julia Coolidge Deane Papers, Schlesinger Library, Radcliffe Institute for Advanced Study.
44. Frederick R. Wulsin to Katharine R. Wulsin, Peking, May 5, 1921, Wulsin Family Archives, bMS Am 2069 (24), Houghton Library.
45. Janet E. Wulsin to Father and Mother, July 17, 1921.
46. Ibid.
47. Ibid.
48. Ibid.
49. Ibid.
50. Janet E. Wulsin to Family, Peking, July 29, 1921.
51. Janet E. Wulsin to Father and Mother, Peking, July 17, 1921.
52. Ibid.
53. Janet E. Wulsin to Family, Peking, July 23, 1921.

BOOK II

1. Janet E. Wulsin to Family, Peking, July 29, 1921.
2. Janet E. Wulsin to Mother, Taiyuanfu, Shansi, August 19, 1921.
3. Frederick R. Wulsin, "Notes on Equipment," Shansi, China, 1921, Frederick Roelker Wulsin Papers, bMS Am 1329 42M-1175 (36), Houghton Library.
4. Ibid.
5. Janet E. Wulsin to Mother, Taiyuanfu, Shansi, August 19, 1921.
6. Chiao-min Hsieh and Jean Kan Hsieh, *China: A Provincial Atlas* (New York: Simon and Schuster Macmillan, 1998), 131.
7. Clipping enclosed in letter, Frederick R. Wulsin to Katharine R. Wulsin, May 14, 1921, Wulsin Family Papers, bMS Am 2069 (24), Houghton Library.
8. Katharine R. Wulsin to Frederick R. Wulsin, March 29, 1921, Wulsin Family Papers, bMS Am 2069 (95), Houghton Library.
9. Janet E. Wulsin to Mother, Taiyuanfu, Shansi, August 19, 1921.
10. Janet E. Wulsin to Family, Ba-Shui-Co, Shansi, September 8, 1921.
11. Ibid.
12. Ibid.
13. Ibid.
14. Janet E. Wulsin to Family, Hung Djen Djun and the Wenshui River, Shansi, September 1 and 2, 1921.
15. Frederick R. Wulsin, "Shansi Farms and Highways," 1, Wulsin-Hobart family archives.
16. Janet E. Wulsin to Family, Taiyuanfu, August 22, 1921.
17. Janet E. Wulsin to Family, Hung Djen Djun and the Wenshui River, Shansi, September 1 and 2, 1921.
18. Janet E. Wulsin to Family, Taiyuanfu, August 22, 1921.
19. Janet E. Wulsin to Family, Hung Djen Djun and the Wenshui River, Shansi, September 1 and 2, 1921.
20. Frederick R. Wulsin, "Shansi Farms and Highways," 7, Wulsin-Hobart family archives.
21. Janet E. Wulsin to Family, Hung Djen Djun and the Wenshui River, Shansi, September 1 and 2, 1921.
22. Janet E. Wulsin to Family, Hung Djen Djun and the Wenshui River, Shansi, September 1 and 2, 1921.
23. Ibid.
24. Frederick R. Wulsin, "Shansi Farms and Highways," 8, Wulsin-Hobart family archives.
25. Ibid.
26. Janet E. Wulsin to Family, Hung Djen Djun and the Wenshui River, Shansi, September 1 and 2, 1921.
27. Frederick R. Wulsin, "Shansi Farms and Highways," 9, Wulsin-Hobart family archives.
28. Ibid.
29. Frederick R. Wulsin, "China Trip, 1921. Journal," Frederick Roelker Wulsin Papers, bMS Am 1329 (17-19), Houghton Library.
30. Janet E. Wulsin to Family, Hung Djen Djun and the Wenshui River, Shansi, September 1 and 2, 1921.
31. Ibid.
32. Frederick R. Wulsin, "China Trip, 1921. Journal," Frederick Roelker Wulsin Papers, bMS Am 1329 (17-19), Houghton Library.
33. Janet E. Wulsin to Family, Hung Djen Djun and the Wenshui River, Shansi, September 1 and 2, 1921.
34. Janet E. Wulsin to Family, Hung Djen Djun and the Wenshui River, Shansi, September 1 and 2, 1921.
35. Janet E. Wulsin to Family, Hung Djen Djun and the Wenshui River, Shansi, September 1 and 2, 1921.
36. Ibid.
37. Frederick R. Wulsin, Journals of F. R. Wulsin on his journey into the Province of Shansi, in China, 1921, 5, Museum of Comparative Zoology, Harvard University Archives.
38. Janet E. Wulsin to Family, September 8, 1921.
39. Ibid.
40. Janet E. Wulsin to Family, September 20–22, 1921.
41. Ibid.
42. Janet E. Wulsin to Mother and Father, Taiyuanfu, Shansi, October 2 and 7, 1921.
43. Ibid.
44. Ibid.
45. Janet E. Wulsin to Mother and Father, Kweiwhating, November 10, 1921.
46. Janet E. Wulsin to Family, Tatungfu and Kweiwhating, October 17 and 27, 1921.
47. Ibid.
48. Ibid.
49. Frederick R. Wulsin, "China Trip, 1921. Journal," Frederick Roelker Wulsin Papers, bMS Am 1329 (17-19), Houghton Library.
50. Ibid.
51. Janet E. Wulsin to Family, Tatungfu and Kweiwhating, October 17 and 27, 1921.
52. Janet E. Wulsin to Mother and Father, November 1, 1921.
53. Ibid.
54. Ibid.
55. Ibid.
56. Frederick R. Wulsin, "China Trip, 1921. Journal," Frederick Roelker Wulsin Papers, bMS Am 1329 (17-19), Houghton Library.
57. Ibid.
58. Ibid.
59. Ibid.
60. Ibid.
61. Ibid.
62. Ibid.
63. Janet E. Wulsin to Mother and Father, Kweiwhating, Shansi, October 27, 1921.
64. Ibid.
65. Janet E. Wulsin to Mother and Father, Peking, November 30, 1921.
66. Ibid.

BOOK III

1. Frederick Wulsin to Dr. J. O. Brew, October 25, 1956, Peabody Museum, Harvard University, Archives, Frederick R. Wulsin Papers, Accession 56-55, box 1.
2. Frederick R. Wulsin to Katharine R. Wulsin, Peking, May 8 and 10, 1921. Wulsin Family Papers, bMS Am 2069 (24), Houghton Library.
3. Janet E. Wulsin to Father and Mother, Temple Tung Wan Tang, Pa Ta Chon [near Peking], April 10, 1922.
4. Janet E. Wulsin to Katharine R. Wulsin, February 1, 1922, Wulsin Family Papers, bMS Am 2069 (145), Houghton Library.
5. Frederick R. Wulsin to Howard Elliott, March 19, 1922, Wulsin Family Papers, bMS Am 2069 (25), Houghton Library.
6. Ibid.
7. Janet E. Wulsin to Father and Mother, Temple Tung Wan Tang, Pa Ta Chon [near Peking], April 10, 1922.
8. Janet E. Wulsin to Family, Peking, December 11, 1921.
9. Janet E. Wulsin to Family, Peking, December 25, 1921.
10. Janet E. Wulsin to Mrs. Rogers, Peking, January 16, 1922.
11. Janet E. Wulsin to Family, Peking, December 25, 1921.
12. Janet E. Wulsin to Father and Mother, 34 Shui Mo Hutung, Peking, February 13, 1922.
13. Ibid.
14. Henry Crosby Emery to Francis Allinson, Peking, June 24, 1921, Henry Crosby

Emery Papers (1908–1985), Special Collections and Archives, Bowdoin College Library.

15. Janet E. Wulsin to Mother, Peking, January 6 and 9, 1922.

17. Henry Crosby Emery to Nancy, March 20, 1921, Henry Crosby Emery Papers (1908–1985), Special Collections and Archives, Bowdoin College Library.

17. "Memorandum of Agreement between the National Geographic Society and Frederick R. Wulsin, Director of the Society's Kweichow, China Expedition," signed Gilbert Grosvenor and F. R. Wulsin, December 29, 1922, National Geographic Wulsin Archives, Washington D.C.

18. Frederick R. Wulsin to Katharine R. Wulsin, New York, December 30, 1922 and January 10, 1923, Wulsin Family Papers, bMS Am 2069, Houghton Library.

19. Ibid.

20. Ibid.

21. Ibid.

22. Janet E. Wulsin to Mother and Father, February 4, 1923.

23. Julia Deane to Mrs. Coolidge, May 15, 1923, Julia Coolidge Deane Papers, Schlesinger Library, Radcliffe Institute for Advanced Study.

24. Frederick R. Wulsin to Frederick V. Coville, February 21, 1923, Research Grants Collection, National Geographic Archives, Washington, D.C.

25. Janet E. Wulsin to Father and Mother, February 15, 1923, typescript, Hobart-Wulsin family archives.

26. Frederick R. Wulsin to Gilbert Grosvenor, February 24, 1923, Gilbert H. Grosvenor Collection, National Geographic Archives, Washington, D.C.

27. Frederick R. Wulsin to Katharine R. Wulsin, May 4, 1923, Wulsin Family Papers, bMS Am 2069 (26), Houghton Library.

28. Susanne Emery Wulsin, "Diary of A Trip into Kansu," Wulsin Family Papers, bMS Am 2069 (171), Houghton Library.

29. Frederick R. Wulsin to Frederick V. Coville, February 21, 1923, Research Grants Collection, National Geographic Archives, Washington, D.C.

30. Ibid.

31. Ibid.

32. Frederick R. Wulsin to Katharine R. Wulsin, March 12, 1923, Wulsin Family Papers, bMS Am 2069 (26), Houghton Library.

33. Ibid.

34. Susanne C. Emery to Frederick R. Wulsin, March 23, 1922, Henry Crosby Emery Papers (1908–1985), Special Collections and Archives, Bowdoin College Library.

35. Ibid.

36. Frederick R. Wulsin to Katharine R. Wulsin, March 12, 1923, Wulsin Family Papers, bMS Am 2069 (26), Houghton Library.

37. Ibid.

38. Ibid.

39. Ibid.

40. Ibid.

41. Janet E. Wulsin to Family, March 24, 1923, typescript, Hobart-Wulsin family archives.

42. Frederick R. Wulsin to Katharine R. Wulsin, March 12, 1923, Wulsin Family Papers, bMS Am 2069 (26), Houghton Library.

43. Ibid.

44. Janet E. Wulsin to Family, March 15, 1923, typescript, Hobart-Wulsin family archives.

45. Janet E. Wulsin to Family, March 26, 1923, typescript, Hobart-Wulsin family archives.

46. Ibid.

47. Janet E. Wulsin to Katharine R. Wulsin, March 24, 1923, typescript, Hobart-Wulsin family archives.

48. Janet E. Wulsin to Family, March 26, 1923, typescript, Hobart-Wulsin family archives.

49. Janet E. Wulsin to Katharine R. Wulsin, March 24, 1923, typescript, Hobart-Wulsin family archives.

50. Ibid.

51. Ibid.

52. Ibid.

53. Janet E. Wulsin to "Viggy" (Anne L. R. Wulsin), October 30, 1923, typescript, Hobart-Wulsin family archives.

54. G. W. Hutchinson to Gilbert Grosvenor, January 18, 1923, National Geographic Auditor's Report, Central China Expedition, Research Grants Collection, National Geographic Archives, Washington, D.C.

55. Henry Crosby Emery to Family, March 16, 1923, Henry Crosby Emery Papers (1908–1985), Special Collections and Archives, Bowdoin College Library.

56. Janet E. Wulsin to Katharine R. Wulsin, March 24, 1923, typescript, Hobart-Wulsin family archives.

57. Janet E. Wulsin to Lucien and Peggy Wulsin, Wei Yuan Pu, Kansu, August 6, 1923.

58. Ibid.

59. Ibid.

60. Janet E. Wulsin to Family, March 26, 1923, typescript, Hobart-Wulsin family archives.

61. Ibid.

62. Janet E. Wulsin to Lucien and Peggy Wulsin, Wei Yuan Pu, Kansu, August 6, 1923, typescript, Hobart-Wulsin family archives.

63. Susanne Emery Wulsin, "Diary of a Trip into Kansu," Wulsin Family Papers, bMS Am 2069 (171), Houghton Library.

64. Janet E. Wulsin to Lucien and Peggy Wulsin, Wei Yuan Pu, Kansu, August 6, 1923, typescript, Hobart-Wulsin family archives.

65. Janet E. Wulsin to Family, May 29, 1923, typescript, Hobart-Wulsin family archives.

66. Susanne Emery Wulsin, "Diary of a Trip into Kansu," Wulsin Family Papers, bMS Am 2069 (171), Houghton Library.

67. Donovan Webster, "China's Unknown Gobi: Alashan," National Geographic, January 2002, 58.

68. Janet E. Wulsin to Lucien and Peggy Wulsin, Wei Yuan Pu, Kansu, August 6, 1923, typescript, Hobart-Wulsin family archives.

69. Ibid.

70. Harry Crosby Emery to Anne Crosby Emery Allinson, Wang Yeh Fu, May 15, 1923. Henry Crosby Emery Papers (1908–1985), Special Collections and Archives, Bowdoin College Library.

71. Susanne Emery Wulsin, "Diary of a Trip into Kansu," April 6, 1923, Wulsin Family Papers, bMS Am 2069 (171), Houghton Library.

72. Frederick R. Wulsin to Katharine R. Wulsin, May 4, 1923, Wulsin Family Papers, bMS Am 2069 (26), Houghton Library.

73. Janet E. Wulsin to Family, May 29, 1923, typescript, Hobart-Wulsin family archives.

74. Frederick R. Wulsin to Katharine R. Wulsin, May 4, 1923, Wulsin Family Papers, bMS Am 2069 (26), Houghton Library.

75. Ibid.

76. Janet E. Wulsin to Family, May 29, 1923, typescript, Hobart-Wulsin family archives.

77. Frederick R. Wulsin to Katharine R. Wulsin, May 4, 1923, Wulsin Family Papers, bMS Am 2069 (26), Houghton Library.

78. Janet E. Wulsin to Lucien and Peggy Wulsin, Wei Yuan Pu, Kansu, August 6, 1923, typescript, Hobart-Wulsin family archives.

79. Frederick R. Wulsin to Katharine R. Wulsin, May 4, 1923, Wulsin Family Papers, bMS Am 2069 (26), Houghton Library.

80. Henry Crosby Emery to A. C. Emery, May 6, 1923, Henry Crosby Emery Papers (1908–1985), Special Collections and Archives, Bowdoin College Library.

81. Frederick R. Wulsin, "The Road to Wang Yeh Fu," *National Geographic*, February 1926: 199.

82. Janet E. Wulsin to "Viggy" (Anne L. R. Wulsin), October 30, 1923, typescript.

83. Susanne Emery Wulsin, "Diary of a Trip into Kansu," 59, Wulsin Family Papers, bMS Am 2069 (171), Houghton Library.

84. Janet E. Wulsin to Family, May 29, 1923.

85. Susanne Emery Wulsin, "Diary of a Trip into Kansu." Wulsin Family Papers, bMS Am 2069 (171), Houghton Library.

86. Ibid.

87. Frederick R. Wulsin, "National Geographic Central China Expedition Journals," Vol. 1. Frederick Roelker Wulsin Papers, bMS Am 1329 (44–48), Houghton Library.

88. Ibid.

89. Harry Crosby Emery to Anne Crosby Emery Allinson, Wang Yeh Fu, May 10, 1923. Henry Crosby Emery Papers (1908–1985), Special Collections and Archives, Bowdoin College Library.

90. Susanne Emery Wulsin, "Diary of a Trip into Kansu," 71, Wulsin Family Papers, bMS Am 2069 (171), Houghton Library.

90. Henry Crosby Emery to Anne Crosby Emery Allinson, May 10, 1923, Henry Crosby Emery Papers (1908–1985), Special Collections and Archives, Bowdoin College Library.

91. Susanne Emery Wulsin, "Diary of a Trip into Kansu." Wulsin Family Papers, bMS Am 2069 (171), Houghton Library.

92. Ibid.

93. Frederick R. Wulsin, "National Geographic Central China Expedition Journals," Vol. 1. Frederick Roelker Wulsin Papers, bMS Am 1329 (44–48), Houghton Library.

94. Frederick R. Wulsin to Katharine R. Wulsin, May 4, 1923, Wulsin Family Papers, bMS Am 2069 (26), Houghton Library.

95. Ibid.

96. Ibid.

97. Henry Crosby Emery to Anne Crosby Emery Allinson, May 10, 1923, Henry Crosby Emery Papers (1908–1985), Special Collections and Archives, Bowdoin College Library.

98. Susanne Emery Wulsin, "Diary of a Trip into Kansu," Wulsin Family Papers, bMS Am 2069 (171), Houghton Library.

100. Ibid., 94.

101. Ibid, 202.

102. Frederick R. Wulsin, "National Geographic Central China Expedition Journals," Vol. 2. Frederick Roelker Wulsin Papers, bMS Am 1329 (44–48), Houghton Library.

103. Frederick R. Wulsin to Katharine R. Wulsin, May 4, 1923, Wulsin Family Papers, bMS Am 2069 (26), Houghton Library.

104. Janet E. Wulsin to Lucien and Peggy Wulsin, Wei Yuan Pu, Kansu, August 6, 1923, bMS Am 2069 (154), Houghton Library.

105. Frederick R. Wulsin, "National Geographic Central China Expedition Journals," Vol. 2. Frederick Roelker Wulsin Papers, bMS Am 1329 (44–48), Houghton Library.

106. Janet E. Wulsin to Lucien and Peggy Wulsin, Wei Yuan Pu, Kansu, August 6, 1923, Wulsin Family Papers, bMS Am 2069 (154), Houghton Library.

107. Frederick R. Wulsin, "National Geographic Central China Expedition Journals," Vol. 2. Frederick Roelker Wulsin Papers, bMS Am 1329 (44-48), Houghton Library.

108. Janet E. Wulsin to Lucien and Peggy Wulsin, Wei Yuan Pu, Kansu, August 6, 1923, Wulsin Family Papers, bMS Am 2069 (154), Houghton Library.

109. Frederick R. Wulsin, "The Road to Wang Ye Fu," *National Geographic*, February 1926: 211.

110. Janet E. Wulsin to Lucien and Peggy Wulsin, Wei Yuan Pu, Kansu, August 6, 1923, Wulsin Family Papers, bMS Am 2069 (154), Houghton Library.

111. Frederick R. Wulsin, "Road to Wang Yeh Fu," 211.

112. Janet E. Wulsin to Lucien and Peggy Wulsin, Wei Yuan Pu, Kansu, August 6, 1923, bMS Am 2069 (154), Houghton Library.

113. Frederick R. Wulsin, "National Geographic Central China Expedition Journals," Vol. 2, Frederick Roelker Wulsin Papers, bMS Am 1329 (44-48), Houghton Library.

114. Janet E. Wulsin to Family, Wang Yeh Fu, May 29, 1923.

115. Frederick R. Wulsin, "National Geographic Central China Expedition Journals," Vol. 2, Frederick Roelker Wulsin Papers, bMS Am 1329 (44-48), Houghton Library.

116. Ibid.

117. Ibid.

118. Frederick R. Wulsin to Lucien Wulsin, Lanchowfu, Kansu, July 8, 1923, Wulsin Family Papers, bMS Am 2069 (46), Houghton Library.

119. Ibid.

120. Ibid.

121. Ibid.

122. Frederick R. Wulsin to Katharine R. Wulsin, Wang Yeh Fu, May 29, 1923, Wulsin Family Papers, bMS Am 2069 (26), Houghton Library.

123. Frederick R. Wulsin, "National Geographic Central China Expedition Journals," Vol. 1, Frederick Roelker Wulsin Papers, bMS Am 1329 (44-48), Houghton Library.

124. Ibid.

125. Ibid.

126. Ibid.

127. Ibid.

128. Ibid.

129. Ibid.

130. Frederick R. Wulsin, "Road to Wang Yeh Fu," 234, typescript, Hobart-Wulsin family archives.

131. Janet E. Wulsin to Family, Wang Yeh Fu, May 29, and Ninghsia, June 4, 1923, typescript, Hobart-Wulsin family archives.

132. Ibid.

133. Janet E. Wulsin to "Viggy" (Anne Lyman Roelker), Peking, October 30, 1923, typescript, Hobart-Wulsin family archives.

134. Frederick R. Wulsin to Katharine Wulsin, Wang Yeh Fu, Alashan, May 29, 1923, Wulsin Family Papers, bMS Am 2069, Houghton Library, Harvard University.

135. Ibid., addendum by Frederick R. Wulsin, typescript, Hobart-Wulsin family archives.

136. Janet E. Wulsin to Family, Wang Yeh Fu, May 29, and Ninghsia, June 4, 1923, typescript, Hobart-Wulsin family archives.

137. Janet E. Wulsin to Peggy and Lucien Wulsin, Wei Yuan Pu, Kansu, August 6, 1923, Wulsin Family Papers, bMS Am 2069 (154), Houghton Library.

138. Frederick R. Wulsin, "National Geographic Central China Expedition Journals," Vol. 2. Frederick Roelker Wulsin Papers, bMS Am 1329 (44-48), Houghton Library.

139. Janet E. Wulsin to "Viggy" (Anne Lyman Roelker), Peking, October 30, 1923, typescript, Hobart-Wulsin family archives.

140. Ibid.

141. Janet E. Wulsin to Lucien and Peggy Wulsin, Wei Yuan Pu, Kansu, August 6, 1923, Wulsin Family Papers, bMS Am 2069 (154), Houghton Library.

142. Frederick R. Wulsin to "Mamie" (Katharine R. Wulsin), Wang Yeh Fu, May

29, 1923, Wulsin Family Papers, bMS Am 2069, Houghton Library.

143. Janet E. Wulsin to "Viggy" (Anne Lyman Roelker), Peking, October 30, 1923, Wulsin Family Papers, bMS Am 2069 (154), Houghton Library.

144. Janet E. Wulsin to Family, Wang Yeh Fu, May 29, and Ninghsia, June 4, 1923.

145. Frederick R. Wulsin, "National Geographic Central China Expedition Journals," Vol. 2. Frederick Roelker Wulsin Papers, bMS Am 1329 (44-48), Houghton Library.

146. Ibid.
147. Ibid.
148. Ibid.
149. Ibid.

150. Janet E. Wulsin to Father and Mother, Lanchowfu, Kansu, July 19, 1923.

151. Ibid.
152. Ibid.

153. Frederick R. Wulsin, "National Geographic Central China Expedition Journals," Vol. 2. Frederick Roelker Wulsin Papers, bMS Am 1329 (44-48), Houghton Library.

154. Janet E. Wulsin to Father and Mother, Lanchowfu, Kansu, July 19, 1923.

155. Ibid.

156. Janet E. Wulsin to Father and Mother, Ningshia, Kansu, October 15, 1923.

157. Ibid.
158. Ibid.

159. Frederick R. Wulsin, "National Geographic Central China Expedition Journals," Vol. 2. Frederick Roelker Wulsin Papers, bMS Am 1329 (44-48), Houghton Library.

160. Ibid.

161. Janet E. Wulsin to Father and Mother, Lanchowfu, Kansu, July 19, 1923.

162. Ibid.
163. Ibid.
164. Ibid.
165. Ibid.

166. Ibid.
167. Ibid.
168. Ibid.

169. Frederick R. Wulsin, "National Geographic Central China Expedition Journals," Vol. 2. Frederick Roelker Wulsin Papers, bMS Am 1329 (44-48), Houghton Library.

170. Ibid.

171. Janet E. Wulsin to Father and Mother, Lanchowfu, Kansu, July 19, 1923.

172. Ibid.
173. Ibid.
174. Ibid,

175. Janet E. Wulsin to Father and Mother, Sining, Kansu, August 1, and Lusar, Kansu, August 3, 1923.

176. Ibid.
177. Ibid.
178. Ibid.

179. Janet E. Wulsin to Lucien and Peggy Wulsin, Wei Yuan Pu, Kansu, August 6, 1923. Wulsin Family Papers, bMS Am 2069 (154), Houghton Library.

180. Janet E. Wulsin to Father and Mother, Lanchowfu, Kansu, July 19, 1923.

181. Janet E. Wulsin to Father and Mother, Sinning, Kansu, August 1, 1923, and Lusar, Kansu, August 3, 1923.

182. Frederick R. Wulsin, "National Geographic Central China Expedition Journals," Vol. 2, Frederick Roelker Wulsin Papers, bMS Am 1329 (44-48), Houghton Library.

183. Ibid.
184. Ibid.

185. Frederick R. Wulsin, "National Geographic Central China Expedition Journals," Vol. 2, Frederick Roelker Wulsin Papers, bMS Am 1329 (44-48), Houghton Library.

186. Janet E. Wulsin to Father and Mother, Sining, Kansu, August 1, and Lusar, Kansu, August 3, 1923.

187. Ibid.

188. Ibid.
189. Ibid.
190. Ibid.
191. Ibid.
192. Ibid.

193. Alexandra David-Neel, *My Journey to Lhasa* (Boston: Beacon Press, 1993), p. 278.

194. Janet E. Wulsin to Father and Mother, Sining, Kansu, August 1, and Lusar, Kansu, August 3, 1923.

195. David-Neel, *My Journey to Lhasa*, p. 278.

196. Janet E. Wulsin to Father and Mother, Sining, Kansu, August 1, and Lusar, Kansu, August 3, 1923.

197. Ibid.
198. Ibid.
199. Ibid.
200. Ibid.

201. Frederick R. Wulsin, "National Geographic Central China Expedition Journals," Vol. 2, Frederick Roelker Wulsin Papers, bMS Am 1329 (44-48), Houghton Library.

202. Ibid.

203. Janet E. Wulsin to Family, Yang Khai Djai, Kansu, August 8, and Sining, Kansu, August 10, 1923.

204. Frederick R. Wulsin, "National Geographic Central China Expedition Journals," Vol. 2, Frederick Roelker Wulsin Papers, bMS Am 1329 (44-48), Houghton Library.

205. Ibid.
206. Ibid.
207. Ibid.

208. Janet E. Wulsin to Lucien and Peggy Wulsin, Wei Yuan Pu, Kansu, August 6, 1923, Wulsin Family Papers, bMS Am 2069 (154), Houghton Library.

209. Janet E. Wulsin to Family, Yang Khai Djai, Kansu, August 8, and Sining, Kansu, August 10, 1923.

210. Janet E. Wulsin to Father and Mother, Sining, Kansu, North China, August 1, and Lusar, Kansu, Friday, August 3, 1923.

211. Janet E. Wulsin to Family, Yang Djai Djai, Kansu, August 8, and Sining, Kansu, August 10, 1923.

212. Ibid.

213. Janet E. Wulsin to Father and Mother, Sining, Kansu, August 19 and 20, 1923.

214. Ibid.
215. Ibid.
216. Ibid.

217. Frederick R. Wulsin, "National Geographic Central China Expedition Journals," Vol. 2, Frederick Roelker Wulsin Papers, bMS Am 1329 (44-48), Houghton Library.

218. Ibid.
219. Ibid.

220. Frederick R. Wulsin to Katharine R. Wulsin, Choni, September 8, 1923, Wulsin Family Papers, bMS Am 2069 (26), Houghton Library.

221. Janet E. Wulsin to Father and Mother, Sining, Kansu, August 19 and 20, 1923.

222. Ibid.
223. Ibid.

224. Frederick R. Wulsin, "National Geographic Central China Expedition Journals," Vol. 3, Frederick Roelker Wulsin Papers, bMS Am 1329 (44-48), Houghton Library.

225. Ibid.
226. Ibid.

227. Janet E. Wulsin to Mother, Choni, September 8 and 10, 1923.

228. Ibid.

229. Frederick R. Wulsin, "National Geographic Central China Expedition Journals," Vol. 3, Frederick Roelker Wulsin Papers, bMS Am 1329 (44-48), Houghton Library.

230. Ibid.
231. Ibid.
232. Ibid.

233. Janet E. Wulsin to Mother, Choni, September 8 and 10, 1923.

234. Frederick R. Wulsin, "National Geographic Central China Expedition Journals," Vol. 3, Frederick Roelker Wulsin Papers, bMS Am 1329 (44-48), Houghton Library.

235. Ibid.

236. Janet E. Wulsin to Mother, Choni, September 8 and 10, 1923.

237. Frederick R. Wulsin, "National Geographic Central China Expedition Journals," Vol. 3, Frederick Roelker Wulsin Papers, bMS Am 1329 (44-48), Houghton Library.

238. Janet E. Wulsin to "Viggy" (Anne Lyman Roelker), Peking, October 30, 1923, Wulsin Family Papers, bMS Am 2069 (154), Houghton Library.

239. Frederick R. Wulsin, "National Geographic Central China Expedition Journals," Vol. 3, Frederick Roelker Wulsin Papers, bMS Am 1329 (44-48), Houghton Library.

240. Ibid.

241. Janet E. Wulsin to Mother, Choni, September 8 and 10, 1923.

242. Ibid.

243. Joseph Rock, "Life Among the Lamas of Choni," *National Geographic*, November 1928, 572.

244. Frederick R. Wulsin, "National Geographic Central China Expedition Journals," Vol. 3, Frederick Roelker Wulsin Papers, bMS Am 1329 (44-48), Houghton Library.

245. Ibid.

246. Ibid.

247. Rock, "Lamas of Choni," 586.

248. Ibid., 611.

249. Frederick R. Wulsin, "National Geographic Central China Expedition Journals," Vol. 3, Frederick Roelker Wulsin Papers, bMS Am 1329 (44-48), Houghton Library.

250. Rock, "Lamas of Choni," 576, 580.

251. Ibid., 606.

252. Frederick R. Wulsin, "National Geographic Central China Expedition Journals," Vol. 3, Frederick Roelker Wulsin Papers, bMS Am 1329 (44-48), Houghton Library.

253. Rock, "Lamas of Choni," 584.

254. Ibid., 602.

255. Ibid.

256. Ibid.

257. Frederick R. Wulsin, "National Geographic Central China Expedition Journals," Vol. 3, Frederick Roelker Wulsin Papers, bMS Am 1329 (44-48), Houghton Library.

258. David-Neel, My Journey to Lhasa, 214.

259. Frederick R. Wulsin, "National Geographic Central China Expedition Journals," Vol. 3, Frederick Roelker Wulsin Papers, bMS Am 1329 (44-48), Houghton Library.

260. Ibid.

261. Ibid.

262. Ibid.

263. Ibid.

264. Janet E. Wulsin to Father and Mother, Lanchow, September 29 and October 4, 1923.

265. Ibid.

266. Frederick R. Wulsin, "National Geographic Central China Expedition Journals," Vol. 3, Frederick Roelker Wulsin Papers, bMS Am 1329 (44-48), Houghton Library.

267. Ibid.

268. Janet E. Wulsin to Father and Mother, Lanchow, September 29 and October 4, 1923.

269. Ibid.

270. Ibid.

271. Ibid.

272. Ibid.

273. Ibid.

274. Ibid.

275. Janet E. Wulsin to Father and Mother, Ninghsia, Kansu, October 15, 1923.

276. Janet E. Wulsin to Father and Mother, Lanchow, September 29 and October 4, 1923.

277. Ibid.

278. Frederick R. Wulsin, "National Geographic Central China Expedition Journals," Vol. 3, Frederick Roelker Wulsin Papers, bMS Am 1329 (44-48), Houghton Library.

279. Janet E. Wulsin to Father and Mother, Ninghsia, Kansu, October 15, 1923.

280. Ibid.

281. Frederick R. Wulsin, "National Geographic Central China Expedition Journals," Vol. 3, Frederick Roelker Wulsin Papers, bMS Am 1329 (44-48), Houghton Library.

282. Janet Wulsin to Father and Mother, Ninghsia, Kansu, October 15, 1923.

283. Ibid.

284. Frederick R. Wulsin, "National Geographic Central China Expedition Journals," Vol. 3, Frederick Roelker Wulsin Papers, bMS Am 1329 (44-48), Houghton Library.

285. Janet E. Wulsin to Father and Mother, Lanchow, September 29 and October 4, 1923.

286. Frederick R. Wulsin, "National Geographic Central China Expedition Journals," Vol. 3, Frederick Roelker Wulsin Papers, bMS Am 1329 (44-48), Houghton Library.

287. Janet E. Wulsin to "Viggy" (Anne Lyman Roelker), 34 Shui Mo Hutung, Peking, October 30, 1923, Wulsin Family Papers, bMS Am 2069, Houghton Library.

288. Janet E. Wulsin to Father and Mother, Peking, October 30, 1923.

289. Ibid.

290. Janet E. Wulsin to Katharine R. Wulsin, Peking, January 7, 1924, Wulsin Family Papers, bMS Am 2069 (147) Houghton Library.

291. Janet E. Wulsin to Father and Mother, Peking, October 30, 1923.

292. Ibid.

293. Ibid.

294. Peter Hopkirk, introduction to Alexandra David-Neel, *My Journey to Lhasa* (London: Virago Press) 1983, p. ix.

295. Janet E. Wulsin to Katharine R. Wulsin, Peking, January 7, 1924, Wulsin Family Papers, bMS Am 2069 (147), Houghton Library.

296. Janet E. Wulsin to Katharine R. Wulsin, Peking, January 20, 1924, Wulsin Family Papers, bMS Am 2069 (147), Houghton Library.

297. Janet E. Wulsin to Katharine R. Wulsin, Peking, January 7, 1924, Wulsin Family Papers, bMS Am 2069 (147), Houghton Library.

298. Ibid.

299. Ibid.

300. Janet E. Wulsin to Family, December 27, 1923, Hobart-Wulsin family Archives.

301. Janet E. Wulsin to Katharine R. Wulsin, Peking, January 20, 1924, Wulsin Family Papers, bMS Am 2069 (147), Houghton Library.

302. Frederick R. Wulsin to Janet E. Wulsin, telegraph, August 15, 1924, Wulsin Family papers, bMS Am 2069 (147), Houghton Library.

303. Frederick R. Wulsin to Katharine R. Wulsin, March 24, 1924, bMS Am 2069, Houghton Library.

304. Janet E. Wulsin to Katharine R. Wulsin, Southampton, August 15, 1924, Wulsin Family Papers, bMS Am 2069 (147), Houghton Library.

BIBLIOGRAPHY

Primary Sources

Julia Coolidge Deane Papers, Schlesinger Library, Radcliffe Institute for Advanced Studies, Harvard University.

Henry Crosby Emery Papers, 1908–1985 (bulk 1917–1924), call Number: M210, Bowdoin College Library, Special Collections and Archives, Brunswick, Maine.

Frederick R. Wulsin Papers, Accession 56-55, box I, Peabody Museum, Harvard University.

Wulsin Family Papers, 1860-1933: bMS Am 2069 and bMS Am 1329, Houghton Library, Harvard University.

Secondary Sources

Alonso, M. E. *China's Inner Asian Frontier: Photographs of the Wulsin Expedition to Northwest China in 1923.* Cambridge, Mass.: The Peabody Museum of Archaeology and Ethnology, Harvard University, 1979.

Aris, Michael. *Lamas, Princes, and Brigands: Joseph Rock's Photographs of the Tibetan Borderlands of China.* New York: China House Gallery, 1992.

Beer, Robert. *The Encyclopedia of Tibetan Symbols and Motifs.* Boston: Shambhala, 1999.

Blanch, Lesley. *The Wider Shores of Love.* New York, Simon and Schuster, 1954.

Bland, J. O. P., & E. Blackhouse. *China Under the Empress Dowager.* Boston and New York: Houghton Mifflin Company, 1914.

Bredon, Juliet. *Peking: A Historical and Intimate Description of Its Chief Places of Interest.* Shanghai: Kelly and Walsh, 1922.

Carey, William. *Adventures in Tibet.* New York: Baker and Tayler Company, 1901.

David-Neel, Alexandra. *My Journey to Lhasa.* London: Virago, 1983 [First published by Wm. Heinemann, 1927).

David-Neel, Alexandra. *My Journey to Lhasa.* Boston: Beacon Press, 1993.

Etherton, Col., P. T. *In the Heart of Asia.* London: Constable and Company, 1925.

Fairbank, John K. and Edwin O. Reischauer. *East Asia; Tradition and Transformation.* Boston: Houghton Mifflin Company, 1973.

Farrer, Reginald. *On the Eaves of the World.* (2 vols.) London: Edward Arnold, 1917.

——. *The Rainbow Bridge.* London: Edward Arnold and Co., 1921.

Fletcher, Joseph. *A Brief History of the Chinese Northwestern Frontier: China Proper's Northwest Frontier: Meetingplace of Four Cultures.* The Peabody Museum of Archaeology and Ethnology, Harvard University, 1979.

Gallenkamp, Charles. *Dragon Hunter: Roy Chapman Andrews and the Central Asiatic Expeditions.* New York: Penguin Putnam, 2001.

Geniesse, Jane Fletcher. *Passionate Nomad, The Life of Freya Stark.* New York: Random House, 1999.

Gillin, Donald G. *Warlord: Yen Hsi-shan in Shansi Province 1911-1949.* Princeton, N.J.: Princeton University Press, 1967.

Hsieh, Chiao-min, and Jean Kan Hsieh. *China: A Provincial Atlas.* New York: Simon and Schuster, Macmillan Publishing USA, 1996.

Holdich, Col. Sir Thomas H. *Tibet the Mysterious.* New York: Frederick A. Stokes Company, 1906.

Kendall, Elizabeth. *A Wayfarer in China.* Boston: Houghton Mifflin Company, 1913.

Knaus, John Kenneth. *Orphans of the Cold War: America and the Tibetan Struggle for Survival.* New York: Public Affairs, Perseus Book Group, 1999.

Lesdain, Comte de. *From Pekin to Sikkim: Through the Ordos, the Gobi Desert, and Tibet.* New York: E. P. Dutton and Co., 1908.

Lhalungpa, Lobsang P. *Tibet: the Sacred Realm.* New York: Aperture, 1983.

Li Chien-Nung. *The Political History of China 1840–1928.* Princeton, N.J.: D. Van Nostrand Company, 1956.

Liu Bin, ed. *Atlas of China.* China: China Cartographic Publishing House, 1999.

Man, John. *Gobi: Tracking the Desert.* London: Weidenfeld and Nicolson, 1997.

Meisner, Maurice. *Li Ta-Chao and the Origins of Chinese Marxism.* Cambridge, Mass.: Harvard University Press, 1967.

Nietupski, Paul Kocot. *Labrang: A Tibetan Buddhist Monastery at the Crossroads of Four Civilizations.* Ithaca, N.Y.: Snow Lion Publications, 1999.

Polk, Milbry and Mary Tiegreen. *Women of Discovery: A Celebration of Intrepid Women Who Explored the World.* New York: Clarkson Potter, 2001.

Preston, Diana. *The Boxer Rebellion.* New York: Walker & Co., 1999.

Rockhill, William Woodville. *The Land of the Lamas: Notes of a Journey through China Mongolia and Tibet.* New York: The Century Co., 1891.

Rijnhart, Dr. Susie. *With the Tibetans in Tent and Temple.* New York: Fleming H. Revell Company, 1901.

Snow, Edgar. *Red Star Over China.* New York: Random House, 1938.

Sheridan, James E. *Chinese Warlord: The Career of Feng Yu-hsiang.* Stanford: Stanford University Press, 1966.

Teichman, Eric. *Travels of a Consular Officer in Eastern Tibet.* Cambridge: Cambridge University Press, 1922.

Tuchman, Barbara. *Stillwell and the American Experience in China, 1911–45.* New York: Macmillan Publishing Co., 1970.

Wellby, M. S. *Through Unknown Tibet.* London: T. Fisher Unwin, 1898.

Werner, E. T. C. *Myths & Legends of China.* London: George G. Harrap and Co. Ltd, 1922.

Younghusband, Col. Francis Edward. *The Heart of a Continent.* New York: Charles Scribner's Sons, 1904.

——, ed. *Peking to Lhasa.* London: Constable and Company, 1925.

ACKNOWLEDGEMENTS

My extended journey to the vanished kingdoms of China, Mongolia, and Tibet has left me indebted to many generous and talented people. There would never have been any book without the years of encouragement from my children, John Hobart Wentworth, Elizabeth Wentworth Yates, Alexandra Elliott Stephanopoulos, and Fiona Brandon. Their insistence that I tell the story of their grandmother gave me the courage to begin the journey. My brother, Dr. Howard Elliott Wulsin, provided indispensable support as I journeyed step by step through the vast accumulation of photographs, letters, and diaries at Harvard University, Bowdoin College, Haverford College, Tufts University, The National Geographic Society, and the Smithsonian Institution.

An expedition always relies heavily on a few key guides. Mine were my extraordinary husband, Louis Wellington Cabot, who not only provided hundreds of images, often copied late at night, but also read proof after proof of the text, and helped me understand the complexities of modern technology. To him I owe an entire lifetime of gratitude.

My other guide has been my wonderful research assistant, Lindsey Shaw. She arrived miraculously on the project from a small notice posted on the bulletin board of a local delicatessen, and has continued to cause wonder and astonishment by bringing order out of potential chaos. The tenacity that Janet Wulsin showed when she scaled the mountainsides of Western China has been reflected daily in Lindsey's work. Her dedication, wisdom, and humor have been invaluable. My thanks are beyond words.

A team of advisers and friends helped me in so many different ways. My agent, Kathleen Anderson, approved the concept when I was at a very early stage. The late Michael Hoffmann took one look at the photographs and said, "There's a book here." These two consummate professionals gave me their benediction at a crucial stage. My editor, Phyllis Thompson Reid, and the designer, Michelle Dunn Marsh, are award winners in every way. Other friends at Aperture offered encouragement and help along the way—Janice Stanton, Michael Famighetti, Lisa Farmer, Sara Federlein, and the late Paul Gottlieb. Aperture Trustee Barnabas McHenry was a friend and supporter from the beginning when my climb to completion seemed most daunting. As usual, he made things happen.

Every expedition hopes for a miraculous discovery. My search was rewarded through an e-mail from a stranger. Clark Worswick, curator of photography, the Peabody Essex Museum, Salem, Massachusetts, was familiar with the Wulsin photographic archives and answered my blind call one spring afternoon. He instantly became a friend, and his advice on every aspect of the book, the exhibition, printing, and design was honored at every turn. To have an expert of his taste and sensitivity involved was a gift from heaven. He, in turn, brought two great experts in the science of imaging to the project—H. L. Hoffenberg and Fernando Azevedo became crucial members of the team immediately, and their enthusiasm and knowledge were invaluable in the creation of the book as well as the photographic exhibition.

The Peabody Museum of Archaeology and Ethnology, Harvard University, opened their photographic archives for almost two years. Dr. Rubie Watson, Director, believed in the book and did everything possible to provide access to research facilities inside and outside of the Peabody Museum. Her guidance and enthusiasm have been invaluable. Genevieve Fisher, the cheerful, energetic registrar, and her helpful assistant, Amy Cay, never seemed daunted by any request, and moved with efficiency and good cheer throughout the journey. Nasrin Rohani was most kind and helpful while she was the Archivist at the Peabody Museum photographic archives. Susan Haskell, archivist, was helpful with the Janet Elliott Wulsin archives.

Every journey reaches difficult passages, and challenges. Dr. Jeremy Knowles, and his wife, Jane, helped open doors at Harvard at a crucial time when many were shut to an outside scholar. Cathy S. Hunter, archivist, Archives and Record Library, the National Geographic Society; Neil S. Philip, manager/editing and research, National Geographic Society Image Collection; and William C. Bonner,

archivist, Image Collection, all helped enormously in accessing the Wulsin collection materials.

The Houghton Library, Harvard University, became the sanctuary where the Wulsin journey came to life through letters, diaries, logs, and maps. It took over four years to follow the trail under the wonderful care of Elizabeth A. Falsey, Reader Services librarian, Thomas P. Ford, reference assistant, and Melissa Banta.

Harvard University provided invaluable help in many departments. At the Arnold Arboretum, Robert Cook, director, and his able staff of Carol David and Judy Green enabled me to examine their extensive collection of the photographs of Joseph Rock. At the Yen Ching Institute, doctoral candidate Romain Graziani spent much time translating documents, sharing information, helping to decipher the database, and sharing crucial volumes for research. Dr. Raymond Lum was kind in showing us other photographic collections, and Lex Berman, The Yen Ching Institute, Harvard University, miraculously provided modern translations of old geographic names to modern titles.

My thanks to Robert Forget, who created the beautiful maps for the book.

The archives at the Smithsonian Institution provided rich materials about the Wulsin expedition. The botanical and zoological collections from the two Wulsin expeditions still reside in the storage of the Smithsonian. Susan Wilkerson, Registrar, National Museum of Natural History, was most helpful in locating data. Tracy Robinson provided invaluable help at the Smithsonian Institution Archives, and David Burgevin kindly copied several important photographs of the To Run tribespeople.

Other generous university libraries allowed me access and helped copy thousands of pages of documents. Their interest and support made the journey so much easier. At the Bowdoin College Library, Richard Lindemann, director, Special Collection and Archives, and Sean Monahan were most generous with their time. At Haverford College, Joelle Bertolet opened the extensive Allinson Family archives, which showed us new trails to follow. At the John Hay Library, Brown University, Martha Marshall was helpful, and at Tufts University, Anne Sauer helped open the Frederick R. Wulsin papers.

No journey is complete without friends. Mine was no exception. In the beginning there were Helen Cabot McCarthy and Melissa Price, who tirelessly transcribed thousands of letters and documents. Jay Deane Crowley made available the marvelous letters of her mother, Julia Coolidge Deane. My sister-in-law, Maud Howe Rheault, gave crucial insights into the Wulsin family. Jane Fletcher Geniesse offered the use of her late brother Joseph Fletcher's manuscripts and archives, and her wonderful book, *Passionate Nomad: The Life of Freya Stark*, served as a daily inspiration. Diana Rowan Rockefeller introduced me to Alexandra David-Neel and shared her brilliant introduction, and Susan Lodge, Lea Iselin, and Mary Enriquez offered support from the sidelines. My niece, Anne Wulsin, and my nephew, Peter Wulsin, were on the journey from the beginning and provided a constant chorus of support.

Then came the wonderful understanding and encouragement from E. Gene Smith, executive director, Tibetan Buddhist Resource Center. Lisa A. Schubert, director, Rubin Museum of Art; Rob Linrothe, curator Himalyan Art and Special Exhibitions, Shelley and Donald Rubin Cultural Trust; and Donald Rubin offered encouragement and support. Jane Gregory Rubin understood the importance of the project from the beginning, and encouraged support from the Reed Foundation, Inc., for a most generous grant. Over a wonderful luncheon Leila Hadley Luce offered additional encouragement as another woman explorer. A new friendship with Milbry Polk, an explorer herself and expert and scholar on intrepid women explorers as shown in her wonderful book, *Women of Discovery*, gave me much inspiration. Martha Avery, a pioneer in her own way, offered to help with the Mongolian exhibition. Other friends who offered encouragement and help in many different ways were Harold Talbott, Elsie Walker, Marieve Rugo, Pebble Gifford, and Sherrye Henry.

My special thanks to Elizabeth Drew, George Stephanopoulos, Diane Sawyer, Cokie Roberts, Milbry Polk, and Professor Romain Graziani for their generous remarks about the book.

—MABEL H. CABOT,
Cambridge, Massachusetts

APERTURE GRATEFULLY ACKNOWLEDGES
THE FOLLOWING INDIVIDUALS AND ORGANIZATIONS
FOR MAKING THIS PUBLICATION POSSIBLE:

THE HONORABLE CARLETON S. COON, JR.

THE FIDELITY CHARITABLE TRUST FUND

THE AMBROSE MONELL FOUNDATION

THE REED FOUNDATION

THE WULSIN FAMILY

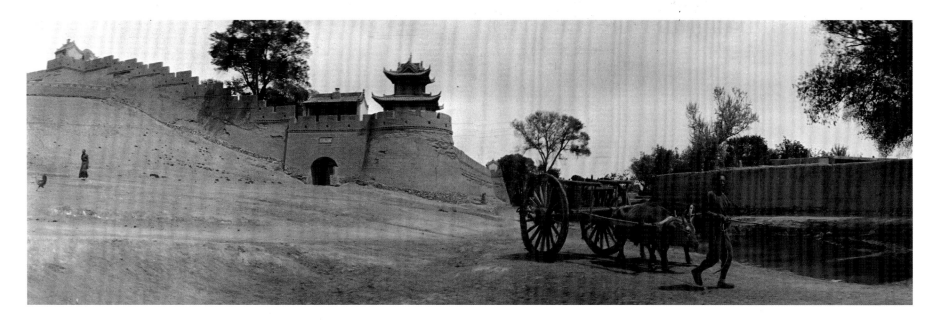

Photographs on pages 19 (all), 21 (right), and 178 courtesy and copyright the Hobart-Wulsin family archives; photographs on page 21 (left), 24, 61, 70 (left), and 142 (both) courtesy the Wulsin Family Papers, The Houghton Library, copyright © the President and Fellows of Harvard College, Harvard University, Cambridge, MA; photographs on pages 160–162 courtesy the Photographic Archives of the Arnold Arboretum, copyright © the President and Fellows of Harvard College, Harvard University, Cambridge, MA; all other photographs are courtesy the Frederick R. Wulsin Photographic Collection, The Peabody Museum of Archaeology and Ethnology, Harvard University and are copyright the President and Fellows of Harvard College, Harvard University, Cambridge MA.

Library of Congress Catalog Card Number: 20-02110404
Hardcover ISBN: 1-931788-08-1
Paperback ISBN: 1-931788-18-9

EDITED BY PHYLLIS THOMPSON REID
DESIGN BY MICHELLE DUNN MARSH

Separations by Koford Prints, PTE, Ltd.
Printed and bound by Tien Wah Press (PTE) Ltd., Singapore

The Staff at Aperture for *Vanished Kingdoms*:
Janice B. Stanton, Deputy Executive Director
Lisa A. Farmer, Production Director
Michael Famighetti, Assistant Editor
Bryonie Wise, Production Associate

Aperture Foundation publishes a magazine, books, and portfolios of fine photography and presents world-class exhibitions to communicate with serious photographers and creative people everywhere. A complete catalog is available upon request.

Aperture Foundation, including Book Center and Burden Gallery:
20 East 23rd Street, New York, New York 10010. Phone: (212) 505-5555, ext. 300. Fax: (212) 979-7759.

Visit Aperture's website: www.aperture.org

To subscribe to *Aperture* magazine, write Aperture, P.O. Box 3000, Denville, New Jersey 07834, or call toll-free: (866) 457-4603. One year: $40.00. Two years: $66.00. International subscriptions: (973) 627-2427. Add $20.00 per year.

First Edition
10 9 8 7 6 5 4 3 2 1